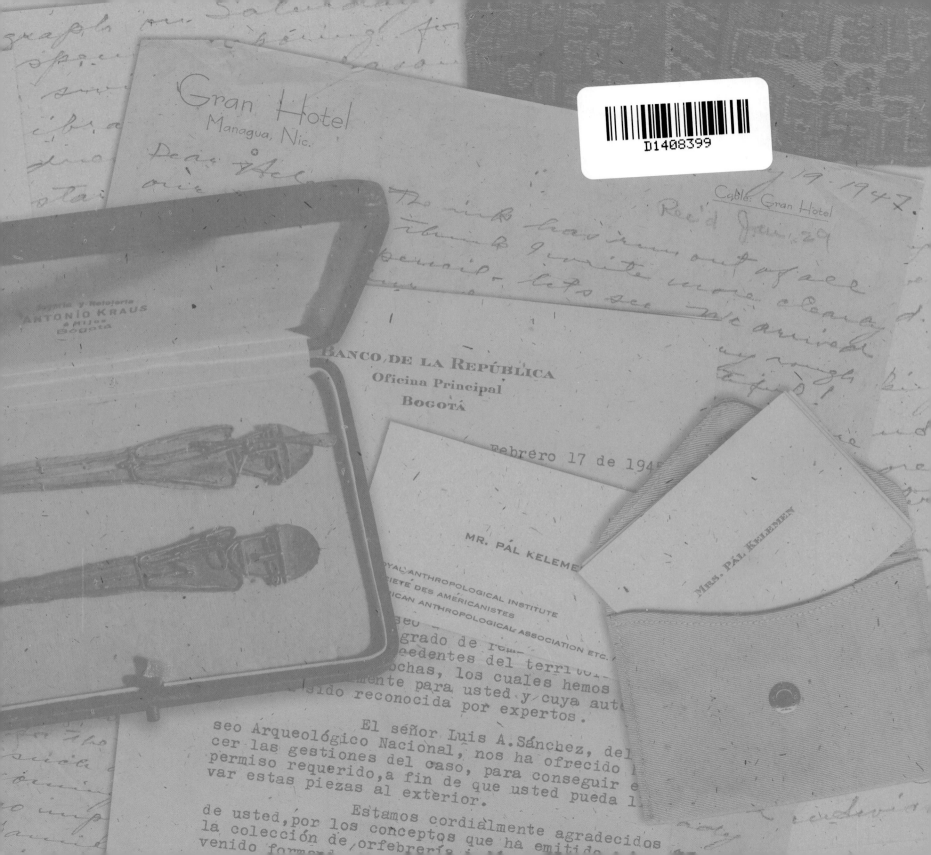

THE KELEMEN JOURNALS

THE KELEMEN JOURNALS

INCIDENTS OF DISCOVERY OF ART IN THE AMERICAS, 1932–1964

by Pál and Elisabeth Kelemen

Edited by Judith Hancock Sandoval | Foreword by Mary E. Miller

SUNBELT PUBLICATIONS

SAN DIEGO, CALIFORNIA

The Kelemen Journals
Copyright © 2005 by Sunbelt Publications

Sunbelt Publications, Inc.
All rights reserved. First edition 2005
Edited by Judith Hancock Sandoval
Copy editing by Laurie Gibson
Book and cover design by Kathleen Wise
Production Coordination by Jennifer Redmond
Printed in the United States of America

Sunbelt Publications, Inc.
P.O. Box 191126
San Diego, CA 92159-1126
(619) 258-4911, fax: (619) 258-4916
www.sunbeltbooks.com

08 07 06 05 04 5 4 3 2 1

Kelemen, Pál.
 The Kelemen journals : incidents of discovery of art in the Americas, 1932–64 / by Pál and Elisabeth Kelemen; edited by
Judith Hancock Sandoval. — 1st ed.
 p. cm.
 Includes bibliographical references and index.
 ISBN 0-932653-67-7 (alk. paper)
 1. Kelemen, Pál — Diaries. 2. Kelemen, Elisabeth Zulauf — Diaries.
3. Mayas — Antiquities. 4. Maya art. 5. Maya
architecture. 6. Mexico — Antiquities. 7. Mexico — Description and travel. 8. Central America — Description and travel. I.
Kelemen, Elisabeth Zulauf. II. Sandoval, Judith Hancock de. III. Title.

F1435.K44 2005
972 — dc22

 2004022742

DEDICATED TO THE MEMORY OF PÁL AND ELISABETH KELEMEN—

A LIFE OF INTELLECTUAL PASSION ALONG WITH GREAT ADVENTURE;

A STEADFAST FOCUS; AND A MUTUAL LOVE AND SUPPORT RARELY SEEN.

CONTENTS:

AT SOME POINT IN THE FUTURE, a larger picture of the origins of pre-Columbian art history will be drawn, but the opportunity to comment on the work of Pál Kelemen brings the period of the 1940s into focus. Art history had yet to determine its relationship to archaeology and anthropology—and of course, one might say that this is still an ongoing question at the beginning of the twenty-first century—but in retrospect, one can see that the late 1930s and 1940s were critical years, in both the United States and Mexico. The names that would shape the field saw their first works published—Pál Kelemen, George Kubler, and Salvador Toscano. The decade started off with enormous public impact as well, for the first great exhibition of Mexican art in the United States, "Twenty Centuries of Mexican Art," opened at the Museum of Modern Art (MoMA) in New York in May 1940, brought together by Nelson Rockefeller, then the museum's president; by 1949, he would finesse the appointment of Rene D'Harnoncourt, the first great promulgator of non-Western art in the United States, as the museum's director, leading to first, exhibitions of pre-Columbian art, and later, MoMA's spin-off, the Museum of Primitive Art (now the Rockefeller wing of the Metropolitan Museum of Art). In short, this was a time of transformation and ferment, when universities and colleges began to offer courses and when art history would take its first hesitant steps on its own.

Kelemen had come to the New World from Hungary in 1932. But from 1926 onward he had been observing pre-Columbian art and thinking about its aesthetic merit—rarely a subject before that time. Roger Fry had written about pre-Columbian art in 1918 in ways that resonated for Kelemen—and perhaps first drew him to the material: "Still more recently we have come to recognize the beauty of Aztec and Maya sculpture... [in] the revolt against the tyranny of the Graeco-Roman tradition." Fry went on to say that "Unfortunately we have to learn almost all we know of Maya culture through their Aztec conquerors, but the ruins of the Yucatán and Guatemala are by far the finest and most complete vestiges left to us," and this may have been part of what prompted Kelemen to visit the Yucatán and write his first book, *Battlefield of the Gods*. But more of that shortly.

What struck Pál Kelemen after his arrival in the United States—as indeed, it has struck me many times in my own life as an art historian—is that, at the time, he could find little to read on pre-Columbian subjects other than the highly specific archaeological site report. Where was the book a well-educated person outside the field might read? Few words had ever been put down—other than those by Fry, some remarks by William Henry Holmes, and the works of Herbert Spinden—about the aesthetic merit of the works, or how they related among themselves. He set out to create a comprehensive history of the art, and he went to see the person we might think of as the "dean" of pre-Columbian studies of the period, Alfred M. Tozzer, the Bowditch Professor at Harvard, who encouraged him in the task. Over the course of a decade, Kelemen tracked down works to add to his compendium, establishing what continues to be the heart of the pre-Columbian canon. He included a few works we can ascertain to be fakes today, but in general, his eye was sure, and he also had a keen sense of the photographed image. Although in black and white, the photographs he directed of the gold objects from Mexico's Monte Alban Tomb VII, for example, reveal a volumetric quality rarely noted and not evident in the conventional straight-on shots; his juxtapositions of figurines of women with children remain insightful in and of themselves today.

When *Medieval American Art* was published in 1943, the lavish two-volume set received almost unanimous raves, starting with the *New York Times Book Review*. Some reviewers found the title perplexing, as indeed do readers today (the term "Mesoamerican" had not yet come into currency, and in any case, Kelemen sought to bring together works from the U.S. Southwest, Mexico, Central America, and the Andes; he also sought to downplay the emphasis that "pre-Columbian" inadvertently gave to Christopher Columbus), but the sheer importance of the assemblage overrode their concerns. Archaeologists wrote the reviews—since this book would be the first "survey" of their field from a different point of view. From Mexico, Alfonso Caso gave the book his highest marks; J. Alden Mason confessed that his commentary was so favorable as to be more "advertisement than review." Linton Sattherthwaite concluded that it was "magnificent." Philip Ainsworth Means extolled the book's many virtues, from the pictures to the typography, from the scholarship to the meticulous presentation, from the organization in general to the somewhat more polemical final chapter, "Evolution or Influence," which dealt with what was and would remain a burning question: was New World civilization an independent invention or the result of contact with the Asia, Europe, and Africa? Kelemen agreed with his archaeological colleagues in seeing New World evolution and denying Old World influence: his pictures effectively demonstrated the subtle connections among works, and by this means, helped one's eye to see—rather than to leap to long-distance conclusions. George Vaillant, an anthropologist whose own popular book, *The Aztecs of Mexico*, had just appeared, wrote what was the most critical review in the *Art Bulletin* (the professional journal of art history), but he ended his comments by saying that "[Kelemen] has presented with sympathy, dignity, and enthusiasm the proof that American Indians had developed an impressive art." In 1956, when the one-volume edition came out, Tatiana Proskouriakoff still treated it as the gold standard for pre-Columbian art history.

Along the way, Kelemen acquired an antagonist, and like many such acquisitions, it did not serve either one of them well. George Kubler (much later to be my adviser in Yale's History of Art Department) reviewed Kelemen's first book, *Battlefield of the Gods*, a slight travel book published only in England, in U.S. archaeology's principal journal, *American Antiquity*. Kubler had just received his Ph.D. for his work on sixteenth-century Mexican churches, and he was teaching pre-Columbian, Iberian, and Spanish colonial art at Yale; he had yet to publish a book himself, but he undoubtedly knew of Kelemen's project in the offing. He called *Battlefield* "at the most charitable, incompetent," which initiated a torrent of ink from Sir Eric Thompson, who lashed out (and this, written during the Battle of Britain), "After reading the verbal Blitzkrieg which Mr. Kubler loosed against Mr. Kelemen's *Battlefield of the Gods* in the issue of *American Antiquity* for April, 1940, one wonders if Teutonic frightfulness is being introduced into American archaeological circles. Never have I read such a bitter, malicious, and arrogant attack." Thompson went on to close with the notice that "no review copies [of *Battlefield*] were sent to scientific publications, and Mr. Kubler's review, if one can call it that, was submitted by him unsolicited."

Thompson, of course, was a senior Mayanist, working for the Carnegie Institution of Washington, and close to colleagues at Harvard. Lines were drawn in the sand between Harvard and Yale, between Maya archaeology and Kubler, between academic art historians and archaeologists in the field. Quickly those lines became fences and then walls. Kubler wrote about the state of Latin American art history in 1942 and 1944, mentioning the nascent development of "professional art historians"; Kelemen wrote a major review article for *American Antiquity* in 1946, "Pre-Columbian Art and Art History," in which he decried the hardening of lines around institutional and academically trained art historians. Kelemen noted the role that the amateur had played all along in New World studies: little did he know the role that amateurs would play in the decipherment of Maya hieroglyphic writing just a few years later, although he probably was not surprised when it happened. And little did he know that his *Medieval American Art*, a landmark for a generation, would be pushed aside by the work of another "non-professional," Miguel Covarrubias, who wore the hats of painter, cartoonist, collector, archaeologist, or art historian when it suited him, and whose book, *Indian Art of Mexico and Central America*, would appear to great posthumous acclaim in 1957. Kubler remained vigilant against the non-art historian, calling Covarrubias only "a Mexican painter" in noting the book.

Kelemen declined the opportunity to hold fellowships, in his firm belief that such emoluments should go to those who needed them. But in so doing, he also determined that he would retain his amateur status. The times were changing, and it would become increasingly difficult to work outside the academy. Later, the museum would have a voice in shaping the course of art history, but particularly in the 1950s, 1960s, and 1970s, art history departments determined the course of the discipline. In pre-Columbian studies, George Kubler began to train art historians for the doctorate, beginning with Donald Robertson in 1957; ultimately this effort would push Kelemen's generation outside the academy to the margins.

Years later, when I first studied pre-Columbian art with Gillett Griffin, we read the Covarrubias book as our text, along with the relatively new archaeological books of Michael Coe. Both Kelemen's *Medieval American Art* and Kubler's later *Art and Architecture of Ancient America* (1962) sat on the reserve bookshelf for us to consult. When I was working on my dissertation at Dumbarton Oaks a few years later, Betty Benson urged me first to write, and then to visit Pál Kelemen, and I did so in 1982, returning the next year with Mike Coe, who much enjoyed meeting this legend of pre-Columbian studies. I had driven up to Norfolk, Connecticut, from New Haven with trepidation, but Pál and Elisabeth received me warmly; the visits were renewed annually until the Kelemens decided to stay in La Jolla, California, year-round. I told Pál that I intended to write a new survey of Mesoamerican art—that none of the existing books—Covarrubias, Kelemen, or Kubler—worked in my classroom. He accepted the fact that his book had served a generation, and served it well. It was time to move on, and perhaps it was also time for the enmities of the 1940s to be laid to rest at last.

—MARY E. MILLER
ART HISTORIAN, YALE UNIVERSITY

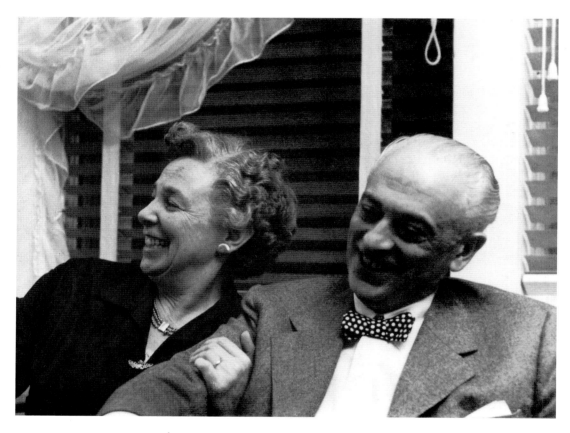

ELISABETH AND PÁL KELEMEN, PHOTOGRAPHED DURING AN INTERVIEW
AT AUSTIN, TEXAS, IN 1953.

IT WAS FEBRUARY 1993. Pál Kelemen was 98 years old and his wife, Elisabeth, 94 years old. He had slowed down a great deal and was tired and quiet most days. She had suffered a major stroke a year earlier yet had worked her way back in her speech, to minimal writing and some assisted walking. She realized it was February 14th, Valentine's Day, and that she had had little conversation with Pál that day. She asked me for a yellow pad and pencil and with a halting hand she drew a very large heart. She proceeded slowly to write a love note to Pál within that heart...

> *To my only love—*
> *Thou best friend of mine and*
> *I am thine.*
> *I have locked there in my Heart*
> *That is the little key so fine.*
> *Searched far and wide to find it,*
> *We found it together.*
> *You must stay in there forever.*
> *Love and kisses —* ELISABETH Z.K.

She then asked me to wheel her into Pál's room where he was resting and she placed her valentine at his bedside without disturbing him. My eyes welled up with tears, witnessing this gesture of love between these two lovely people. This was the last such gesture, among many I had seen, for Pál Kelemen died the following morning.

I met Elisabeth and Pál Kelemen the year these memoirs end, 1964, six months before I married one of their "adopted" sons. They were unique people and as a couple quite daunting at times, and yet somehow even upon first meeting them, I knew that just knowing them would bring into my world many new adventures and that I was open to the challenge.

Everything the Kelemens did, they did "from the heart." Whether personal or professional, they were always deeply involved, always working from what they believed in and always working together.

On one occasion, while visiting them in their Connecticut home, I recall a lively discussion with Uncle Pál about art. I had just started studying art history and he engaged me in dialogue, questioning my use of the new (to him) term "Mannerism" as applied to a style of European art after the height of the Renaissance, and as it was particularly applied to El Greco. I realized that this was not a term used within his framework and he wanted me to justify its use. I was slowly learning of Pál's ever-inquisitive and challenging mind.

At another time I recall being with Aunt Elisabeth in their study, going through some of her negatives from their survey trips. She was trying out various methods for storing these negatives so that they could be preserved. She was in her late 80s by this time and had not been photographing for some time. I was discussing with her ideas I had seen at a local camera shop, when she went to the phone, saying she would call the president of Kodak to access the latest and most professional information. Needless to say, I had learned long before that this was a lady who had spent a married life deeply enthusiastic about her career path with her husband and had assisted and supported him through every adventure, with directness, talent, dedication, and modesty.

Pál Kelemen was born April 24, 1894, and died February 15, 1993, just short of his 99th birthday. He was born in Budapest,

Hungary, to parents Joseph and Jenny (Gratt) Kelemen. He was the youngest of four children; the others were Irene, Frigyes, and Olga.

He grew up in a comfortable middle-class family, living on a broad tree-lined avenue close to the heart of the city, a few blocks from the opera and the National Museum. Being considerably younger than all three siblings, he was never close to his family, except for the youngest sister, Olga, whose husband, Emil Boehm, was very much a father surrogate. It was Emil who gave Pál his first job after finishing his schooling, in an import/export business that dealt with spirits, wines, coffees, and teas. Pál speaks, in his *Hussar's Picture Book*, of a secret admiration of his real father that grew only after his own growing-up but that was sadly never expressed.

In this comfortable family life, Pál was surrounded by the arts. He spoke to me about his recollection of growing up with regular chamber music concerts in his home. Music, art, and literature were stressed "for the educated man." Pál attended the universities in Budapest and Berlin with serious interest in the arts, primarily art history. He also attended universities in Munich and Paris as well as doing museum research in Budapest, Vienna, Florence, London, Madrid, and Seville.

By 1914, during the First World War, Pál Kelemen was called into service as an officer in the Light Blue Hussars of the Imperial and Royal Army of the Austro-Hungarian Monarchy. He traveled by horseback through western Europe for four years, adding Italian to his knowledge of Hungarian, German, French, and Spanish languages. Throughout his service to the monarchy he was writing poetry and essays. He carried in his saddlebag a notebook to write down, not the horror of blood and dying, but the feelings and thoughts of a young poet. He filled nineteen notebooks in all, which were culled through by Pál and Elisabeth while they were still in Europe and by 1972 these words were published as *Hussar's Picture Book: From the Diary of a Hungarian Cavalry Officer in World War I*. This book was given second place in a non-fiction contest by *Atlantic Monthly* and Little Brown Company.

At the university in Budapest, Pál continued course work in art history after WWI and worked on a thesis entitled, "Impressionism Before the 19th Century." In his mid-20s his interest shifted to the artist El Greco and his Greek/Byzantine roots. It was during this time Pál attended lectures by Henrick Wolfflin in Munich. In a statement about his early art training, Pál is quoted, "Henrick Wolfflin, a Swiss, was one who greatly influenced my broad humanistic approach to art. Wolfflin taught that a student should reach out for himself what he selects to read and not be restricted by any list prescribed by a professor." This influence shaped his entire career. He was always thinking, reading, and questioning and never forgetting the esthetics of art—nor the people who created it.

Elisabeth Zulauf Kelemen was born in Jefferson, Indiana, December 31, 1898, and died June 6, 1997, also just shy of her 99th birthday. Her mother was Agnes Matilda Hutchings from Madison, Indiana, and the granddaughter of Dr. William Hutchings, whom she wrote about in her *A Horse-and-Buggy Doctor in Southern Indiana 1825–1903* (Madison, Indiana; Historic Madison, Inc., 1973).

Her father, John C. Zulauf, a banker, economist, and lawyer, was born in Switzerland, arriving in the United States as a 1-year-old. He attended Harvard Law School and at 26 became the vice president of Citizens National Bank, and president of Citizens Trust Company, Jeffersonville, Indiana.

Elisabeth had a sister, Agnes, two years older, with whom she was very close. The Zulauf girls grew up in upper-middle class ease and were encouraged to express themselves in music, poetry, and drama throughout their early schooling. When Elisabeth was 19, her father retired from banking and moved the family to New York City. She and her sister both studied music, with Elisabeth attending Wellesley for just one year to reach the eligible age to study with a notable teacher. In a tragic accident, Agnes died, and in grief the three Zulaufs moved to Europe.

In the 1920s, Elisabeth continued her music studies in Italy, Florence, and Milan and much to her acknowledged good fortune, became the only pupil of the great contralto Sigrid Onegin in Munich and later in Berlin. Her parents were living in Florence and the three would spend their summers in the Bavarian mountains near Salzburg, Germany, near Sigrid, who was taking part in the Munich Festival Theater just initiated by Bruno Walter.

Elisabeth wanted to learn to sing German Lieder and oratorios, Mozart and Bach. Her voice was that of a soprano of particular richness

and she sang German, Italian, and French as only a talented linguist could, speaking five languages fluently. This led her naturally to a succession of concerts over four or five seasons (over 100 concerts in all), which included such places as East Prussia (now Poland); throughout Germany, Paris, London, and the United States (New York, Boston, and Chicago) from 1927 to 1929.

In 1930, Elisabeth and Pál met in Lago de Braies, in the Italian Dolomites. Elisabeth was there with Sigrid Onegin and others, including Erika von Telman, who was a famous ingénue with Fritz Reinhardt. Erika von Telman was the daughter of Pál's General in the World War I. As it happened, a group including Elisabeth and Pál drove by car from Italy through the Tirol for a sightseeing tour. Pál acted as guide of this tour, which included Vipiteno, an important resting place after crossing the Bremmer Pass, for he had traveled this area on horseback during the war.

At this time Pál, an art historian and archaeologist, was researching his interest in El Greco in European museums. Elisabeth remembered that their first conversation was on El Greco. Their second topic explored was the ancient American Indian, and why Americans all flocked to Europe instead of investigating their own continent. Elisabeth and Pál found that they both shared deep interests in the fine arts, and each other. They soon decided that he, born in Budapest in the Deak Ferenc utca (street) and she, born in Jefferson, Indiana, on the Ohio River, would find a way to marry.

On May 2, 1932, in Florence, Italy, Elisabeth and Pál became husband and wife. They lived for a while in Florence in a reconstructed farmer's house perched on a bastion of Michaelangelo's fortification walls, with a wonderful view of the city. The Kelemens, along with the Zulaufs, spent a few months touring Europe, making the rounds of several museums and generally indulging in their mutual interests in art. In the fall of that year Elisabeth's parents, apprehensive about the political conditions in Europe, coaxed the newlyweds to spend time in the United States. The Kelemens fully expected to stay for only six months and then return to Europe to live.

In October 1932 it was at the Peabody Museum, Harvard, with Dr. Alfred Tozzer, that Pál recalled moving toward a new direction in his work. It was pursuant of his Spanish research at Harvard in a cellar of the Peabody Museum of Archaeology and Ethnology, that he stumbled upon an authoritative collection, mostly Mayan. "The beauty of it just shouted to me," he was quoted. With no one pursuing this collection, Pál Kelemen decided to take it on.

Pál worked hard to convince Dr. Tozzer that a survey should be written on the esthetic side of pre-Columbian civilizations. He had seen no such surveys so far in following this new area of interest and there were many "holes" of knowledge which needed to be filled. Between 1932 and 1934 Pál started collecting materials on pre-Columbian art for such a work, as it was a little-known subject in Latin America, Europe, and the United States.

In the spring of 1933 Elisabeth and Pál sailed down to the Yucatán on an empty banana boat. Chichén Itzá was being restored by the "greats" of the Carnegie Institution. They slept in huts and showered from a water-filled oil drum on stilts, boiling hot from the tropical sun. From there they went on to Uxmal, reached by a narrow gauge railroad and a model-T Ford, so full of malaria that they had to return before nightfall. *Battlefield of the Gods, Aspects of Mexican Art, History and Exploration, 1937*, was Pál's record of this first venture and his first writing in English. It came out in London and won an award as travel book of the month.

For a while the Kelemens moved easily between Europe and the United States. They initially took three survey trips into Spanish America for their firsthand observations and two to Europe for comparative museum material. Many new photographs were taken by Elisabeth to emphasize artistic qualities and to make the art more comprehensive to the general public. During this time, Pál also lectured in the United States and abroad on pre-Columbian art, bringing the latest results of archaeological research to his audiences. From the very beginning he urged closer relations with our neighbors to the south and the recognition of their great artistic wealth from Spanish colonial times.

The Kelemens were spending the winter of 1938 in Budapest when Hitler marched on Vienna. After a nightmare drive through Nazi Germany, they made it out of Europe and to New York City. They gathered their various belongings stored in Italy, Hungary, and New York and built a home in the hills of northwest Connecticut and called it "The Ark."

In 1943 Pál's *Medieval America Art, Masterpieces of the New World Before Columbus* (Macmillan 1943, '44, '45, '46; reprint by Dover, 1968) made its first appearance.

In the spring of 1945 with commissions from the Pan American Union and the Library of Congress, the Kelemens flew to Colombia, Equador, Peru, and Bolivia—a six-month tour. It was here, impressed with the wealth of colonial material surviving in spite of the general indifference of the population, that Pál decided to make a survey also of this phase of Latin American art history. By this time, Elisabeth had become Pál's official photographer since so much that they wanted to document had never been recorded before. Elisabeth had started taking photographs from their very first venture into the Yucatán and had become quite proficient behind the camera, and invaluable to Pál's objectives.

More trips followed, to Mexico, Central America, and again to Europe to study various museum collections and check up on what were professed to be real and fancied parallels. *Baroque and Rococo in Latin America, Spanish and Portuguese Colonial Period in the Americas 17th and 18th Centuries* (Macmillan, 1951; Dover, 1967) was the result.

In 1956 Pál was lecturer for the United States Information Service in Portugal, Spain, Italy, Greece, and Istanbul, always on Americanistic subjects. Pál and Elisabeth found that in general, the people in the landlocked capitals (with their chauvinism) showed some condescension toward the lecture material, but that the harbor cities of Lisbon, Barcelona, Trieste, Genoa, Salonika, and Istanbul were quite open to the new impressions of the early American art. Also, on this trip, the Kelemens visited Byzantine churches in Crete and Macedonia to further Pál's continued interest in El Greco. By 1961 *El Greco Revisited, Candida, Venice, Toledo, His Byzantine Heritage* (Macmillan, 1961) was published.

It was in 1964 that the Kelemens made their final survey trip, into the Sonora region of Central America in a Jeep wagon equipped with a portable kitchen and sleeping bags all around. They were delighted with the new material they saw and were impressed that at their ages (now in their 60s) they got through the "roughing it" in good shape.

Pál and Elisabeth made a total of ten survey trips throughout Central and South America, including the American Southwest, with Pál making observations, taking notes, and giving lectures as Elisabeth developed her skill in using a camera to make permanent records of what they saw. She was always in full collaboration with Pál in his research, contributing many fine photographs to his publications as well as observations and the editing of final materials. Together these observations and photographs became the basis of all the books authored by Pál.

The Kelemens had no children of their own but were of great influence to many young people both professionally and personally. They considered their "children" a Hungarian-born great nephew who came to the United States in 1948 and lived under their wing while in college and became a Professor of Surgery and leading transplant surgeon on the west coast; and a godson, Sigrid Onegin's son, who became a Professor of Romance Languages at a southern college. There were other young Hungarians who had become good Americans and wives—English, Swiss, and American born, to whom they tried to pass on their vast experiences and personal philosophy and to whom they became surrogate parents.

The Kelemens were a couple whose lives spanned the entire twentieth century. They both came from privileged backgrounds framed by European culture, and yet they enthusiastically embraced a New World art with sensitive eyes and educated minds. As individuals they were both bright, strong, and talented—together those attributes were magnified and resulted in their collaborative efforts in this field of art history. They relished the exploration of this New World art and they set out to reveal the vast artistic richness they saw so that it would not be lost and would be accepted into its rightful place in art history.

—DIANE HINSHAW HALASZ

THE RAW MATERIAL of the Kelemen memoirs includes thousands of pages of handwritten and typed letters, as well as various edited versions and compilations. It is a jumbled and inconsistent body of material, left unorganized at their deaths, although they wanted the memoir published and left funds for it in their wills. The letters were written to Elisabeth's father and, after his death in 1938, mainly to their secretary, Helen Hartman, who re-typed many of the letters upon receipt, and presumably some of the numerous edited versions, if not the last in 1987. Many of the letters have been preserved only in Elisabeth's handwriting; a large number of the original letters are missing, and some versions were cut and pasted into later edits, making retrieval of the originals impossible. Wound into reports of their travels were instructions for handling correspondence, shipping books, housekeeping and the garden in Norfolk, accounting matters, and even shipping instructions for personal items such as Elisabeth's stockings.

Almost all of the letters were signed "Palisabeth," to signify joint authorship. However, Elisabeth Kelemen wrote the letters, by hand or on a typewriter, and was certainly responsible for the form and language of subsequent versions, and probably the books, which credit Pál as the sole author. (Diane Halasz, their niece, has recounted hearing them discuss and argue over work in progress, even into their later years.) The letters are full of the positive attitude, generosity, and delightful spontaneity which characterized Elisabeth all her life. Pál's native language was Hungarian, and he and Elisabeth courted in German. He began learning English at the age of 38 in 1932, when they came to live in New York. An extant version by him of a trip to Nicaragua in the 1940s is an indication of his inability to write coherently in the new language. Much of the research for the books on Latin America, as well as *El Greco Revisited/Candia, Venice, Toledo*, was done in Europe and by corresponding with scholars and institutions in Europe and the Americas, and Pál, Elisabeth, and the secretary likely collaborated.

Elisabeth had been writing since she was a girl; essays, poetry, and her diaries, many of which are preserved and display her talent for expressing emotions and making intelligent observations. Her artistic abilities and training at the Julliard School of Music and with Sigrid Onegin, and her distinguished professional career as a concert performer, gave her increased confidence and sophistication. She devoted herself completely to her husband and his work, from their marriage in 1930 until his death in 1993 and hers in 1997 (they both died just a few months short of the age of 99 years old). In spite of his unfamiliarity with English and close cooperation between them in the production of the books and other writings, the books were credited solely to him. This was perhaps reasonable considering that he was the expert in the visual arts, did most of the research on the subject matter, particularly in libraries, and his ideas, knowledge, and observations were the basis of the books. Elisabeth expressed the wish even in her will, calling it "appropriate," that Pál be given sole credit as the author of the memoir. Their nephew and the executor of their estate, Dr. Nicholas Halasz, agreed with this editor that Elisabeth should be given at least equal credit, since she wrote the letters on which the memoir is based. Her decision to abandon her musical career and become Pál's photographer, chronicler, and helpmate gave him a great wealth of talent, along with the benefits of the lifestyle provided by her inheritance. All through their more than six decades of life together, the brilliant couple enjoyed an unusually seamless meeting of minds and professional cooperation. But although Pál acknowledged her in

the books and in life, this is the first time that Elisabeth is being afforded credit more accurately reflecting her contributions.

In the present memoir, the first chapter is credited to Pál, since only his version exists, and he speaks in the first person. In the other chapters, in respect of "Palisabeth," the teller of the tales is "we," and the individual activities of each Pál and Elisabeth are indicated by using their given names. The memoir has been compiled from the various versions left by the Kelemens, from the first letters from the Yucatán in 1933 to their edit of 1987, when they were almost 90 years old. Apparently, at that time, the projection of their legacy (actually well established since publication of the books decades earlier) took on a different cast and, unfortunately, often did not improve on the original letters and lost much of the charm and enthusiasm of their first impressions. The editor has, therefore, returned to the original letters whenever it was feasible and appropriate, and has revived information, observations, even places and monuments, later included in the books, but omitted from later versions of the memoir. The objective has been to present the best of both of the Kelemens in their clearest voices, and to illuminate the remarkable journeys which inspired their lives and work.

—JUDITH HANCOCK SANDOVAL

ACKNOWLEDGEMENTS

SO MANY PEOPLE ASSISTED in the process of gathering photographs and text for *The Kelemen Journals* that we cannot possibly thank them all. However, below is a list of those without whom this book would not have been published.

From the Latin American Library at Tulane University, Dr. Hortensia Calvo, Director; Dr. David Dressing, Curator of Manuscripts and Photographs; Sara Klein, graduate student and research assistant; and Dr. Guillermo Nañez, former Director.

From Arizona State Museum at the University of Arizona, Dr. Alan Ferg, Curator; Kathy Hubenschmidt, former Director Photography Collections; and also of the University of Arizona, Dr. Bernard L. Fontana, who was a friend of the Kelemens.

We'd also like to acknowledge the contributions of Dr. Sidney David Markman, Professor Emeritus of Art History, Duke University; Dr. Marion Popenoe de Hatch, Director, Department of Archaeology, Universidad del Valle de Guatemala; Charles R. Connolly; Ms. Denise Bacon, a friend of the Kelemens and former Director, Kodaly Center of America; Dr. Suzanne de Borhegyi Forrest, a friend of the Kelemens; Mr. E. Knox (Marq) Mitchell, godson of the Kelemens; Mrs. Gay Mitchell Reynolds, goddaughter of the Kelemens; and Dr. Edith Moravcsik, Department of Linguistics, University of Wisconsin, a relative of the Kelemens.

To Dr. Kornelia Kurbjuhn, special thanks for her tireless work on the manuscript.

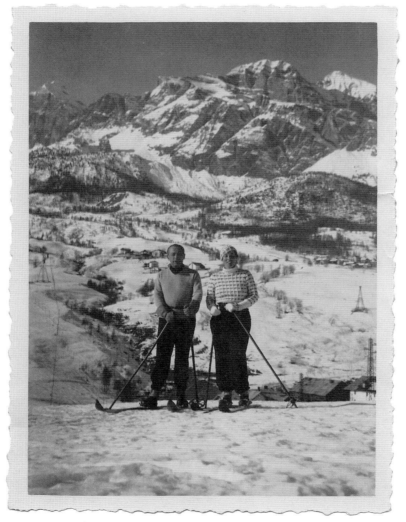

PÁL AND ELISABETH KELEMEN SKIING
IN CORTINA D'AMPEZZO IN THE ITALIAN ALPS, 1935.

COMING TO AMERICA, 1932:
NEW YORK, BOSTON,
AND NEW ORLEANS

IN THE SPRING OF 1932, I married a beautiful girl whom I had met two years before in the Dolomite Alps of northern Italy named Elisabeth Zulauf, an American lyric soprano performing in Europe and traveling with her parents. Our courtship was a tale so romantic that if it were a novel, the critics would call it a fantasy! We planned to reside in Florence so that I could continue my research on the paintings of El Greco. But after living for ten years in Italy, Elisabeth's parents, who were originally from Jeffersonville, Indiana, wanted to return to New York and to have me learn about life in the United States. They suggested that we come to the United States for a six-month visit, and that I use the opportunity for research at important libraries and museums. I was rather reluctant at first. The word "America" in those days comprised, for many, the entire Western Hemisphere, with little distinction between North and South America. So I made it clear that I expected to visit only, neither to bask in the lap of luxury nor to hide from the law for some misdeed at home! Afterwards we would return to Europe and continue our life there.

In early October, we booked passage on the *Bremen*, a North German Lloyd blue-ribbon ship, one of the fastest in the service, which took four and a half days to cross the ocean. The voyage was nothing special for Elisabeth and her parents, as they were seasoned travelers. But for me, who was seasick whenever any large body of water had to be crossed, the trip couldn't be over quickly enough. At first sight it really was a New World. The sky was a blazing blue, and even the grass was a more vibrant green from that we had seen at Cherbourg, as the ship left port. While Mother Zulauf and Elisabeth bustled about the luggage in Customs, my father-in-law walked me over, on my uncertain sea legs, for a last look at the ship in her serene, almost arrogant beauty. From the port we taxied up to the Hotel New Weston, on the corner of 50th Street and Madison Avenue, and I began to get accustomed to the brilliant light of the American sky and New York City's roaring tempo.

After luncheon and a short rest, Elisabeth's father took me to Fifth Avenue. There stood St. Patrick's Cathedral, a placid neo-Gothic construction as dark as smoke, and opposite a great block of brownstone houses which he told me were Rockefeller property. At 52nd Street, a rather shapeless and not very gracious building was identified as the empty Vanderbilt mansion, that to me looked like a big, dirty cake of ice starting to melt. Eventually all these dwellings were demolished to make way for Rockefeller Center and the surrounding skyscrapers.

We went over to Park Avenue to see the new Hotel Waldorf Astoria, recently transferred from further downtown, as the city grew northward. This was once the edge of town where the railroad tracks ran to Grand Central Station at 42nd Street. In 1932, the trains ran underground and were covered with a splendid boulevard appropriately named Park Avenue, with garden plantings down the center covering the ventilation gratings, and elegant mansions and apartment houses running along the sides. At the south end of the avenue stood a great archway gate, where traffic streamed around the sides of the railroad station and met again at 40th Street. Further uptown the subway became elevated and ran among tenement buildings.

That was my first day in America and quite enough to absorb. The next morning, I felt excited and energetic and familiar enough with the grid of New York streets to walk the eight blocks to the famous New York Public Library at 42nd Street. At first I was confused in the crowds of pedestrians, passing on the left as they moved uptown and on the right when they faced downtown, the opposite of what it was in Hungary. I caught on to the new rhythm easily, but crossing the street I was careful to move with the crowd and the traffic lights. The library stood apart from the sober commercial buildings nearby on a sort of dais, with two friendly lions at the entrance and a number of names carved on the cornice, highly visible in light and dark lettering. I was impressed that this library, unlike those in Europe where both libraries and museums are supported by the government, was put up by private contributions, and with the exception of some state and city monies, was also kept up by private donations. I went in and admired the beauty and grand proportions of the entrance hall, stairway, ceiling, and corridors. A pleasant young woman in the lobby directed me upstairs to Room 315 labeled "Art and Architecture." On a landing of the broad stairway, I came across a painting, "Milton Dictating 'Paradise Lost,'" by the famous Hungarian painter Munkacsy, which struck me as an encouraging omen.

I turned left as directed and found room 315. A young girl at a desk pointed to a book, indicating that I should sign in. When she saw that I came from Hungary, she asked with marked friendliness what she could do for me. I said that I had come to consult art history literature in English on El Greco, as such books are too expensive for many European libraries. After a short pause she said, "Could you come back tomorrow?" I made a little face as I didn't know quite what that meant, then thanked her and left. As I walked the eight blocks back to the hotel, I was reminded of my experiences in European libraries. In Paris, for example, the first reaction is to get rid of foreign students with remarks such as "Do you have a letter from your embassy?" Or, "Come next Monday," or "That book is out," or "We can't find it." They make it clear with such rudeness and indifference that the public institution, the museum or the library, is for the staff and not for the student, and any disturbance of their leisurely life (at such a low salary) is an unwelcome interference.

So I felt some foreboding about my research possibilities, but Elisabeth said, "I don't believe this is the same thing. Why don't you go down tomorrow and see?"

The next day, I knew the tempo of the streets better and also the way to room 315. I was relieved to see that the young lady of yesterday, who had been sitting in the back by a large glass case of rare books, saw me enter and immediately came over with a pack of library slips where she had written in book titles and other information. "Just sit down at that empty table and write in your name and address on the slips, and we will bring the books to you." There were twelve slips with titles and numbers clipped together, and no payment requested! I sat at the table as indicated, undid the clip and realized that of the twelve titles that she had written down, I was familiar with only two or three. (Indeed, nor was I familiar with the library's excellent system for organizing a bibliography.) I looked around the big room full of bookshelves, the fine wood paneling, and the people reading at the handsome, long tables with lamps every few feet, and thought, "What a paradise!" That was a wonderful morning, and I went home very elated and confident about my prospects for doing serious research in America.

A few days later, Elisabeth's father took me down to his bank, the Citizens Trust Company. At that time the large banks were all downtown, and on account of the distance, he warned me that we would have to take an express train in the subway. Inside the car, some of the passengers were sitting in sloppy poses, and a number of riders were reading big newspapers in Italian and Hebrew. The bank was quite an elegant place but not as stuffy as banks in Europe. Elisabeth's father was a very distinguished man and graciously introduced his new Hungarian son-in-law to all his associates.

One day, I visited the Metropolitan Museum of Art. I was rather surprised that New York had such a big building for its art. In Europe not very much was known about it, except that occasionally we would see in a bibliography that an important book was there or a famous picture. Once inside, from the first moment on I felt what a monumental and sympathetic place the great museum was. As I walked around getting my bearings, I came to a big room of lovely pictures excellently framed, including a Rembrandt. Over the entrance a plaque read "B.J. Altman Collection." So a Mr. Altman

had donated all that material to the museum! In another room, another name was over the entrance: another gift and another Rembrandt! Later, in a room on the West Side, still another Rembrandt: three Rembrandts, all originally from private collections. Toward the north of the building was the Morgan Wing, thus someone had even given a whole wing to the museum! It struck me that in America if one donated a room or especially a wing, the gift afforded a kind of nobility which in Europe also costs plenty of money. In bygone centuries one obtained noble status for courageous and exemplary behavior, or for putting up a regiment to fight whomever the king regarded as his enemy. In the nineteenth century, outstanding charitable works or commercial achievements were reasons for being granted a title.

Relating my impressions of the morning to Elisabeth later, I came to the conclusion that there were many works by big artists, but the painters of lesser fame were absent, those who furnish an overview of the artistic performance of an epoch. After all, a mountain range is not only composed of peaks; there are also valleys and high plateaus, glaciers, and little brooks. But at the Metropolitan Museum there were only the major artists, because as I found out later, so many of the paintings were furnished by the dealer Lord Duveen, who recommended what to buy to the museum's rich patrons and then sold them the works of art. At the Museum of Natural History, again I was taken by the technical excellence of the displays, and noted with great interest the material collected from Mexico and South America. Elisabeth and I also visited the Hispanic Society of America, and received a fine reception when they learned that I was working on El Greco.

I had my first taste of the city's social life at a dinner with an old friend of the family, a child of Old New York. She still lived in the family apartment on the already not so fashionable West Side. The furniture was a mixture of inherited antiques, practical William Morris and, as Elisabeth called it, "sturdy Grand Rapids." The table setting was exquisite. We had cream of tomato soup, a favorite of mine, with a dab of whipped cream floating on top. I had to butcher half a broiled chicken, a task that I had never had to face before. Served first as guest of honor, I helped myself to a molded jelly with a creamy sauce, which I took for dessert. But it was a vegetable salad

with lots of cucumbers and a tart mayonnaise dressing! Last came ice cream and a delicious lemon cake.

There was one art collection that was of special interest to us, although not among the public museums. It was connected with the plans for the Cloisters at Fort Tryon Park, the work of George Gray Barnard, a minister's son from Madison, Indiana, whose famous statue of the homespun Lincoln was rejected in Washington but placed on display in London. As a young sculptor of modest means he had gone to Europe. Wandering in the border region between France and Spain, he came upon remnants of churches and monasteries from the Romanesque and early Gothic periods and bought some of them for small amounts of money. When Elisabeth's mother, Agnes Hutchings, was married in Madison at the end of the last century, the young sculptor's sister was in her wedding party. Ever since the families had kept in touch, and one afternoon we went to call on Barnard. By that time he was famous and lived at the edge of Fort Tryon Park, where the city had donated land for his collection. When the gaunt but sturdy gray-haired man opened the door, his first words were, "Well, well, Agnes's daughter!" We sat in a vine-covered pergola viewing an ingenious arrangement of columns, broken cornices, a carved well head, and fragments of statues amid the greenery. A large, barn-like studio attached to the house was a museum for smaller objects. We talked about Spain and heard how he had found, purchased, packed, and shipped these treasures to America, where they later became one of the jewels of the city, the museum known as the Cloisters.

We had never intended to spend the winter in New York, and a few weeks later traveled to Boston for me to research El Greco. We took an apartment at the Hotel Charlesgate, with Beacon Street on one side, the Fenway on the other, and direct access to the bridge into Cambridge. As the hotel had expanded, adjacent private houses were purchased to provide a variety of suites. There was an excellent dining room and near the entrance, to Elisabeth's delight, stood a player piano with rolls made by contemporary virtuosi. My first foray was to the Boston Museum of Fine Arts to see a Catalan mural with pronounced Byzantine characteristics. I had a letter of recommendation to the director, and on the way to his office I asked his secretary what his title was or how I should address him. She smiled and said, "You are in America, and this is a

democracy. He is just Mr. Saunders." The director was very friendly and immediately took me to the library to introduce me to the librarian, who showed me the card catalog, and then we went to see the Catalan mural. The transfer had been skillfully executed, and the mural was effectively displayed. I made good friends with the librarian, and spent my first happy days in Boston at his library. Then I visited the Gardner Museum on the Fenway. Just inside the entrance I was overwhelmed by the spectacular display of flowers under the glass ceiling. The whole courtyard could have been in a Venetian Palace! The director went around with me to show the extraordinarily fine paintings. I ventured a remark that here and there certain things were a little dusty. He replied that nothing could be touched, because those were Isabella Stewart Gardner's instructions! Of course, that was in the days when trustees respected donors' wishes; today museums have done away with some of those binding traditions.

On an early November Sunday afternoon, Elisabeth and I neared the end of our list of places to visit and arrived at the Peabody Museum at Harvard. We climbed the rather high steps and went from room to room on each floor. I was simply amazed by what I saw there. On shelves covered with plain brown paper, as if in a police station where lost and found objects were on display, there were lovely pieces of sculpture, pottery, and textiles. (Later I learned that a teaching institution had no obligation to please the general public.) The labels indicated that these works were from the native Indian cultures of the Americas. I had seen similar pieces in European collections and at the British Museum in 1926. As a European art historian specializing in painting and sculpture of the Italian masters, I was amazed at the quality of sculpture of the Maya, the delightful pottery from Mexico, the intricate textiles from the South American coast, and the sophisticated black-and-white pottery from the southwest of the United States. This confounding variety of pieces were all dated from before the landing of Cortés in Mexico! I said to Elisabeth that there must be other museums with similar material, and that it should be studied in its entirety and adequately presented to show its wonderful, unusual aesthetic qualities.

As we were leaving, I spoke enthusiastically to a woman at the door. She replied, "Why don't you telephone Dr. Tozzer, the Chairman of the Department of American Archaeology? I think he would like to talk to you." We walked home in the brisk autumn wind blowing across the Charles River Bridge, very excited about the world of pre-Columbian art that had just blown into our lives. The next morning, we called Dr. Alfred M. Tozzer, who was one of America's most prominent archaeologists. He invited us to his office, and as soon as we sat down, I started unloading my enthusiasm on him. He listened without any expression as if wondering, "Why is that man here and what does he want?" Slowly, in my stumbling English and trying to use new words having to do with the unfamiliar American archaeology, I told him that I thought a broad study, perhaps in the nature of a survey, should be made by someone familiar with the pre-Columbian material. He asked, "A survey?" I said, "Yes, a survey, to produce an art book." And I said that it should contain ample photographs taken from the aesthetic point of view to show every object and building at their best. Only in this manner would people realize that these were important civilizations which produced magnificent works of art. He asked about my background, and I answered that I had attended universities in Budapest, Germany, and Paris, and done research in Spain, England, and Scottish museums. He replied, "We can't do much for you here. There is no position where we can place you."

I said that an American scholar acquainted with the material should do the survey. Dr. Tozzer asked, "How would *you* do it?" I answered that I would start with architecture and sculpture, then cover textiles, metallurgy, and every facet of daily life, making a broad survey from the American Southwest down to Bolivia in South America. He shook his head, pondering. "We have nobody with your background. Why don't you do it?" I said, "Dr. Tozzer, I am going back to Europe." Tozzer said, "If you don't do it, nobody will. You seem to know exactly what you would do and how. We can give you all the facilities that you need at the Peabody, and we can introduce you to people who can help you." We then went around the museum from one room to the other, emphasizing the Maya material, as he was a specialist in Maya culture. I pointed out the lines of the statuary, the mixture of the patterns, the unbelievable variety of textiles, the combination of metallurgical techniques, all of this hesitatingly because I knew so little about the

material. He listened without saying much in reply, and then we thanked him and left.

As we walked home, we reasoned that Tozzer was so friendly that he really would cooperate. But I was still pulled very much toward Europe, so making a decision was not easy. After several days, during which we went back to the Peabody several times, finally I told Dr. Tozzer that I really had come to America to work on El Greco and his Byzantine heritage. I would have to put that project on the back burner and not go back to Europe, but if I could get help I might consider making the survey myself. I emphasized to him the beauty, the grace, and the interesting parallels in the New World and particularly in the Maya culture, with medieval Europe. In the Americas the most splendid period was between AD 600 and 800, when the Roman Empire was falling apart and the Gothic world was not yet formulated. The Maya civilization did not decline before the tenth century, at which time Christianity took root throughout the European continent, and art began to flourish. The decisive moment had come. Tozzer settled it by saying, "You are always welcome at the Peabody, and we will do all we can to assist you. You can come and go as you like." So that is how Elisabeth and I began our travels and investigations into the Indian and colonial worlds of the Americas.

I finished my research at the library at the Fine Arts Museum and then divided my time between the library at the Peabody Museum and the Boston Public Library, which had excellent material about the historical periods before and after the Conquest. I was treated very courteously at both places. The Special Librarian at the Boston Public was a Hungarian, and when he learned that I was working at the Peabody, he gave me a special place where the more advanced students sat. I reviewed books about early travelers in Mexico and Peru, to familiarize myself with the attitudes of the early American explorers when they encountered the strange new languages and a completely different type of human being, the Indians of the New World. Fascinated, I gradually became immersed in the pre-Columbian world, and almost before I realized it, El Greco was forgotten.

Whenever Dr. Tozzer and I chanced upon each other at the Peabody, he warmly inquired how I was coming along. It was my opportunity to ask if I could get someone to advise me on a selection of books and help me get acquainted with the terminology of American archaeology, at the same time broadening my knowledge of English. He recommended a graduate student who had just returned from Uaxactun, Robert Wauchope. Meanwhile, Christmas had come and gone. The parents visited from New York, and we had one of our last parties on Beacon Street and Louisburg Square. All the "open house" lights were on in the handsome old colonial houses, and their owners stood in the open doorways, greeting neighbors and passers-by alike, even inviting some of them in. Such good times were memories of Boston that we never forgot.

Bob Wauchope proved to be an ideal companion. He was a southerner and had not only the bibliographical information for his Ph.D. thesis to offer, but also his experience in excavation and the restoration of Maya ruins in the jungle, that the Carnegie Institution of Washington had cleared, excavated, and was now about to publish. I could not have found a better friend, and this association lasted all our lives. He later became Head of the Middle American Department at Tulane University in New Orleans. I remember Wauchope well, in rainy and snowy weather which was so frequent in January and February in Boston, coming to the hotel or meeting me at the Peabody Library, bringing all kinds of books and pictures which I could not have found myself. By then, I had an outline of the cultures of the American Southwest, Mexico, and Guatemala in Middle-American territory, and finally South America, from Panama down to Bolivia.

A curator at the Peabody Museum named Frederick Orchard, who worked with the repair, conservation, and arrangement of the artifacts, helped us in many ways. He even carried Maya heads and other small objects over to the Fogg Art Museum, where there was a better photographer to shoot them for us. The Fogg had a room on the second floor where Maya objects, jade, and other sculptures were displayed as art, among them a full-length statue from the Hieroglyphic Stairway at Copan, Honduras. Orchard also showed us the plates taken in the late 1800s by an Austrian officer of Emperor Maximilian in Mexico, Teobert Maler. He remained in Mexico after the Emperor was shot and wandered among the pre-Columbian

ruins, at that time still smothered by the jungle. Maler proceeded to make an amazing record of the ancient Maya sites on 8 x 10 inch glass plates, which had to be processed immediately in the wilderness. His photographs and those of Alfred Percival Maudslay, somewhat later, recorded structures and many glyphs that time had erased by the time of the Carnegie excavations. These early explorers of the Maya territory were inspired by the amazingly clear and accurate sketches by the English artist Frederick Catherwood, who accompanied John Lloyd Stephens on his travels to the Yucatán and Central America in 1839 and 1843, recording structures and glyphs. When one considers the difficulties required by the work, both physical and technical, their results are astounding and a treasure trove for later researchers.

The year 1932 was bygone, and we were already deep into March. In just six months, I had collected as much as I could with the benefit of my European training and already mature eye. Come April, when I met Dr. Tozzer again after he had advised Wauchope how to help me, I told him in that I had by then "read everything." Tozzer said, "I have heard from Bob that you are pretty well informed about books and have a great pile of notes. And now, if I were you, I would go down and see the ruins in the Yucatán." Elisabeth said, "Well, why not?" With her enthusiasm, there was no reason not to go. We broke up our little apartment and left Boston for New York to prepare for the trip. We made arrangements to visit Tulane University's Middle American Institute in New Orleans, where there were just the right people to advise us.

It was quite a long train ride to New Orleans. After Washington, it began to look like real spring and was so warm that we spent the morning on the observation platform. Georgia and Alabama were certainly wild country: sweeps of red land lying fallow and weed-grown, just plowed, or with the pods of last year's cotton crop sticking up with wilderness in the background. The clearings among the fields and trees would usually have a little plank cabin, standing on short, brick legs in a grove of gorgeous trees. Further south came large farms and pecan groves, then almost tropical swamps with palms and wild magnolias among the other trees. All this undeveloped land was remarkable to me, accustomed as I was to the more civilized (and crowded) world of Europe.

The Middle American Institute had two men of importance at that time: Frans Blom, a Dane who had been originally a petroleum researcher in the Veracruz region of Mexico, and Hermann Beyer, a German, who was one of the early epigraphers of Maya glyphs. Blom had stumbled on some Maya ruins and become more and more interested in them, turning into one of the first specialists. I believe that Beyer had been a newspaperman in Mexico. These two interesting men gave us very valuable information about the Yucatán, everything from what kind of clothing to take and where we should stay, to the people we should meet.

Dr. Beyer showed us around the city a bit. One evening we went for dinner at the "Patio," a charming old New Orleans house fixed up as a restaurant, with tables in the garden and a picturesque iron balcony on one side. The elaborate iron grillwork so characteristic of the city was manufactured mostly in Madison, Indiana, Elisabeth's mother's home town, and floated south down the Ohio and Mississippi Rivers to New Orleans. We had crabmeat, fried chicken, and strawberries with ice cream for a dollar. The famous New Orleans coffee was a shock: roasted to bitter blackness and full of chicory. Did it ride to fame because it was French too? Then we visited the legendary Cafe Dumond at the old market, and had more chicory-rich coffee and French style doughnuts in the all-night café where everybody in New Orleans went, from dockhands to society beaus. Farmers camped about their trucks, lounging on sacks as they waited for dawn and the opening of the market. Some were strumming guitars and banjos to pass the time. If anyone had told us a year earlier that we would be in New Orleans and sailing for Yucatán, we would not have believed it!

Professor Beyer took us to the art museum, in a handsome building near Lake Ponchartrain with a large flower bed and fountain in front and an avenue of palms. The collection was a hodgepodge of legacies, mostly from the golden age of river traffic and thus mostly Victorian. The paintings were from this period or the last decade, for a modern school had sprung up in the romantic garrets of the French quarter. One painting had a very imprecise provenance, so I took it on and completely changed its attribution from Italian to French, from one century to another, and finally in the interpretation of the subject! I hoped they would, at least, have it cleaned, because it was the best painting they had.

A few days before leaving New Orleans, Elisabeth tried photographing some of the Maya pieces at Tulane's museum. The light was rather uncertain, but in any case it was good practice for the work ahead. The photographs all turned out well, although not as good as she hoped to take for the book. At least she found out that her two Kodaks would take as good a photograph as a fancier camera. She resolved the next time to try putting the objects against a dark background. Her little vestpocket camera also turned out several terrific little pictures that would be just fine when enlarged.

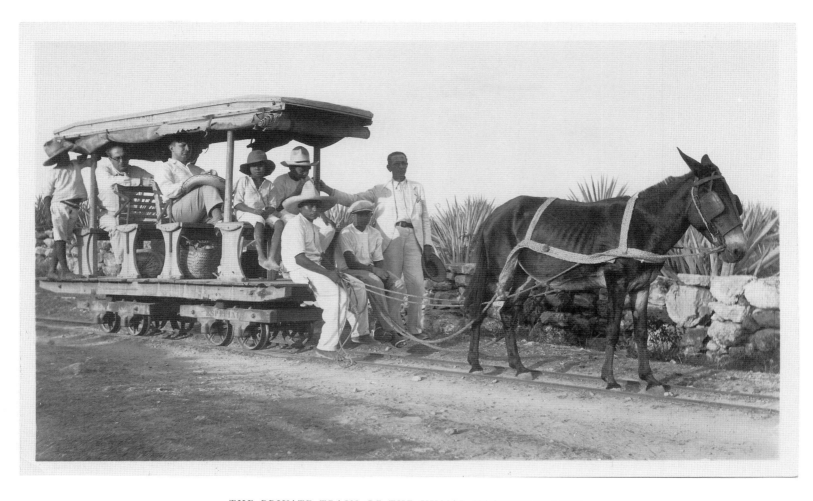

THE PRIVATE TRAIN OF THE UXMAL HACIENDA, 1933.
PÁL (SECOND FROM LEFT); MR. REGIL, OWNER OF HACIENDA (RIGHT).

THE YUCATÁN, 1933:

OUR FIRST TRIP TO LATIN AMERICA;

BY BANANA BOAT TO THE YUCATÁN

HOTEL ITZÁ
CALLE 59, NO. 594
MÉRIDA, YUCATÁN
MAY 1933

THE ONLY TRANSPORT TO YUCATÁN IN 1933 was a boat of 2,500 tons with six cabins that came to New Orleans loaded with bananas, and returned empty to the port of Progreso. The morning we sailed, we visited the Southern Pacific to ask about the trip home from Mexico City, and learned that going to New York cost 106 dollars for each passenger, whether via New Orleans by boat or Chicago by rail. Fortunately we would be able to select from the 2,000-mile tickets to be had on all American railroads west of the Mississippi that included a stop in Chicago. We decided to return that route, so as to see the El Greco paintings and an important pre-Columbian exhibit at the Chicago World's Fair.

We boarded the ship at 3:00 but didn't sail until 6:00. Meanwhile we got a look at an old stern-wheeler at the dock, unpacked a few things and took advantage of a cooler breeze on deck than was blowing anywhere else in town. Many local people boarded, chatted leisurely, looked over the ship, and got off again. The only other actual passengers were a Mexican fruit merchant named Mr. Massa, returning home after a long voyage, and a young boy supposedly from Chicago but who did not hazard a word of English the whole trip. As the boat swung into mid-stream, we were called to supper, so we slid behind a long fixed table under the curve of the stern and started out with a good meal. The dining hall shook a good deal with the rhythm of the propeller, like the diner at the end of an express train. The current swept us down the Mississippi at 17 miles per hour, faster than the 10 that the boat would have done on its own. It was thrilling to cruise down that wide, beautiful, old, yellow river edged with clumps of bright green. Beyond the dikes along the banks, an occasional roof stuck up or a factory (probably sugar refining plants), but the rest was marsh, signal lights, and bugs. When we rounded a bend and lost the wind, the air became thick with all sizes of mosquitoes, beetles, moths, and electric lightning bugs 3 inches long! A lovely, jigsaw-patterned sunset was all light on one side and darkness on the other, with plenty of dramatic streaks and blending reflections.

A number of boats passed us, tooting in salute. We passed our time sleeping, reading the *Saturday Evening Post,* and pacing the iron deck to watch the flying fish. Elisabeth was the only woman on board, and we dined with the captain and officers. Everything was very pleasant and the food very good, but unfortunately Pál's stomach wasn't quite up to it, and for most of the journey he subsisted on iced tea and vermouth with a few sandwiches. It was somewhat consoling to know that so many famous archaeologists, from Beyer and Sylvanus Morley to Joe Spinden himself, weren't any better sailors! Most of the time the sea was smooth, with a long, slow roll, and the scene completed by a dripping trade wind, blue water, and a copper-reflecting sun as described in the "Ancient Mariner." One night we ran into a violent storm. The ship began tossing

uncertainly, finally gave a great heave and then rolled far to one side. Suitcases leapt from their racks; dishes and utensils crashed off the shelves in the kitchen and continued to roll from one side of the narrow galley to the other. All we could do was brace ourselves in our bunks by clutching the side rails. Thanks to the care of the tall Negro steward, we managed to get ourselves together as the ship approached landfall.

Progreso was the port that shipped out all the sisal or hemp, the chief product of the Yucatán. We were twelve hours late, finally reaching the area of the harbor where it was so shallow, even for our small vessel, that the passengers were loaded onto a barge and ferried to the pier. On the dock we saw our first Maya Indians, reddish-brown young fellows with features vaguely recalling the Malay. All they wore were short cotton drawers and sleeveless jerseys, and a few had straw hats. It was an endless tramp to the end of the pier, but the Maya boys carried our luggage, not even perspiring.

Fortunately we had radioed ahead, and a boy from the hotel appeared to escort us to the shack which served as a customs house. The official asked for our passports, then announced that those with American passports could land, but not "that foreigner," meaning Pál. We protested that we both not only had tourist cards, but also Mexican visas from the Mexican Consulate in New York. The official was adamant. "Yucatán is not Mexico," he answered. (We didn't know that during the Revolution of the 1920s Yucatán had a strong separatist movement, and its sentiments persisted.) When we pressed him, he said, "Foreigners are coming in and taking away jobs from our own people." Finally, after much argument (assisted by Mr. Massa) and showing a letter from the Carnegie Institution, the official conceded that with a deposit of 500 pesos, Pál would be allowed to land. We replied that we did not have so much money on us and showed him a Letter of Credit from the Hanover Bank in New York for 3,000 dollars. But he waved it away. Finally Mr. Massa, who apparently carried some weight (and later turned into a good friend), guaranteed that we would go to the bank in Mérida and return with the money, which we did the next day.

The boy from the hotel loaded our luggage into a rickety, open Model-T Ford for the ride to Mérida, 21 miles away on a ruler-straight road through burnt-out brush and tangled scrub woods. It was 105 degrees in the shade and very dry, with the wind blasting everything like a gigantic hair-dryer. Hemp plantations began to appear, fringed by tall cactus in long fence rows. Occasionally an oasis of lovely, tall ceiba (silkcotton) trees and palms marked the location of baroque manor houses of ancient, weathered limestone with courtyards and colonnaded verandahs. Not far away, at the end of the little railroad tracks where the carts came in piled high with cut henequen stalks, stood factories where peons extracted the fibers. In that barren land they called hemp the "gift of the gods." It needed no care, no irrigation, matured in five years, and produced for thirty. Nevertheless most of the big planters had gone broke, because the Philippine Islands were producing more henequen faster and cheaper, if not as fine. A few Indians in large sombreros were on the roads, their women wrapped in heavy shawls and children trailing along, carrying limp dogs apparently passed out from the heat.

The Hotel Itzá on the outskirts of Mérida was a private villa recommended by an acquaintance in New Orleans. It belonged to a wealthy *hacendado* or plantation owner, J. Rafael de Regil C. (generally known as Rafael Regil), who took in paying guests due to diminished profits in the henequen trade. Regil was a very interesting person: gaunt, tireless, and full of humor; quite an original, but they all were in that part of the world! Guided by this gracious host, we acquired a wonderful introduction to the Yucatán and were able to visit the archaeological ruins at Uxmal and Chichén Itzá, near his family's haciendas. In 1933 these were the only ruins we could visit without going into the jungle by mule train.

At Regil's comfortable villa we had two large rooms, one facing the patio, and the other the northeast where the wind came in. Fortunately the breeze was constant, and we kept cool by sitting in the draft. We learned to fit into the routine of the tropics. "Take advantage of the morning," went the proverb, "since it is cool and delightful; be as quiet as possible in the afternoon, and walk out late in the evening." Our first afternoon was spent at the museum, which didn't have much to offer except a small exhibit of the latest finds from the Carnegie excavations. The next day was an important holiday. In the morning we had a look at Mr. Regil's collection of Maya and colonial pieces, much finer than the ones in the museum. He generously gave us our choice of his excellent photographs and

offered to loan an Underwood typewriter, so that we could write our travel notes, a proposal for the book, and some articles for magazines and newspapers.

Afterwards we all went out walking to the grand marble opera house, where a dance was taking place on the open promenade and a movie in the auditorium. Maya girls were out in their white dresses, with gay flowers, birds, and animals embroidered on the borders and big bows in their hair. The men wore large straw hats, white cotton trousers, and short jerseys that showed off their deep bronze skin. They all looked happy, energetic, and dignified. It was really an Indian city, for white faces were in the minority. According to Spanish custom, children of 6 or 7 were already confirmed, and a number walked about in white veils. Little boys in overalls with wide, dark eyes and wheedling pleas followed us for hours to sell their everlasting lottery tickets. That afternoon we drove around town with Mr. Regil and went through a typical Yucatán house and gardens belonging to his brother. All the decorative trees were fruit bearing: date and coconut palms, avocado pears, even a pepper tree. The house was one-storied, of stone with bright-tiled floors but no rugs or curtains. The simple layout was a row of rooms in L formation with an outside porch all around, and one on the inside that could be shuttered off (into a room) when it rained.

After dinner Mr. Massa took us to a *mestizo* dance held in an open patio near the hotel, *mestizo* designating a proud class of mixed Spanish and Indian. The girls wore flimsy dresses in the latest fashion and high-heeled shoes and sat in long rows around the walls with plenty of chaperones, while the men wandered up and down. The band was dominated by guitar, mandolin, and stringed instruments accentuated by rattles and the muffled tones of a wooden drum, playing a series of dances called *jaranas* which were similar to the rumba, but slower. The couples danced with great feeling for the music, dignity, and elegance cheek-to-cheek, then ceremoniously promenaded hand-on-arm to their seats. At another dance around the top gallery of the Government Palace, we observed girls wearing the elaborately embroidered Maya dress called a *huipil*, their thick braids tied by big, bright ribbon bows. The men wore white cotton trousers, short jerseys, and sandals. Small bands in each corner provided continuous music, and the Indian mothers nursed their babies between dances. The party was still going at midnight, when we left. An outdoor café beckoned us for a cool drink, and we became acquainted with a new fruit, *guanabano* (custard apple), which combined the best points of pineapple, orange, and banana. Growing more enthusiastic, we took a romantic ride in the moonlight around the luxurious villa sections of the city. Finally we stopped for a bunch of exquisite pink roses from a garden belonging to a friend of Mr. Massa, and took a look at his grapefruit, papaya, orange, lime, and mango trees. The whole place was laid with irrigation pipes and blooming gorgeously due to the good work of a Chinese gardener.

We got up at 4:00 in the fresh morning breeze to catch the train to Chichén Itzá. It was still dark, but the cocks were yelling their hymn to the sun. All the trains left the Mérida station at 5:30, and there was a great bustle all around. The most impossible bundles were lifted up and piled on the seats. Our section of the United Railways of Yucatán consisted of a wood-burning locomotive, two freight cars, and three passenger cars. First class had nice straw seats (preferably turned so as to face each other with the feet up!). Second class had worn wooden seats, but third only backless benches. Glass or wooden lattices covered the windows. Fashion was dictated by the climate: the local man's shirt being minus a collar, his coat finished off with a fold at the neck and standing considerably away from the skin. Pál wore a cotton seersucker suit he bought for five dollars in New Orleans and was scarcely out of it while in the Yucatán. We saw all kinds of hats: one lovely cream felt sombrero, but mostly fine white Panamas.

The trains steamed out of the station side by side. First we passed through a long stretch of hemp plantations with oases of irrigated fruit gardens at the locations of the hacienda houses, chapels and huts of the Indian workers. All these places were connected by narrow gauge railway for shipment of the hemp, and the regular roads had gone to pieces. Instead of an auto, a flat car with benches drawn by a mule met the trains. On this original contraption (sometimes with a buggy-top) via the miniature track, the dignified planter or a pyramid of white-clad Indians would go sailing off to the farm. At the windows of the train, Indian women and children sold fruit, cake, and tortillas filled with wild turkey. There was a long wait at every station. People got on to drink at the train's water-cooler, and got off

to walk in the fresh air and buy deadly looking fruit concoctions and ices. The vendors came and addressed each traveler personally, who were expected to reply politely each time.

Later the country grew much wilder: a tangle of leafless vines, cactus trees, and palms, which we were assured was only "bush" but must have looked a lot like jungle growing fat and green in the rains. We reached Dzitas at 9:45 and loaded bags, boxes, and packages into a faded blue Ford that did noble work on a 20-kilometer stretch of pretty bad road. There were two Indian villages on the way with small, clean thatched houses that the Indians say are just like those of their ancestors at Chichén. Wells, small white churches, and a few grazing horses represented the colonial epoch.

Suddenly, between the dry brown walls of tangled branches, we had our first glimpse of Chichén Itzá's El Castillo, one of its most famous buildings, that was dedicated to Kulkulcan, God of the Winds. We had read a lot about the site and seen many pictures, but as is usually the case with works of great beauty, reality far surpassed mere description. Nothing could have prepared us for the sight of this magnificent building abandoned in the bush, bathed by intense tropical light under a translucent dome of sapphire blue sky. The car drove past countless overgrown mounds and heaps of broken stones on the way to our quarters. Our Maya lodge was a plaster addition to a wattled, thatched native house inhabited by an Indian family. We saw two girls, two boys, and two large matrons; the husband or husbands were probably working on the excavations. Our room was divided in two by a wooden partition, with a roof and ceiling of *zapote* beams and a tiled floor. The wattled walls let the wind blow through, and wooden shutters protected the glass-less windows. Outside was a little square bathhouse served from a huge metal oil tank set up in a tree; pulling on a string brought down a grand shower! At noon the water ran almost scalding hot from the sun, but when evening came, it was refreshingly cool.

We had an early lunch in the Indians' dining room, scrupulously clean in spite of its earthen floor and chickens running about. The meal consisted of fresh eggs, young chickens, black beans, and all sorts of fruit: bananas, little sweet oranges, dark red mameys like large, rich persimmons, and *zapote*, which resembled a cinnamon pudding! Mr. Regil had brought innumerable bottles of soda water; a pitcher of

cool lemonade from boiled water came with every meal. One could die of thirst in the Yucatán, because the very dust—from the limestone—was lye! The thermometer had registered 103 degrees Fahrenheit for three days, and the three before that were reported as 105. We didn't feel the heat very much because the humidity was only forty percent, and there was always a high wind. (Thank goodness we missed the rains, for although the temperature usually dropped a little, the humidity would rise to eighty or ninety percent.) After lunch we slept for an hour in our hammocks, wondering how the Yucatecans could do it all night lying crosswise.

At 4:00 in the afternoon we set out past the goat, the wash house, and the turkey-gobbler, and within a few yards saw our first mound, the House of the Dark Writing. It was replete with hieroglyphics and probably once a palace. Chichén Itzá had a long life and evidenced a variety of influences, schemes and motifs. Each building had its own original beauty, for the Maya never seem to have conventionalized anything. But while every building on the site was unique, the complex had a harmonious overall design and a fine rhythm. The great buildings were so well proportioned that a sense of poise dominated their massive bulk. We saw neither snakes, scorpions, nor mosquitoes, only a few black gnats, and our high boots proved to be comfortable foot-savers from the first step.

In the evening we made a visit to the Carnegie Institution hacienda not far from our quarters and were introduced to Dr. Sylvanus Morley and his filigree-delicate young wife, Frances. They were sitting on the great terrace in front of a scarlet blooming *flamboyan* tree, playing Stokowski-Wagner on the Victrola. Professor Morley and Pál hit it off at once. He was an expert on dates, but also had a strong artistic appreciation and eagerly responded to Pál's ideas. Later Pál commented that Morley was the first colleague who confirmed something in his mind since we had gone to Harvard: that considering Maya art as though it were something from the Hellenistic epoch was ludicrous and short-sighted. For its greatness and originality to be appreciated, Maya studies required a new attitude, more appropriate evaluations and a whole new chapter in aesthetics.

Afterwards our party and some of the younger men went off to enjoy the ruins by moonlight and try out the acoustic properties of the huge Ball Court. Elisabeth gave them a lullaby, "Ru, Ru, Barnet."

With its little runs and a gentle rhythm it was very much in tune with our mood. Morley played Beethoven's Fifth Symphony on the Victrola, and the dramatic orchestral chords resounded from one end of the playing field to the other.

The next day we were up by seven and out at the Castillo, apparently the only structure with a pyramidal base. Nine stepped terraces were set on the base, each with a stairway in the middle leading up to the temple on the top. Huge yawning serpent heads guarded the steps at the base, their bodies writhing over the balustrades. What tools could the ancient masons have used to calculate the length and the height of El Castillo with such perfection, let alone the fine precision of the sculpted decoration?

The Nunnery was the last ruin to have been restored by the Carnegie and among the oldest buildings on the site. It was a huge, solid block of masonry, unbroken except by a broad cornice around the upper edge. The cornice was covered with a succession of huge, carved masks with protruding, hooked noses, representing the Rain God. The structure's inner rooms had a floor of fine cement and walls covered with smooth stucco, an excellent ground for the mural paintings that had since disappeared. An imposing stairway, so steep it was almost a slanted wall, led to the terrace at the top of the structure. But when Regil started up we followed him without a thought of how we were going to get down. Later on we became quite expert at this by scrambling sideways. The steps were even and level but had very narrow treads, and the trick was to never look down. The stairway probably led originally to a structure on top of the building, but in our time it led only to the sky.

Attached to one side of the Nunnery was a dainty, ornate annex, which earned the building its name from a series of cell-like rooms. Above the smoothly planed walls was a wide, heavily decorated, projecting entablature of almost the same height as the building supporting it. The Maya method of building was dictated by the inner structure, consisting of rooms closed by pointed vaults (corbelled arches). Since the arches began a little above the height of the doors, the heavy cornice usually leaned slightly outward to counteract the push of its immense weight against the temple walls.

The Observatory, called the "Caracol" because it somewhat resembled a snail shell, was built by the Maya to study the heavens; their calendar was more accurate than any European calendar of the time. The structure rose up on one side of its vast terraced platform, as though sprung from the earth like a great forest tree. How we marveled, standing before that intelligent building, at the skillful combination of terrace, stairway, low balustrade, entrance, and the unusual round upper section of the building with its heavy cornice! At the top were four openings oriented to the four cardinal points of the heavens, reached by an interior spiral stairway and marked by a deep cut in the lintel in the center, which signified the equinox. Near the balustrade of the second terrace were incense burners still containing remnants of copal.

As we stood there gazing out into the bush, we could visualize the Maya priests burning incense and divining the change of seasons. What was life like around the observatory? No doubt there were priests who were employed to count the days and months, make notes when the rains came, and the wind and other changes could be expected. They must have been important figures in the Maya hierarchy, since agriculture was the basis of their civilization. The common man was probably not permitted near the ceremonial centers but observed from afar: the smoke curling up to the sky, the dignitaries and priests attired in elaborately contrived garments, headdresses, gold and stone jewelry, masks, and feathers. The bloodletting ceremonies, processions, erection of temples, and presentation of captives must have been as dramatic as any opera or piece of modern theater.

The Temple of the Jaguars was small but exquisite of line. Its only entrance was on the side overlooking the Ball Court. As at the Castillo, two rattlesnake columns divided the broad opening of the doorway, the tails and rattles curling over the lintel, and their fierce heads with gaping jaws guarding the entrance. Despite its small size, this temple had the most varied decoration at Chichén on the wide bands of carved relief that wound around the top. The procession of moving "tigers" was a masterpiece of Maya carving in low relief. Energetic life and movement emanated from the springy gait and lolling tongues of the animals. The night we were there, the gracefulness of the building and its decorative details were dramatized by the light of a full moon. The delicate structure, fantastic as a fairy tale, seemed to hover above the wall of the Ball Court. Europeans, in the same epoch, raised only gloomy and unwieldy piles of masonry.

The interior of the Temple of the Jaguars was a single, vaulted room, its walls covered by the vanishing remains of multi-colored paintings. In the early decades of the twentieth century the pictures were still in good enough condition for the English artist Adele Breton to make accurate sketches of them. On one wall Maya warriors were depicted fighting an enemy force. In addition to the animation of the scene, our admiration was awakened by the drawings of each warrior in a different pose. The round battle shields, scattered throughout the scene, accented the liveliness of the design. Red, reddish-brown, blue, green, yellow, black, and white were the colors mainly employed in Maya frescoes. The mural we viewed that memorable day contrasted very favorably to European battle scenes from medieval times with whole sections en masse, and the soldiers all in identical positions.

The last construction period at Chichén Itzá produced the Temple of the Warriors, which evidenced many signs of changing methods and introduced new symbols. Standing on three similar terraces, the small building had thinner walls than the Observatory and no structure on top. Apparently vaults were no longer built, and the roof may have been made of thatch. Despite the large number of square pillars gathered at the foot of the stairway, the carved warrior figures on each side had notable differences. The separate profiles were individualized, the movements were varied and the costumes diverse. Even in this period of heightened artistic activity, an effort was made to avoid repetition. The temple was more squarely placed, more symmetrical than its predecessors were: stalwart and imposing but missing the exotic impact of the others.

The first serious investigator of Chichén Itzá was Edward Herbert Thompson, who, as British Vice Consul, lived in the nearby hacienda he purchased at the end of the last century. Spending more than forty years years in the Yucatán, Thompson was host to all the people interested in the site. Later the Carnegie Institution of Washington bought his property for use as the headquarters of their reconstruction projects. It was Thompson who initiated sending divers into the Sacred Well continued later by the Carnegie. Many relics were brought up from the depths including jade and turquoise masks, gold and copper bells, and copal incense. Chichén's two *cenotes* were natural limestone sinkholes, 50 feet down from the surface to

the water, deep, green, mysterious pools that never dried up. No wonder they were centers of pilgrimage and sacred rites including human sacrifice to placate the Rain God!

Lunch was back at the Carnegie hacienda on the verandah. A group of intense young men who were working on the excavations sat at a long table. Busy Chinese houseboys filled tall glasses with cold water. Morley, his wife, and guests were at one end of the table. He kept up a lively conversation in his accustomed style, energetic, unfailingly enthusiastic, and delightfully original. The next morning we went a piece into the bush with Indian guides to see some buildings recommended by Dr. Morley that had not been restored. Our companions were the brothers Xiu, three of the direct descendants of the reigning house of Uxmal at the time of the Conquest. The Spaniards had granted the family a title and some tax exemptions for cooperating with them. The Xiu brothers didn't seem to care much about their former glory and were just agreeable, prosperous Indian farmers. They resembled the old sculptures remarkably, as indeed many people did there. All the Maya we met appeared to be a kindly, self-respecting people possessed of great natural dignity.

We returned to Mérida that afternoon and spent the evening at the *confiteria* on the plaza enjoying coconut ice and guanabano-flavored soda water. Thursday we had supper with Mr. Massa and his friend Mr. Glasing, a German engineer who managed the local brewery. At that one meal we had more Mexican food than in our entire stay so far. First came corn meal tortillas with wild turkey meat and sauce to be eaten in the fingers, served with peppery chili; second, brain omelet and beet salad; third, tamales, a fine paste of corn-meal with a fine ragout, wrapped in banana leaves and served with the Mexican chocolate of powdered cocoa with water, vanilla and cinnamon. Last came a compote of exotic fruits and the strong local coffee. Mr. Massa brought along two Indian musicians with guitars, who sang a charming variety of Maya and Spanish folksongs to us all evening. They performed with the authority of real musicians, and when the daughter of the house sang and played, they applauded her warmly. There was nothing servile about them, but nothing presumptuous either.

After dinner Mr. Glasing showed us his valuable collection of photographs taken in the 1870s and 1880s by Teobert Maler, the

MEXICO, 1933:

YUCATÁN TO VERACRUZ

AND MEXICO CITY

HOTEL GENEVE

8A. CALLE LIVERPOOL 133, MEXICO CITY

300 ROOMS STEAM HEATED

"OWNED AND OPERATED BY ANGLO-AMERICANS
WHO KNOW WHAT ANGLO-AMERICANS WANT"

MAY 17, 1933

AT THE PORT OF PROGRESO on Sunday morning, a big crowd on the wharf was taking the trip on the tender as a joy ride to our ship *Moro Castle*. The trip began in an unsteady sea which made us very uncomfortable, but we both weathered it. We had been assigned a cabin way down in the hull, but our letter from the Ward Line officer in New York effected a change to a fine room on deck "A," where a cheery German steward took wonderful care of us. The sea became as smooth as glass, and we ordered an immense lunch in the cabin, slept until 5:00, then had iced tea, talked and read, ate dinner, and slept again until 7:00 A.M., making up for all those mornings of rising at 4:00 A.M. in Yucatán! The sea was calm, and Pál was okay.

Veracruz was very hot and muggy, with everything burned and all the creatures panting in the heat. Even the well-to-do showed marks of suffering, and the plain folk appeared dirty and shiftless. We were glad to catch a train at noon to Orizaba, a good place to rest between the harbor of Veracruz and Mexico City. A resort, it lay at about 4,000 feet and was recommended as a good place to adjust from sea level to the higher altitude of the Valley of Mexico. The River Orizaba ran through the tidy, colonial village with a snow-capped volcano, the highest in Mexico, adding to its charm. Orizaba was described by a number of travelers in colonial times, when they disembarked from Europe and took the old *Camino Real*, the "Royal Road." It has always been an arduous journey, although the train was a decided improvement over a stagecoach on sixteenth- (or even some of the twentieth-) century roads!

On the express to Mexico City we spent most of our time on the observation platform, fascinated by the climactic changes. The track wound up the heights as if on a giant stairway. Lush coffee groves gave way to banana plantations, and the people seemed to become more energetic and determined-looking. The most gorgeous fruits were sold on the train platforms, as well as baskets, *serapes,* and some carved wooden pieces. The flowers were wonderful, even though the summer rains had not yet come. The type of house changed entirely from cane and thatch to windowless adobe huts with high-walled courts like Arab houses. As we approached the heights of the great plateau, the car porters came around closing all the windows and doors, and we swept into a desert-like plain of cactus. Although the land was under intensive cultivation, little whirlwinds of fine grains rose everywhere, like spirals of smoke. The dust drifted through the cracks in the train windows, and we emerged covered with it from head to heels.

The Geneve Hotel in Mexico City, Canadian-owned and run, was out of the heat and dust of the city, with a quiet clientele and

clean, comfortable rooms (in contrast to the noisy, crowded and run-down business hotels). The whole country comprised less than seventeen million inhabitants, and we started getting an impression of the city of less than one million people. It was laid out on a grand scale, with beautiful parks kept luxuriantly green, and leafy avenues. All the gardens were blooming riotously. The climate was most agreeable, even at noon not too hot, and at night we needed a blanket. The natives seemed good-natured, lively, courteous, and honest. What a shame that the Spaniards ever arrived to sit on the necks of this excellent race!

The country was beautiful, wild, and strange. Although the rains had not yet begun, threatening cloudbanks gathered every evening, and everyone said how unusually dry it was. We drove through the village of San Angel, south of the center, and visited the interesting sixteenth-century church of El Carmen, with Baroque walls and three bright Majolica tile domes. Most of the churches in the city were completely plundered during the Revolution of 1910, but the church still boasted a golden chapel with some fine woodcarvings. From there we went to a strange desert mountain called El Pedregal, "the rocky place," with dried, brown fields, large cactus trees blooming red or yellow, huge boulders, and ledges of black lava rock with fertile fields in the hollows. The freshness of anything green was quite startling, as if the plants had roots in secret springs. There were even clumps of willows and great mimosa trees just beginning to bloom. As it was Sunday, we saw many natives sitting stoically behind piles of fruit or other market wares, trudging along the roads or riding burros. The mangoes were just ripening, and everybody was eating them. Everywhere we looked was a "picture perfect" photograph to be taken. Luckily, all our photographs thus far were coming out beautifully.

We had a simply grand time at the Hotel Geneve. Our rooms were comfortable and quiet, and we had very effective mosquito screens of fine net stretched on a frame across the windows. There were not many of the little pests, but those few made a noise like baby airplanes! The food was wonderful at thirty pesos per person a week. For breakfast we always ordered the most delicious ripe pineapple. One slice covered the whole plate (we tried to put the second slice away for the afternoon, but it always fermented). For luncheon, there was a Mexican dish if one wished and excellent fruits and ice creams. For dinner, a choice of several meats and fresh fish brought up from the Gulf on ice on the overnight train. In the Aztec Emperor Moctezuma's time, there was a system of fish relay runners who took not much longer than the modern train, although supposedly those fish were carried alive in bowls of salt water. Strange to say, the cooks in our time were often Chinese, even when the food was typically Mexican.

The National Museum of Anthropology was our first goal. At that time it was housed in the old mint, the Casa de Moneda, around the corner from the National Palace on the north, and east of the cathedral. Inside was a tremendous jumble of fascinating things, some very beautiful, some only ethnologically interesting, all huddled into inadequate spaces. Some rooms were locked off from the public. A number of the exhibition cases were empty, and some had the labels of the missing contents scratched off the glass or so dirtied that they were unreadable. Museum pieces on exhibition had been stolen and scattered; President Porfirio Diaz's collection went with him to Paris in 1911. And so after years of quarreling, revolution, fire, and earthquake, there was reason enough for disarray.

Apparently there was no one in the museum but a lone woman in charge of everything. Casts of smiling Veracruz Totonac masks and the famous *hachas* (axe heads) were for sale. Pál had seen an illustrated catalog of the museum at the Peabody, but at the museum no catalog was available. When we asked about photographs, the woman pointed upstairs and indicated that she would accompany us. Mounting a narrow stairway, we emerged on the roof, where stood a small, wooden lean-to (without a door or inside light) that felt the full power of the sun and was well over 100 degrees. Glass plates and curling film negatives were lying in disorder on shelves, covered with dust and soot. Any envelopes that existed were either moldy or crumbling, so that it was dangerous to take anything in hand. We drew up a box and a stool to sit on and started sorting through the pile. When we found a negative of an interesting piece, the object was seldom to be located in the museum. When we wanted a picture of an object, there was none to be had. We looked hopelessly into a pile of typewritten catalogs to find objects listed as "Item 1245, A Pottery Figure, No. 1678, A Pottery Figure" and then

Austrian officer in Maximilian's army who stayed in Mexico and surveyed the Maya ruins, and whose photographs had inspired Pál when he saw them in Boston. It was late when we left the Glasing's, but a light was on in the photographer's studio on the main plaza where we had taken Elisabeth's negatives to be processed. We were anxious to check the exposures and also any possible damage from the extreme heat and humidity. The photographer told us that the films were being washed, but he would be more satisfied if he had some ice to lower the temperature and ensure the fixation. The only place open at that hour was the ice cream parlor across the plaza. The owner said he would be glad to give us ice, and there we were at midnight carrying buckets of it across the plaza to the studio. Consequently those negatives were still in perfect condition fifty years later!

On Friday, May 11th, we went to Uxmal. The trip had to be accomplished in one day because of the danger from malarial mosquitoes rising out of the swamps at twilight. Señor Massa was persuaded to go with us, and he made a very pleasant companion. At 5:00 in the morning we were already on the tracks in our rail-auto so as to be ahead of the train. With special metal wheels to allow it to drive on the rails, it made more noise and speed than the train. Those early mornings were always lovely: dark and cool with birds and cocks in full voice. Señor Regil arrived, loaded down again with provisions. He said that he never left anything to the Indians, who, as obliging as they were, could not get used to the habits of civilization. Sometimes he even brought gasoline, oil, and an extra tire in case the driver neglected to do so. Our little auto tore along, stopping occasionally so the engineer could telephone ahead to make sure the track was clear. The sun rose at 5:30, but it was still cool. We met many Indians out hunting deer and wild turkey, walking or riding on the tracks. It was amusing to watch our engineer, who would not look through the glass pane in front of him but leaned far out the side as if in a locomotive. The region was more marshy and had a chain of artificial lakes built for ancient Uxmal. We saw so many birds: orioles, big, blackbird-like fellows of an iridescent blue, little red birds, quails in the brush, and soft brown, wild pigeons whose cooing filled the air.

We reached the station at Muna at 6:30 and were already loaded into a Ford by the time the train came through from the opposite direction, causing a picturesque round of activity on the platform. We then proceeded to make our way over 15 kilometers of the most vicious road I had ever seen. On hilly stretches it was like driving in a creek bed full of holes and boulders, but our Indian driver eased the car over the rough places as patiently as though he were coaxing along a well-trained horse. An hour later we reached Regil's large, dilapidated hacienda that had been in his family since 1560 and was near the ruins. Queen Elizabeth spent the night there in the 1960s, when the noted archaeologist Sir Eric S. Thompson was brought from England by the Mexican government to be her guide. (Sir Eric had been, like Morley, with the Carnegie Institution; he became a loyal friend and read the manuscript for *Medieval American Art*, based partly on our journeys in Yucatán.) The day of our visit some broken wagon wheels and a mule were the only things left in the hacienda's once impressive front courtyard. Off to the rear were remnants of an irrigated garden with a few coconut palms, pigs and chickens. Regil was restoring the place little by little, planning to make it Uxmal's tourist headquarters after the swamps were drained and the roads repaired.

The ruins of Uxmal—where the Queen also stayed overnight—were a kilometer past the hacienda, through a mass of dry bush down a narrow dirt road. Immediately, we made for the immense "pyramid" of Kukulcan and climbed to the top for a wonderful view of the whole complex. Also known as the Temple of the Magician and the House of the Dwarf, the tall ruin was the most majestic building we saw that day. It rose up 90 feet on an elliptical stone base, more like a truncated sugarloaf than a stepped pyramid. A chain hung down the steeply sloping back wall, and we laboriously drew ourselves halfway up. The great stairway that ran up the other side of that massive mound was completely dilapidated and impassable. From the different heights of the trees in the thick forest beyond it, we could tell that at one time the city had occupied a vast area, later completely overgrown.

Uxmal was a purely Maya city and seemed to have been more deliberately planned than Chichén. The latter, although on an older Maya site, was rebuilt at a later period and occupied by the Toltecs, thus it showed both Maya and Toltec influences. Uxmal was more grandiose than Chichén and more solemn, partly because of the

greater mass of the buildings, and partly because of their ruined and deserted state. Every building differed from the others in its size and ornamentation, and all the buildings had rich and varied decorations. Unfortunately, little had been done except to clear the ruins and stabilize them to prevent further collapse. The immense buildings at Uxmal were constructed with a superb feeling for drama. The famous Nunnery, for instance (then being reproduced at the World's Fair), was a quadrangle, the north wall built on a much higher base so that when approached from the main gate to the south, the two massive structures appeared to be one on top of the other. Vast raised terraces supported several buildings; the stairs were gone, but we climbed up ladders to the tops. Hills of rubble in the background, grown over with trees, indicated the existence of even larger buildings where reconstruction had not yet begun.

Each of the four buildings around the Nunnery courtyard had a different decoration on its broad entablature section, formed by the inner corbel vaulting. On one, the Rain God mask was the decorative motif, on another repeated cube-like native huts with peaked roofs. On a third, two monster snakes writhed over a rigid, geometric pattern. We wondered how the sculptors could have carried out this complex design of realistic movement amid precise, static patterns so skillfully without the use of metal tools. Or how other artists could paint a story on a cylindrical vase in fluent, graceful, unhesitating lines, without cramping the last figures or leaving a gap at the end. The Governor's Palace stood on a high platform with an open atrium at the front that conjured up festivals and spectacular parades. In niches above every portal were seated elaborately dressed sculptured figures missing their heads, stolen by early explorers or destroyed by fanatic Catholics during the Conquest. The gables of the Doves' Palace originally were entirely covered with sculptured figures, and the archaeologists hoped to find remains of some of them in the debris at the foot of the building. All of this was once brilliantly colored; some faint traces of paint were still visible.

We were completely worn out at that point and lunched at the hacienda, then had a *siesta*. Bumping along in our Ford again, we changed to the auto-car and charged along in the hot wind about halfway back to Mérida. We arrived at a little side station, nothing but a platform and a spur of narrow-gauge tracks. There stood an old, open streetcar and a little mule tied to a tree. When we were all aboard an Indian boy loosed the animal, which immediately pulled off at a swift trot. We rode past endless fields of hemp and a row of white-thatched Indian houses, with hammocks hung between the doors to catch the breeze. Little Indian boys in clean white cotton suits and straw hats rushed at us and hopped on the car only to drop right off again. Suddenly we came face to face with a similar car; the overseer was heading out to meet the train from town. The Indians with him simply lifted the car off the track and waved, smiling, to let us by.

We came to another Regil hacienda that our host wanted to show us. First appeared the hemp-crushing factory, a maze of tracks, a flight of steps, and the little chapel of the plantation, very neat and lovingly kept. Next was a wide, covered porch with kitchens and servants' quarters and men sitting around on the steps, a few of them weaving hemp rope. Then came the manor house itself, with four immense, barren rooms completely surrounded by verandahs and at one time by a garden. Since no one was living there except the overseer, the front court had been turned into a stomping-ground for horses and mules. The majestic baroque gate, which Maximilian von Habsburg's Empress Charlotte (Carlota to the Mexicans) once drove through in state, opened into a dusty corral.

We walked through the garden trying to identify the trees of all the new fruits we had become acquainted with. In one corner of the garden was the *cenote*. The underground water had hollowed out a shallow cave, a true grotto with clear, emerald water and a dripping roof. One side sloped down gently with built-in steps. No one but Señor Regil went in swimming, as we were too overheated. But he splashed around for all of us and came out looking like a new man. In the meantime, an Indian brought down a bunch of green coconuts. He plugged each one with a deft turn of his knife and poured the milk into glasses. There is nothing as thirst quenching as iced coconut milk, as clear as crystal with its delicate taste lasting for hours on the tongue. He split the fruit with a *machete*, a vicious-looking, short sword—and offered us the meat in its natural bowl to be eaten with a spoon. As if this were not enough, we also had iced *guanabano*, which Regil by this time knew was our favorite. We cooled off nicely on the verandah for a while. I sat in the Empress

Carlota's chair and wondered if she found the road to Uxmal any better in her time...maybe it was repaired for her visit! We drank a cup of hair-curling coffee raised on the plantation, which kept us animated until we reached Mérida and the Hotel Itzá.

On Saturday we spent the day packing and typing out three interviews from Pál's original Hungarian manuscript into English, to be translated into Spanish for several newspapers and magazines in Mérida. At Señor Regil's request, Pál put in a plea for better roads and simpler tourist regulations. In the evening we were invited to attend another dance, this time at a middle-class social club. After we were introduced, Elisabeth was led out to dance by the head of the dance committee. At our departure, the president of the club formally escorted her through the hall on his arm. It must have been a terribly funny picture, since he came only up to her shoulder and walked so fast that she could scarcely keep pace. He swept her to the door, where he bade us a gallant "Adios" and bowed, to the delight of the crowd outside. That night we were wakened at half past one by a moonlit serenade with two voices, two guitars, and a violin lamentoso. Perhaps it was not meant for us, but what a lovely and fitting climax to all our wonderful Yucatán adventures!

PÁL IN MEXICO, 1933.

PÁL WITH EDUARDO NOGUERA AT THE TEMPLE
BASE AT TENAYUCA, VALLEY OF MEXICO, 1933.

pulled up ladders to reach high rows of shelves and look through the dusty plates one by one.

Pál remembered that one of Dr. Gann's books (an anthropologist famous for his early work in Belize) revealed that some of the museum's objects had turned up in New York. Then Pál recalled having seen some glass plates of a lovely, large, carved jade which must have been in the museum, but many years later was published in the *British Museum Quarterly* as from their own collection! Later we ourselves discovered museum-quality pieces for sale at La Lagunilla, the "Thieves Market," for considerable prices; the seller evidently knew the provenance! We did not buy anything. In the first place we were traveling for a purpose, and starting a collection would have diverted our course. Secondly, we could not allow any shadow to fall on the U.S. institutions whose umbrellas we were working under.

We bought some reproductions of pre-Columbian objects on display at the desk for souvenirs. No kind of descriptive book was to be had, but we took along a large, colored lithograph of the port of New Veracruz. Judging from the printing technique, it was probably from the early nineteenth century, but the subject matter was closer to the early seventeenth. It showed a fortress and a canal leading through the town, the Royal customhouse, and the fortified island at the mouth of the port. There also were a miniature bullring with a wooden palisade, the main church, a number of convents with green, enclosed gardens, and a small mule train headed down the road labeled "To Mexico City." Everything was explained in a scroll to one side. The viewer was drawn into the scene by the figure of a lady rider with a plumed hat and parasol in the foreground, a skillful visual device.

At the Museum of Anthropology we presented a letter from Dr. Tozzer, and as a result made the acquaintance of a nice young archaeologist, Eduardo Noguera, who was enthusiastically helpful from the first moment. He first called our attention to the museum at the back of the cathedral just behind the sacristy. Superbly embroidered vestments, some old pictures, and woodcarvings were gathered together all in a jumble. There were embroidered brocades with a silver background, gold design, and a free-flowing spray of flowers on top, also somber silver and gold designs on black in the manner of Toledo metal work. A sumptuous set of robe, slippers, and hat for the Archbishop, robes and stoles for the attending priest, and altar cloths were embellished in gold and silver brocade and embroidered copies of Raphael's tapestry designs, so delicately executed that they had the warmth of pictures and were reminiscent of the saints' robes in El Greco's "The Burial of Count Orgaz." According to the young sacristan in charge, most of these had come from the sixteenth and seventeenth centuries as gifts from religious missionary establishments in Spain or the Philippines. A scultpure of the Holy Family had Chinese features. Each figure carved from a separate tusk of ivory, which caused Joseph and Mary to incline protectively over the Child Jesus between them.

Most of the following day we spent trying to get permission to photograph that beautiful cathedral museum, or rather trying to find the official to whom to present Mr. Noguera's letter of recommendation. But once we had located the proper *jefe*, we had our papers before we even recited our carefully prepared speech. For the business of photographing, we engaged a young, starved-looking acquaintance of Noguera's by the name of Manuel Alvarez Bravo. When we called for him in a run-down apartment house in the old part of town, his wife was hanging out the laundry on the gallery of the courtyard. He worked with a high-powered Kino-light and a fine camera with negatives the size of a typewriter sheet. He was very original and modern in his lighting, using shadow effectively and carefully studying the angles at which to focus without producing distortion. He had no objection to taking some of the carvings into the courtyard to compare the result with the light out-of-doors. In the brilliant outdoor light, even in black and white the delicate tonal differences were clear in the *estofado* of the robes (a technique of cutting designs through top layers of paint or gilt to reveal the color underneath). Color photography was in its infancy then, and in any case would have been impossible to have properly developed as we traveled. We were delighted with Bravo's work. Small wonder that he became one of Mexico's most distinguished photographers.

Wandering about the city in a section originally assigned to the Augustinian Order, we came upon remnants of the canal system that had connected the capital with its surroundings. For the Tenochtitlán of pre-Columbian times lay in the middle of a lake, and canals and

causeways permitted farmers to transport their produce into the heart of the capital. There was also an interesting causeway, where the Spanish conquerors broke the strategic power of the city by filling the canals with broken-up Aztec buildings. In 1933 the causeway still stood on its ancient stone foundations and ran through flat, sandy pastureland. Most of the canals have been covered over with time, but this one was still in use in the early thirties. It was bounded by wide quays and ended in an elaborately carved stone fountain of fresh water flowing through a shell-like basin into the canal. The stagnant water was yellow with the slime of floating offal, broken leaves, faded flowers, and rotting vegetables. Boats lined up at the edges were piled full of fresh flowers, vegetables, and smiling market folk. These were vestiges of the Aztec world that had lasted into our century, and we were to discover many more.

A green strip that was part riding path and part promenade with trees and benches divided the principal avenue, the freshly laid-out "Avenida de la Reforma." The whole town seemed to come out on Sunday mornings after church. *Charros* came riding in from their ranches wearing wide hats, tight trousers buttoned down the sides, and embroidered jackets glittering with silver buttons. Saddles, blankets, bits, and harnesses all shone with silver. The proud horsemen sat on their shining steeds with studied nonchalance. A touch of the silver spurs, as big as silver dollars, kept the horses prancing and mettlesome, some even foaming at the mouth. Rustic charm was still prevalent even in the center of the city. Every morning in our room at the hotel, we were awakened by cockcrows greeting the sunrise. This hymn to nature came from a neighboring house with a hen house on the roof, where the owner daily gathered the eggs!

One evening we went to the theater. There were two performances, one at 7:30 and one at 9:00. We arrived a little early for the later show, so we bought our tickets and strolled around the streets crowded with people mostly eating and drinking. There seemed to be two types of restaurants: the Chinese shops that called themselves "cafés" and specialized in appetizing cakes and sweets, and the Mexican ones, more like beer halls that served hot food, thick with the smells of chilies and tortillas rolling out of the wide doors. The whole section had an astonishing resemblance to Montmartre in Paris with fine old houses tumbling down. A magnificent cloister

had been turned into a tenement enlivened by straggling flowers on the balconies and garish, red electric signs.

The theater performance was a sort of a review. The ambitious "European" scenes were ridiculous and vehemently hissed at, while the less pretentious ones were applauded and repeated. The star was a plump and slow-moving Cuban mulatto, who walked through the performance in dignified costumes suggestive of the old plantation days, and sang blues songs without much expression in her voice. She was a tremendous success; perhaps people saw in her the same exotic sultriness of the tropics that we did. The audience did not hesitate to react verbally to everything. If there were any curtain waits, there was whistling and stomping. Not an easy audience to play for, but at least they always waited until the curtain fell to express their opinion! The audience was a strange mixture of rather flashy bourgeois in the front rows, good, solid Mexicans with their families behind, Indians and working men in the galleries. It was a large barn of a place and quite full. Music was furnished by Agustín Lara, a skinny, nervous man who played the piano without sheets of music, improvising on occasion, who was very responsive to the performers. A person of considerable talent, Lara became famous all over Latin America and was called "the Irving Berlin of Mexico."

The rains started last night about 7:00 with a refreshing shower of about two hours and some distant thunder. We were glad, because the dust would be laid for our field trips. Conveniently, even at the height of the rainy season, it never rained in the morning and seldom before 5:00. The auto roads were usually quite good, and we didn't intend to go anywhere very far away or difficult of access. A good, closed Ford taxi could be had for two pesos an hour, and we already had two drivers who comprehended our dislike of fast driving.

Noguera took us to a number of archaeological sites then relatively little known. Our first trip was to the temple base at Tenayuca, built by a little-known tribe that preceded the Aztecs in the Valley of Mexico. Compared to the Maya cities, the site was like a folk song versus a symphony, but it still had many interesting features. Those people did not possess the quality of building materials the Mayas did, and constructed a foundation wall of rubble which they faced and made firm with small brick-like pieces of stone, then plastered it over with a fine, polished stucco and painted

it (which must have been very effective). When we were there most of the stucco was gone, and only traces of color remained. The building consisted of a large, pyramidal temple base with two impressive flights of steps side by side, because the major temples always had two temples on top. These, according to the Codices, were simple thatched huts that have since disappeared.

Excavations have shown that the structure was enlarged five separate times, a larger one being built right over the old one, and thus leaving everything below more or less intact. Even Elisabeth, with her dislike of narrow spaces, crawled through the archaeological tunnels to see the remnants of the older structures. The re-building was done at the end of every fifty-two year period. The priests had calculated that only after fifty-two solar years did the same day, with one numeral in a year, repeat with its numeral. The fifty-second year, special intercession was necessary to insure that new life would be granted to the world. The year was one of despair and fasting during which all the household goods were destroyed and "killed." When the first day of the new "century" dawned successfully, everything was built anew amid great rejoicing.

Unique to Tenayuca, as far as was known, were the coiled bodies of guardian snakes of all sizes, shapes, and workmanship that surrounded the base of the "pyramid," except on the west side where the stairs ascended. The archaeologists made a study of all the varieties represented. There were fifty-two of them, symbolic of the sacred cycle of fifty-two years of the ancient "century." On each side of the pyramid a different color predominated: the South was yellow; the North was white; the East was red, and the West was black (Hell was in the North). The pyramid was beautifully oriented in the landscape, and on the north and south sides were impressive figures of the Fire Snake wearing a crown, which faced the exact point where the sun sets at the solstices of summer and winter. But after 260 years, the people of Tenayuca covered up their temple with earth and rocks and disappeared, and for centuries the site was thought to be a natural hill in the mountainous country.

From the top of the pyramid we had a fine view of the surrounding country, with the roads lined by great cypresses thriving along the irrigation canals. Little brown and white Indian houses dotted the landscape, and the cattle were coming in for the night in clouds of dust, driven by cowboys riding their pretty horses bareback or on bright-colored blankets. The air was very clear and the colors startlingly distinct. The earth was dry before the rains, the trees bright green, the mountains were lilac and seemed very near. The volcanoes were so completely veiled in mists that one would never know they were there except for the guidebooks!

A few Indian children met us at the gate of the pyramid enclosure with little baskets of broken pottery and obsidian they had collected from the fields. There was no doubt that these things were genuine. They existed in such quantities that they could be picked up everywhere, as Elisabeth used to pick up arrowheads back home in Indiana. We took a piece from each child's box and gave them ten centavos, at which they ran off giggling and delighted. The people knew enough to take any large or especially perfect pieces to the museum, where they were well compensated. But the little pieces were too numerous for anyone to pay much attention to.

MEXICO CITY AND NEARBY TOWNS TO SAN ANTONIO, TEXAS

NOGUERA AND A LIVELY UNIVERSITY STUDENT (a nephew of Don Regil in Yucatán) also took us to a number of other sites. One of these was the ancient and magnificent Teotihuacan, where so far only three buildings had been cleared off: the gracefully proportioned Pyramid of the Moon, the imposing Pyramid of the Sun, and the Citadel. In one corner of a wide, walled-off area stood the Temple of Quetzalcoatl, recently revealed by the removal of a larger building superimposed upon it. A section of two man-high terraces with huge heads of protruding dragon-serpents alternated with enigmatic heads with staring, wide eyes, interpreted as masks of the Rain God. There had been remarkably little damage to the stone sculptures, still bearing traces of color. The place was almost deserted, and the heat was terrific. We found a scrap of shade against a crumbling mound to eat our lunch. It was baffling that the *Conquistadors* rode by those hills and did not realize Teotihuacan had

been the greatest and most influential settlement in all Mexico; but even the local inhabitants knew little of the old glory by then. The same held true for the once-powerful Tula. At the time of our visit, all that was left were two (and a half) "warrior" columns and a scrap of carving on the wall of the ball court.

In Pál's opinion, Teotihuacan was the most spectacular, fiercely vibrant, and characteristic site we had seen in the whole Valley of Mexico, built with an assurance of design and an expert technique, despite the limitations of primitive tools. The veining of the masonry on these pyramids was very interesting. The stone facing was laid in a different manner for each of the terraces, which gave each terrace a different tone and shading. In great contrast to the pyramids of the Yucatán, at Teotihuacan there was hardly a tree to be seen. Everything was buried in the sandy soil and thickly overgrown with brown grass and weeds. The huge, purple volcanic mountains all around the city made it appear to be in the bottom of a great bowl, and the fact that there is no building beyond the pyramids standing with complete walls or a roof, made the place seem more "dead" than the cities of Yucatán. Our wonderful guides then took us to the nearby Augustinian monastery at Acolman, a Renaissance building from the middle of the sixteenth century. Startling, double-life-size murals in the apse were very unusual, in that the figures were painted without any background or other decoration on a blank, white wall. There were three tiers of them: popes in golden chairs; cardinals in their red hats, and monks. Walls and even the ceiling showed remnants of black and white painting in fine Italian Renaissance style, which must have been done by the missionaries themselves because of their early date. One wonders what romantic biographies have been lost in this barbaric land! Besides us that day there were only the swallows, which flapped their wings entering and exiting the empty windows.

Mexico was the first Latin American country intensively visited by Americans, and the vast amount of publicity it was given in the early decades of this century was largely due to the photographers, painters, and writers enchanted by its exotic culture. Small groups of foreign businessmen and European refugees appeared in Mexico in the 1930s, bound together by common interests and language. Some delved into the recent past and post-Revolutionary muralist painting, some studied the pre-Columbian world, while some were interested in folk art and tradition, and others in Spanish colonial art. Some simply wanted to learn the melodic Mexican Spanish and soak up the atmosphere of the lovely provincial cities, where one could live and travel comfortably on very little money.

Diego Rivera was probably the most outstanding painter of that epoch, or at least the best known abroad. He had studied in Europe and lived through the 1910 Revolution in Mexico. His adoption of Communism was more or less a natural development; extreme ideas are often welcomed by artists. His murals at the National Palace and the National Preparatory School visualized his political and social convictions, and artists need to be understood according to their own point of view and as part of their particular surroundings. His polemic work struck us as superbly decorative and well organized, but also over-crowded, over-stated, and by then rather stale. Rivera's unique abilities as a designer were evident in his portrayal of a boy walking along a road offering a calla lily to an Indian woman with a basket on her back, trotting home to her village. The artist has never been surpassed in his renditions of the peasants in the marketplaces of Mexico, where the rich folk culture is continually intriguing.

Another painter of the time, José Clemente Orozco, who came from a bourgeois family, similarly was swept to the Left. His work recorded the Zapatista rebels with the rhythm of destruction on the march. His style was angular, thrusting, and intellectual, exhibiting sharp observation almost entirely without emotion. The personal involvement, warmth, and passion of Rivera was missing. But Orozco's raw painting ability and talent for composition came out in all of his work. It is entirely a matter of taste whether one prefers Rivera or Orozco. In the Rivera murals, the decorative, polemic compositions were essentially static, with the extensive use of caricature to express emotions. His unerring sense of line was most evident in his portrayals of peasants going about their daily activities. Orozco, on the other hand, was full of motion and violence, even ruthlessness.

In an earlier period, a painter born in Catalan Spain in 1840 flourished in Mexico: José María Velasco. He grasped the character of the landscape of the High Plateau better than many a native artist. His luminous vistas across the wide valley with the majestic, snow-capped volcanoes on the horizon have never been surpassed in Mexico in depicting the clarity and foreshortened perspective of the

high altitudes. Velasco was highly regarded in his lifetime and is today; his landscapes are painted music.

Some years later, we had an interesting glimpse into Rivera's personality because of *Medieval American Art*. Walter Pach, a painter and art critic who had lived in Paris and translated the diary of Delacroix, helped his American readers to visualize the nineteenth-century artistic turmoil in the French capital. We met him when he was living in New York in a sunny apartment on Washington Square with his wife, also a competent painter. When the pre-Columbian survey book, *Medieval American Art*, was distributed in 1943, Pál received a letter from Pach praising the book and saying he was on his way to Mexico to lecture and would take the book along to write a review for the *Virginia Quarterly*. That fall he telephoned us in Norfolk, and we arranged to meet in New York. Pach's comments about the survey showed how well he understood its goals. We exchanged travel experiences, and he asked, "Do you know Diego Rivera?" "Chiefly by his work," Pál replied. Pach then recounted the following episode: "During our first days in Mexico City, Rivera, an old friend, came into our apartment. *Medieval American Art* was lying on one of the beds. Rivera leafed through the pictures, picked up the two volumes and went into another room to a big table, where we could hear him talking to himself about the illustrations: 'Where did he get this! I never have seen that one! Here's one I know...' And Diego spent nearly his whole visit with that book." Pach's lectures were well attended, and the couple enjoyed Mexico very much. At Rivera's studio the artist showed them some very fine pre-Columbian pieces, which explained his interest in the book. When the Pachs were packing for New York, Rivera appeared unexpectedly, and seeing they were almost ready to go, wrote out a check and handed it to Pach. "For the Kelemen book," he said. "It's not any good, but you shouldn't have to carry such a heavy thing back with you to New York, where you can buy another one."

On one of our first evenings in Mexico, we went out for a quiet evening stroll. At the curb in front of the hotel, sat an Indian woman selling small pieces of cotton cloth embroidered in black wool in a running stitch, depicting sampler-like figures of little men and women holding hands, flowers, and geometric patterns, beautifully arranged and each different from the next. We bought a few pieces for a peso each, admiring the ingenuity of the variable pattern. It opened our eyes to the native weaving not only in Mexico, but also in all the Latin American countries where weavers excelled.

Among the most interesting people we became acquainted with were the Hungarian Vice Consul (also coach of one of the most successful football teams), and his vivacious Viennese wife, who was attached to the German Consulate. There was also a pleasant, good-natured Austrian friend of Hermann Beyer's in New Orleans, *Ingeniero* Roberto Weitlander, who invited Pál to the Austrian Club. There sat Pál with Weitlander and his cronies, all pre-Columbian fanatics, discussing theories and raving to their hearts' content. At the next meeting, Pál took along Brehme's prints and gave them an illustrated talk on Chichén Itzá and Uxmal. It was surprising that not one of these men, as much as they knew about every square foot of the Valley of Mexico, had ever been to Yucatán. In those days it was still difficult to reach the Yucatán Peninsula from the mainland. The train ran only as far as Túxtla Gutierrez in Chiapas, and the road stopped just across the border.

A few days later, *Ingeniero* Weitlander took us to the ruins at Calixtlahuaca to see one of the few round buildings that had been excavated. It was of fine, smooth masonry; a well-planned opening at one side revealing that once again it was built over two earlier structures. Beneath lay the vestiges of a good-sized community outlined by the flattened walls. The route home took us through Toluca, where it was market day, and local weavers were exhibiting their wares. Our eyes were drawn to the *serapes* worn by the natives. The soft, unbleached white wool of the background was decorated with brown and yellow designs around the slit for the neck, with a touch of a beautiful coral color and a narrow edging of natural grey wool at each end. The harmony of the colors and proportions of the decorative elements showed a high degree of artistic sophistication.

Not realizing the rarity and the quality of such work and being already overloaded with souvenirs, we thought to pick those up at another time. But only a few years later, when we returned to Toluca, not a single example of this type of serape could be found. The accelerated disappearance of quality in the folk art is catastrophic, whether one looks for it in Mexico, Guatemala, or Alto Peru and Bolivia. The blame rests partly on the demands of

American mass production in the quest for something new and exotic; and partly on the tourist, who seems to feel that the "primitive" or the "naïve" must be garish and grotesque. Just as in weaving, a great deal of the native folk music, lovely old melodies from the colonial epoch, and also the period instruments have tragically disappeared. The musician of pre-Columbian times had to accept the instruments of the Caucasian intruder and even the scale on which the melody was constructed. Enchanting folk harmonies that enveloped the listener gave way to Spanish instruments and rhythm, but musical talent remained. A vast literature composed by local Indians and *mestizos* was then coming to light in the old churches, and *charangos*, which looked like small banjos, and various flute-like instruments were still used in remote villages. The late nineteenth century brought in the primitive gramephone, which caused havoc. Records became cheap, could be distributed to distant points, and were played in the evenings on loudspeakers or shouted from a jukebox in the plazas for promenades. Just as with folk weaving, the present connoisseur may have no idea of what the beauties and varieties of folk music were in the past.

On our return from Toluca's heights, we had a fine view of the Valley and City of Mexico. The volcanoes of Popocatepetl and Ixtacihuatl were obscured by a dust storm's huge yellow cloud rising at Texcoco and hanging over the valley. In 1910, the Revolutionaries had promised to distribute land among the peasants, not realizing that, as Lake Texcoco is salty, the land around it was not suitable for planting crops. As an astute interpreter of Mexican life, photographer Hugo Brehme, remarked, "The Indians never would have done such a thing. It took the Spaniards to place their blooming city on the edge of a desert!" The colonial oligarchy that ruled Mexico did not want to give away any part of their own landholdings, and seemed to think they could designate arable soil for the Indians where it did not exist.

Another day we drove to Tlaxcala, crossing a mountain pass with superb pine and Mexican cyprus forests. At last we had a close view of the famous volcanoes Popocatepetl and Ixtacihuatl, looking very Chinese with a dense haze near the earth, causing the snowy peaks to look painted on the sky. Even at that time the main Mexican roads were excellent, straight, and smooth, with deep irrigation ditches at the sides and a double row of ancient trees. Our driver said that banditry was still rife along the modern civilized auto road, and that the government thought the way to curb it was stationing a patrol of soldiers every 3 miles along the road, and their families with them. A favorite method of the robbers was to stretch a piano wire across the road at night to stop the oncoming cars, which usually killed the occupants before the outlaws even put in their appearance.

We crossed the watershed line in the forest with the sign "Pacífico" on one side and "Atlántico" on the other. Shortly afterward we reached the village of Rio Frio, famous as the headquarters of the highway robbers, a messy group of hovels with gasoline stations and refreshment stands by the road. Our goal lay somewhat off the main road, and getting there we encountered dust and bumps but also the quiet but prosperous characteristics of an out-of-the-way agricultural community. We crossed a marshy pasture and came to a river with a deep gorge and fine gravel sand, and rows of kneeling women on the shore washing clothes and chattering without end.

In Tlaxcala, a fine church called the *Parroquia* (parish church) stood on one corner off the plaza, and the Governor's Palace and Municipal Palace faced the garden in the center. The buildings were all faced with brick-shaped, smooth red tile, and one of them dated from the earliest years of the Spanish colony, its exterior columns carved with flat, tapestry-like designs probably done by an Indian hand. The irregularly shaped windows and portals of the government buildings were frosted with the elaborate stucco work famous in the area. In the central plaza was the usual iron-fretted bandstand and off to one side a simple, early fountain with four protruding little heads, mouths pursed to spout water. On another side of the plaza stood arcades of heavy columns, and opposite a strange building with stone bas-reliefs on the facade reminiscent of medieval Europe: figures of hoary, bearded men. Tlaxcala, we decided, preserved a rewarding measure of colonial history.

On top of the hill at one side of the city, walled and turreted like a fort, stood a Franciscan ex-convent dating from 1521. The complex included a handsome, free-standing bell tower at the top of the main ramp to the churchyard, a small early chapel at the end of a long ramp up another side of the hill, some small processional chapels, a two-story monastery, and a large church. The door of the church was

kept locked, but the little son of the sacristan came running with a key. The building was Renaissance in feeling, and the interior, in proportion to the whole group of buildings, was high, broad, and massive. Inside was a remarkable *mudéjar* style beamed ceiling with a design burned in black in the natural, dark reddish wood and a series of rich gold rosettes. The church held many elaborate, gilded Baroque altars with twisted, flower-bedecked columns, and row upon row of life-sized, carved and beautifully painted wooden religious statues. The heavy stone baptismal font, where the first Spaniards baptized the four Indian *caciques* of the Tlaxcala nation, was still there in a side chapel.

The whole place was in a deplorable state, neglected and deteriorated. Some of the statues had been replaced by pasteboard saints of the crudest colors and outlines. Oil paintings had been cut out of their frames, and in one of the remaining pictures that depicted the Passion, the faces of the soldiery were scratched out or holes had been punched through their eyes. The monastery was being used as a barracks, and outside in the broad atrium soldiers and their families were camping in tents and straw huts. Chickens scratched about, bundles and baskets were strewn everywhere, and youngsters were shrieking as they played. We wondered what the Spanish Abbot, who ruled this stronghold of celibacy would have thought, had he seen this camp of the Republic's careless, modern soldiery!

Our trip to Mexico was much more a voyage of discovery than we had expected. To be sure, by then there was a smooth path worn by Cook's Tours and the Ward Line, but those routes were little-traveled and left out many significant and fascinating places. We realized that we had to really go digging for the photographs we wanted, not only on the rooftop of the museum, but also spending many hours at the German photographer Hugo Brehme's studio going through old albums. He turned out to be a very well-versed, intelligent, and helpful person, and we found some excellent pictures. We were glad we had shot so many pictures on our own, however, and Brehme and his technicians printed them with excellent results after developing each negative by hand. Elisabeth realized that she had taken many unique photographs and was glad there were so many. She consoled herself for the uncertainties of time and exposure

with the notion that if they didn't come out well, we could buy a postcard. The guidebooks were so inadequate (especially Terry's), that without our agreeable new friends, we would have seen much less of Mexico's interesting facets.

But it was time to go home. Early in the morning, on June 15th, we boarded a train for the two-day trip from Mexico City to San Antonio. The journey was entertaining but dusty, as the track ran through mountains and wild lands, cut by deep gorges overgrown with cactus. In the evening the plains began, with successful agricultural pursuits in evidence, and farmers irrigating the fields by treading on water-wheels or driving a blindfolded burro pushing a long pole. It rained all the second day and flooded everything that had looked so parched the day before. At 6:00 in the morning we reached the frontier. A Mexican border soldier came in and carefully examined a whole box of our slides, leaving his fingerprints on each one! The engine was uncoupled, and an American locomotive was attached to our car and pulled it to the middle of the Rio Grande bridge, where the American Customs agents boarded. We got through without any difficulties. It seemed that everyone was being summarily vaccinated, because of a smallpox epidemic in the area, but fortunately we could show scars enough to convince the authorities that we were not at risk, and thus avoided being stuck with any needles.

San Antonio had some remarkable old Spanish missions right inside the city, and we were amazed at their neglect. A local newspaperman, who took us around, agreed with our dismay at how little had been done to preserve such important historical remains, and we had quite a discussion. Only after leaving Mexico did Pál realize how fluently he could speak English, when the preservation of art was the topic! We decided to take the 2,000 mile return ticket home that we had learned about in New Orleans, which seemed such a long time ago after all our adventures. The train would take us from San Antonio to Chicago in four days, and after staying over a day there to see the El Greco's and other exhibitions, on to Minneapolis five days later. We thought we would stop in Buffalo, since the New York Central Railroad was offering a free trip to Niagara Falls to the holders of long distance tickets. Even following this plan, we should reach home only a few days later.

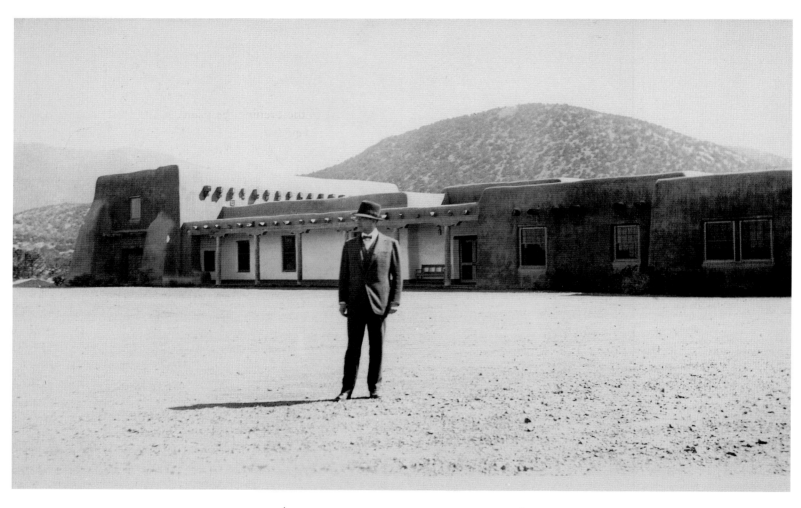

PÁL IN SANTA FE, NEW MEXICO, 1936.

NEW MEXICO AND COLORADO, 1936: SANTA FE, MESA VERDE, AND PUEBLO

LA FONDA HOTEL, SANTA FE
OCTOBER 9, 1936

JUST BEFORE LEAVING NEW YORK for New Mexico, we went to a Jung lecture. There were interesting references to folk psychology, which we are learning more about in New Mexico. Jung spoke about collective ideas and the fact that certain general, accepted symbols such as the rose and the circle for unity, dual parentage, and the physical and spiritual in age-old religions, were also present in the individual, who may not have come in contact with these ideas before, but to whom they expressed the same things. He demonstrated this by first showing symbolic representations from ancient pictures and manuscripts, and then some parallel drawings from dreams by his patients and pupils. In all cases the symbolism was very marked, and his interpretation of the designs produced some interesting conclusions. His point was that there is a common consciousness in humans that emerges as a common expression that is not learned, but rather the outcome of instinct. This was a very interesting contribution to ethnology and the subject near to our hearts, "parallel psychology."

The train to Chicago was ultra-modern, of streamlined steel with double and single sleeping compartments, air-conditioning, and an observation section with easy chairs and a bar. It was all very handsome to look at, but exceedingly uncomfortable to ride in, because of inadequate leg room and space for baggage, and the lightweight train shook and rattled rather badly, as it was built for speed more than comfort. Nonetheless, we arrived safely in Chicago and cheered up considerably upon seeing Betty Edwards and her father at the station, beaming confidence. Betty whisked us off to their pretty apartment at the university. We were treated to a sumptuous breakfast, beginning with ripe strawberries and continuing indefinitely with hot waffles and much animated conversation. Afterwards, we re-loaded into the Lasalle and reached the station with plenty of time to admire the fine lines of our transcontinental engine.

On board the "Chief," we had a good, old-fashioned, heavy Pullman car that ran smoothly and without excessive noise. We crossed the prairie, very pretty with its clumps of trees and rolling fields. Every two or three hours the train stopped, and everyone jumped off for a walk and a breath of air. When we awoke Monday morning, we were traveling through the most desolate plains with sand and sagebrush as far as the eye could see, but soon this broke into interesting hilly formations. As we breakfasted in the dining car the Rockies suddenly burst into sight, superbly abrupt. Their sharp snow crowns dominating the view looked almost close enough to touch!

The peaks disappeared a short time later as we rode south out of Colorado into New Mexico, and the mesa formations grew higher and higher above the floor of the land. The desert country seemed softer than the lower lands between the mountains, and we traversed a number of green valleys with large, intensively cultivated farms. An excellent road ran right alongside the track, and the desolate land with its grayish grass was all fenced off, evidently as grazing land, although no herds were in sight. The train track climbed steadily higher, and the country suddenly changed from gray soil with gray

bushes to red soil with round, green juniper trees, hillock after hillock exactly alike with a few towering hills in between.

We were the only ones to get off at Lamy, the station for Santa Fe. Although it was the state capital, it didn't have a passenger railroad, and the track was only used for freight twice a day. We were loaded into a large touring car serving as a bus, which immediately roared off at full speed. We soon lost sight of all human habitation and went charging up and down hillocks along a ruler-straight road, as if on a scenic railway. An old railroad hand sitting in the front seat got very chummy with me. He had worked on the Santa Fe Railroad since he was fourteen and was then over seventy, yet he had never stayed in Albuquerque for longer than a few hours and was going there to vacation for a week. He launched into a rambling, picturesque reminiscence of the big flood a few years ago and how they brought the express train through. All the people in New Mexico were the best storytellers imaginable! Supposedly, they had enough time and leisure. They never hurried a point, and when they made one, it created a lasting impression.

We came upon Santa Fe as abruptly as we had left Lamy, lying in a bowl of low hills protected from the winds and storms in the mountains. The Rio Grande River was little more than a creek and almost dry at certain seasons, but had enough underground water to make the valley fertile and supply irrigation ditches. The Spaniards, who founded the city, had been colonizing there for a number of years and originally placed their capital on a riverbank, near the pueblo of San Juan. Soon quarrels over water rights arose between the Whiteman and the Indians, but the colonists in the region were by no means as powerful as in Mexico. Instead of slaughtering their neighbors wholesale, as Cortés and his followers did further south, they moved to this spot on the Rio Grande.

The limits of this small city were about the breadth of New York's, so we passed the city line long before we saw a house. Even after wandering about, it was difficult to get an idea of the town. A typical Spanish central plaza fronted the Governor's Palace built in 1610 (when the city was founded), which had also served as a fortress. It was very moving to stand before this decaying old Palacio, once the administrative center of New Mexico, its paint flaking and the protruding ends of its great vigas (ceiling beams) so eaten away they looked like petrified sponges. During peaceful times later on, windows were cut in the outside walls, but the old rooms were still intact and housed the museum. When the roof leaked it was the custom simply to pile on more adobe, and when the Palace was repaired and put into use again, the roof was 4 feet thick in some places. The old beams sang like a violin when rapped but still held fast! There were some very nice murals painted by an artist who nearly starved in Colorado Springs but in the end had a grand funeral! Few other buildings around the Palace were built in the local style; some echoed the taste of the eastern United States, others the taste of a bazaar. This plaza was the most awful jumble of square red brick buildings and liquor stores all bunched together, as in the days when the railroads first came through and towns mushroomed overnight.

Leaving the plaza, a ten-minute stroll in any direction led to the suburbs and the hills. The outskirts were full of mud-colored adobe houses with tumble-down walls and wisps of gardens. Beyond the flat desert around the city, the distant, ragged edges of the Sangre de Cristo (Blood of Christ) Mountain Range gave the appearance of a granite curtain shutting out the rest of the world. A strange quiet floated over all, and we breathed with some difficulty in the unaccustomed altitude. It seemed like a few centuries rather than just a year ago that we sat on our terrace in Florence, enjoying the glow of the sunset on the cupola of the Duomo, the Giotto tower, and the weathered crenelation of the Palacio Vecchio. The vast differences between the Old and New Worlds took a great deal of effort and sensitivity to comprehend!

After the Indian rebellion of 1680, the Spaniards were allowed to go home to Mexico. But the Indians realized they (or others like them) would return, and withdrew to the hills. That was one reason many of the ancient pueblos of the valley were abandoned. The Pueblo Indians and the Spaniards probably would have gone on fighting for centuries had they not been forced to combine forces against the sudden rise of the Navajos, Apaches, and Comanches, whose mastery of the horse brought by the Spaniards turned them into a serious threat. The war against these marauders ended only about fifty years previously, when the tribes were rounded up and put on reservations. By 1936 the Navajo people were increasing much faster than the neighboring tribes, and spread out beyond their own

boundaries. They repeatedly took over Hopi land, but the Hopi did not seem to care, still having enough to get along.

When Mexico revolted against Spain and declared her Independence, she also claimed New Mexico and the adjoining territories. The Southwest never revolted against Spain, although there were many who considered the Mexicans usurpers. But in 1820 Spain was too weak to press her claim for such a small section of the country and lost it along with Mexico. The famous Santa Fe Trail came down from Kansas City through the prairies and ended there, making it a trading center of goods from the East, the Far West, and Mexico. How great the profits must have been was indicated by the tale of a tyrannical Mexican governor who exacted a tax of 500 dollars on every wagonload of goods which came through town. The traders would stop outside the city, load everything they had on one wagon, burn the rest, and enter town with only one twenty-horse team!

When Texas was an independent country for a few years, it set out to conquer New Mexico. But the Texas army couldn't negotiate the desert, and returned utterly broken without even fighting one battle. Whether it was for this reason or not the New Mexicans continued to hate the Texans, and jibing rivalry continued to exist between them. New Mexico was won over to the U.S. in a bloodless battle in the 1850s, when a troop of U.S. cavalry rode into the country proclaiming that henceforth justice would be accorded to everyone through the offices of the U.S. government. The Mexican government was completely demoralized, the tyrannical governor fled or was bought off, the people turned to better ways to settle their troubles, and that was that! The Mexicans were very proud of their heritage and of being earlier settlers than the "Americans." But they felt no allegiance to Old Mexico and traced their ancestry and traditions directly to Spain. During the Civil War, Texas was for the South and New Mexico for the North, which also could have caused antagonism.

New Mexico was the youngest state in the union, and Santa Fe claimed to be the oldest capital. A handsome state capitol building with a shining dome was located on the far edge of town. The city was slightly larger than Elisabeth's hometown of Jeffersonville, Indiana, with 14,000 inhabitants. Since about 1912, led by good Dr. Edgar Hewett of the Museum of New Mexico with our friend from the Yucatán, Dr. Sylvanus Morley, in charge, there was a movement for the restoration of the city to its old and unique style. Starting with the museum and the restoration of the Governor's Palace, a number of public buildings had been raised in adobe or colored cement to resemble adobe: the library, the Fine Arts Museum, the new post office, and our own noble hostelry, modeled on the grand old mission churches of the region. There was even a filling station on one corner, not at all grotesque, with a wide porte cochere and a wooden-beamed entrance. The adobe building material was so cheap that it lent itself very well for small, private houses and even some amusing "bachelor-apartments" built in the manner of the terraced Indian pueblos of two or three stories, with outside entrances and wide sun porches on the upper floors.

Santa Fe was still a frontier town, with the majority of its population Mexican or Spanish American (as they preferred to be called). Indians and cowboys came in to trade, parking their ancient Fords in front of the columned galleries of the stores, where they used to park their horses. After new arrivals would observe this scene for a while, the town began to make some sense and become quite enchanting. Add to this the landscape, the incredible clarity of the air and blueness of the sky, the snow-capped mountains to the east reflecting a dark red Alpine glow every sunset, and one can understand why we succumbed to Santa Fe's charm. We even looked casually at apartments in adobe cottages (at 50 dollars per month), although our limited time would not permit settling in.

The adobe architecture gradually became very seductive, and what started out looking like a mud ball came to wear a monolithic dignity. The houses were put up by hand, rambled, and had rounded edges and uneven walls, which made them as lazy and delightful as the local stories. The interiors had whitewashed walls; cedar beams in the ceilings were warm, soundproof, and spacious with plenty of light, and thus were most agreeable and easy to furnish. One might even claim that the present day "modern" architecture expressing itself in asbestos and steel to great practicality, might in part have been derived from Santa Fe. For did not that pioneer of modern architecture, Frank Lloyd Wright, evidence an appreciation of the Southwest in his rambling structures of monolithic blocks? The La Fonda Hotel was built in the same fashion with modern improvements, and decked out with Indian rugs and brightly painted

furniture. The food was extraordinarily good, and no wonder, for the German Kaiser's former chef was officiating in the kitchen! We chose the hotel because it was centrally located and just around the corner from the museums. Since it was off-season and somewhat empty, the hotel manager gave us a good price for two comfortable rooms.

Dr. Hewett was awfully nice from the first moment of our meeting. He outlined the best trips for us to take and even came over personally to arrange certain stopovers and side trips with the Detour people, who will take us to Mesa Verde. We planned to go with him on a tour of the early mission churches that were being excavated and restored by the museum. Eager to get started, we took a car yesterday to the two nearest cliff-dweller ruins of Bandelier Monument and Puye, passing by three Indian reservation pueblos along the way. Once more the road led up and down over red hillocks, but the country was more intensively cultivated here than what we had seen before. In the little valleys were oases of springs and little rivers, white adobe ranch houses among circles of pretty poplars and cottonwoods turning yellow. Trees were loaded down with dark red apples, and fields of corn were being harvested. Strings of bright scarlet pimientos hung from the eaves of every house, with pumpkins and gourds set out to dry on the roofs.

The pueblos were adobe villages, usually built around a large, trampled earth square with a huge tree in the center. The village church was often quite picturesque, but the cemetery always barren and desolate, since grass was the hardest thing to grow. Village women were shucking their corn and spreading the grains out on blankets to dry in the sun. The Indian corn was dark red or dark blue (incredible, but truly blue), or a charming mixed mosaic of the two colors. The men were out in the fields, and from one house we could hear someone playing a tom-tom, probably in preparation for the harvest dance on November 12th. Hopefully, we would get to see it. The Indians were remarkably Mongolian in type, even Tibetan, with very small hands and feet. We found the women and even the little girls rather homely, but the men and boys graceful and handsome. They were courteous and spoke English, and all of them greeted us as we passed by, but then ignored us and went about their business. One had to pay to take photographs, which was only fair, as it was a source of income for such poor communities.

Arroyos (dry creeks) constantly crossed even the main roads. In times of rain they were often impassable for several hours, while the water ran off. People just waited or took another road around. There was not the rush of the East; the local people seemed to have adopted the patient attitude of the Indians. We felt the 7,000-foot altitude only in spurts, sometimes getting suddenly tired, and other times tremendously stimulated. After making our first big excursion successfully, we both felt much better acclimated. Driving closer to the Bandelier Monument, we turned away from the beautiful valley of the Rio Grande with its wide bed and trickling streams into higher country. Soon we were among red mesas, honeycombed by natural caves with evergreens thrusting up from their midst. We realized, with great excitement, that all the round holes above these caves were post-holes, where the ancient cliff dwellers inserted their roof beams. The geological formation was volcanic "tufa," or ash with a layer of much harder rock on top, preventing the soft cliff from washing or blowing away and making the stone easy to work.

Miles of these pre-historic dwellings had never been excavated. But at Frijoles Canyon, a Swiss named Bandelier made his home from 1885 to 1890 and out of personal interest excavated and explored the ruins. We could not imagine how he got out there without any roads and 40 miles from any civilization. When he reached the canyon, he had to let himself down from above on a rope. But live there he did and loved it! Arriving by car on the newly built road (in relative comfort), we could understand his enthusiasm. When Bandelier left, the place was again forgotten until Dr. Hewett re-excavated it, made some restorations and honored his predecessor by naming the ruins for him. At the time of our visit there was a ranch house and a CCC camp for building a proper road. A young officer was in charge of the place, and took us around after a delicious lunch of fried chicken and home-made bread still warm from the oven. Immediately, as happens to many visitors, we were captivated by the mystery of the cliff dwellers.

Dr. Hewett held that the cliff people were originally occupants of the natural caves, and therefore arrived in a pretty primitive state. Later, they excavated and deepened the caves and began to construct walls and new rooms in front of them. Still later, they developed the pueblo type of storied apartment houses, the population increased and some moved into nearby valleys. The archaeologists found pretty good links

to establish the continuity of the various phases and changes. Then all the early inhabitants suddenly moved out into the river valleys, and there was evidence of a new people coming to live there. But who came and how they got here remained a mystery. The modern pueblo people were descendants of those people and had many handed-down stories about their ancestors and the ancient customs.

Late in the afternoon we went on to Puye, a cliff dwelling of the same type, but with a large community house built on top of the mesa. We had never seen such a view! The land fell away to the Rio Grande Valley with masses of golden trees, then rose again to the reddish foothills and the rocky back of the Sangre de Cristo Range. Half of the valley was in shadow as the sun was setting, and the mountains glowed a rich crimson and purple in the reflected light.

We enjoyed a beautiful Indian summer and became quite fond of Santa Fe. Even the cheapest shops were attractive, showing bright, checked cowboy shirts and handkerchiefs, and fancy boots and belts. One morning we spent nearly 5 dollars buying tramping moccasins, a cowboy shirt and three real cowboy bandannas at the noble emporium of J.C. Penney, which was really thriving there! Many places had Navajo rugs, and weavers creating conventional pieces on modern looms. The exhibitions of silver changed from day to day. The junk-shop near the moviehouse had a fascinating collection of antique wooden saints like old-fashioned dolls, still clad in ribbons, dusty lace, and embroidered rags. The more conventional antique shops showed a great many Mexican imports, as Mexico had a more highly developed industry in knickknacks and souvenirs. When buying a seat at the movies one paid extra for "rocker-loges," and sure enough, on entering would find a row of huge rocking chairs on a raised platform. When the crowd thinned out, one could tilt back and put one's feet on the railing.

Cooking at the area's height had special problems. We wondered why we could not get our home-brewed tea any stronger, until we realized that water boils at a much lower temperature here. Eggs had to be cooked almost twice as long, if one wants them anything but raw, and there was a science to baking a cake, for the ordinary amount of baking-powder would blow it sky-high and cause it to collapse miserably afterwards! Some of the churches issued a Santa Fe cookbook for newcomers, with favorite recipes and tricks to help

them succeed. We were anxious to see *The Texas Rangers,* a movie which had not yet arrived in Santa Fe. It was filmed at the San Ildefonso Pueblo, and we hoped it might show some of the country. Why a story about the Texas Rangers should be made in New Mexico, only ironical fate and the movie magnates could say!

We met some truly delightful characters, in contrast to the motley crowd on the street of stylish little tourist-typists, cowboys and Indians, ranchers, and women artists in overalls. Sylvanus Morley and his wife from Chichén Itzá and the Carnegie were there (they had a home where they spent part of each year), and we had quite a talk last night; also Dr. Karl Ruppert (from Chichén) and Eric Thompson (late of the Field Museum and then of the Carnegie), whom Pál had intended to see in Chicago. Santa Fe didn't kowtow to its artists, as Taos did. In fact, people here spoke with some scorn about the recent article in *Vogue,* saying that only one person mentioned really was of any renown in the town, and the others were just a clique of no consequence, who got themselves mentioned in the papers. In Santa Fe, the general opinion seemed to be that no one was particularly proud of being written up in eastern papers, and it certainly did not constitute being of consequence!

LA FONDA HOTEL, SANTA FE
OCTOBER 20, 1936

We left Santa Fe about ten in the morning for Albuquerque and an appointment with Dr. Hewett at the University of New Mexico. A small Buick four-passenger car was provided for the 65-mile trip, very roomy and comfortable. Our driver was a tall, thin young fellow named Russell Nelson, a typical Scotsman with sandy hair and a long face, born and brought up in New Mexico. He was wearing the company uniform consisting of a riding habit and a large cowboy hat. The women guides wore velveteen Navajo jackets with a heavy silver belt, so very becoming that Elisabeth decided to adopt it at an opportune moment in the East! The road led straight over the rolling countryside, its reddish dunes and circle of mountains never seeming to get any closer. After about an hour the valley of the Rio Grande opened before us with its green fields and yellow poplars, and we followed it for an hour into the city.

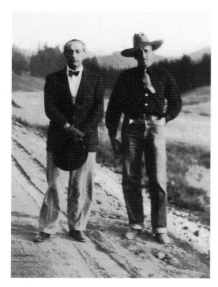

PÁL WITH RUSSELL NELSON,
DRIVER/GUIDE TO MESA
VERDE.

The hotel was inside the railroad station and pretty noisy, but fortunately, our room was on the opposite side from where the track ran! Time was when the trains used to stop for an hour for the people to have lunch or dinner, but when we were there, the train stayed only half an hour to load mail and take on water. Meanwhile, the passengers walked up and down the platform and peered curiously at the Indians and their wares laid out for sale. It was spectacular to see the Los Angeles Express roar up at night in the glare of floodlights, pulled by its enormous engine. Truckloads of mail were rushed up and loaded, as the Negro porters sprang down with little pitchers to get fresh ice for the water coolers, and the big engine was unhooked and sent off for coal and water. The Indians sitting by the station held up their little pottery bowls and vases and called out coaxingly, "Buy a souvenir, lady!" After the engine was hooked up again, the conductors would shout out the "All aboard!" that every American traveler imagines no journey can do without. Then the engineer pulled the throttle, and eleven sleek steel cars tore out of the station with not even a jolt to the passengers.

Albuquerque had none of the romance of old Santa Fe, although it once had an old section subsequently torn down to make way for wider streets and more stores. The city was large, rambling, brick, and ugly: just what Santa Fe would be if it had been on the railroad. Albuquerque was the main metropolis of the state and inhabited by 35,000 of the state's 400,000 people. As a railroad center, it was busy and modern with the latest fashion of all kinds of goods in the shop windows, to tempt the cowboys, Mexicans, and farmers from the country round about, who streamed in to shop and loaf.

We went out and spent the afternoon at the University. The place was a mass of workmen and torn-up ground. Dr. Hewett said that it was growing so fast they could scarcely keep up with the needs of the students, since every high school graduate wanted a college education. All the new buildings were being done in the New Mexico adobe style, so suitable to the landscape and climate and well adapted for institutional use. Dr. Hewett was the Chairman of Archaeology and one of the guiding spirits of the place, as well as one of the pioneers of southwestern archaeology. Chaco Canyon (where we were bound on this trip) was a favorite child of his, and he was responsible for the scientific excavations of most of the sites in the area. He was also behind the revival of the old adobe style which was replacing the awful, ramshackle brick buildings in Santa Fe and elsewhere. That energetic little man on the verge of seventy thought nothing of driving round-trip twice a week between Santa Fe and Albuquerque to lecture.

Dr. Hewett wanted us to see the drawings of some kiva paintings his students had excavated, and laid them out on the floor. It was almost always customary to paint the walls of the ceremonial chambers called kivas. The plastered walls would soon become blackened by smoke and had to be re-plastered, and an entirely new technique had to be devised to remove and reclaim them. One of the students had developed a method adapted from the European technique for removing frescoes to save the thin, adobe murals and mount them on stiffened canvas. No wonder the young students were so enthusiastic about a university that gave them such thrilling problems to work out!

The frescoes we saw were stunning, and another day we viewed the originals. On the first wall we examined there were seventy coats of adobe plaster, fourteen of which had been painted. Unfortunately, but inevitably, much had been ruined. Nonetheless, the pictures showed a remarkable grace, a ripeness of design and lovely coloring. The colors employed were mainly of mineral pigments, and very different from those of the Central Americans, with a great range of tone. A fine sea green and a deep vibrant gold were extraordinary. Pál remarked on the artistic understanding shown in the grouping of the pictures utilizing wide, deliberate spaces; most "primitive" people tended to crowd their work. As we were leaving, Dr. Hewett patted

Pál on the shoulder and said, "We need a man of your viewpoint and vision here! Stay with us for two or three years and work out these theories with us." This informal but definite invitation was very flattering. Pál said that he would accept right away if the University was in Santa Fe, but Albuquerque was not as beautiful, and being at a lower altitude did not have as good a climate. It did have its attractions, nonetheless. Later that afternoon we went to the zoo to watch the bears, hear the cougars "cough," and smell the coyotes! We had one quick glimpse of a prairie dog, but he vanished as we went closer, because they never get tamed by peanuts or used to people.

The region around Albuquerque was full of ruins that had not been excavated. The next day we dressed in our heavy shoes, leather jackets, and cool, soft shirts and left civilization (although we followed the railroad for a few miles). Our first stop was Laguna, an Indian pueblo with a handsome adobe church. A huge wooden *retablo* (altarpiece) behind the altar was carved and brightly painted in imitation of the grand, gilded altar screens of Mexico, exhibiting great charm in its simplicity and naiveté. The Southwest was a bitter disappointment to the Spaniards, who had adapted their spending habits to the rich loot in Mexico and Peru. In New Mexico they found only deserts and mesas, so they left it mainly to farmer colonists and priests.

Upon their arrival in New Mexico and Arizona, the Spaniards found some eighty Indian cities in fertile valleys, which they named "pueblos"; they numbered eighteen when we were there. The houses were built of stone in brick-like blocks held together with adobe, the native clay. Although these pueblo people were not always related and spoke four separate languages the others could not understand, their cultures seemed very similar to each other. They were an agricultural people, raising corn (maize), squash, and beans, and living in apartment house communities with terraced houses, five or six stories high. They were a peace-loving people and traded among themselves, communicating with the famous Indian sign language and later Spanish. Always prey to fierce nomadic tribes, they constructed their villages in a circular form or the shape of a D, with a high wall for protection and perhaps only one small entrance. One could only imagine how fierce their enemies must have been! The prevailing opinion was that the cliff and cave dwellers of prehis-

toric times were the ancestors of the modern Pueblo Indians. The most primitive "Basket-maker" people, with their round, semi-underground houses, evolved into the early pottery makers, who used the bow and arrow and planted corn. More changes occurred about the time that the cliff dwellers of the "golden age" (about the ninth to the twelfth centuries AD) began to move out of their mountain strongholds into the valleys. New blood and other cultures must have been absorbed at various times.

When the Spaniards came, they found the Indians living in the valleys, and, as they had done elsewhere, they destroyed the native communities and enslaved them. In the early sixteenth century the place was priest-ridden and the people extremely poor and susceptible to disease. The Spaniards taught them the use of adobe bricks mixed with straw and dried in the sun (which the people of the Valley of Mexico used before the Conquest). The villages were re-built with adobe, instead of the old stones, and enormous churches were raised. About 1690 there was a savage Indian rebellion, and it took the Spaniards a number of years to re-conquer the harsh and arid territory.

The Indians did not need running water to drink, and could subsist on the most stagnant, slimy pools. In some parts of the country they developed a method of dry farming in sandy riverbeds, other times using irrigation. In any case, they could often survive where the white man could not, and were therefore left alone in certain areas. That is why the Hopi in Arizona were still pagan, while the Pueblo people of the richer valleys had a veneer of Christianity mixed with their ancient beliefs and rituals. Even after years of enslavement to the church, they refused to support a priest and only tolerated one, when he came around occasionally. Otherwise, they got along as best as they could with their own medicine men.

The church at Laguna was decorated with a superb, bold design in black and yellow, reminiscent of paintings on ancient kiva walls. A kiva was not exactly a religious house, but rather a community house, with one for each clan or family in the tribe, and sometimes a great big one for the whole community. Kivas were always round and at least partly underground, with certain standard features, such as a fireplace in the center, a clever built-in vent for the departed spirits to enter and the smoke to go out, and a bench all round for the members to sit and lie down on. Women were invited for certain

APPROACH TO ACOMA, NEW MEXICO.

rituals, but the kiva generally seemed to serve as a sort of men's club, where serious matters were deliberated. The ones still in use were jealously guarded from strangers. At Taos we saw an Indian's eyes peering at us over the edge of the entrance (descent was by a ladder through the roof). Most likely, if we had gone closer, he would have chased us away.

Leaving Laguna Pueblo, we turned off on the road toward Acoma through a barren valley with a ragged carpet of sagebrush ringed by high mesa cliffs. In the deep bowl of this valley two mesas rose up, as perfect as the one at Orvieto, which we had visited while living in Florence. The one was never inhabited; on the other lived the people Willa Cather described in her historically based, dramatic novel *Death Comes to the Archbishop*. Sent to Acoma by the church after the Pueblo Rebellion, Bishop Lamy evidently felt that discipline would be good for the Indians' souls. It was he who had them build the enormous church at the "sky village."

This church was the most beautiful adobe building we had seen so far. Two huge, buttressed towers framed the entrance; the nave, with its rounded apse, must have been 300 feet long. On one side stood the priest's house, then in ruins, with a charming, carved wood balcony and a cloister to walk about in. The cloister and the yard in front of the church had been filled in with soil carried up in baskets from the plain below, one for a garden and the other for a graveyard. When we visited, the garden was a heap of dust for lack of water to keep it up, but the cemetery was still in use, although bare of grass, desolate, and decorated only with typically stark, wooden Indian

LOOKING DOWN ON APPROACH TO ACOMA, NEW MEXICO.

crosses. The work involved in raising the church obviously was incredible. In the first place, the mesa was of hard rock and as high as Orvieto, approached only by a rock-climb, using handholds and footholds dug out by the inhabitants centuries ago, or by way of a steep defile, ankle deep in dust. Every adobe brick and wooden beam had to be carried up that crevasse. Since there was no big timber in the region, the huge beams for the roof must have come from mountains 40 or 50 miles away. The Indians, tired of all this labor and discipline from their insatiable priest, one day threw him off the cliff, right over the edge into the valley far below!

Thanks to those Herculean efforts, the community thrived to such an extent that the village on the rock could not accommodate all its inhabitants, and a colony moved away to found Laguna Pueblo. The Indians of Acoma attributed their prosperity to the good offices of Saint Joseph, whose picture the priest had given them to place over the altar, when the church was completed. But the daughter colony did not get on well and begged Acoma to lend it the picture. The Acoma Indians at first refused, then reluctantly let the picture go. Fine harvests followed for Laguna, and poor ones for Acoma, and Laguna refused to return the image. There were quarrels, raids, and desperate skirmishes over the matter for years. Finally, when the United States attached New Mexico, the Indians were persuaded to take the affair to court. The decision came down that since Acoma had originally owned the picture and badly needed it, the image should go home. Laguna's people carried it to the Acoma line and hung it on a tree, where the Acomas found it. They still say that their Saint Joseph was so glad to return home that he walked the distance by himself.

The Acomas spoke a language related to almost none other, and their houses still contained ancient beams cut with stone axes. They climbed up and down the cliff to cultivate their fields, keeping corrals with horses and burros at the foot of the hill. They seemed mild and polite to us, but very determined. There was a story that they were asked to reproduce their village for the San Diego Fair, and were allowed to charge a dollar entrance fee. When they returned to Acoma, they logically said that as the real village was so much grander than the reproduction, they would charge a dollar entrance fee there also. They also charged a dollar to take photographs, but we didn't blame them at all! They were extremely poor and intensely

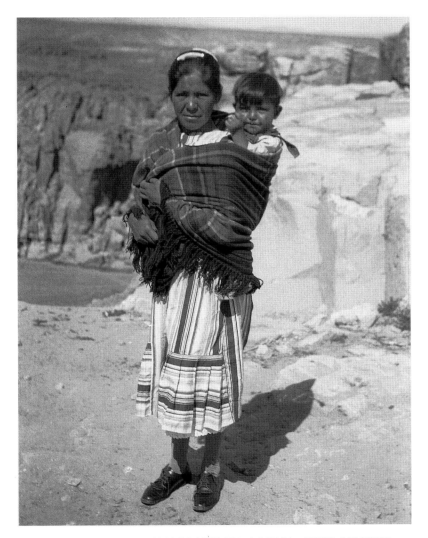

POSING FOR A PHOTOGRAPH IN ACOMA, NEW MEXICO.

resented being treated as curiosities. The fee helped keep out non-serious folks and added to their meager community chest. But we thought that having paid, Elisabeth could photograph everything in sight, and turned to take a man mounting the steep path on a pony. "Don't take him!" said the diminutive woman who was guiding us; "Men don't like it." "But I paid for it," Elisabeth replied, "you can persuade him." "I know he doesn't like it," the woman said, "because he is my husband."

We played around Acoma for some time. It was a strange place, completely barren of all vegetation, with the houses just like formations of the rock cliffs. As in all other Indian pueblos, we noticed scraps of dried meat, bones, battered tin cans, and feathers were lying all about. In a few places there were ancient bowls hollowed into the rock beside the houses, with indications that they were used to catch the blood of butchered chickens and small animals. The Hopis, people said, were more sanitary. But the few houses we looked into were swept clean, and the very dry air and blazing sun outdoors disinfected everything, so that nothing was repulsive and soon turned into dust.

An overgrown, green pool of stagnant rainwater was the community cistern and springs below the cliff were another source of water. Although the trash heap (the kitchen midden in which the archaeologists delighted) was but a short distance away, channels were dug into the rock to direct the impure water away so that only fresh rainwater could flow into the cistern. We could not imagine that these people drank such water straight, but used it only for washing. The Indians endured the desert heat and climate so much better than the white man that we wondered if they ever drank water by the glass! The men were coming in for lunch, and the place seemed completely deserted, except for the ponies standing around the plaza. The church interior was immense and rather barren, but had a fine *retablo* in brilliant colors on the far wall. On both side walls, brackets had been placed from the doors to the altar to hold pottery candlesticks of varied and attractive designs. We found out that the woman escorting us was the one who had made them, but she had none to sell that were exceptional.

Climbing down off the scorching rock, we determined to have lunch as soon as we could find a cool spot but had to drive for miles before coming to a satisfactory place. The little junipers were as reserved as the Indians, and drew their shadows about them like a cloak at midday, leaving little shade, while the few cottonwoods were in dusty pastures behind barbed wire. We finally stopped at a small American settlement on the main road, a roadhouse reminiscent of one in the Painted Desert, with some adobe houses nearby, and the large shed of an Indian trader. Inside the trading post, we occupied a large booth curtained off from the food and drink bar. We unpacked

our sandwiches and enjoyed our respite under a real roof, all for the price of several cups of muddy-looking but perfectly delicious coffee, boiled on the back of the stove.

Outside was a little stream running over barren rocks. Little girls dressed in calico, with unmistakably Midwestern accents, were drawing up water in tin buckets advertised as "pure mountain water." When we walked over we spotted an old wreck of a car, and a lot of tin cans scattered about. The water may have remained "pure mountain" for all that, but we were glad to have brought along coffee and canned peaches. We had a flat tire (you always got one at Laguna, our driver said), and while waiting for it to be vulcanized at the trading post garage, watched the cars whisking by from California, New York, and Pennsylvania. Then, along came truckloads of Mexicans going back across the border after harvesting or doing road work, pickup trucks with an inscrutable looking Indian behind the window, or a cowboy in blue overall pants tucked into his fancy boots, and riding a light-stepping, jaunty little horse.

We had heard that it was considered rude to ask people around there anything about their past, but Elisabeth tried it out on an old man of the town. He was a huge, toothless fellow, ancient but still wiry. They talked about the weather; then she sprang her little shot, sugaring it by saying that he talked like people in the Deep South. Well, he really didn't like it a bit, probably not so much because he had anything to hide, as because she was impolite making such a personal remark. He said that he had lived "down Texas-way" for a long time, then spat some tobacco-juice and moved off. One of the Midwestern girls approached and proved to be more talkative. She was visiting in this "God-forsaken" place from Detroit and was crazy about it. Indeed, beyond the dead Ford and the tin cans were the "wide-open spaces," and they were pretty thrilling!

We sped on over countless miles. The atmosphere was so clear that the distant mountains never seemed to advance or recede, but always remained at the same distance, near when we were miles away, and far away as we approached them. The terrain was a series of great plains, rimmed round; we would approach one mountain wall, pass over it, and suddenly be enclosed again in the same kind of landscape. The road was excellent, except where it was being repaired. In one section they were rebuilding it straight across

mammoth lava-beds, with the black stuff rolled up like black loam cut by a giant plow. It seemed silly to blast their everlasting straight road right through the rock when the old road wound picturesquely along the side of the lava, but that was how the government was spending our money.

We were fast approaching the country of the Navajo, a distinctive and interesting tribe. When the white man came, the Navajo and the Apache were the most primitive of the existing tribes, living in squalor and stealing from the agricultural communities of the Pueblo Indians. But when the Spaniards introduced the horse, cattle, and sheep, the

NAVAJO HOGAN

Indians quickly became nomadic herders with some remarkably Mongolian traits. The Apache never developed the high culture of the Navajo. Both tribes became so fiercely predatory, raiding and robbing peaceful Indians and the white pioneers alike, that the government carried out the famous Indian Wars of the last century.

Little by little by little, the Army rounded up all the survivors of those two long-invincible tribes. They were sent to Florida or to Peeks land, a place on the eastern side of the Rio Grande in New Mexico. It was an insane idea. The Indians brought up in very high desert country died like flies in the wet lowlands of Florida, and the Peeks land was too dry to be used for pasture. It was impossible to convert these Indians into an agricultural people, and after ghastly results, it was decided to let them return to their own lands in the Navajo country. The pitiful survivors of the experiment were again transplanted, and many died on the long walk home. But they had thrived so well in the past fifty years that an estimated 50,000 lived on a reservation about as large as the New England states. The Navajo were the most vigorous and best-adjusted of the full-blooded Indians. They seldom mixed with whites, but took many wives and much of their later culture from the Hopi living near the Grand Canyon.

All the most sensational of Arizona and Northern New Mexico country was Navajo land: the Grand Canyon and Canyon de Chelly, where there were rich pastures hidden within a forbidding moun-

tain-pass; Rainbow Bridge, and the famous Shiprock, which looked like a full-rigged sailing ship in the middle of the desert. The Navajo claimed that the ship brought their ancestors to their homeland and told them never to leave it. That was clear proof of the recent origin of their culture, for in pre-Columbian days the Navajo had never seen a sailing ship. Their myths were a combination of primitive tales and the folklore of the Hopi, and they learned weaving from the Hopi as well. From the Spaniards they learned to craft silver jewelry and raise sheep. The adept and adaptable Navajo combined all these elements into their own modern culture.

They lived in "hogans," round cabins made of willows and wattled clay. The summer houses were mere shelters of branches, but the winter ones were quite weather-tight and roofed in an interesting manner. They laid four poles along the walls to rest on four pilasters built against the walls, then four more transverse to these, etc., until a sort of corbelled wood dome was produced, extremely pretty, high, and airy. The dome was then covered with adobe. The whole cabin was so disguised that it was difficult to see unless hunting for it. Some of the ancient kivas of the cliff dwellers were thought to have been domed in this manner. Perhaps the Navajo devised the dome trick to honor the ancients, for they claimed that the spirits of their ancestors rested in the deserted cliff dwellings. But all indications were that the inhabitants of the cliff houses had departed long before the Navajo appeared.

NAVAJO WATER HOLE

With nearly all of the Western Indians the tribal inheritance was through the mother. The girl was married off for a very high price and chose her own husband. She owned her own sheep and horses as well, and the young man moved into her parents' house. In case of death or divorce, the property was hers. The women did the weaving and heavy housework, while the men herded livestock and created the silver work. Polygamy was practiced so there were more wives for the heavy work, but was dying out because of its expense.

Laws were upheld by the men, and everywhere the Indians were left to policing by Indians. Supposedly, it worked much better than having white men ride after the culprits, as of course the red men would band together to protect each other. There was a peculiar and complicated custom of having the boy children brought up in the families of their aunts, a matriarchal practice, evidently employed to break up too-close family ties. The pueblos were divided into "summer" and "winter" people, as well as clans, with all kinds of taboos about marrying within the group. The Navajo spoke quite a simple language with tongue and lip sounds like our own, while the Pueblo people spoke a language we could only approximate, full of strange guttural and nasal sounds that sounded almost Chinese.

We rolled into the small town of Thoreau, which consisted of a row of houses on each side of the road, a sheep pen near the train tracks, and a water tank for the locomotive. While our driver filled

up on gasoline for our plunge into the wilderness, we wandered into a shop marked "Indian Trader" to buy film and Lifesavers. A Navajo family was trading, including two girls with immensely full skirts and hung with silver chains and bracelets. One carried a baby, tied on the typical Navajo cradleboard and wrapped to invisibility in bright scarves and covers. The man wore the usual velveteen jacket with silver belt and buttons, and they all lounged around fingering printed materials and various knickknacks. They had come in a big spring (or rather springless!) wagon with two horses, and it was obviously a holiday they were going to make the most of.

The road out of town turned abruptly north between the high red cliffs, known as the "Gates to Navajo Land," and the landscape changed immediately. There were higher evergreen trees, and thick, grayish turf. Being just to the east of the Continental Divide, the land got much more rainfall than other parts of New Mexico. The road was dirt and very dusty, but smooth enough going, particularly as we met no one else winding through the ravines. We saw a number of hogans, some with modern barns and automobiles standing out in front. The Navajo readily bought whatever was affordable, whether canned fruit, flashlights, or autos.

The women and children were extremely shy, but curious nonetheless. As we passed a flock of sheep, two little girls madly rushed out to two telegraph poles, where they hid to peer out at us. When we waved, they waved back. Further along we saw a little boy with some horses; as soon as he saw us, he plunged into a hole where he hid like a rabbit, and only his barking dog circling about betrayed his presence. Later we saw no more hogans and flocks, only occasional riders on sprightly, small shaggy horses making for home in the diminishing light of the setting sun. We drove out on an immense, high plateau that seemed to curve along the round of the earth, with only the tops of the mountains rising over the horizon. It looked very stormy, and the sunset was spectacular. To the east a shower fell, a deep coral-colored veil between us and the distant landscape. The western clouds turned purple and then a translucent, dark blue that showed late into the evening. After this the going was extremely rough. It was pitch-dark, and we spent our energies looking for the diagonal ruts at the bottom of each slope that threatened to bump our heads against the roof of the car. Occasionally, a rabbit

or chipmunk darted across the road in the headlights. We could tell that we were entering a deep valley, and finally drove over a bridge to stop outside a lighted house. It was the Indian trader's at Chaco, our home for the night.

The building was partly of stone and partly of adobe, built about 1800 by a member of the famous Wetherill family, which discovered Rainbow Bridge and figured in many legends of the early times. Somebody from the trading post came out to escort us into a large sitting room with a big fireplace and Indian rugs hanging about. The other decorations consisted of ancient pottery and baskets strung from the rafters, and set on a plate rack around the room. Calico curtains framed the windows, and it was warm and cozy. The whole place was ablaze with light and full of people. We could scarcely see on entering from the darkness outside, and were quite startled by the abrupt change of scene.

As we got used to the light and activity, the company resolved itself into Springsted, the trader, a young, blond fellow of about twenty-five with a slow drawl and humorous eyes; his wife, still younger and also Swedishly blond, a cheerful, energetic person who was a wonderful cook, and (as we later discovered) did everything about the household with great efficiency. Somebody's college textbooks on history and economics formed the greater part of the library, and they were probably hers. There were also Jack, "the helper," slim, dark, and in his early twenties, and a young married woman guest who helped with the cooking, most likely a friend of Mrs. Springsted. The hired hand drifted in later, a mild and good-natured, huge, fellow who ate his supper at the "second table." Then an Indian woman appeared, who had been putting the babies to bed, a little boy of three and a chubby infant of four months, who appeared the next morning.

They had waited supper for us, which we all ate in the kitchen. The big wood range was going full force, and two luscious apple pies sat on the windowsill. The table had a bright cloth and pretty, colored pottery dishes. In the middle stood a huge plate of bread, a whole sliced loaf flanked by big pitchers of milk and saucers of jelly, butter, and pickles. Everyone was extremely polite and had excellent table manners; no reaching across the table, and the food was continually passed back and forth. We had well disguised mutton, baked potatoes,

a delicious salad, and pie. The women served and ate after the rest of us had finished. Jack and the hired man helped wash up, while Springsted showed us the outhouse by flashlight, with the ragged walls of a ruin looming behind it. Our host speeded up the Delco motor, and we were illuminated as if on Broadway, just the way to be seen at the outhouse!

No one put himself out frantically to entertain us, so we sat around without much conversation, but felt quite comfortable and soon retired. We never did get the hang of that house, but it was apparent that we were occupying the master bedroom and Nelson, our driver, the "guest-room," where the washing machine stood. Probably the trader couple slept on the daybed in the parlor and the two men in the store. After we went to bed, there was scarcely a sound, only a little shuffling about before the lights went out. We might have been entirely alone in the place, but for the master's violent curses when the watchdog barked at a coyote or some other wild creature. Thankfully, our large, iron double bed had two big comforters. Compromising doors had been draped with Navajo rugs, and we had a washstand and pitcher to ourselves (the others washed up back of the kitchen). It was as cold as out-of-doors, for the room was only an adobe lean-to with a beamed ceiling. We managed very well, however, and felt vigorous and bright the next morning. By the time we arose, everybody was up and about, everything in order, and where they all put themselves away at night remained a mystery.

The Indians were already coming in to trade. They like to take all day about it, purchasing a nickel's worth every hour or so, and otherwise loafing around and enjoying the atmosphere. They were exceedingly sharp and clever traders and respected the man who could make a good bargain. Their custom was to pawn their silver jewelry over the winter for credit, until the sheep shearing time came, when they redeemed it all back again and brought their rugs in to sell. Woe to the trader who sold or lost anything! If the Indians considered themselves cheated, they would run the trader off the place or boycott him out of business. Three traders had been killed at Chaco, but everyone said they had it coming to them. It was strictly forbidden to sell liquor to the Indians anywhere, or to even have beer on the reservations.

We got into the car and drove over to the research school head-quarters, where we were taken around by the young man in charge, an expert photographer named Dr. Karl Reiter. He and his wife and baby were living in an Americanized hogan, roomy and delightful, except that everything was together in one big, round room. At the summer school at Chaco the students lived in tents, and the scientists stayed out there one place or another practically all year round. They didn't have much money but were so dedicated to their work that they did not seem to mind. Chaco Canyon was not scenically spec-tacular, as Frijoles or Puye, but a rather wide, shallow valley flanked by cliffs. It must once have been prosperous with plenty of water, for no less than eighteen huge communities were established there, some at the same time.

The remarkable system of dating artifacts used at this site was worked out a few years ago by astronomer E.A. Douglass at the University of Arizona in Tucson. He crosscut living trees, matching up the sequence patterns of the rings on certain species (each one counting as a year) back to 11 AD. They compared those to wood from ancient buildings and even charcoal. This "calendar" dated the flowering of the Chaco communities between about 950 to about 1130 AD. Some of the beams in the old *Palacio de Gobierno* in Santa Fe furnished valuable specimens for Douglass's tree-ring calendar. Indications were found of a terrible, continuous drought in the twelfth century that endured almost fifty years. The archaeologists believed that was what drove people out of the canyons and down to the river valleys. Probably it happened gradually, as the dry period came earlier in some regions than others, one family and then another leaving until the ancient cities were deserted. Evidence existed that some of the Mesa Verde people came down to Chaco in the last years, and tried to make a living there by taking advantage of the more abundant water.

We visited three of the largest houses. They were built like walled villages in circular form or rather like a capital D, resembling a huge beehive. The only entrance was a low, narrow door through a 6-foot wall, so it would have been hard for an enemy to get in alive. Inside were one or two wide-open courtyards, with the huge community kiva in the middle. The houses were placed in a semi-circle around the courtyard, terracing up toward the outer wall and estimated to

have once reached 60 or 70 feet, with 5 or even 7 stories! The ground floor rooms had no doors and were entered from above by means of ladders, another method of defense. Although the rooms were pretty big, averaging about 9 by 12 feet, and 8 feet high, many were windowless and pitch dark. It was concluded that they were only used for sleeping and storage. The pueblo's inhabitants actually lived out-of-doors most of the time and withdrew to these strongholds only at night, and in case of danger.

Communal fires were usually kept going out-of-doors in the courtyard. Hundreds of *metates* (grinding stones) that were discovered have been collected and imbedded five and six in a row in a single chamber, as if in a community hand mill. Chetro Ketl (enchanting name!) and Pueblo Bonito, the two largest and most fully excavated house groups, each had more than fifty small kivas, indicating how many clans or families lived in the community. The kivas were perfectly round, and some had interesting, individual features. Some were even built on the second floor and roofed only by the cavern above them. Dr. Judd of the Smithsonian Institution thought that the women built the houses just as the Pueblo women did later, while the men built the kivas and did the weaving, which was ceremonial in purpose. He believed the houses were much better built than the kivas, and the women continued to build better than the men! That was certainly a feather in the women's cap, or rather headdress…The ancient pueblos were built of brick-shaped pieces of worked stone from the nearby hills, cemented with adobe, and strengthened by poles of wood from distant forests.

Modern architects threw up their hands in holy horror when they saw those great walls, 6 feet thick at the base and laid down at intervals on a strip of three or four round pine logs. Nevertheless, the walls had not broken down at these points, and the wooden lintels and ceilings held up remarkably well. Perhaps in our age of steel we did not know as much about building with wood as the builders of the ancient pueblos! Dr. Reiter, our excellent photographer-guide, pointed out the expert repair work that had been done in crucial places. The ceilings had an interesting type of construction, worth describing. Large, round beams were laid from one side of the wall to the other, stretching across two rooms if long enough. The sockets, where they lay, were carefully built up with small stones and plaster.

Across these, in herringbone pattern or straight in the perpendicular direction, were laid the slender, blond trunks of mountain aspen, a kind of birch tree. On top of this was spread shredded cedar bark, and then the floor of the room above was filled in with dirt pounded hard, or plastered with adobe. The finished ceiling was a beautiful, effective paneling, still used in the adobe houses of the "Santa Fe type." The floors were as solid as cement. We walked over many 1,000 years old, without realizing that solid ground wasn't underneath!

In some places only the stumps of walls were left. We climbed around over the second and third stories, staring suddenly into the abyss, with the original ground floor below the level of the soil. In other places, the walls still rose to 30 or 35 feet and were very imposing, with a fine, even curve to fit the D-shaped design. One of Dr. Hewett's helpers made some model reconstructions that breathtakingly revealed the beauty of this beehive architecture. Nobody knew how long it took to construct the buildings, but undoubtedly the great kiva was laid down first. Since the pueblo dwellers were always on the defensive, the community house must have had sufficient structural form to serve as a safe fortress from the outset, while the rest could have grown cell by cell. Burial grounds were placed far outside the city, although few had been discovered. Above Pueblo Bonito, a huge section of the yellow cliff was eroding away, and threatened to fall on the building. The Indians carefully built walls under the cliff, not as the soil scientists used to say with superior grins, "to hold up" the huge mass of stone, but just as modern engineers would do, to lead off the seepage and prevent further erosion. What accomplished builders the ancients were!

With our heads whirling with facts, fancies, and the brilliant sun, we went back to the trader's for a late lunch. Later in the afternoon, we drove off to the next station to be able to reach Mesa Verde the following night. We made a hair-raising ride right up the canyon cliff to arrive at an immense plateau. Then the road fell again, crossed a river, and swept through a miniature desert of shifting sands onto an endless plain of pasture. Once more in the middle of nowhere stood a little house with a windmill, barn, and a large sign, "Indian Trader." Nelson said this was the place to look for rugs, if we wanted any, for Springsted, the trader at Chaco, had practically sold out his stock to the summer students. It was the usual country store equipped with a large stove, counters on three sides, and shelves with calico, leather, and canned goods. The Navajo loved canned peaches and tomatoes as much as a small boy loves ice cream, and we also learned their value, when we had to lunch in the parching sun out-of-doors. The trader took us into his back room, where a handsome young Indian was lounging about in a bright blue shirt and a large quantity of turquoise and silver. They laid out a heap of rugs, spreading them over the floor and the bed. Not liking the geometric designs, we bought a "chief's" blanket with stripes of natural black wool and a bold star design in white and zigzag red. After its purchase, we both felt very elated.

The rugs were marked with the initials or some other identification of the Navajo woman who wove them, who was then given credit at the trader's for whatever amount was agreed on. Usually she took it out in canned fruit, tin utensils, or other household goods. The Navajo were eminently practical and often traded in beautiful blankets for softer, machine-made lap robes and bed blankets. The hand-woven, hand-spun wool blankets made fine hangings and floor rugs, but the Indians knew by experience that they needed a comfy material to wrap up in, when the north wind began to howl. We later read about Indian blankets and learned that white, black, brown, and gray are natural tones of the wool and usually were hand-spun directly from the homegrown sheep. Red was the most beloved hue, being the color of the sunshine on the red sandstone cliffs, and was then usually created using aniline dyes bought from the trader. In early days the Indians used to buy red flannel or red wool cloth, unravel it carefully, re-spin the yarn, and then weave it into their work. All the colors of the rainbow were later used, but the natural tones along with a soft earth yellow and a deep blue seemed to be the most effective. As we drove off, we saw the blue-shirted Indian galloping away in the opposite direction, and wondered if he carried a message to some squaw that we had bought her blanket.

Nelson was very disappointed to see a haze rising to the west, which prevented sight of the famous Shiprock in the distance. We did see the Colorado mountains, our goal, 150 miles away, and were satisfied with that. In a short while we drove through a riot of canyons, red, yellow, wild, and every which-way. The road was hard clay, but turned into axle-deep mud when it rained, water swirling

about in all directions. Nelson was stuck right about here with his last party, who had to be hauled off in a lighter Ford. He showed us the skid marks, as hard as rocks! A short time later, we dipped into the San Juan Valley, and the landscape changed again completely, as if for the new scene of a play. The river was lined with immense cottonwoods, all a dazzling yellow in the evening sunlight. Once across it we were in country which had been settled and irrigated by the Mormons, before they moved on to make a garden state of Utah. Little wooden farmhouses with comfortable front porches dotted the landscape, and rows of big trees were everywhere. The corn was being harvested, the fields were full of squash and yellow pumpkins, and orchards hung heavy with delicious little hard, juicy, red apples. The valley smelled strange and unpleasant, for there were hot sulfur springs all about, certainly not appetizing to whiff, even if good for rheumatism!

We drove into Farmington, New Mexico, for the night and found a comfortable, modern hotel with hot baths. We dined at the Chinaman's down the street and got very good food, too, sitting in a booth. Men in ten-gallon hats and high-heeled boots lit into huge hamburgers there at night and stacks of buckwheat cakes in the morning. We had a lunch put up, including the accustomed can of peaches for dessert, filled our thermos bottles, and retraced a part of the road of the previous day to the ruins of Aztec. The place name had no connection with the inhabitants of the Valley of Mexico, except perhaps in the minds of the early white settlers who named it, for the ruins were Pueblo III, like those at Chaco. They were reconstructed by Earl Morris, who later won fame by rebuilding the Temple of the Warriors at Chichén Itzá in Yucatán. Aztec was a National Monument with two rangers assigned to it, a rambling ranch house, a museum, and suitable rest rooms. Chaco was more rough-and-tumble, being owned partly by the government, partly by the University of New Mexico, and partly by private individuals, with work going on continuously. In contrast, Aztec was set out for show. Moving even a stone was forbidden, unless it could be written up as repair work.

We encountered there the same type of D-shaped house block familiar from Chaco. The pottery and implements that were discovered had been placed on shelves in the rooms where they came from, which lent color and authenticity to the rather barren stretch

of cells. Aztec's most interesting feature was its great kiva, differing in many ways from the usual type, as it had a series of small outer rooms at ground level around the sunken main room. On one of the side walls was an interesting experiment in the use of strips of green stone, which produced a handsome, decorative frieze on the plain gray walls. The kiva was one of the largest discovered, and had been beautifully reconstructed. Its fire pits, four central pillars supporting huge roof beams, and strange little stairways, like built-in ladders, reached down from the rooms above. Our guide said that he had never been able to get a satisfactory photo, because the glare from the smoke hole and the outer window always blurred the plate. It was rather a gray day, and remembering that Dr. Reiter at Chaco told us how he got all of his best interior photographs by a long exposure on dark days, Elisabeth tried a few shots with swell results. As in the Yucatán, she had just plain good luck with her Kodak. No amount of mere skill would have produced such results!

After leaving Aztec, we drove through more familiar, alpine country with rich, cultivated lands on the hillsides and farmhouses similar to those we encountered repeatedly from Ohio westward. This was Colorado, its more abundant water supply apparent everywhere. On our left rose a huge shoulder of reddish and metallic lavender rock, a spur of the La Plata Mountains still being mined for silver. We treated ourselves to an ice-cream soda in Durango's main drugstore, and noted that the soft Southern accent of the New Mexicans had given way to a harder, Western twang. Durango was a thriving mining town, and the sooty smokestacks and overhead pulleys of the mine stood just inside its gates. A red and white brick hotel displayed the date 1894, and neat little cement bungalows were lined up in the suburbs. Autumn was much farther advanced in that country. The mountains were covered with deep green pines, and leafless aspens in the gullies glimmered a strange, silvery gray. Here and there, where the trees were better protected, startling patches of still-bright pink and yellow leaves flashed against the black evergreens. At the end of a valley of wild, mountain scenery, Mesa Verde suddenly shot up in front of us, a huge yellow cliff, looking absolutely inaccessible. When we crossed the border of the National Park, there were still 26 miles to go. The road wound up the side of the cliff, broad and well laid-out and reportedly kept open by big snowplows in winter. Due to the

skiddy road, up until a few years ago, visitors were sometimes marooned on top of the mesa for a week at a time. Nelson insisted that there actually was no danger, because the road slanted in toward the mountain, but looking over the sheer drop on the other side, we couldn't blame anybody for not wanting to take the risk.

The highest point was about 8,000 feet and reached up above a great plain like the huge prow of a ship, with distant settlements only colored patches among tiny groups of yellow trees. There were few fields, but instead a sweep of pale gray-blue sagebrush in deeper tones along the streams. Two hundred miles away, on the edge of the horizon, the blue mountains rose up again. Toward the south they were closer, mound on mound disappearing in the distance. This bit of tilted table-land sloped rapidly away to the southeast, and looking over the rolling green of the pine trees we could see how the lower side was torn into numberless canyons leading into the San Juan Valley. Some 80 miles beyond, Shiprock jutted up like a phantom sail above the dark back of yet another mesa. The cliff dwellers built their settlements in that astonishing labyrinth of canyons, after following the aspens up the waterways to locate safe places. The canyons were cut into the mesa like the spreading fingers of a hand, so the grand cliff cities did not huddle together in neighborly fashion, but were isolated by numberless miles.

It was late afternoon when we reached our goal, a tourist camp on the edge of a canyon. We moved into a good-sized, comfortable log cabin for two with a huge stone fireplace and a stack of fragrant piñon wood. When we pulled aside the chintz curtains and looked out the window, we felt like Charlie Chaplin when he wakes up the morning after the blizzard in *The Gold Rush*. Our little house fairly teetered on the edge of the abyss, or at least it seemed to! A vicious wind slithered through the canyons in sudden puffs, and the depths below were that same heavenly, transparent blue as the heights at Meran. Elisabeth put on her fur coat, carried all that way, and we hurried back up the road to the museum. As it was closed, we walked up a path that led toward the hill and reached the edge of the canyon. Gazing across, our first cliff dwelling smiled from the other side, set in the mouth of a great cavern. How indescribably serene, how enchanted it looked, fitted so neatly under its protective bulge of yellow rock! The delicate, powder-gray outlines of the masonry

stood out sharply against the black weather streaks etched into the cliff. The tip ends of the tall spruces on the valley floor just reached to the edge of the cliff. Above, the descending roof of the cavern converged at the sides into a distinct world of level land with trees and grass. There was no way to get across, so we hurried down the path to the bottom of the canyon and climbed up the other side. We wandered around ankle-deep in dust, enthralled by the silent city around us: a stage without actors, all set and ready for the play.

The approaching dusk drove us back to camp, by then officially closed, and we ate our supper in the mess room of the park office, before hunting for our hosts. The park was a reserve in the strictest sense with every bit of flora and fauna jealously guarded, and no cats or dogs allowed. Not a single stick could be razed, unless it was harming the growth of another plant. There was quite a colony of park officials and caretakers, but the area where they lived was so carefully hidden that with all his experience, poor Nelson had a hard time finding the entrance road.

We found a jolly party of young people assembled there, but none of the higher officials we expected to meet. Somebody, somewhere, was giving a birthday party and afterwards a supper, so we were advised to come back about nine. In the interval, we visited several other houses and were delighted to see so much varied and individual taste in the decorations of those cute adobe cottages in the woods. We had a nice long visit with one of the rangers, a sturdy, jolly, second-generation German named Feja, who was crazy about photography. He taught us some tricks to overcome the special difficulties in photographing the contrasting deep shadows and brilliant sunlight of the canyons. Afterwards, we made our official calls and retired to our own cabin. The wind was rising rapidly, and it was as dark as pitch. Everybody was talking about snow, and we wondered how we would enjoy getting out even by the modern road, if it were all slippery slush!

The wind roared all night, and the trees outside sawed mournfully back and forth. In the lulls we could hear chipmunks scampering over the roof. We slept wrapped up in two comforters apiece, and when the man brought our hot water in the morning and lit a leaping fire, we felt cheerful and energetic. It was a gray day, but calm, and it hadn't snowed. Arriving on time for an early breakfast,

we learned that the cook had gone to the nearest town 35 miles away, and gotten stuck in the car! Nelson and the little waitress made our breakfast on the huge wood range, frying pancakes and bacon right on the polished surface without a pan. We ate enormous quantities of everything and were at the museum by 8:00.

To our joy, Feja, the photographer and ranger we had met the night before, was appointed to accompany us. Familiar with the changes in the light and knowing that we cared a great deal about taking good photographs, he turned the usual schedule upside down and took us first to Balcony House ruin. He explained that we could save an hour's walk through the canyon, if we were not afraid to climb a 30-foot ladder. We opted to climb up as the Indians did centuries ago, and it certainly made us respect them. The car carried us to the brink of another canyon, where the horns of a ladder looked up out of nowhere, wired to the rock. If it had swayed outward during the climb Elisabeth at least would have died of fright, but it only trembled slightly and landed us on a small platform with the men and our equipment. From there, a shallow path cut in the side of the rock wall led downward, protected by steel chains and iron bars. The Indians used hand-and-foot holds chiseled in the rock and worn smooth from use. We had climbed on some in Bandelier, and a more comfortable and secure ascent we had never experienced. Just where one reached for help and at just the right angle, the fingers found a hold.

But at Balcony House the drop was too sheer to risk it. After a few zigzags along the path, we came to a great boulder about 15 feet high. There was only a crack between it and the cliff wall, where the ancient inhabitants had built a sort of gate to guard the city. A narrow passage about 6 feet long led to an opening where we could ascend to a tower of sorts with a window at the top, and then came another crawl of about 6 feet through the rock on an angle. We could just see the light coming through at the end. As Feja explained how this ingenious passageway made the city totally impregnable, Elisabeth leaned weakly against the wall wondering how to crawl through it without dying on the way. She hated caves of any kind, and had refused to enter a storeroom at Chaco because it meant crawling in. Nelson assured us that Branson de Cou, who weighed about 300 pounds, had gone through, but we were not any less anxious. After

the others went ahead, Elisabeth gathered up her skirts and shot through without taking a breath, and certainly without a glance at the famous defense tower. It was a rotten experience, as we had to crawl on hands and knees, and twist the shoulders sidewise. But once inside the ruined city, it was worth it. We thought it was named Balcony House because it sat on a balcony on the top of the world. But it also had a real balcony on one of the houses, a solid affair made of the projecting beams that formed the floor of a room, plastered over with adobe.

The separate cities were fitted so exquisitely into their caverns that each one had the charm and perfection of a fairy-tale castle. The canyon cliffs glowed as our eyes leapt out over the chasm. It was breathtakingly beautiful, and indeed we did not think of the more grim aspects, until we looked at our stark black and white photographs and could see the broken walls and frowning rocks. Not every city was built clear back to the sloping back wall of the cliff. Balcony House, for instance, had a small alleyway behind the houses, where a hidden spring covered with a round stone provided safe access to water. There were many kivas, communal fireplaces, and corn-grinding places. A charming feature was the T-shaped doorways, which always seemed to lead to a balcony or platform. Those practical people did not see why they should make double room for slender legs; perhaps there was also some trick of ventilation in the design. It was extremely graceful, when someone came through such a door, stooping slightly, with the hands resting naturally on the two sills at the sides.

The houses had plazas in front and picturesque, narrow streets in between. Elisabeth tried to photograph several of these, but they did not come out well, because the shadows in the depth of the caverns were dead black, and the back walls were always sooty from smoke. Feja helped her tremendously with the photographs, climbing walls and lugging along his own heavy tripod, because ours was too unstable. He assured us that we should be thankful it was an overcast day, for else the sunshine would be so brilliant that every picture would be divided into contrasting, irreconcilable parts. He and Elisabeth figured out angles and timing, the joy of every photographer, while Pál explored remote recesses, and Nelson swung his feet over the view.

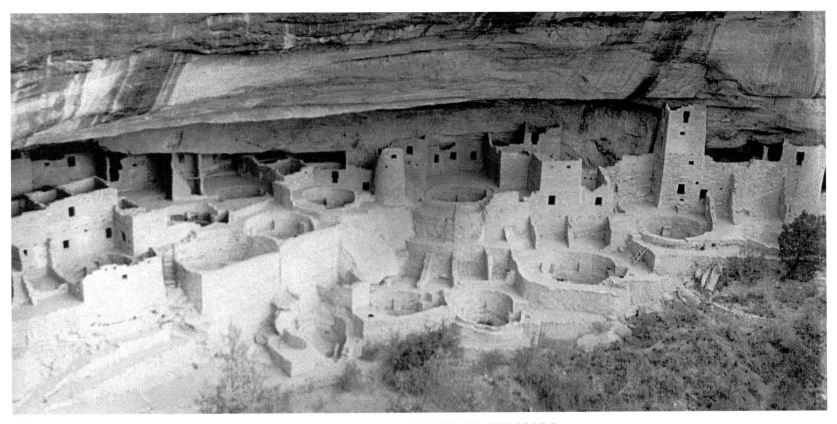

CLIFF PALACE AT MESA VERDE, COLORADO.

Balcony House ruin was more exciting on account of its approach than Spruce Tree (which we visited the day before), and also because it was dizzyingly high above the floor of the canyon. According to Feja, all the cliff dwellings were approached from above, and he thought that the people cultivated their corn on the upper mesa. Another park official said that there could not possibly have been water enough on top of the mesas for the large crops needed by such densely inhabited cities, so their fields must have been in the rich valley lands. The modern Hopi thought nothing of running from their mesa to fields 35 miles away, working in them all day and running home at night. Of course, not every day! The mesa must have been occupied since the dawn of time, for traces of the very primitive basket-maker people had been found on the upper levels. Everywhere we looked were scattered pottery shards, worked

stone, or mound-like heaps of ruins. On a high place were the remains of a D-shaped building with two round kivas but no living quarters. It was said to be the last building raised at the ruin and probably was never finished. It was carefully oriented and may have witnessed the Indians' last, desperate effort to call down rain upon the drought-stricken fields, with many of their number already departed for more fertile regions.

A few burial grounds had been found, but not enough to account for all the inhabitants of such thriving communities. In spite of their agility, the Indians suffered many accidents. Numerous skeletons were found with legs and arms broken and sometimes badly healed, laming their owners. The cliff cities were usually carefully oriented to get the maximum of sun and a minimum of sharp wind, but life in them must have been rigorous. In spite of this,

people thought of their occupants as mild and contented. Indeed, the more modern Pueblo Indians were so peace-loving that after their revolt against the Spaniards in 1690, when they had all the Spanish lords bottled up in the Governor's Palace on the Square, they let them march away on a promise never to return.

We crawled out of Balcony House the same tortuous way we came in, and drove for several miles through another fork of the canyon to Cliff Palace, the largest of the cave communities. The descent there was not as steep as the last one because of a recently improved trail. The beauty of the city was its depth and the rows of fine kivas all along its front edge. It had one round tower and several square ones. At the very back were several fissures or ledges, where erosion had scooped out narrow shelves, that had been walled up and probably used for storage. The inhabitants of those carefully measured cities must have needed all the space they could get. Standing in the middle of Cliff Palace, Elisabeth noticed that the diaphragm of the camera lens was so small and tight as to leave only a pinpoint opening. We had only two more pictures to take and needed a very long time exposure. But isn't it always the way that machines break down in the middle of nowhere, when one needs them the most? Luckily, Feja took the camera home during lunch and was able to fix it.

We left the ruin by the same route the Indians had used, scaling 30-foot ladders between the boulders. Along part of the way we could see the hand and footholds above our heads that the ancients used to climb up and down. Later we drove around the edges of other canyons, and almost everywhere we looked was a piece of some ruin. Even the smallest ledge, if under a projecting rock, had its wall of brick-like stone. We couldn't determine if some of those narrow and hazardous "balconies" were homes or used just for storage. One of the most impressive ruins was a large cave, with the remnants of a temple and directly above it another cave with two large ledges, a terrace and a two-story city. Ladders led from one huge "step" to the next. Each settlement had its own beauty and individuality adapted to its special setting. At the very end of that glorious day, the sun came out and showed off all its colors.

Back at camp only a honeymoon couple in overalls appeared for supper, although somewhere out there was a large party going around with a guide that we had glimpsed flocking through Cliff Palace. Overalls were the ubiquitous and practical everyday costume in this country, for everybody from Indians to school children and young ladies at dude ranches. Overalls were cheap and indestructible, two undeniable assets. Because they shrank so terribly in washing, it was the custom to buy them very large and turn up a big cuff at the bottom until the pants accommodated themselves to their owner's size. The cowboys wore them tucked into fancy, high-heeled boots.

A dance was to be held at Mancos that night that we would have given much to see; but the prospect of going down those roads for 20 miles and coming back at 3:00 in the morning was too discouraging. So we lit a snapping fire in our cabin, while the others went off to the party, Nelson among them. His dress costume was a clean, black shirt, overall trousers over riding boots, and a leather jacket. Most of the men wore something on the same order, for they were all local farmers or cowboys. The girls turned out as gay as they could, using the rare occasion to show themselves off in evening dresses and bright-colored silks. There was no lack of partners for every girl, for in the West many more men were on hand than women. A lottery was held with prizes donated by the town, supposedly practical things such as a free wedding, a free tooth pulled, a choice of baskets of groceries, and so on. Most of those, unfortunately, were not of much advantage to the winners. Nelson said that people came from miles around and behaved themselves pretty well. The sheriff and two deputies were on hand with revolvers in their belts, just in case! It was a terrific shame to miss a party like that one, but we were comfortable and contented in our cabin. The wind was still, and it was very pleasant to stir the embers and see the firelight flickering on the walls. In the morning we had to drag Nelson forth, as he had arrived home after three and never heard the morning call. The cook had also been to the ball, so again we had our breakfast made by someone filling in, but it was very good.

When the Kodak was broken, Feja brought his Zeiss along for the afternoon with some extra film. His camera was a big 4 x 6 Zeiss, with a fine lens that could take museum objects, as well as distant landscapes. He said that he needed a smaller and faster camera to photograph the animals he sees on his patrols, and showed us some fine images of beavers. He agreed to sell us the Zeiss, so we planned

to meet him on our way back to pick up the camera. Feja was then on patrol at the border of the reservation, for the deer season had just opened. No one knows how the animals sensed this, but they flocked across the boundary as soon as the shooting began, and it was difficult to keep the hunters from following after them. We were rather skeptical about finding Feja on the wide-open range, but he assured us that he would see us coming miles away. Sure enough, when we rounded the appointed corner there he sat in a Ford truck, not on horseback as we had expected. The horse must have been somewhere near at hand, for later we learned that as soon as Feja left us, he had to chase after a Mexican sheepherder wandering too close to an inviting piece of woods.

The rangers had to go through quite an education to obtain their posts. Not only did they have to be physically strong, good riders and marksmen, but they also had to know all the flora and fauna of the park, be able to report unknown species of birds and flowers, and have a general understanding of the region's geology. Mesa Verde must have been a particularly good post, for it was extremely beautiful and had a large enough community of officials and workmen to afford some social life. Their little houses were charming and comfortable, and there was even a small school on top of the mesa for all the children. With Elisabeth's new camera safely in the back seat, we re-traced the road as far as Durango and then branched off east to cross Wolf Creek Pass. The trees began to grow much taller, and we ate our lunch under the shadow of a group of 60-foot, sighing Douglas firs. The roads were all of dirt, graded and level, but very dusty. Everything that had not been carefully covered up, including the car and it passengers, arrived a nice, even cream color. Elisabeth put away her face powder from the beginning of that trip until the end!

As we neared the mountains invitingly topped with snow, the Douglas firs with their reddish trunks gave way to blue spruce, as perfectly shaped as in a millionaire's park, only much bigger. Cut through by our windy, dusty road, the pass was gorgeous. Here and there the road ran over huge tree trunks fallen down across a mountain torrent. Everywhere a thick carpet of blue spruces stretched to the very tops of the mountains. A little snow lay at the summits and in the hollows of the gorges below, but it was not at all chilly in the

brilliant sunlight. At the highest part of the pass, we got out and read the inscription on a bronze tablet: 10,200 feet. We had arrived at the Continental Divide. The water which ran off the west side went into the Pacific Ocean, and that on the east side ended up in the Gulf of Mexico. From there on the road sloped rapidly down, as if on a tipped-over table, and the little foothills ran down into the plain 3,000 feet below. The road was crossed and re-crossed by riotous brooks, a rare sight for travelers coming from the desert country of New Mexico. An occasional summer cottage or log hunting lodge stood at the edge of the woods.

Down on the dusty plain once more, we took a long detour and came upon a herd of cattle being driven to the railroad station in the dark. With shadows looming from the headlights, it made a fantastic scene as cowboys dashed frantically from one side of the road to the other after the animals milling about. Our day ended at Monte Vista, a Colorado cattle town not even on the map. But we found good accommodations at a modern hotel, and then ordered fifty-cent suppers at the cafeteria, the best beefsteaks we had ever eaten. Cattle were the most abundant product of this country, and from then on our standard for good meat was the beef of Conejos County!

It was Saturday night, and Monte Vista was teeming with folk. We started out to see *Ramona* in the only movie house, but realized that much better theater was taking place right in the streets. Indian families, wrapped in Pendleton blankets, were busily making purchases, keeping apart from the rest of the crowd. The always tall, lanky cowboys were extremely courteous when making room for us on the sidewalk, and even more polite when slightly reeling! Most of the population consisted of Mexican sheepherders and local hands from the vegetable farms: short, mean-looking fellows, lithe, ragged, and smoldering. We could imagine the famous fights fifty years ago between them and the cattle ranchers over pasture land, a monumental battle between two different worlds.

All the stores were wide open, as well as the street booths, shooting galleries, and dance halls. Not much drunkenness was to be seen, although we imagined there would probably be a general massacre before midnight, just for the fun of it. We drifted into an interesting-looking store on a side street and came upon an old scout named Ted Jones. He was a slight, lithe fellow like an Indian, who had

traveled the world from Guatemala to Shanghai. We had a most interesting time talking with him and bought two more rugs, a Hopi "chief" rug and a small Navajo. After bargaining for an hour we emerged with our bundle and found the town almost deserted. The rough crowd was driving off in rickety Fords and trucks, leaving only a few parties sitting quietly in their parked cars, watching the street as though from a grandstand. For the stunt of it, we made some purchases at the drugstore, and had our shoes shined at 10:30 in the evening. Then we went to bed, perhaps a bit disappointed; the anticipated shooting and yelling never came off.

Conejos County raised many vegetables, principally sugar beets and iceberg lettuce, as well as cattle and sheep, and we drove past many of the farms the next morning. We neared the southern rim of the mountains (we were always crossing seemingly endless plains, fringed round with distant peaks), and came upon a row of parked cars. A genuine roundup was taking place in a nearby field. The white-faced cows were milling around, hemmed in by a ring of horsemen. The cattle evidently had various owners, who were separating the summer's crop of calves into each one's herd. In the excitement, the mother cow would seek its calf, and then be driven into its respective corner. When the cows pulled away and ran for the main herd, there was wild riding and a whirling of lariats very grand to see. The costumes ranged from full cowboy outfits to ordinary felt hats and overalls. Several small boys sat on the sidelines, thoroughly equipped with spurs, chaps, and horses to match their size, but were sensible enough to stay apart and not interfere with the most difficult work. The men leaning on the fence were evidently the cattle owners, and the oldest, heaviest one climbed off the fence in his city clothes and took his seat on one of the big horses, riding like an expert. We were sorry to miss the action of catching and tying down the calves to brand them for easy identification out on the range. But this was evidently to take place somewhere else, for bunches of men and cattle were moving off in various directions.

We turned down a dirt road and soon lost sight of the herds of dumb-looking, shorthorn cattle. Once again we entered a narrow valley rimmed with mountains, but much closer than before. Between the hills the yellow plains flowed like a river, and the snowcaps up ahead were our familiar Sangre de Cristo range. As the landscape changed perceptibly into the arid New Mexico desert we felt nearer to home, but it was an illusion. The plains ran on for hours without changing. We amused ourselves by looking for prairie dogs, which didn't seem to mind the passing automobiles. Shy as they were, they stood on their fat legs to stare or went about their business nosing the sagebrush, their gray-green fur blending into the background.

The deep crevasse of a riverbed appeared in the middle of the plain. A large number of sheep grazed nearby, with the wagon-houses of the herdsmen standing out against the horizon. Crossing an iron bridge, we saw a charming little cottage with a garden below the rim of the riverbank among cottonwood trees. Quite an oasis in that sea of sagebrush! This land was once excellent grazing country, but the ranchers put too many sheep on it, and the grass was eaten off to the roots. Nelson said that if it were left to lie fallow for six to eight years, the grass could once more conquer the sagebrush to make fat land again. We came across a huge hawk sitting on a fence post, almost the size of an eagle. We often saw the Rocky Mountain jaybird, especially in the woods of Colorado. He was a bright blue fellow, very showy and noisy. There were also numberless magpies with the most beautiful white markings on their brown-black shoulders when they spread their wings and long, almost pheasant-length tails. The Mexicans were accustomed to slit their tongues and teach them to talk. These magpies were terrible thieves and as mischievous as crows, but much prettier.

As we bumped along, Elisabeth remarked that she could imagine how unhappy a man like D.H. Lawrence must have been in this kind of country! A neurasthenic, who however much he claimed that he wanted to be alone in peace, always managed to be surrounded by fussing women and a circle of admirers. Without them, the very width of the horizon and the endless monotony of the hills would have made D.H. shrivel up and become utterly depressed. Certain souls "lose themselves to find themselves," but she didn't think he was one of them. On hearing this, Nelson launched into a most amusing tale about Lawrence's stay in Taos, along with some delicious details about Mabel Dodge Luhan, whom everyone knew and called by her first name. It seemed that she wished to divorce her Indian husband and marry a Chinese poet, but the Indian let her know that he would first cut her throat. So she remained happily married to

him, or at least married. We saw him the other day, a very affected figure in stunning riding clothes, with a Pendleton robe wrapped around his shoulders, his hair in braids, and his wrists hung with turquoise. He must have been a gorgeous figure when he was young and savage, standing about six feet two. But then in his late forties, he looked effete and spoiled.

The plains ended abruptly in a wall of hills. Entering a forest of pines, we spread our lunch under the spreading branches, and reclined for a time on the soft floor of needles. It was only about 3:00 when we arrived

SANTA CLARA PUEBLO IN NEW MEXICO.

in Taos, so we went directly to the famous Indian settlement that is one of the most perfectly preserved pyramid-type of pueblos. It had two large, ancient apartment house complexes and a number of smaller, more modern ones, set one on each side of a small river, and surrounded by a moldering adobe wall. The houses rose to about five stories and dated from pre-historic times, having endured multiple repairs, for adobe had to be constantly re-plastered and re-roofed.

The people living there were very picturesque and virile-looking, having mixed with the Apache, a wild tribe related to the Navajo. They wore colored cloths draped over their heads, and resembled Arabs in burnooses. The women wore a kind of boot made of deerskin, presented by the bridegroom. These boots were pleated into huge folds, and each pair was supposed to last a lifetime. When the feet wore out, a fold was let out to make new feet, so that the young women went clumping around in huge, ungainly footwear, while the old ones had much neater and daintier boots! People were harvesting, and everyone was talking about the coming

snow. Nelson said that it was only because they were worried about their grain, because they were unable to predict the weather as accurately as the Plains Indians did. Nevertheless, it did snow a few days after we reached home, so for once at least they predicted it correctly.

Taos was set magnificently in rich and protected country on a gentle slope on the very knees of the mountains. The trees were golden yellow and the colors incredible. No wonder it was the center of a thriving artists' colony, but that was just what rather spoiled it for us! The whole place, including the Indian pueblo, was overly self-conscious and set out for the admiring tourist. After all the beauty that we had seen elsewhere, we did not need that pueblo presented to us on a platter with a vain smirk. As for the artists, Monmarte in New Mexico was similarly unconvincing. We took a delightful room in the famous Sagebrush Inn, also gotten up rather obviously, but comfortable nonetheless. It had delicious food and Mexican servants to carry out the effect of an old ranch house. We sat in the large living room after supper amid Navajo rugs, listening to Lotte Lenya on the

radio. According to Elisabeth, she sang "Du bist der Lenz" from *Walküre* very well and "Vissi d'arte" from *Tosca* with heavy German feet. Then she sang two or three short, popular Lieder horribly, starting each one with a little pep and color like a good pupil and falling back after the second phrase into a monotonous tone and dragging tempo. That she was the great Lieder exponent of the day was sad indeed! Her Wagner had body and style, but nothing else she sang. At breakfast we talked to the mother-in-law of the hotel owner, who was traveling about the country with a woman doctor friend. It was interesting to hear of those pioneering efforts, for although there was a district doctor, the service was inadequate, and the suffering in these remote regions must have been overwhelming. Mabel Dodge Luhan offered one of her many houses for a hospital, but the upkeep would have been so expensive that the community hesitated to accept it without an endowment.

BAKING PLUM BREAD AT SANTA CLARA PUEBLO, NEW MEXICO.

We got off early the next morning and passed through another beautiful gorge, where a large herd of sheep was coming over the edge and heading down the side of the canyon to water. We drove to the Indian pueblo of Santa Clara to photograph its fine old adobe church. Elisabeth took a most satisfactory picture with the compliance and absorbed attention of six little Indian girls in gingham dresses. They chattered away in perfect, colloquial American that only served to make them even quainter. We rewarded them with the rest of our rolls of Baby Ruth, the hard, sweet candy we carried to suck along the dusty roads, and the girls were much happier than they would have been with pennies. After a lunch of good boiled beef and delicious pie in a little country hotel along the road, we reached Santa Fe at about 3:00 and dashed off to have our film developed. Once at home, we spread out our new rugs to gaze at their splendors in a familiar environment.

In Santa Fe, an interesting woman named Mrs. de Huff lectured every other night on Indian customs, the history of the state, the nearby ruins, and so on. Her purpose was to advertise the various "Indian Detours" offered by the Santa Fe Railroad. She had beautiful slides and was remarkably intelligent, so we went to all of her lectures (some of them twice) and knew her quite well. She was the wife of the superintendent of an Indian school and one of the first who urged the Indians to record their legends and customs. She was also the first to have an Indian boy illustrate a book of folk-tales she had collected. Not even twenty years ago, there was still enough bigotry among the missionaries and others to cause her husband to lose his job on account of her activities! People said that Mrs. de Huff was urging the Indians to revert to their old "paganism"! Later on, of course, these "pagan" practices were fostered in every way, and she was at least consoled to know that she was a pioneer.

One Saturday, we were invited by a Mr. Kelly, the head of one of the largest trading firms, to go out to Chimita to see the loading of the summer crop of lambs, purchased from the Indians and other natives for shipment to Denver and Chicago. It was a brilliant day, and the drive was less than 30 miles along a familiar road. Mrs. Kelly took us in her car driven by young Mose from the museum. When we reached the pueblo of San Juan, we all climbed out to see the big trading store. It was full of Indians with broad-faced Mongolian-looking children astride their mothers' hips. The harvest of red peppers was hung up to dry in the courtyard, a lacquered, dark red wall with the sun shining through it and turning the peppers into lanterns. In the shed hung strings of Indian corn of the most fantastic colors: salmon pink, a rich, dark henna red, and the famous "Indian blue," favored for making tortillas; also cobs of mixed yellow and blue or red and yellow. Shelled, the selected colors of grain were lying in bins, glistening like glass beads in the sunshine.

It was baking day, as we found out by walking through the village. Those people a little off the tourist road were much more friendly and natural than any other Indians we had visited. We watched an old man skinning a sheep. He strung it up under a shelter raised on poles the Indians used to keep corn and dried meat safe from thieves, dogs, and the bright sun. The air there was so dry that the women washed their grains of wheat and corn and lay them out on blankets, where they dried without molding. Just around the corner, two older women were raking out a round adobe oven, where they had been burning corncobs to heat it. They cleaned it carefully of ashes and then, as a finishing touch, swept some strips of wet cloth tied to a stick around inside. Two boys brought out the prepared loaves and laid them on long, polished wooden trays. Next the women transferred the bread onto a wooden shovel, which they fitted deftly into the oven. They were very friendly, and we promised to come back to buy some of their wares.

The loading of the sheep was taking place quite a distance away, at the little narrow gauge railroad that did a thriving freight business between there and Denver. An eight-car freight train was drawn up at the siding, with an old-fashioned, wood-burning locomotive puffing away. A complicated system of pens held the animals, as each sheep had to be selected, counted, and weighed. We expected a terrible noise of bleating and shouting, but the business went along quickly and quietly. Mr. Kelly and two or three other ranchers, in blue shirts and big hats, were standing by the scales on a huge, fenced platform. A grand-looking old Indian in a dark blue shirt with his braids bound in turquoise blue was handling the loading of the scale. When the sheep had been weighed, a gate at the farther end was opened, and as they poured through, a Mexican with a face like a painting of a Madonna counted them. They were loaded into two-tiered cars, just so many for each tier. When each car was full, the train pulled up a little so that the chutes and gates would connect with the next car.

During the loading, new herds poured into the corral below. Beside the loading and counting, the men had to keep track of the number and weight of each of the various herds. Off to one side, two herders were cleaning a sheep for their dinner, the neatest job, with no blood or mess anywhere. The pot for the stew was boiling over an open fire. Some of the Navajo sheep-owners watched from the fence, among them two magnificent old men. One wore overalls with a woven red belt, and the other had a bright red jacket. They all wore braids tied with brilliant colors, and buckskin moccasins with calf leather soles and silver buttons, showing off their remarkably small, slender feet.

Crossbred sheep or ones with inferior wool were marked with red paint as they passed through the gate. We did not know before that sheep and goats crossbreed, but they do! The unfortunate outcome was a funny, straight-haired sheep with coarse and ugly wool. The only noise was the sharp whistles of the herders when they called their sheep. The Indians and Mexicans included some wonderful looking men, as did the regular American far-westerners, but none of them liked to be photographed. Elisabeth had to get the portraits she wanted in a general picture of the crowd. A wild turkey dinner was to take place after the loading, but since that would mean staying at least until 4:00, we regretfully excused ourselves and went back to the pueblo. Some singularly charming and dignified Indian women sold us steaming Indian bread, of whole wheat and corn meal with a filling of wild plums and apples, and we ate it greedily on the way home.

SANTA FE, NEW MEXICO
NOVEMBER 19, 1936

The day after the Indian dances we had an invitation to tea with Miss Eckles, a delightful, middle-aged lady who lived in a bungalow in the midst of a fine garden. As we came through the garden, the Indian gardener was gathering up a basket full of green walnuts from a huge tree. When Miss Eckles and her sister came to tea last week, Pál showed them some of the illustration proofs of the *Battlefield of the Gods* book. They were so enthusiastic that they wanted the sister's husband, the editor-in-chief of the local newspaper and a clever little magazine named the *New Mexican Quarterly*, to see them also. The other guests were already there, a Mrs. Wilson, who had just run on the Republican ticket for Senator (and been badly beaten) and Karl Ruppert, the Carnegie Institution's architectural engineer, who reconstructed the *Caracol* at Chichén Itzá and had just brought out a monograph about it. We sat around a brightly snapping fire, balancing plates of delicious food served from antique silver and old Wedgewood. Pál and Mr. Johnson, the editor, got along very well and shared a number of hobbies. Pál brought out the pictures, and they were viewed with much enthusiasm, even by Ruppert, usually too shy to hazard a word. Pál didn't realize he was giving an interview, but the next day he was amused to find an excellent article in the paper that we bought to look up the movies. Although a little superficial, it did hit the high spots.

The next evening we invited our good friends, the Kellys, to our hotel for a farewell dinner. We were very glad that everything turned out marvelously, for after all they had done for us, they deserved a good *fiesta*. The *pièce de resistance* was capon breast done "Mexican" with roasted almonds and a deceptively mild-looking, hot chili sauce. Later, since it was Saturday, we all went dancing. A number of people we knew were in the hall, and the party was very lively. On Sunday, we had the musician Edgar Varese to lunch, whom we first met at the Pataky exhibition in Italy. He was a charming Frenchman, the only one of his nationality we ever heard admit the faults of his country. He spoke excellent English and was married to a Pennsylvanian. He was the head of the Modern Composers League and probably wildly atonal. In his dark tweed trousers, blue shirt, and corduroy jacket,

with his black hair flying about, he looked like a modern version of Jean-Christophe. Varese was a great friend of Bachner's, then in New York and married again (his first wife ran away with Schlusnus), and we had much in common to talk about. He stayed with us until the Kellys called for us, and then returned to his symphony. As a young boy Varese lived in Rodin's house in Paris for about fifteen months, and the old sculptor wanted to adopt him. They parted after a quarrel, whose nature Varese did not disclose. Both must have been extremely hotheaded, and no doubt the old man liked the young one especially because he would not allow himself to be bullied. Pál had interviewed Rodin in Paris, before he was generally acknowledged, for one of his first published essays. The City of Paris had even rejected Rodin's *Balzac* as a gift!

Another perfect day arrived with a blazing, turquoise blue sky. We drove out to Chimayó, a little village in the hills northeast where they made beautiful, if rather conventional blankets. Here the Indians mixed thoroughly with the Mexicans and by then considered themselves Mexican rather than Indian, as were the type of blankets they wove. A little miracle church had been constructed around a spot where San Diego reportedly appeared. Later, it was discovered that the earth the saint stood on had wonderful healing powers, and for years it was dug up teaspoon-by-teaspoon, and sold to believers, so there was a 10-foot hole in the sacristy! For some reason the Catholic Church did not favor the proceedings, the chapel was placed under a ban, and slowly went to pieces. Recently, a society for the preservation of things New Mexican bought it, restored it, and gave it back to the church as a museum.

It was a sweet little adobe chapel, facing a tiny brook and standing between two immense cottonwoods still golden yellow at the time of our visit. It had two towers and a carved wooden gallery across the front. Inside were several interesting *retablos*, with painted saints and carvings, very primitive and utterly delightful. Some of the less-restored figures had all the grace and delicacy of figures in an old manuscript, which they actually may have been copied from. The modern plastic figures were all dressed up like dolls, even to a tiny straw sombrero on San Diego, who held a plaited quirt in his hand. The arch before the altar was hung with fruits made of the bright balls of Christmas tree decorations. Strangely enough, the effect was

not as garish as in the newer country churches, with their insincere, smirking, plaster *santos*.

The sun was setting; how early it descended those days! We drove farther into the mountains to an enchanting little village in a hidden valley, called Córdova. There we also viewed the ancient saints in the church, and passed by the wood carver's, expecting to find something interesting. But he was overly impressed with modern sculpture and had foregone the solid technique of his forefathers. Alas, his newer work was affectedly grotesque. In that village we encountered the most beautiful and Spanish-looking children thus far. As the sun was about to set, we hurried down the winding road, before darkness caught up with us.

After a hurried supper, we were out once more to the Indian school, where Kelly had been asked to speak but foisted the job off on Pál. The experience was well worth our efforts. Some 300 Indian children, from about 13 to 19 years old, sat in the huge gymnasium, looking more bronze than ever against those white walls. They were all dressed in red overalls, sweaters, and polo coats, like any ordinary schoolchild. The program was given by a Girl Scout troop, very pretty in green uniforms as they marched onto the stage. All sang, and Elisabeth was astonished at their clear, rich voices and absolute accuracy of pitch. The boys' voices sounded especially fine. Pál gave a five-minute talk on the value of keeping up the Indian traditions of arts and crafts, and later we learned that he made just the right point, for the school was a vocational one specializing in arts and crafts. Recently, the government had been pouring so much money into the local economy for manual labor that it was hard to keep boys out of temporary relief jobs. Nor could they comprehend that some-day those jobs would end, requiring them to return to farming and their own crafts. The children were polite and attentive throughout. We thought they resembled a band of little mustang ponies, trained and anxious to do everything just as their white teachers wanted. If there hadn't been any white people there, smiling indulgently and making them stiffly self-conscious, it would have been a much more interesting party. We hoped to have an opportunity to go back again and see the pupils at work.

The program was over within an hour, and we went to hear the concert of the "Mexicana Tipica" orchestra making a one-night stand.

There were some good singers and dancers, a variety of folk costumes, and the whole event was very gay and diverting. In addition to the usual instruments of an orchestra such as strings, winds, drums, and the piano, the typical Mexican instruments appeared: a marimba and two salters, a form of zither, which had a much sweeter tone than the mandolins usually played to give the Mexican effect. The folk tunes and dances were fine and astonishingly varied in rhythm. The more pretentious music was rather silly, modeled on the French, and as out of place as a Post-Impressionist color palette for the New Mexico landscape. What a busy, wonderful day!

On Monday Mr. Kelly again dragged Pál in for advice about placement of the (inherited) new organ in the auditorium of the art museum. The question was whether to build an extra room for it, or put it up in the transept. We both argued as violently for the transept destination, as a number of the committee members argued for the new room, so it became a very heated discussion! The nice part was that everyone disagreed from true conviction, and not out of meanness or politics. Then we said a final farewell to the Kellys, who left that evening on the midnight train. They were to spend Thanksgiving with their two sons at college in the East, see as many big football games as possible, and (incidentally) attend the meeting of an archae-ological society of which he was a director.

We dined that evening at the home of Mrs. de Huff, the lecturer, who telephoned that morning asking if we could make it to "an informal dinner." We guessed at unexpected guests or food, and indeed, it turned out to be quail, since her husband had been hunt-ing the day before. Unlike Pál, Elisabeth had not eaten much quail, and since those gray New Mexico ones were bigger than any back in Indiana, she was a bit apprehensive. But served with a cream sauce and spoonbread made from stone-ground, white corn meal, they certainly made a feast! The house was a charming mixture of mid-Victorian and modern New Mexican, with fine ironwork done at Mrs. de Huff's behest by the village blacksmith and an astonishing row of kachinas, the little Hopi dolls representing the good spirits, hung around the walls. Mr. de Huff turned out to be an Indiana man, born in Terre-Haute. He had a great deal of experience in the Philippines and locally in the Indian schools, where Mrs. De Huff gathered her famous collection of folk tales. We had never met

anyone quite so rabid on the present politics. He regally proclaimed: "Our forefathers took down their guns to preserve their liberty, and we shall too!" Fortunately, we had no more such busy days in sight, although there were several nice invitations. The photographs from the museum's archives turned out splendidly, so Elisabeth's new Zeiss was already beginning to pay for itself.

LA FONDA, THE INN AT THE END OF THE TRAIL
SANTA FE, NEW MEXICO
NOVEMBER 21, 1936

We continued to enjoy life in Santa Fe. The weather remained unbelievably beautiful, quite brisk, and dropping to around freezing some nights, but in the morning the sun would wheel across the sky with the intensity of a burning glass, and descend into a luxurious sunset. Occasionally, we wished that we had taken advantage of the fine weather to go to Canyon de Chelly, a romantic spot in Arizona, which was the last stand of the Navajo before they were captured and deported by Kit Carson. However, we had enough to do to fill the time, and as everyone assured us that the weather could go on like that for months or change into a blizzard overnight, we realized there was no rush and trusted in our luck. It usually stood by us in every crisis, and that kind of fatalistic attitude was the norm in New Mexico.

The latest important event was Pál's speech to the Rotary Club on Thursday. He was getting along very well in English by then, and thought nothing of such little addresses. Our friend Kelly was responsible for the invitation, although he could not be present. Elisabeth was not invited to the all-male luncheon, but heard all about it from several sides later. Pál was introduced by Dr. Hewett, who said that because he was a native of Budapest, one of the most beautiful cities, it was a special compliment that he ranked the charm of Santa Fe so highly. They all expected Pál to speak in the usual Rotarian manner about the situation in his homeland and Europe. But he overlooked that obvious subject, and spoke instead about the preservation of the beauty of old Santa Fe. He drew a parallel between Cambridge and the boom conditions of the last century, which led to the erection of factories, ugly stores, and cheap workingmen's quarters in the heart of the city, ruining its atmosphere, and the dangers that industrialization was bringing. He pointed out the beauty and unusual congeniality in the style of the Palace of the Governors as the standard to be followed. The Rotarians were all intrigued by the talk, because the subject was of considerable moment. Dr. Hewett enthusiastically called it "a jewel of a speech." Many in the audience came up to congratulate Pál afterwards, and a number also sought Elisabeth out at dinner. Pál had such a good manner of speaking and well-spaced phrases that his audience could easily follow every word.

We went around looking at the *santos* (the local carved and painted saints of the churches), and the antique shops. The most beautiful statues were still to be found inside the churches, among them the carved Madonna, which the Spanish Governor De Vargas was supposed to have carried with him during the re-conquest after the Indian rebellion. The Madonna was still carried in a procession around the city once a year, in fulfillment of his vow, if he was victorious. Behind the cold and tasteless high altar in the cathedral, we found an interesting chapel with a huge *retablo* carved in sandstone, an unusual feature, since everything there was usually made of wood. A remarkable work, it had seven great bas-reliefs and a complicated frame of richly painted fruits and flowers. In the same chapel were many life-sized wooden saints, among them St. John Capistrano standing in the middle of the *reredo* (altar screen) on his prostrate Turkish enemy. The chapel was originally a military one, and the distant saint was evidently chosen because he also conquered the "heathen."

Sometimes, the wooden statues showed the influence of Spain and Old Mexico. A number were elaborately painted and enameled, but most were primitive, and distinctively characteristic of that part of the country. It was a poor land, and the friars who arrived did not bring along the great and proud artistic tradition which flowered in Mexico, facilitated by a profusion of gold and slave labor. Instead, the local artisans created only simple, pioneer *santos,* rendered with touching faith and devotion. A fund was being collected to convert the little hidden chapel into a separate sanctuary, almost like a museum, where the *santos* and various interesting books and historical relics would be on exhibition.

Naturally, we too wanted our little wooden souvenirs from the region. After much searching, we selected a little Saint Anthony and a painted plaque of the "Mater Dolorosa," the Suffering Mother. They were "primitive," as could be expected, but sincere enough to hold their own in any company. Thanksgiving was on the horizon. How nice it would have been to send a wild turkey or some of the wonderful New Mexico gray quail back home!

701 SOUTH MARIPOSA AVENUE, LOS ANGELES, CALIFORNIA
DECEMBER 22, 1936

It was three days before Christmas, and we were looking forward to a trip up the coast, leaving about December 31st with stopovers at Santa Barbara and Monterey. We had a fine session in Los Angeles with Professor Annis, a friend of Dr. Hewett's, who was to furnish us with his photographs of the ruins of Peru. He brought over his handy little movie apparatus with a silver screen on its own stand, and showed us several reels of colored pictures of Peru and the Andes. It was rather hard on the eyes, but certainly worth it. For the first time we had some concept of that remote country, colored red-brown like New Mexico, with magnificent blue skies and snowcaps in the distance. The Indians were extremely picturesque wearing their bright colors: reds, yellows and browns, not only the black and blue "permitted" in Mexico by the *Conquistadors*; and the llamas (pronounced "yamas") were charming, with the dignity of camels and the gentleness of sheep.

We had an all-day visit to the Los Angeles County Museum the following day. It housed chiefly bequests and loan exhibits that were very much tied up in politics, so the material was not always adequate in some lines, while enormously rich in others. A remarkable loan show was up, which the museum was considering purchasing, a Chinese collection owned by some Norwegian general. The pre-Columbian and Indian material was mainly what might be called "curios." The few good pieces had no data attached at all, having been picked up on somebody's travels somewhere. Nevertheless, we had an interesting time with a charming German Baron von Kröber, who was Head of the Oriental Division, and with a violent, bullet-headed Americanist named Woodward, who fortunately agreed with us and our ideas throughout the conversation.

Woodward was studying the evolution of the various Indian tribes after contact with the white man and just bringing out a paper on the sources of designs in Navajo silver work. He had traced some of them via the Iroquois clear back to English and Dutch patterns. Another one of his activities was dating the more recent Indian graves by the beads found in them; these were the trade beads that came from Europe. The creation of his bead calendar probably would take him to Europe, namely Venice, the source of most of the glass beads used in trade. He was planning a large museum full of Americana for the Fur Trade Museum in St. Louis, since the earliest trade between the Indians and Europeans was in furs. Undoubtedly it would be very interesting.

PÁL AND ELISABETH AT COPÁN, HONDURAS, 1940.

CENTRAL AMERICA, 1940:

HONDURAS AND GUATEMALA

EVEN BEFORE OUR COUNTRY was drawn into the Second World War, it became clear that Europe would be a very unpleasant and even dangerous place to be. At the same time, countries on our own continent had begun to see the possibilities of tourism that had never existed before. We realized that Pál's work on El Greco would have to be put in the background, and finally (as urged by Dr. Tozzer) determined to concentrate on the Western Hemisphere. Guatemala seemed the logical destination for our next trip. And there was just one way to get the survey published originally intended for Europe, and that was in America. The United Fruit Company had ship connections to Puerto Barrios, Guatemala's only eastern harbor, from New Orleans and also New York. We looked forward to stopping in New Orleans, remembering our first visit there in 1933.

Meanwhile we had a sweet and quiet Christmas in our new home in Norfolk, opening our packages on Christmas Eve, and finding some lovely things. There were no complaints about the new house. Although the temperature fell below zero one evening, we kept it at 70 degrees all over the house. That was actually a little too warm, but Elisabeth had two frail friends visiting, who were awfully afraid of the rigors of our country place. They were her dear friend Laura Henry, Head of the Music Department at Dana, and Lucy Pratt, a writer and housemother. We had a lot of fun together, and the music rolled from the newly tuned piano and Elisabeth's own throat. She said that she only wished they could come more frequently and for a longer time! That Sunday, the girls prepared a

dinner that would cook itself in the grand electric stove, and we all went to church. It was an inspirational service, and the severe New England church was wreathed in garlands of ground pine. The expected Christmas snow arrived just before New Year's and certainly was lovely with the moonlight streaming across it through the evergreens.

We finished getting the house in good shape by the time we were to leave for Central America. Wool things were put away, the larger pieces of furniture covered up, the shutters closed, and the heat put down to about 45 degrees. Benedict was to be in the place every day during our absence for a full day's work and to make an inspection. We turned off all the electricity at the main switch so if a thief were to wander in, he would not be able to floodlight his activities! We had burglary and fire insurance, but certainly would hate to lose anything. Mrs. B. and Catherine were to return about two weeks before us to wash the windows, wax the floors, and so on, enabling us to arrive home with everything set right and cozy.

On New Year's Eve we went prosaically to bed, for we chose Christmas week to have the typhoid injections required for Central American visas, and we both had an unpleasant time with them. As so often happened, Pál was the hardest hit with a bad chill and fever. Elisabeth dragged around pretty successfully, although she spent the mornings in bed and was later taken with a bronchitis germ, just when she was eager to be doing last-minute shopping in New York. It did not seem to be anything serious, as she had no fever and wasn't coughing, probably because it was caught so early. The chief treatment was staying in bed, and she was not at all sorry to lie in her comfy room with her feet up, waited on by Catherine and Mrs. Brown, and only hoping it wouldn't last too long! Our excellent

doctor would not let her up before it was quite safe. Meanwhile, Pál went to New York to finish up last-minute things, and Elisabeth joined him a week later, a bit sallow in color but full of anticipation. She was intrigued about exploring the wonders of color photography, and bought a hand-cranked, 16-millimeter movie camera, before we left for New Orleans.

Pál was received as an old friend at Tulane, and given the same helpful advice as before our first venture into Latin America. Various people knew the book *Battlefield of the Gods/Aspects of Mexican History, Art and Exploration* (Pál's first book in English), published in London in 1936, and designated the "Travel Book of the Month." Professor Hermann Beyer was pleased to have recognized himself in the sketch describing his little pigeonholes for studies of Maya epigraphy. We met Doris Zemurray Stone, daughter of the founder of the United Fruit Company, who gave a cocktail party for us with appropriate guests. She was a renowned archaeologist, having done valuable research on the grounds of the fruit plantations owned by United Fruit in Guatemala and Honduras. Her name was a power in those regions, as we found out later to our great advantage.

The United Fruit Company's Great White Fleet of ships made the trip from New Orleans to Guatemala in two and a half days. We sailed on January 17, 1940, on the "Ulua" of 6,500 tons, which looked more like a private yacht than a banana boat. On the top decks were very agreeable cabins for about 150 passengers, although our voyage carried only about eighty. A quarter of them were making a round-trip without getting off, and about thirty-five others made an excursion to Guatemala City, and took the next boat back a week later. The rest were coffee planters and business-men, along with two elderly doctors, bacteriologists, whose hobby was hunting for ancient germs possibly surviving in the ruins. Both were enthusiastic photographers, and were soon comparing notes with Elisabeth about films, cameras, and techniques in the tropics. It was a smooth voyage across a lovely, azure sea, although, as always, Pál spent most of the time lying down. Watching the constellations in the sky shift and change was an intriguing pastime. Enormous, strange cloud masses, like an impending hurricane, would appear in minutes and disappear just as quickly, and we even saw a double lunar rainbow. The stewards plied us with food, and huge trays of bananas were always on the tables. An amusing fellow in a short white jacket played a different tune on his five-toned gong before each meal to summon us to the table.

Early one morning, we raised the coast of Mexico, and late that afternoon we landed in Puerto Barrios, a steamy port notable for its shabby, wooden houses and railroad tracks. United Fruit had arranged for two parlor cars to take the party to Guatemala City. With a shriek of its whistle and a tug of its little locomotive, the train chugged into the brilliantly colored, tropical landscape. That narrow ribbon of rails was the only connection of Guatemala's solitary eastern port with civilization. On both sides rose up impenetrable walls of jungle, not the dry brush of Yucatán, but the climbing, spreading, lush vegetation of eternal swampland, where rain was continuous nine months a year. The most magnificent foliage engulfed us: royal palms, fan palms, fern-like bamboo, immense white-trunked ceibas wound with vines and weighted down with moss, and air plants, probably orchids. Occasionally, we had a glimpse of a village, a few open shelters with thatched roofs on a high, cleared knoll, accompanied by banana trees and a patch of burned-off ground for a garden. The varieties of intense, shining greenery were overwhelming to our northern eyes.

After about two hours we left the train at the Station Bananera, a genuine banana town, and the clearing station for the United Fruit Company's plantations. The two elderly doctors accompanied us, heading for the ruins to chase down pre-Columbian microbes. The huge, open clearing was laid out with rows of bright yellow houses with green window blinds, standing on concrete stilts about eight feet off the ground to keep out dampness and termites. A pleasant young fellow, the son of the chief superintendent, showed us to the bungalows belonging to some officials away on vacation. There were no glass windows in the houses at all and very few doors, only screened apertures closed off with shutters, to keep the interiors cool and prevent mildew. The furniture was ugly, heavy stuff made of solid mahogany, a hardwood readily available in the area. Laundry was hung to dry under the houses, where the servants sat and gossiped between the chickens. They were a mixed group: Indians, Negroes (Caribs, as black as coal, lithe and cheerful for all their fearsome reputation), Filipinos, and many mixtures.

The lawn was a startling bright green. Trees, bushes, and vines were blooming madly in all shades of scarlet, orange, and yellow.

Hibiscus and poinsettia bushes were solid masses of flowers, and a huge, lavender morning glory rioted over the weeds at the wayside. We were the guests of the Company and dined at the club with various officials, and on Saturday, there was an American movie and dance. The workers stood outside and seemed to enjoy the party as much as the invited guests. They had been brought in by train from the villages, to where they were taken back around midnight. It rained all that night and turned to mist in the morning. We boarded a Pierce-Arrow car, set on railway tracks, and sped 20 miles to Quiriguá in the midst of some banana farms, on marshy ground near the Motagua River. United Fruit had donated the site to the Guatemalan government, but still maintained it as neat as a park. It was rich in natural beauty, with lovely birds the size of robins, yellow-breasted with russet wings, and others as graceful as magpies with a sweet whistle. Quantities of vultures waddled awkwardly across the lawns. While the ruins were not as spectacular as those at Copán, archaeologists working in the Maya field visited it relatively early, as it was on the route to Copán only 30 miles away. John Lloyd Stephens actually tried to buy the site in 1839, but ended up with Copán instead!

Quiriguá was famous for its carved stelae, and "altars" of dark red sandstone, dating from about the fifth to the ninth century. These "altars" were actually huge, rounded river boulders, carved to symbolize zoomorphs (composite animal gods): jaguars, toads, crocodiles, and birds. The intricate designs covered their entire surfaces, quite an accomplishment in such hard material, without using metal tools. The glyphs were still sharp and clear, untouched by time and weather. The anthropologist Ralph Linton, who was part of an expedition making molds of the monuments at Quiriguá about 1914, related that the heat in the jungle was so intense, they could work only at night by the light of torches, for the glue used for the molds would not set in the heat of the day. When the molds were completed, they were lashed to canoes and paddled out to a waiting ship, and sent back to the United States, where the final casts were made. Linton did not see the finished product until many years later, when he viewed them at the San Diego museum. The casts of the 8-foot Quirigua figures stood in a semi-circle in the rotunda, and he said that it was like coming unexpectedly upon old friends!

We lunched with the superintendent, a Scot named Turnbull, who spoke with a burr. Later we visited the hospital run by another Scot, MacPhail, who was famous for his single-handed battle against the tropical diseases of the region and reportedly had greatly reduced the recurrent malaria in its various forms. There was a lovely, blond baby in a crib, whose mother seemed fearful and defensive, while the men were completely at home with this precarious manner of living. Meanwhile, Mr. Turnbull had sent back to the port and obtained passes for us to cross and re-cross the Honduras border. We boarded the train again and passed through more civilized country. Elisabeth hazarded various moving photographs of men plowing with oxen, yokes tied across their horns, and women washing clothes and bathing in the streams. We skirted huge banana plantations, where strings of empty cars were waiting to be loaded with fruit.

Bananas could be harvested all year round, but since the market fluctuated in the North with the weather, there was much greater demand in the summer. Each palm bore only one stem and then was cut down, after which a young shoot sprang from the stump and matured in nine to fourteen months. Bananas bore seeds in pods, and new plantings matured in a year. All the way, we passed long banana trains going down to Puerto Barrios from as far away as the Pacific Coast, to load the fruit on the boats arriving every week. The bananas were packed in airy, open cars among thick leaves. On reaching the port, workers loaded the fruit hurriedly all night, and the ship sailed as soon as it was full. The leaves were burned so as not to spread any fungus or disease. Some of the plantations sprayed with copper sulfate, which cast a romantic blue shade over the landscape.

We had hoped to go to Copán across the Honduras border, if everything else worked out all right. The two doctors wished to go also, so we decided to try it together. We took the train as far as the station of Zacapa (the junction for San Salvador), and left most of our baggage at the hotel there. At that time, the road the Carnegie had hacked out of the jungle was the only road in the region. The early archaeologists all had to go in by mule, plagued by swarms of mosquitoes. We hired a sturdy Dodge from a lad named Eduardo who said that he knew the way, set out over a fairly good, but very dusty highway, and soon went over a mountain pass. The sensational, exotic scenery and brilliant light were a delight. On reaching the

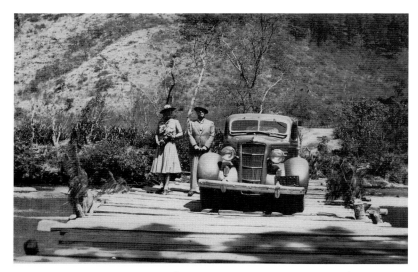

ELISABETH AND PÁL ON THE ROAD TO COPÁN.

border town of Chiquimula, we were held up for two hours, obtaining permission to leave the country, waiting for the General who ruled the place to finish his afternoon *siesta*. Although it was quite late, there seemed nothing else to do but go on. By dusk we had whirled over half a dozen more mountain passes, but the border didn't seem any closer. We wondered if our boy driver really knew the way, but the expert manner in which he shifted gears for the sudden ups and downs of the road, and glided around hairpin turns, kept our confidence up.

We supped on coffee and the sandwiches we had packed that morning, and drove on and on, hoping we would not have to spend the night in the car, and singing familiar hymns to while away the time. From time to time the reassuring lights of hearth fires appeared on the hillsides. Finally, we burst upon a crowd of men and boys all in white clothing, standing in the middle of the road at the Honduran border. Half an hour later we were in the rarely visited, unspoiled village of Copán at a hacienda belonging to an aged, one-legged General. Gustav Stromsvik was the Carnegie's man in charge. He treated us to whiskey and soda, freshly opened boxes of crackers, filtered water, and all the other luxuries of a primitive settlement. The Carnegie brought four contributions to the community as well as the road: a sewage pipe, a small electric light plant, a kerosene-run

refrigerator, and of course the supply truck, which worked constant wonders. Our food was good, if a little exotic; it seemed one could always fall back on the soup (in Mexico it was the chocolate). We slept in our clothes on camp cots in an unfinished "motel" with cold, wet, adobe walls. It was not exactly quiet; no sooner had we settled down that first night, when a symphony of snoring in different keys began in the adjacent room. We got quite hysterical, until we were exhausted enough to fall asleep. The wake-up call at dawn was the clatter of chains and braying of burros in the stable yard next door.

The ruins at Copán, built in the well-watered valley of the Copán River, were quite different from the Maya cities in Yucatán. Our first impression was of the open monumentality of the place. First, we crossed a wide, level field framed with low mounds and ruins, among them one tall stela. There was a sort of acropolis, a vast, apparently man-made mound, 100 feet high with irregular additions, the sides of which seemed held together by stairs, as if bound by giant ribbons. The soft green color of the stone enhanced the grace of its outline. On the face of the longest wall, perhaps the first to be built, the riser of the top step was decorated with a bold band of glyphs. Huge ceiba trees broke through the ascent (hopefully, they would be left standing), and warped the flowing line. On top was a series of open spaces, surrounded by low buildings. The building stone seemed to have especially lent itself to carving in the round. The sequence of the various stairways added to the total effect of astounding lightness and grace. A demon figure, holding a writhing snake in its mouth, crouched at the top of the stairs on the other side. On another wall, a jaguar in high relief was part of the masonry of the wall itself. It must have been pre-carved in the careful planning of the structure and was more effective, as we saw it, than it must have been covered with a smooth, painted surface of stucco, as some reports have suggested it was originally.

A little farther on, our attention was attracted by a small structure standing at one end of a sunken court, the spectacular, so-called Structure 22. Amazingly, this building remained in fairly good condition until razed by an earthquake in 1934. Maudslay's careful notes and photographs from the 1880s were of great help when excavations were undertaken shortly afterward. It stood on its own e-shaped podium on top of the 20-foot terrace that framed the entire

court. The building was dated to the mid-eighth century, and had not been erected over an older structure. A flight of seven massive steps raised it above the level of the other buildings, their risers apparently carved with much-eroded glyphs. We entered into a narrow passage through the gaping jaws of a scaly monster with two curving stone tusks at the sides. Beyond was another carved portal, set back and shielded by the outside walls. The central chamber was raised about a foot and supported at the ends by two large skulls, each made of a single stone. Above at either side were sculptures of large human figures. On their hunched backs, the figures supported the twisted mass of a fantastic, two-headed monster, whose writhing body formed the lintel, held in place by a thick wooden beam. In and out of the creature's convoluted body wove small, grotesque human figures, with elaborate headdresses and jewels, their arms and legs interwoven as if struggling with the elements. The high sill was also carved with skulls and glyphs, so that the entire entrance to the inner room was framed with sculptures. It appeared that the carving was originally covered with a thin layer of plaster and brightly painted. It had been refurbished so often that some of the exquisite detail of feathers, incised decorations, tassels, and individual hands and feet were lost underneath the multiple coatings.

The work was Baroque in feeling, in its complication of design and ebullience of detail, in the dramatic dynamics of its whole concept, and in its untrammeled, monumental freedom. This profound document in stone voiced the supernatural, occult elements behind Maya religion. It was not one sculptor's interpretation of some religious tenet, but the articulation of a complete, collective imagination, expressed with such clarity that even a twentieth-century Christian could not help but be struck by the physical power and fantasy of this alien world.

Approximately adjacent, on a separate substructure, was the Hieroglyphic Stairway, under reconstruction at the time of our visit. It rose at a characteristically steep angle and was 26 feet wide. The risers of the steps, calculated to have numbered some eighty to ninety, and each about a foot high, carried carved hieroglyphic computations, the longest Maya inscription which had thus far been discovered. The glyphs were executed with beauty and precision and arranged to read in lines across each step, not in columns as usual. The many figures and symbols, human, animal, and monster heads in various positions within shield-like frames, and the dots and bars representing numbers, constituted a gigantic, open scroll. We gazed on this intricate and elaborate work in fascination, recognizing our own mental limitations to fathom its meaning. As the stones had been scattered during the centuries, it was impossible to try to put them back in sequence. The workmen were hauling them up with a hand-turned pulley.

About every twelve steps, in the center of the risers, sat carved figures of priests or dignitaries or perhaps rulers, magnificently arrayed, each with its head framed in a the jaw of a monster. One statue was missing, and the rest were heavily damaged; yet each one was arresting in its individuality. A yard or two of the flanking balustrade was visible, bearing a series of crescent-shaped masks. Apparently, the carving was only roughed in before the stones were set in place and later finished. The inscription was said to date the stair around the end of the eighth century, placing it, like Structure 22, among the latest at Copán. Stylistically, it also showed some of the most mature work.

The ball court was laid out on the plain at the foot of the great mound. One tall, carved, fallen stela at the far end had been raised and dominated the scene. The monument-studded field with its surrounding buildings and the distant mountains beyond must have been an overwhelming and stunning panorama. The construction was an ideal arena, where from any angle the spectators would be able to have a good view of the game. While certain Maya sites, excavated more recently, could be placed among the most monumental of the classical Maya era, it is still Palenque and Copán, which in their variety and visual impact reach the pinnacle of Maya art. It rained, drizzled, or misted all the time, and Elisabeth was desperate about her photographs. At the end of the second day, Pál was struck down with chills and a high fever. Gustav Stromsvik put him to bed in his own room, dosed him with Atabrine and buried him under a pile of Indian blankets. Fortunately, at the time we did not know that John Owens, the head of Harvard's second Peabody expedition in 1893, had died of fever in Copán and was buried at the edge of the site. Earl Morris (of Chichén Itzá fame) described taking Sylvanus Morley out in 1912, "faint with sudden fever, tied onto his saddle on a burro," which could have been the origin of Morley's extreme distaste for mules!

By the next morning, Pál seemed to have shaken off his fever, and we drove back to Zacapa in good spirits. Nevertheless, we arranged to have the two doctors situated not far from our hotel room. The last train that night was to leave for Salvador at 9:00 P.M., and we walked down the platform to see its departure. A number of passengers were wearing their handsome traditional costumes. One slim young woman lay flat as a rug with her baby in the curve of her arm, both sound asleep. When the train left, we retired to our room and hung the bedspreads over the un-curtained, open windows. The puffing of the dynamo ceased outside, and all was quiet for about half an hour. Then there was a shriek from a locomotive under the windows, and the crash of railroad cars. Bananas from the many plantations were being shunted for hauling to the port. The clash of metal shock absorbers and signals of approaching engines were unrelenting, far into the night.

GUATEMALA CITY
AND THE HIGHLANDS

IN GUATEMALA CITY we were surrounded by the amenities of civilization again, although it remained unusually cold. The capital was a picturesque, provincial, Spanish colonial town, one-tenth the size of Mexico City, and 5,000 feet above the sea. On account of bitter experiences with earthquakes, the entire city was constructed of one-story houses, usually built around a garden patio, which along with facades of stone or soft-colored stucco, gave the whole place a very friendly aspect. The windows and doors, especially in the older houses, were beautified by fancy iron grillwork, and massive, brass-studded doors and knockers. Another Latin touch was the tile of the floors and patios, sometimes in flamboyant majolica, as frequently used in Mexico. The streets were full of the latest models of American cars, although they had to be hauled up from the port on flatcars or reassembled here. There was quite a traffic problem in the narrow streets, and every means of transport, including handcarts and bicycles, honked, whistled, or rang a bell at every corner. The carts

were swung on old auto springs and often used rubber tires, but nevertheless, each one had a license number.

The Indians filled the street, for it was still the Indians' land. The traditional women's costume usually consisted of a wrap-around skirt, a loose-sleeved, highly colored embroidered blouse, a thick, woven belt, and the ever-graceful *rebozo* or shawl draped over the shoulders or head, wrapped around the baby, or tied around a bundle. Woven cloth

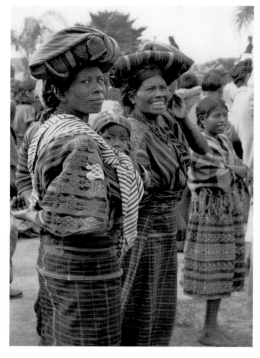

WOMEN WEARING TRADITIONAL
DRESS NEAR GUATEMALA CITY.

was twined around the head. The regional styles were so characteristic, so individual in the selection and combination of colors, in the techniques and motifs of decoration, and in the manner of wearing that the different provinces and towns could be distinguished. The Indian man of the city wore more ready-made clothes, mostly blue jeans, but reportedly their dress was more colorful in the country. As might be expected, the greatest sight were the markets, especially those where the roads from various villages converged upon the city. The pack mules were tied up in a row, and the women came to the public laundry-place to wash their clothes and gossip. In strange contrast was the attached pool, with a simpering, neo-Classic goddess in white marble in the center, a tribute to the pretensions of the nineteenth century. In the covered market the most exotic fruits and vegetables of the region were laid out, from the tiny, wild tomatoes like big cherries, to the guavas, melons, pineapples, and plantains (cooking bananas). The vendors were not at all importunate, and

everyone moved quietly about, without jostling or shouting. Around the market, goods were spread on adobe shelves on the walls or sometimes on wooden tables covered with bricks. Women cooked in earthen pots over charcoal fires for people gathered for a hot lunch, vegetable soups, chicken and meat stews, and bowls of spiced rice. They all looked appetizing, although we hesitated to taste anything. The custom was to eat hot food even when traveling, and little heaps of ashes were left by the roadside, where groups of natives stopped to roast tortillas on the coals.

Guatemala was primarily agricultural. Peonism existed practically until 1936, and when finally free, the Indian simply refused to work at all. He had his breadfruit tree and his poultry yard, so why should he bother? A very rational conclusion! A system was finally worked out by which, if a man could not show that he had worked a certain number of days a year, he had to work them for the government at much lower than the standard wage. However, the dictator-president who had taken over in 1930, General Jorge Ubico, seemed to be constructive and practical in his policies, and to have the welfare of the nation as a whole at heart. One of his methods was appearing unannounced at the opening hour in the offices of consistently tardy officials!

We had hoped to get away from the European situation as far as possible, but it was having repercussions in the farthest corners of the world. Germany, Holland, and Scandinavia dominated the coffee market in Guatemala, which had been closed down by the blockade. The price of Guatemalan coffee, along with Colombian considered the best in the world, had dropped by fifty percent. The planters were much perturbed, as coffee deteriorated unless picked and tended with great care, meaning that work had to continue on the plantations in spite of the fall in the market. Interestingly enough, this led to a violent, anti-Nazi spirit, even among half-Germans, who for a while had favored the Nazi regime and believed its exaggerated promises. The Nazi Party in Guatemala was strong for some time, but both the collapse of trade and the steady opposition of the government caused a reversal of feelings after the outbreak of war. There were plenty of Germans about, and it took a while to know whether they were stranded or exiled; but all of them were longing for a home. The German Embassy was sending around handcarts, openly laden with piles of mimeographed Nazi propaganda in Spanish, that trundled through the streets for general distribution.

Our Pension Geroult was a square, one-storied house, with a beautiful garden in the patio full of caged mockingbirds and orioles. It was run by a German and his native wife, who prided themselves on good food and an occasional bathroom (we had one all to ourselves). At night, the police discipline was audible. Every quarter of an hour, the police sounded their whistles from their post: one to show they were still alive, and two, that they were all alert. The pension was populated mainly by people connected with the Carnegie Institution of Washington, a number of whom we knew from Chichén Itzá and Santa Fe. The following week a group of Carnegie officials arrived including the new president, Vannevar Bush, and his wife; Director of the Historical Project, Alfred V. Kidder; and former U.S. Senator Wolcott, a trustee and friend of ours from Norfolk, Connecticut. Dr. Kidder told Pál that Dr. Bush was so science-minded and so worried about the tension in Europe that he wished to see Copán for himself, to decide whether or not there was any reason to continue support of the Carnegie Institution's Maya Project. After the first evening meal, Bush took a walk with Pál in the moonlit patio. Pál tried to make him understand that the little money the Carnegie was spending would be multiplied in the archaeological and broader cultural value of their work. Later it was said that Bush had no inclination towards such values, and was only impressed by the golden treasures that might be dug up. Sad to say, his visit to Copán was fatal to the Project.

A number of Maya cities were known and visited for a preliminary check-up in the last century, mainly in the lowlands. Some were still undiscovered, overgrown by jungle or crumbling away. Little was known about Kaminaljuyu, until well into the twentieth century, and the proximity of the site to the modern capital of Guatemala City encouraged plundering. The Carnegie Institution of Washington worked there, with Kidder as the dig's director, from 1936 to 1941, but was unable to prevent the artifacts that remained on the site from becoming articles of trade, when tourists began visiting Guatemala. The excavations and later studies have shown that it was an early highland center with a long existence, from 800 BC until 1,000 AD. It enjoyed two phases of cultural florescence, the late pre-Classic

from 200 BC to 200 AD, and the Classic from 400 to 600 AD. Influences from the Mexican high plateau reached there from both Teotihuacan and Monte Albán in Oaxaca. It became a satellite of Teotihuacan about 500 AD.

When we saw it, the site was just a heap of rubble, but the height of its culture could be discerned from fine quality pottery, on display in a formerly private villa. It was obvious that neither in shape nor decoration did the pottery resemble the "Maya style" that at that time was considered characteristic of the Classic Period. The incense burners of Monte Albán were highly formalized, and although the figures were human or gods in human form, they appeared in elaborate costumes decorated with many shingle-like bits of clay. In contrast, those from Kaminaljuyu had a more plastic, realistic form, recognizably human and individual, even though their relationship with Oaxaca was obvious. (The Carnegie's Kaminaljuyu report, published in 1946, included Anna Shepard's study of the ceramics; she determined that except for a small number of imported pieces, all the ceramics had volcanic material in the clay and therefore were locally produced.) Sir Eric Thompson reported remnants of a wooden litter found in a tomb, with other funeral objects and the bones of a dog (perhaps to lead the soul into the world of the dead). That verified the early date of the Maya practice of preparation for an after-life, and corroborated the *Conquistador* account that chiefs were carried on litters in processions. Spines of fish were also found, probably used in the bloodletting ceremonies that have been repeatedly reported. We were the only people visiting that day, and were allowed to take the pieces outside to be photographed in daylight, which made a world of difference in the quality of the pictures.

A magnificently beautiful country, Guatemala was subject to natural and human disasters. Pedro de Alvarado, the First Lieutenant of Hernán Cortés in Mexico, was the Conqueror of Guatemala. He established himself in the region in 1524, and within a few years conquered the surrounding Indian tribes. Criticized for his greed and ruthlessness, he was nonetheless named Captain General of Guatemala, which comprised much of Central America, as well as the territory that is now the Mexican state of Chiapas. In 1527, he established his capital at the foot of a volcano, bordering the city of Antigua. Insatiable for conquest, Alvarado returned to Mexico, and was killed in an Indian

revolt a few months later. A year later, his capital in Guatemala was washed out by an avalanche of water, due to an earthquake, and was moved to its present location.

Antigua was a monumental city, some 25 miles from the actual capital of Guatemala City. At the time of our visit, it was an open-air museum of the rich colonial Baroque that flourished in the Americas in the seventeenth and eighteenth centuries. Guatemala was one of the few countries in Latin America to have ports on both the

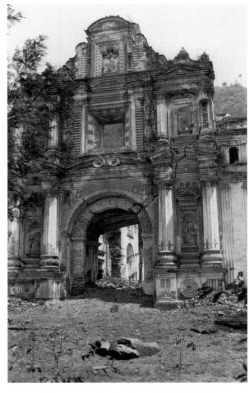

"EARTHQUAKE BAROQUE"
IN ANTIGUA, GUATEMALA.

Atlantic and Pacific Oceans. In pre-Columbian times, it was a trade route by land and water for salt, fabrics of cotton and other fibers, obsidian, jade, herbs, and gold. The prosperous trade continued in the colonial period, making possible the spectacular development of the city. Rich in material goods, it was also plagued by natural catastrophes, such as volcanic eruptions, frequent earthquakes, and floods, destroying the architecture and art repeatedly, into the twentieth century. In futile defense, artists and builders created a prime example of "earthquake Baroque." The earthquake of 1773 finally forced transfer of the capital to Guatemala City.

The buildings in Antigua that were standing in 1940 were still proud but with cupolas collapsed, arches broken, windows blinded, and pedestals and niches missing their statues. They were constructed of stone, brick, and mortar, according to some reports mixed with

honey and animal blood. It was a unique and fascinating scene, for the ruins were not only very romantic, but also revealed details of construction as practiced in colonial times. The Cathedral of the Very Noble and Very Loyal City of St. James of the Knights of Guatemala, illustrated in a woodcut published by Francisco de la Maza (the Mexican art historian), showed workmen on a scaffold made up of primitive beams and struts held together by vegetal ropes. It was fascinating to see the insides of Antigua's old structures.

Among the other guests at our pension in Guatemala City were two young Hungarians, who approached us when they heard our name. It turned out that they were victims of the dismemberment of the Austro-Hungarian Empire after World War I, who had refused to accept Czech citizenship. Julius, a former lawyer, went to Holland and studied cheese production, which became his livelihood after he migrated to Guatemala. His cheese became popular not only there, but also in other parts of Central America, and was served on Pan American planes. Later, he switched to making plastic bags for the hygienic shipment of bananas. When we first met Julius and his friend, they were just establishing their first enterprise. We made an excursion to the Pacific Coast with them, to a dreary place with a few scattered, thatch-roofed huts, and turkeys pecking in the backyard, alongside flopping, ungainly vultures. Some men were fishing on a rickety pier, with heavy poles, dangling large hooks. Pelicans swarmed around them, screaming and scooping up the flapping fish and hooks together, which the men tore roughly from their bills before throwing the birds back in the sea. We ate sandwiches in the shade of a ramshackle hut. The housewife cut up a pineapple for us, freed from its thorns by her skillful chop of a machete, and then, with another stroke, she opened a green coconut. The cool juice was wonderfully thirst quenching. Imagine what it would mean to travelers in a desert! The whole scene was one of desolation, and the heat was terrific. Years later, after World War II, we were delighted to run into Julius in

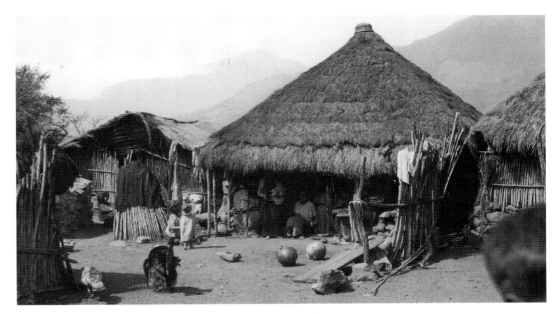

VILLAGE ON LAKE ATITLÁN, GUATEMALA.

a New York restaurant, and hear that he had expanded his activities and brought forty-two of his countrymen to live in Guatemala.

We journeyed into the highlands, as the western region was called. Lake Atitlán (measuring about 15 miles one way and 18 the other) was one of the loveliest lakes in all Central America. We made our headquarters in a village called Panajachél, the only one on the lake where outsiders had a foothold, inhabiting a small hotel and some charming villas. Just beyond the little bay, the volcanic cliffs heaved their brown shoulders straight out of the water. A few scattered Indian villages lay along the lake or nestled into the hills, but only one could be reached by means other than a boat or precipitous footpath. Due to isolation, each village conserved its own customs and special dialect, although the people were tribally related, and vigorously traded. Extinct volcanoes dominated the lake view. From our window, we looked out on three cones that grew blue and lavender, then retreated into the haze as the hours of the day rolled by. The suggestion of the European Riviera was so pronounced, that we had to get used to the ragged vegetation, even during the dry season in the best-watered gardens. The surrounding area had a very wild aspect. Gradually, we fell in love with its wildness and wished

that the place would never grow any more civilized. The lake was without an outlet; only constant evaporation due to the hot sun regulated its level, which could rise 6 to 8 inches a day in the rainy season. Some of the villages that seemed high and dry later on, would be at the water's edge; one was even built on stilts in anticipation of the floods. Immediately after sunset, the hills became enveloped in a sea of clouds; an hour later the sky was crystal clear, and the stars shone with a vehemence only seen at high altitudes in southern climates.

Comfort in Guatemala was a relative term, as many a dismayed tourist found out as he took possession of his "room with bath." We, fortunately, were given a bed with a mattress and very decorative Indian blankets, which weighed a ton apiece. Happily, the plumbing was modern, the water ran hot most of the time, and there was a shower, although it had no curtain, and the water splashed all over the room! We were attended by barefoot Indian boys, extremely gentle and eager to serve. They wore the traditional costume of the vicinity, red-striped blouses with red, embroidered sleeves; quarter-length, wide, red-striped drawers, embroidered cloths on their heads like turbans, and long, fringed red sashes. Apparently, they had long ceased trying to fathom the ways of the tourists. They knew that we liked lots of towels and plenty of silver on the table, and generously heaped up both, leaving us to choose what we needed from the uncounted piles of spoons and forks! Beyond a few obvious words, the boys knew little Spanish, so it was difficult to converse with them. They were very conscientious and devoted, being at at the same time chambermaid and table boy, and they kept things spick and span. A room flitted against mosquitoes by one of those boys swam in oil, for they took great pains to execute whatever their orders were without restraint, no matter if they understood the reason or the outcome.

Several times a week, a small launch made its way around the lake carrying mail and traders with their packs. Time did not seem to exist for the Indians. They trudged in from miles away, bearing loads of all sizes: vegetables and fruit from the well-watered fields of the region, huge crates of pottery jugs, or flat dishes for roasting tortillas, and even shocks of corn for fodder. They would spend a quiet night on the ground or sleep in the shelter of some open shed, and at dawn file up

to take their places in the boat. No shoving, nor shouting, and each man got his bundle in as best he could, while the others waited patiently. Many were not on their way to local markets, but taking the shortcut of prehistoric times from the mountains to the Pacific shore. The constant movement and general sociability indicated the atmosphere of the great shrines of prehistoric days such as Copán and Chichén Itzá, as well as the astonishing diversity of articles found in those places. The Indians of the lake rowed about in awkward-looking, dugout canoes with square prows and high sides that were remarkably steady on the uncertain waters. The men rowed standing, each with his own rhythm and no one steering. Even a single stroke at the wrong moment could overturn the high-riding craft.

We took a tourist launch to Santiago, situated at the foot of the largest volcano. It was a tropical village, with huts of reed, thatched with palm leaves, and bananas growing all about. The women wore dark red, wrap-around skirts and had their braids bound with long red streamers, wrapped round and round their heads until they stood out in a stiff halo. Some eight to ten women sat in a comfortably spaced semi-circle in the shade of ancient, feathery-leafed trees, with their few wares laid out on white cloths. The market had an abundance of pineapples and exotic fruits, and seemed more of a social than a business affair. Nobody paid any attention to us, except a troop of little girls selling textiles. The great church was barren, as the gilded *retablos* had all collapsed. A few carved fragments were stacked into a corner, probably to serve as firewood. However, the carved wooden figures that once adorned the elaborate altars had been placed, sometimes in rows on whitewashed altar tables, as though in a neglected storeroom. Some of the favorite *santos* had been crudely repainted. The village was a mission, a *visita* where the priest arrived only once in a number of weeks or months. But the people were of a very religious nature and had taken their religion in their own hands. Traditional religious brotherhoods were allowed to preside over some ceremonial occasions.

It was the Saturday before Palm Sunday when we arrived. The Indians had removed the figure of the dead Christ from its glass casket under an altar, where it lay all year on a tufted mattress, with a white silk pillow under the head. The statue was lifted down tenderly, and placed on a table before the altar, where the floor was

covered with fragrant pine needles. A number of women in red skirts were kneeling and holding long candles. As we watched from a distance, the men washed the body, and changed the linen as gently as if they were preparing a real corpse for the grave. They used beautiful towels, such as we have never seen before or since, woven with wide, lavender stripes. One woman gathered the old cloths into a basket. Occasionally one or two others would approach, kissing a hand or foot of the image and praying a while, while the men laughed softly and talked in muffled tones, exactly as described at peasant funerals. There was a naturalness and complete lack of any kind of idolatry, and yet a profound symbolism in the whole scene. After Palm Sunday, the altar was veiled in most churches, usually with a lavender curtain, perhaps embroidered with symbols of the Passion. On Good Friday, a life-sized Crucifix was placed before the altar and deeply mourned. The Indians' religion was markedly concerned with death.

A few days later, we drove to the famous Chichicastenango, a religious center that with the halt of travel in Europe would become a tourist destination for Americans. Tourists in Chichicastenango could find a night's lodging at the new Maya Lodge, and be soothed by lively music from a wooden *marimba*. Market day was in full force, involving little noise, but dense crowds were milling about. People played pipes and drums or sent up rockets to herald their approach. The marketplace was bright with the brilliant red of the women's many-colored *huipiles* (striped blouses), solidly brocaded and embroidered, until their texture seemed like velvet. The wraparound skirt was dark, vertically striped, and characteristically knee-length. We were told that this costume was woven by the men of the village, who also tailored and embroidered the male costume of heavy, natural black wool with short trousers and a brief, open jacket. Costumes for both men and women bore significant symbols that sometimes even indicated their ages and marital status.

The famous Father Rossbach had presided over the church for more than thirty years, so impressed by the Indians' religion that he let them practice their own form of Catholicism. Standing on a knoll, somewhat above the floor of the plaza, the church was approached by a broad, semi-circular expanse of stairway, where a Maya shaman (native religious official) was permitted to perform his own Maya service. Swinging his incense burner filled with smoking copal, he murmured his prayers, before the group entered, with the clouds of smoke almost obscuring the doorway. As it was near planting time, the Indians had brought along their seed corn to be blessed. The middle of the nave floor was one mass of burning candles and strewn pink, white, and yellow petals. The precious ears of corn and other garden produce were laid out in fanciful patterns on strips of brightly colored cloth, creating a rug of intricate and varied design. On the left knelt either the family or the representative village group taking part in the ceremony.

Shifting his chair from group to group, as the ceremony was too long for him to stand through, old Father Rossbach made his way down the line, blessing the corn and saying prayers for the various dead, whose names were whispered to him by the head of the village. Farther along, men were preparing their patterns of flowers and candles, and reciting preliminary prayers. Their chanting had the ring of incantation, or the persuasive accents of a personal conversation. There were also women in these groups, but they took no part in the ceremony. After the priest had passed, the corn was carefully gathered up, and the party left to mix with the market crowd and get some food. Later in the day, we met Father Rossbach briefly and looked in again at the church, empty and swept, but still smelling of fresh produce and incense. In the evening, there was a little circus performing in the plaza, surrounded by a colorful crowd, as silent as puppets. A tent had been set up lit by an acetylene lantern, where the actors retired after their stunts, and changed costumes. Standing at a distance, we saw an eerie shadow play on the flimsy walls. Outside, a little dancer in a ballet tutu practiced her pirouette, while a sword swallower picked up his weapon and lit the torch for his next hazardous venture.

We spent two days photographing Father Rossbach's collection of jades and pottery, while he told us details of his life and how his collection was gathered. At his suggestion, we went up on the hill beyond the town where the Indians practiced an ancient rite. On a plain stone altar lay the leg bone of a chicken, a few scattered feathers, dark drops (perhaps of blood), and a small heap of ashes. It was rather desultory, but might insure the goodwill of whatever ancient spirits might still be around. On the way back, an irresistible

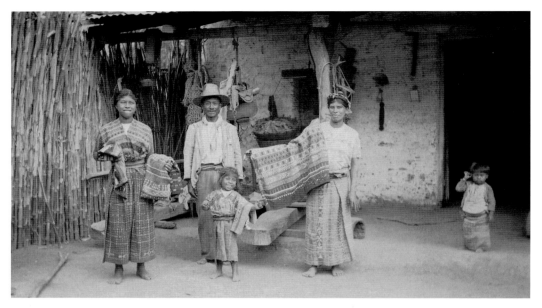

TEXTILE WEAVERS OF SAN ANTONIO AGUAS CALIENTE, GUATEMALA.

different places. The artists wove the subject matter of the world around them into their textiles: flowers in different stages of growth and bloom; birds flying over beguiling landscapes; threatening volcanoes, believed to have mystic powers; human and animal figures; and geometric forms.

In Guatemala, we first became conscious of the power and importance of folklore. As more and more archaeological excavations revealed the ancient crafts, they traced a thread reaching from the prehistoric past, through the viceregal and nineteenth centuries, into the modern age. A contemporary Latin American weaver might weave a policeman on his motorcycle, or the double-headed Habsburg eagle, and ancient symbols into a blouse, just as the Navajo in the southwest of the United States might put onto a blanket the image of a locomotive pulling a long train across the horizon. We were fortunate to visit such places, before mass production distorted the native cultures. We experienced the power of the Spanish colonial art before it was overwhelmed by the twentieth century, as well as the originality, rich variety, and vitality of the folk art, before it became contaminated.

little boy met us in the meadow and held out a handful of shards, for the ground was peppered with broken bits of pottery. Among the mud-colored pebbles was a small, turquoise matrix slab about as big as half a silver dollar. Carved into the polished surface was the left eye, the nose, and part of the mouth of an ancient Maya face.

It seemed as though a living map had unfolded before us, characterizing the highlands and the lower regions. In the latter were the villages surrounded by tropical vegetation, and in the lowlands, corn and vegetables were grown on the slopes. The Indians loved their own lands, and always returned to them whenever possible. In places where most of the population was not decimated working in the mines and coffee plantations, the Indians carried on their ancient ways of life and expressed their talents in spiritual and artistic creations. Weaving was a craft that was practiced from prehistoric times. Native cotton was cultivated early, and spinning thread an occupation inherited from generation to generation. Women traveling along the roads with spindles whirling were a common sight, and men knitting as they walked. Journeying through the countryside, we noted different techniques, motifs, and individual choices of color from village to village. A certain rivalry also seemed to exist between

EL SALVADOR, GUATEMALA,
AND MEXICO

EVERYONE IN GUATEMALA ASSURED US that there was not much of interest in nearby El Salvador. But Pál had seen a diminutive, cylindrical, pre-Columbian type flask from El Salvador, decorated with a series of little heads in low relief, on a shelf at the Smithsonian Institution. When he heard about our field trip, A.V. Kidder asked us to look around for anything similar. A Guatemalan friend later showed us a photograph of the same type of vessel in his collection, which

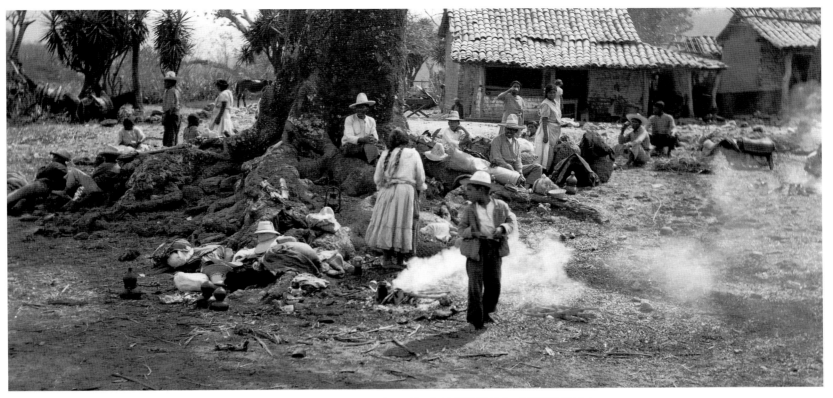

PILGRIMS ON THEIR WAY TO ESQUIPULAS, GUATEMALA.

he said came from El Salvador. With those incentives, as well as the Carnegie Institution's list of the country's outstanding prehistoric collections in private hands, we decided to make the 150-mile trip.

Most of the road wound through Guatemala over a series of vast steppes, and at the end of each valley came a descending pass. The landscape was rich, green, and intensively cultivated, mostly in coffee. The method differed from that of Asia Minor and other coffee-producing countries, being adapted from the local prehistoric method of cultivating cocoa. The coffee bushes were planted in the light shade of avocado trees, for protection from the intense noonday sun and sudden cold of the high altitudes. The bright red berries were picked by hand (often by children), put through a complicated process of fermentation, and broken out of two separate shells, before turning out like what we saw in the marketplace. The harvest took about three months, beginning around Christmas. During the rest of the year the workers were kept busy pruning the "mother trees" and the bushes, setting out new groves, and so on. It was a wonderful sight across the coffee grove valleys, with their ferny, feathery forests.

On the road, it got hotter every hundred feet that we descended. The road was full of gangs working on the Pan-American Highway, laboriously widening the mountain paths, easing curves, and prying away the volcanic rock and packed ash, using hand labor and only the most primitive implements. We passed groups of pilgrims on their way to spend Easter at the famous pilgrimage shrine of the black Christ at Esquipulas. Each group carried a small bundle of reeds wound with flowers, both fresh and artificial, enclosing the candles to be offered at the church. As we neared the border, our driver asked permission to make a stop for gasoline at the "Judio's" (the Jew's), a small, well-kept building amid a few scattered huts. The smiling proprietor came out to greet us and was noticeably Chinese!

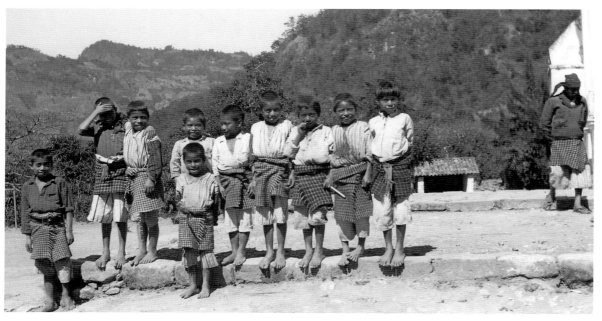

GRADUATING CLASS OF SAN JORJE AT ATITLÁN.

broad, smiling valleys, incredibly opulent and rimmed with lovely, smoothly rising volcanic cones. It was said to be one of the most densely populated countries of the world, difficult to believe, as its villages lay in serene little groups, usually around large plantations. The main products were coffee and sugar. Boys astride little *burros* sucked on bits of sugarcane. All the inhabitants were "Ladinos" (mixed-bloods), and few admitted to being Indians or kept up any tribal customs or costumes, although they were just as brown and straight haired as their Guatemalan brothers. The loosening of caste and class distinctions seemed to make life much gayer, freer, and more "modern" than in Guatemala, although it was not half as picturesque.

The country was crisscrossed with wide-spanned bridges, although the rivers were only trickles of water. The country was remarkably verdant, considering there had been no rain for months, and numerous brooks were dammed up for irrigation. Many of the valleys had interesting groups of "hills" or mounds of unusual shape, suggesting prehistoric ruins. Both of the border stations were crowded with officials. We had to open all our baggage and spell our name half a dozen times, but the examination was perfunctory, as we chattered as best we could about how much we liked the country and wanted to see. Two officers in white, sitting in a hammock, paid no attention to us, as they were industriously translating a paperback English novel about some Scottish castle!

Once across the border into El Salvador, we found an excellent asphalt road, which led straight to the capital, interrupted only by short detours due to repairs or bridge building. Our Guatemalan driver, unused to a long stretch of good road, took some time learning to keep his foot on the gas without continually slowing down for bumps. It always surprised us how different each new land appeared. El Salvador seemed to have a mild temperament, with

San Salvador, the capital of the country, was a large, thriving, and very noisy city, surrounded by suburbs of beautiful villas mostly in the Spanish or Hollywood Spanish style. It lay in a rather narrow valley full of water, with gurgling springs and rushing brooks, and the gardens were exquisitely tended and luxurious. Characteristically, the city did not have any good hotels, for everyone of any standing was, of course, invited to stay at one of the villas or *fincas* nearby. We were fortunate to have a recommendation to the Casa Clark, a one-story boarding house that turned out to be quite a rest haven. It was run by an American-trained nurse, a sturdy, jolly soul who, by the very force of her good nature and common sense, made her wilted, irritable guests cooperate for their common good and comfort. She knew just what each person wanted, when he wanted it, and made him or her comfortable in the uncomfortable situation.

We had an inside room facing the second courtyard. The lack of an outside window was a blessing, for the cars honked and dinned all night, while the closed-in shade was a relief for tired eyes in the

daytime. At night, there was always a breeze, and the patio was lined with comfortable divans and big chairs facing the coconut palm in the garden. When we came in from the terrific heat, we just dropped our damp clothes outside the door and made for the row of showers opposite. Freshly laundered apparel would be lying on the beds the next morning, when we returned after breakfast. We learned to stay home from noon to about three, then to shower, if necessary, and start out again. Around 6:00, after another shower, we suddenly began to feel gay and invigorated again.

El Salvador was more cosmopolitan and international than Guatemala. We met some delightful people, and everyone was charming to us. Through Doris Stone, the daughter of the president of the United Fruit Company whom we met in New Orleans, we had a recommendation to a Mr. Wilson. He was the head of the International Railways of Central America, a very efficient, and well-equipped, narrow gauge line that transported mainly bananas. That helpful gentleman knew everything and everyone in the country. He liked to ramble off about the subjects that interested him, and we would sit an hour at a time in his office, while he off-handedly scribbled down names, waited for a telephone call about an address for us, or had a letter typed on our behalf. By the time we left him, after what appeared to be a leisurely chat, we would have several days' work all scheduled in our pockets.

We were able to visit an excavation that Tulane was just beginning, and it was great fun, in spite of the ferocious heat, to see the archaeologists at work and to recognize the outlines of buildings and walls. We collected a number of remarkable pieces of art in Salvador. The pottery was fine and varied: some painted cylindrical jars in bold colors with stylized figures of animals and birds, and some rather abstract designs showing the influence of prehistoric cultures present in the region. We found a number of the typical, diminutive flasks we were seeking for Dr. Tozzer, seldom taller than from 2 1/2 to 3 inches. Some showed the expert hand that fashioned their balanced contours, with clearly delineated decorations of figures, glyphs, or pseudo-glyphs, undoubtedly applied with stamps. One of the finest, some 3 inches high, had clearly defined figures facing one another between a column of glyph-like characters on the two flat sides. The elaborate costumes and important symbols were fitted into a circular rim in a highly sophisticated design. The workshop must have been in the southern Maya territory. Imitations and variations in form and material were found as far as Yucatán in the north and El Salvador in the south. Traces of mercury or cinnabar, sometimes both, were found in some examples. In others, medicines may have been stored.

Everyone told us there was no jade in El Salvador, but we found some of the best pieces in the whole region, with all the marks of having been manufactured about where they were discovered. Most of what we saw was in private collections. There were a number of carvings, generally irregular in shape, as if from broken fragments, of a buttery white jade with bluish tones. As we had seen this type only in Father Rossbach's collection at Chichicastenango, which he had gathered from many places, we wondered if this milky stone was not native to El Salvador. We use the term "jade" freely to describe the green stone (*Chalchihuitl* to the Aztecs, *Tun* to the Maya) that was sacred to most of the Indian peoples of Central America. The name has been derived from the Spanish "piedra de hijada," or "loin stone," which the Spaniards adapted from the Indians to treat diseases of the loins. (In our book *Medieval American Art,* the subject was discussed at length.) Suffice it to say that jade is not a generic name, and the American jade is quite different in mineralogical content from that of China and Burma. Specimens of various colors have been found in the western regions of the Americas from Alaska to Brazil. As we made our way to various collections, the job of photography was very strenuous, but proved again that the best photographs were taken in the sun. We were glad that we did it that way, even though we had to seek the shade at intervals and gasped like fish out of water. We were armed with huge hats, Pál in a planter's straw and Elisabeth in a floppy felt. Elisabeth determined that in photographing in black-and-white, as we were forced to do for illustrations, the Panchromatic type of negative was better than the Verichrome in rendering the various shades of green, especially in close-ups.

We had a very charming dinner with Mr. Wilson on the wide, screened verandah of his villa. A hidden radio played in the garden, and the wild cranes roosting among his lilies screamed at intervals. He told us about riding through the country on horseback as a young man and about his varied interests, which ranged from tracing the footsteps of the pioneer archaeologist John Lloyd Stephens, to

the work of the modern young Salvadoran painters. He took us to the studio of one of these, actually a Spaniard from Aragon named Valero Lecha, who had found himself in this new and exotic environment. He was a delightful fellow, who immediately became very familiar and assured us that the day was a *fiesta*. We were so struck with the man and his work that we bought his latest picture, to our own amazement and continuing pleasure.

One evening we attended a cocktail party for Finnish Relief at the home of Mr. Frazier, the American Ambassador. The house was exquisitely furnished, and everyone was in his or her best, which in some cases was rather fussy and overdone, a tendency in these torrid regions. Our hostess was a lady of vast international experience. We were inclined to feel sorry for someone of her ability and charm stuck away in the tropics, until we learned that her husband was very much the man behind the dictator's throne, and the political game was intense and exciting. The dictator's wife was also present, a dumpy, arrogant, unimaginative little body. Pál had quite a pleasant talk with her, but Elisabeth retreated, saying she did not speak one word of Spanish. A marimba was playing in the garden, and there were all sorts of raffles, auctions, and games. Mrs. Frazier was assisted by the wife of the Ambassador from Chile, a completely different type of Latin American, suave and feline, dressed with ultra sophistication and extremely animated and amusing. It was astonishing how few wives of our various acquaintances we met in Central America. The women were still quite cloistered and seemingly kept deliberately provincial, even though their brothers and husbands may have gone abroad for their education and spoke several languages. The social life among those of Spanish descent must have been extremely rigid and stuffy.

On our last day we set out at 7:30 to visit a coffee *finca*. About three-quarters of an hour after starting, the route turned off from the smooth Pan-American Highway, and there our troubles began. The road was ankle-deep in volcanic ash and ribbed throughout, chopped up by the sharp hooves and solid wheels of ox carts bearing sack after sack of coffee. We made scarcely 12 miles an hour. The landscape was picturesque and very beautiful, as it skirted the foot of several volcanoes. A passing group of women on their way to the market all wore shades of bright pink, orange, and green shawls and carried broad, flat

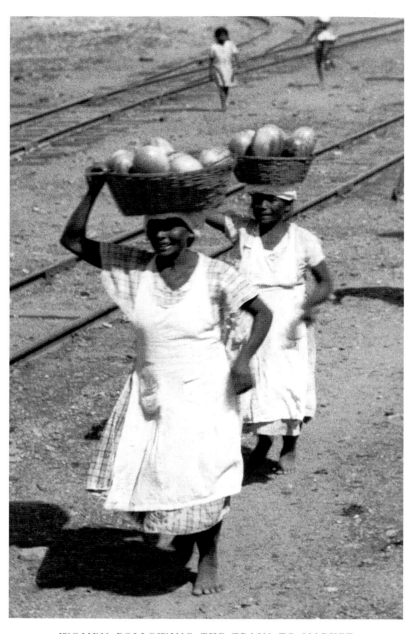

WOMEN FOLLOWING THE TRAIN TO MARKET
IN GUATEMALA.

baskets loaded with fruit on their heads: oranges, bananas and pineapples. Everything was deep in dust, the children especially smeared with dirt, and mostly naked. We lurched through lush valleys, and sighted a stretch of overgrown mounds that surely were ruins. The road was often sunk 10 to 15 feet below the banks, probably washed deeper each season by the rains. This made for cooler traveling, as they were in shadow, and gullied through with deep drainage ditches, an indication of what the rains would mean when they came.

Our coffee plantation destination was on a smooth mountain slope. We were greeted by the supervisor, an Italian named Colonel Zanotti, and two compatriots: animated, enthusiastic, well-educated, and warmly hospitable Europeans at the end of the world. They ushered us into their shady house and brought out pitchers of warm water, and plenty of towels. The mirrors reflected us plastered red, as if masked from the volcanic dust! Above the big desk in the main room was a larger-than-life poster of Mussolini, and stretched beside it an Italian flag decorated with a quote from one of the Duce's speeches, and the Fascist Party emblem. We were given a delicious lunch and talked about Florence and the countryside around it. The pre-Columbian collection had been gathered mostly on the plantation. Practically all of it consisted of carved figures and faces, outstanding for their varieties of colors and forms. Everyone ran about to set out tables, and arrange backgrounds for the photographs outside against the huge water tanks, where the sun was the brightest. Pál asked with a deliberately casual tone if anything was for sale, but the Colonel was not interested and, indeed, seemed annoyed at the suggestion. But several years later, we received a letter from Colonel Zanotti offering his entire collection for sale. We forwarded it to Dr. Kidder at the Carnegie Institution. It would have been interesting to spend the night at the *finca* and see its workings in the morning, but our permits to stay in the country ran out the next day. So we plunged into the dust again, with the car full of carnations and huge pink roses, which lasted until we arrived in Guatemala. We reached Santa Ana in the dark, with the smoke from the annual burning-off of the cornfields choking us in the heat. By the next day at noontime, we were gratefully breathing the clear mountain air of Guatemala City.

Early on during our stay in the Guatemalan capital, we made the acquaintance of the Minister of Public Education, J. Antonio Villacorta. He was a small person of Indian ancestry, who had published a number of volumes on the Maya. Upon hearing about our project, he was immediately very cooperative, and his interest grew as he learned about Pál's background at European universities. His inquiries about our work at Harvard and Tulane brought out an unsolicited comment: he held his hands beside his eyes, imitating the blinders on a horse to illustrate the limitations of some of the American archaeologists. He felt that they had started specializing too early and lacked a broad cultural overview. He helped us greatly to solve a number of local problems, and his son Carlos Villacorta being the Director of the Archaeological Museum was a tremendous advantage. At that time, the museum was somewhat outside the city in an old private villa. It was not very appropriate for a museum, and we were assured that a new building in the heart of the city was about to be constructed. We had the advantage of being alone in the place, except for Carlos, who assured us we were the only ones who had ever taken the trouble to view the material. He allowed us to handle the objects and take them out into daylight. Pál put a lot of effort into making a broad selection of the great variety of painted, sculptured, and engraved pottery pieces, for it seemed there was no form of plastic language the Maya had not employed. It was amazing that, without any external influence, they had invented and applied the entire scale of sculptural possibilities.

The negatives we brought from Quiriguá and Copán turned out dull and unsatisfactory because of the clouds and rain, so we planned a second trip. When the Villacortas heard of it, Carlos announced that he would like to go along, but on his motorcycle so he could return by a different route. He would meet us in Zacapa. We located Eduardo, our driver on the previous trip, who told us proudly that he was a Protestant, and that in Chiquimula would arrange our stay for the night at the Baptist Mission. This time there was no waiting at any village entrance to show our papers and no delay while the Colonel at the border finished his afternoon *siesta*! The tollgates were opened as we approached, for the president had telegraphed all the stations to alert them of our arrival.

At the main plaza of the village of Copán, Gustav Stromsvik received us cordially, like old friends. He offered us the little museum building, which the Carnegie Institution maintained there,

instead of the half-finished rooms in the new "inn." The more we saw of the ruins, by then more conserved, the more its overall monumentality was evident. The layout of the ball court spoke for itself, with a tall stela placed at the far end, before the suave background of the distant hills. The Hieroglyphic Stairway had a few more risers in place than before, and the balustrade had been added as well. The sunny days were a blessing. We had learned the lesson that the sun played a major role for the ancient builders. When the workmen left for their midday meal, we hung around to see the sun reach the zenith, when carved details of figures and glyphs took on unexpected clarity in sun and shadow. This was a unique case, where a stairway carried an intellectual record, another Maya first. By 4:00 we shot the pictures we had planned for the day and retired to Stromsvik's office, because the malaria mosquitoes would rise from the Copán River after twilight. As the sunshine abated, the natives began to circulate, and soon young and old gathered before the large office window, as if before a television screen, to watch the amusing *gringos*.

After an early supper and considerable gossip about other Maya sites familiar to us all, we retired to the museum, where there was plenty of space and running water. A display of small sculptures from the site gave a special local color to our night's rest. Elisabeth worked out plans how, suspended from a tall ladder, she could photograph the striking ball court marker that lay on the museum floor. The Carnegie dynamo stopped its rhythmic throbbing, and we slept soundly. At dawn, Elisabeth suddenly cried out, "Pál, there is a tarantula in this room!" To this day she cannot say what warned her. We sat up abruptly, and there it was, just crawling under the door. Pál grabbed his heavy jungle boot and whacked the pest before it found cover.

The following days were used intensively. Elisabeth knew the angles by that time, and the light cooperated. All the photographs turned out with the desired sparkle and covered the ground we wanted to record in Copán, from the Great Plaza and the Ball Court with its tall stela newly set up before the hills, to the Hieroglyphic Stairway and Structure 22. At the latter we got some good details of the sculptured doorway where Maudslay had removed the British Museum's corn god statuette.

The Protestant Mission at Chiquimula could not accommodate us on our way back, because they were hosting an evangelical meeting of about fifty natives from outlying villages. It was a very moving experience to stand at the back of the vine-covered arbor, and hear familiar hymns with Spanish words and the thrilled declarations of the newly converted. So it must have been when the Spanish friars built their first chapels and brought the Indians into the fold. We found quarters at a small boarding house run by a Swiss. The rooms were large and spotlessly clean, and the ceiling covered with thin cotton sheeting to keep out all the insects that creep, hop, and fly in the tropics. We were practically the only guests. We heard the mother and her two sons chattering in German-Swiss in the kitchen, and as we set out after a copious breakfast, the father, a grizzled, dusty, bearded, elderly man, returning with his mule, his pans and shovels, after a prospecting trip for gold.

As soon as we arrived back in Guatemala City, we had to start getting our visas in order and permission to leave the country. At the suggestion of the Mexican Consul we telegraphed the border station at Suchiate (where we would board the Mexican train) for Pullman reservations and got a confirmation back. Pál traded in an old suit for a new one at our little Czech tailor's, and we stopped twice a day at the photographer's to see how the films were coming out, and practically all were excellent, although Elisabeth wished (as always) that she had taken more. All business had to be finished by the next Wednesday noon, for all the shops would be closed three days before Easter. Even the drivers refused to drive on Good Friday, as neither man nor beast should have to work on those days, especially Good Friday. Servants appeared for only the sketchiest meals, as the whole town (including many outsiders) drifted about the streets all day in the wake of the religious processions. As early in the week as possible, many rushed off to vacation places, or Antigua, to see the religious festival, so the streets were strangely barren of traffic.

These processions were a heritage from the Spanish Catholic Church Holy Week, especially those in Seville. But there was also some connection to the five "extra" days left over each year in the Maya calendar of twenty months of eighteen days each. Those five days were considered dangerous, even unlucky, and no business begun or finished on any of them would have a satisfactory future,

so they were wasted and played away. As the Maya year ended in the spring, it was not difficult to transfer this idea to the Easter holidays. To celebrate Holy Week, special images were taken from their places in the churches, and carefully outfitted for the occasion. Sometimes they were kept in separate chapels and carried into the main church in a preliminary procession. Indian boys came in from the mountains with bales of pine needles on their backs, which were strewn before the churches and shrines. The boughs smelled delicious and made the air moist and cool. Each church had its traditional procession time and route, and amazingly enough, they began on time in spite of the complicated organization of traffic. On Thursday, when we reached the Carmen church a bit late, the procession had already left, with only a few fruit vendors and old people still sitting around.

Our driver took a short cut to catch up, and we could see the rows of painted banners swaying toward us. First came a group of little boys in lavender gowns and skull caps, collecting coins from the crowd to keep alive their *incensarios*, thickening the air with smoke. Then came various *cofradías*, or "societies," religious organizations, of young men bearing banners, and a series of paintings depicting the fourteen Stations of the Cross. Then appeared, amid a mass of lavender and gold statues, a very fine ancient image of Christ bearing the Cross. He was dressed in a red velvet robe, thickly embroidered in gold, and born on a great litter that took twenty men to carry. The Christ figure was poised on a large blue globe of the world, before him a mass of brilliant red lilies and white Easter lilies behind and little doves swaying among them on wires. The street about the litter swarmed with young men, eager to take their turn at carrying the heavy weight.

Behind came the band, led by a Goyaesque figure with a leonine head and a flowing white scarf. The music was "Roll Out the Barrel!" in funeral march tempo, while the bearers swayed in time, giving the figure on their shoulders a strangely realistic gait. The Virgin Mary followed, borne by young girls and women, with John on one side and Mary Magdalene on the other, each holding golden cups wired onto their hands, and glass Baroque tears on their cheeks glinted in the sunshine. The people were very reverent, some falling on their knees, and many crossing themselves. A cheerful holiday mood prevailed. They watched with curiosity as Elisabeth took some movies

of the scene. After the procession passed by, they broke away quickly to meet it again at another corner, or drifted about the refreshment stands, and into each other's doorways for a visit. The little acolytes dashed for ice cream cones, and one young man peeled off his silken robe and handed it to a companion, who dashed off after the procession, eager to participate. One very small child, no more than three and attired like a little gnome, was wailing mournfully because he was too tired to march. An older boy caught him up and put him on his shoulders, and he went swaying away, grinning happily!

On Good Friday we went to the Church of Santo Domingo to see what was known as the most "traditional" of the processions. This was very much a social matter. The elegant young men wore black robes of silk and velvet, black silk gloves, and were distinctly of the elite. Large porcelain groups were borne out first, representing the various scenes of the Passion Week: the Garden of Gethsemane, Christ before Pilot, and the rest. The figures were conventional and factory-made, not very interesting. Then came a crucifix so large that it could scarcely be gotten through the door and then, apparently, the climax of the procession, a huge gold and glass coffin, with a figure of the dead Christ wrapped in silk and lace. A wonderful Baroque *Dolorosa*, "Mother of Sorrows," followed in black velvet and gold with a most realistic sword stuck in her breast. Her float was deep in flowers, both real and artificial, and arched with electric light bulbs for nighttime illumination. As all the bells were muffled at the time of mourning, the figures were heralded by music from the band, and by the clatter of wooden clappers and rattles, strangely pre-Columbian in effect. Elisabeth tried a few photographs in the churchyard. Some of the natives seemed angry and turned their backs, while others grinned and waved.

The next day, we left for Quetzaltenango in the western part of the highlands. We traversed some of the ground we had seen on our trip to Lake Atitlán and Chichicastenango and crossed two 11,000-foot passes. One was overgrown with bamboo, and hoary cypresses weighed down with orchids. Elisabeth picked a strand of rose-colored bells to pin on her red tweed suit. The other part was thick with juniper and pines as in our own northern forests. At last we came down near Totonicapán, where even the hills were intensively cultivated and wheat was grown, rare in that country. People were

threshing it by driving a coupled donkey and pony round and round over the sheaves on a hard-beaten circle of earth. The children winnowed the grain by tossing it high from a shallow basket; the wind blew the chaff away, while the grain fell straight into the basket again. Apparently in anticipation of the coming rains, the trees had begun to bloom and the early planted corn to sprout. It was strange to pass through scenes of softest, early spring, while the colors of the background, the hills, the forest and sky, were those of autumn. The dry season, which runs from December to May, was called *verano* (summer) and the wet, productive season, May to November, *invierno* or winter.

It was a dull day, for the huge clouds were already forming for the rains beginning in a few weeks. Occasionally, a chilling fog swept through, and a few drops of rain fell as we passed a small village near our destination. As we had seen little of human habitation, and no Easter celebration at all (though we did catch glimpses of festive costumes on the road), we stopped there and entered the church. It was so dark inside that at first we could scarcely see, but the place was crowded with figures seated on the ground and wrapped in the brilliant shawls of the region; glowing ruby red, purple, and deep blues suddenly winked out at us from the candlelight. They were just unveiling the figure of the Risen Christ, and as there was no priest for the community, the service was being held, with all due solemnity, by the lay brethren, while the congregation watched as if in a theater. Outside the church afterwards, they gathered in groups about the lemonade stands at the foot of the steps, and the children played and romped. It was very rare to see an Indian speak roughly to or mishandle a child, and it was a source of constant amusement to note how well the children's clothes always fitted. They could be in rags and crusted with dirt, but the little serape was just the right length to cover the shoulders properly, the faded overalls fit firmly about the waist and hips, and the little hat was cocked at just the right angle. The girls were like miniature women, with heavily gathered skirts swinging gracefully, and wrapped in shawls, just like their mothers.

Quetzaltenango, the so-called Indian capital of Guatemala, was a picturesque, hilly, provincial town with the atmosphere of an Alpine village, and was indeed at a very high altitude beneath the Santa María volcano. Its agreeable climate made it a favorite vacation place, not only for Guatemalans, but also for members of the diplomatic

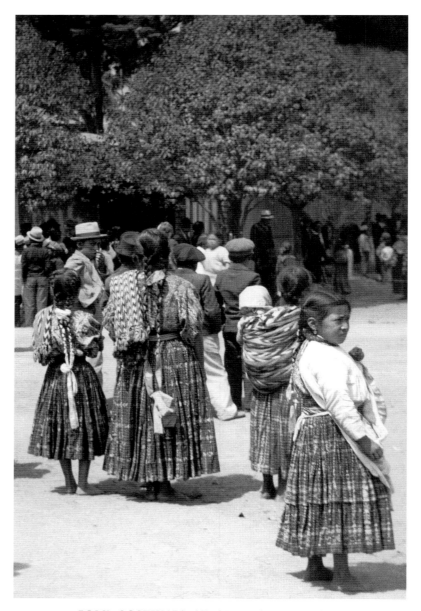

FOLK COSTUMES AT QUETZALTENANGO.

corps from the Central American capitals. The development of the coffee industry in the late nineteenth century made a commercial shipping center out of the city, and the influx of foreign traders who settled there, inspired the creation of buildings in the

neo-Classic, Parisian manner. Remnants of this period of affluence and national social ambition still stood (in spite of a severe earthquake in 1902). While the architecture contrasted favorably with the hodgepodge construction of Guatemala City, Quetzaltenango had suffered the imposition of sculpture depicting simpering, very white, marble ladies in bustles, carrying dainty baskets of flowers. There were also several thriving factories in the town making shoes, textiles, and some kind of chemicals. Yet the Indian population remained predominant, and many of them were wealthy. They remained conservative and lived their own type of life, preserving their

QUETZALTENANGO, EASTER, 1940. PICTURED LEFT TO RIGHT: TWO VISITING PRIESTS FROM SAN FRANCISCO EL ALTO, INN HOST, CHILEAN AMBASSADOR AND WIFE, ELISABETH AND PÁL, TWO GERMAN TOURISTS.

traditional folklore and costumes, which were noticeably distinct in color and design from that of the lowlands. Our first treat was another religious procession in the street. A row of men bearing candles walked before the image of Christ, while the women, with their long *rebozos* draped over their heads, followed the Madonna. Electric bulbs were lighted around the images, but the fervor of the worshippers, the pungent odor of incense, the shuffling of feet, and the other aspects of the scene overwhelmed that incongruent token of the modern world. Elisabeth took a lot of color movies, which fortunately people did not seem to resent.

As we had arrived rather late, we had a difficult time finding a room. We came at last to a *pensión,* a boarding house suggested by our driver. The Hotel Europea was owned by a hearty German, Herr Keller from Cologne, and he was very happy that we both could speak German. His hotel was a one-story building, with two patios surrounded by a row of rooms. He also said that he didn't have space for us. But his wife said that she had read about us in *El Imparcial,* the newspaper from Guatemala City, and they could offer us their own

bedroom, as it would be a warm night and they could sleep outside in one of the patios. The host's bedroom might have been in a provincial German town. The furniture was Biedermeier and the chest of drawers loaded with family photographs. Actually, it was cold, but hot water was brought to every room in a thermos jug, and hot water bottles put into our beds. The food was very good, and to our delight, we ran unexpectedly into the Guzmans, the Chilean Ambassador and his wife, whom we had met in El Salvador. He turned out to be quite a famous poet with a poet's fine sensibility, while the lady, considerably younger and developing a talent for sculpture, was remarkably warm and spontaneous.

The next morning as we approached the plaza, the joyous procession of the Risen Christ was passing through. The native women were all dressed in festive costume, and their thick black hair hung in braids down their backs. Little girls walked in front, dressed as angels with wire wings, and strewing rose petals. Behind them a strikingly lovely young woman carried a bowl of smoking copal incense, half-turning at intervals, as if to salute the Madonna behind

her. The band vigorously played the "Beer Barrel Polka" in rapid tempo. We dropped in at the market and after considerable parleying with an aristocratic-looking, young saleswoman and a visit to her home, we bought a fine *huipil*, or blouse, heavily embroidered in golden yellow, lavender, and bright red.

We drove up to San Francisco el Alto with the Guzmans to pay a short call on Father Knittel from St. Louis, Missouri, and his hunchbacked sister. Not finding them at home, we drove on over a lovely, wild, winding pass to Momostenango, where their older brother had a parish. They were all enjoying coffee and raisin cake in the old cloister, converted into the priest's home; after a strenuous Holy Week the place was deserted and the church closed. They received us like old friends, and Elisabeth ventured an inquiry about the availability of textiles. They replied that, unfortunately, the colored ones had all been taken. Only two black-and-white, natural wool blankets were left that an old man brought in regularly as his gift to the church. The motifs were inevitably corn sheaves and pine trees, but always in a different arrangement. That was exactly what we wanted! We bought one, even though it would be a problem to pack, and in the end strapped it on the outside of a suitcase. Later we regretted not taking the other blanket as well, for when the old man died, the type would never be made again.

Easter Monday, the whole place was rolling. While Elisabeth was arranging the packing of our new acquisitions, and the driver was checking the car, Herr Keller started up a conversation, after Pál mentioned that he was at Berlin University in the early months of 1914. He related that he had come to El Salvador as a young boy and met his wife there, as not very far away were coffee *fincas* owned by second- and third-generation Germans. Pál told him we had just visited a coffee plantation in El Salvador, to see the ancient Indian objects that had been dug up as the fields were enlarged. Herr Keller responded, "That's all very fine what you archaeologists are doing, but last year we had a German scholar here, a linguist. He was here for six months, studied the Quiché language, and went around with the Indians, made notes, and when he left, he told the Maya the correct way to speak!"

We were off early. At an altitude of 6,000 feet, the valley spread and widened until it looked like Mexican country, including the

MARKET AT SAN FRANCISCO EL ALTO.

great, blue-green spikes of maguey cactus everywhere. Then came several wooded passes, up and down, which did not seem to get us anywhere. We came to the brow of a ledge and could see nothing beyond it—the atmosphere was so hazy, as it always was that time of year, that the world just seemed to drop off. Somewhere far below, almost straight down, lay the Pacific Ocean and the strip of tropical coast that was our destination. Descending, we could make out the contours, the churned-up volcanic hills, and the great plain at about 3,000 feet, where the familiar coffee plantations were planted under banana groves. The drop was terrific. In three hours, we were down in the thick tropical heat with vicious gusts of dust swirling around us.

Our driver escorted us to the Guatemalan border at Ayutla (the name was later changed to Tecún Umán), where an irritable official

dug around in our entire luggage, extracting and examining every small box with sadistic curiosity. (As a matter of fact, we only had our suitcases with us. The various textiles and souvenirs we had bought in the capital and all of our films had been sent from Guatemala straight to New Orleans by boat.) Soon we arrived at the real border, a very wide, shallow river spanned by a small plank bridge. Evidently the crossing was often made in a dugout flat, but it was being used to ferry barrels of oil across from Mexico. So we walked across the planks accompanied by a young boy who made several trips with our suitcases on his back. On the opposite side were some Mexican officials lounging under a thatched shed, including a woman official who examined Elisabeth's luggage. They were all very friendly, and soon we were welcomed to the new land across a stretch of meadow, where women were bathing and washing clothes and babies at the river's edge. Then came a rustic sort of a gate, the official entrance to the town of Suchiate, and passing beneath this we arrived at an aqueduct with a dusty path on each side. Crossing a railroad track, we approached a wobbly looking frame building as the likeliest place to be the hotel. We were shown a room upstairs, furnished with several canvas camp beds and a rack with clean linens. The washing arrangements were a tin basin on a shelf outside the door, and we were requested not to wash in the room, as the water splattered through the gaping floorboards into the room below (this admonition was immediately disregarded).

We were given as much service as possible in such a place. A strange run-down Spaniard brought mineral water and limes to our room and put us at his special table in the dining room, serving us before the other guests. Our fellow travelers were all courteous Easter holiday travelers, Mexicans, and like us, were pretty worn out by the too-sudden change of altitude and landing in that airless, dusty, and horribly dirty hole. The place consisted of one rutty street and a row of uneven, brown-painted buildings, with burros and cowboys' horses tied up in front of the cafe. As there was nowhere else to go, we promenaded up and down the platform of the station and watched the packing of a freight car of bananas by torchlight, to go out the next morning. We were looking forward to settling down into our Pullman "drawing room," when the station master hurried up to tell us that the Pullman car had been requisitioned for use by the president and his party, politicking in that region, and that all reservations were canceled. We decided then and there that we could not spend one more day in Suchiate and would travel on in First Class, getting off that night, if it proved too bad.

As seemed the custom, our traveling companions at the hotel apparently rested fully clothed, on unmade beds or strolled up and down the gallery all night. In the cold light of dawn, after a cup of cold coffee (for the proprietors refused to get up so early to make breakfast), we hurried downstairs to the train, which had pulled in four hours late the night before, and was heaving and puffing to start off again. The worst part of the prospective journey was that we had not brought any food, since the Pullman carried a buffet. Fortunately, in the station bar one could buy bread and cheese, oranges, bananas, and bottled soft drinks. We found seats in a corner of the large, plush-covered First Class car, stowed away our bags, and drew a deep breath for the long pull. The prospect of buying what the Indians offered on various station platforms was dismal, but there was a longer stop at the next station of Tapachula, an airport terminal, where we could have a hot, hearty breakfast. Just then, an official appeared and cheerfully informed us that the president had canceled, so the drawing room of the Pullman car was at our service.

First class was quickly becoming crowded with baskets and babies, and the sun glared first on one side and then on the other. We divided our emergency provisions among our fellow passengers, and quickly made the change. The Pullman seemed more luxurious than ever before, with screens to open or shut at will and an electric fan going constantly. The porter was an excellent cook and bought vegetables and live chickens on the station platforms, which he turned into very good meals. As the car's only occupants, we had the choice of any of the soups and canned fruits he kept in a little cabinet, and even a bit of ice in our afternoon tea. In this comfortable situation we could enjoy the tropical landscape outside the windows: the squalor and picturesque folk living in it, and even a dash through the smoke and flames of a brush fire along part of the track.

We crossed the Isthmus of Tehuantepec that night, and the next afternoon saw the Atlantic Ocean, or rather the section of it called the Gulf of Mexico, reaching Veracruz four hours later because of the constant waiting at switches for all the freight trains to pass. Veracruz

was historically very interesting, teeming with life and romance. But just as on our previous trip there in 1933, we could only feel the heat and notice the crowds and the dirt. We slept in a rebuilt cloister with broad arches, a lot of blue and white tiles and carved beams, with mold running halfway down the walls and mosquitoes buzzing about us. It was good to pile the luggage into a neat new Chevrolet the next morning and wind our way beyond the imposing, if moldering colonial facades, out of the swarming crowds, away from the thousands of sun-bleached tram cars, and head for the hills, lost in the hot morning haze. The road was excellent and appeared doubly so in contrast to the ruts, bumps, and curves of Guatemalan mountain paths. There was much more water in this land; rivers crossed by high-arched colonial bridges and streams where cattle drank and women washed clothes. Even the hot country was greener! We lunched at the picturesque town of Jalapa on the edge of the first "steppe" of the highlands, with a wide view of the coastal country ahead and the paws of the hills edging downward.

From Jalapa the road rose abruptly in great spirals. On the slopes below we could still see the Baroque towers of Veracruz, but soon the sun lost its oppressive power, the trees grew taller and thicker, and the familiar rows of adobe houses appeared all powdered with dust and smeared over with the name of the new presidential candidate. In the distance, former convents appeared with imposing gates, abandoned or used as tenements or stables. We passed through a great pine forest that might have been anywhere, entered a strange, bowl-shaped, shallow valley which was clearly once the bed of a lake. Apparently almost uninhabited except for two little dust-colored villages clustered about ancient forts, the area was nevertheless intensively cultivated. Dozens of tiny figures behind ox plows were scattered over the bone-dry fields. The soil was evidently held down by rows of the stalwart blue-green maguey cactus and cultivated in between them. An intense, vicious wind was whirling dust about us in floating columns. The beautiful, snow-crowned volcanic peak of Orizaba followed us all the way. It had the singular beauty of Fujiyama and the same symmetry and aloofness. The Aztecs called it "the Mountain of the Star."

The fair Valley of Puebla was in many ways richer and more charming than the Valley of Mexico, and bore deeper marks of civilization. There was no wild wasteland, water flowed on both sides

of the road in many places, and tall groves of eucalyptus and cedar trees grew along the ditches. It was said that at one time Cortés considered removing the capital from the former Aztec city of Tenochtitlán (which became Mexico City) to the town of Puebla, where the whole atmosphere is certainly more peaceful. The rich and serene valley was seized upon by the church, and innumerable monasteries and nunneries thrived, with all they could desire in wheat, cattle, fruit, Indians as a labor force, and enough land to fatten up on. After we spent some days in Puebla, the reasons for the violent reaction against the church were obvious. Supposedly there was a church constructed in the region for every day of the year, but it seemed that there were more than 365! On a trip into the country, we saw one town with four establishments within view, each with its fenced fields, radiant tiled dome and carved portico. Many were abandoned, but the Indians were singularly loyal to others. Without a doubt, each chapel had its charm and individuality.

A majolica tile factory was started in the region shortly after the Conquest upon the discovery of a special kind of clay. The church facades and domes were encrusted with tiles to the loveliest effect, some of them with large, interspersed blue and white squares. The tiles stood out handsomely against the red brick used as a decorative element as well as in the construction. The whole was topped with foamy white stucco. Some churches had their whole facades finished in colored tiles, even curved to form the pillars. The interiors of these little churches got wildly rococo, with deep encrustations of stucco-like intertwining vines, dotted through with fruit, flowers, and little angel heads, and supported by the more massive figures of saints at the bases of columns and arches. One of these interiors had been recently repainted by the Indian congregation, with an excellent result, although incredibly barbaric. At this same church until recent years, the grave markers were also made of blue and white tiles, brilliant in the dusty ground that held the bones of people with ancient, tribal names.

Puebla was particularly dignified and aristocratic, with a style all its own reflecting its splendid colonial days. The city was always fiercely independent and conservative, refusing for a time to join in the Revolution. When Maximilian was raised to his ill-fated throne, Puebla held off the French for weeks. The anniversary of the Battle

of Puebla, the "Cinco de Mayo," or the Fifth of May, has become one of Mexico's most important national holidays. We lived in a marvelous old hotel, a palatial mansion where Maximilian was reputed to have stayed, still full of furniture and bric-a-brac from the epoch. Overstuffed sofas sat in every corner, accompanied by a dozen immense mirrors in heavy gold frames, stuffed birds, and majolica vases as tall as a man. The beds were all king-sized, and we had two of them in our room. The dressers were topped with Puebla alabaster called "Tecali," from the town of the same name.

The courtyard of the hotel was a mass of potted palms and ferns and hung with canary cages. It also had a parrot, which should be in a book! Delighted to be on her perch again in the morning, she would begin to call all the service people by name in various voices, first the harsh old landlady, next a child, then from singing elaborate coloratura went into a diabolically mocking laugh, finishing up by barking like a distant dog. The lady in charge of all this was a Victorian-shaped lady from Bozen (now Balsano), South Tyrol, who spoke many languages, all with an accent. She poured out her woes to us: how the noisy, paper-walled modern hotels were taking away all of the tourists, how her sister was lonely and wanted to return "home," where they sent 5,000 or 6,000 dollars each year to loving nephews. We advised them to stay and hold on to their property for a while, as home might not be as attractive when they once got there after so many years.

The Cathedral of Puebla was a splendid building. Its slender, soaring spires and lofty arches made it amazingly graceful for its size and extension. A golden grill of fine workmanship closed off each chapel, and there were three organs, all dating before 1900 and ornamented with natural-colored carved wood and enameled Baroque figures. Santa Mónica was another extremely interesting establishment, which functioned in secret for fifty years after the edict dissolving such institutions, not being discovered until 1934. It was built around three courts that were protected by the houses of the faithful, so that one entered what was apparently a private house, crawled through a small door at the back of a cupboard, and came out suddenly into a large room. There were also altars with false backs, from where the nuns could attend worship in the public church and the crypt where they were buried, and eerie, underground chapels for meditation.

We also got to see the fine collection of colonial furniture and other treasures of the late cigar magnate, Mr. Bello, soon to be incorporated into the regional museum. Elisabeth was allowed to play a few chords on an enchanting, carved house organ of the early eighteenth century at the Bello mansion, and Pál gained considerable respect by identifying some of the paintings. At the only surviving ceramic factory in Puebla, only tourist souvenirs were for sale such as ashtrays, small vases, plaques, and bowls. But after some urging the manager opened a large room off the courtyard where examples of the famous Puebla Talavera ware were preserved. Our enthusiasm was appreciated, and the manager promised us copies of a few examples if he could still find an old worker to make them.

We had an unusually clear day for the trip over the pass to Mexico City. Where seven years ago we caught only a glimpse of the famous volcanoes, that day we had both Popocatepetl and Ixtacihuatl before us all the way. The pass was no longer as wild and dangerous as on our earlier trip, though soldiers were still stationed there, and constant plumes rose up from forest fires. Once famous for its bandits, Rio Frio had become a lunch station and the road full of buses, trucks, and private cars.

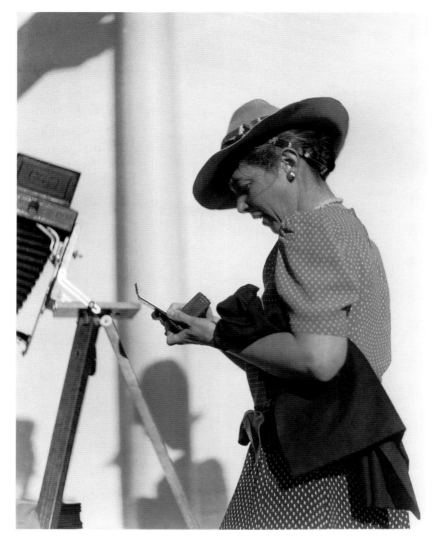

ELISABETH PHOTOGRAPHING A MASK
IN THE H.H. BEHRENS COLLECTION, MEXICO CITY, 1940.

MEXICO, 1940:

OAXACA, TOLUCA;

OLD FRIENDS, NEW PLACES

AFTER AN ABSENCE OF SEVEN YEARS, we again arrived in the Mexican capital. It seemed as if the local political atmosphere had quieted down for the moment, although the advent of World War II caused complications. Travel to the Old World was interrupted, and the Mexicans had time and the impulse to look back to their pre-Columbian and colonial worlds, which had been neglected for so long. For the outside investigator, it meant seeking out archaeologists and collectors, calling on officials, and visiting *aficionados* in their homes for information. By 1940, two organizations had branched out from the National University under an Institute for Anthropology and History (INAH), with the anthropological branch headed by Alfonso Caso. His highly respected older brother, Antonio Caso, a humanist who taught philosophy at the National University, had been an important influence on his development. The younger Caso's studies were originally in law, and for a few years he published in this field. But soon the ancient ruins of the high plateau, half-forgotten and barely investigated, and the call of the buried, early causeways and canals leading into the Aztec capital caught his imagination. While he had only a master's degree, he had talent and skill in handling people, proving that one can be a fine scholar in archaeology without a Ph.D. His fame will always be connected with the discovery of the Mixtec Tomb VII at Monte Alban, Oaxaca, which for many years was the greatest sensation in Mexican archaeology. When Tomb VII was discovered in 1932, Caso became the archaeologist who established the Mixtec origin of the famous treasures. His photograph with the jewels was widely reproduced, resulting in a worldwide appreciation of their extraordinary artistry and craftsmanship.

Caso's office was in a run-down, red brick building where some of the windows were missing glass, and dust from the street lay on the old black leather furniture. When Pál laid before him the table of contents of the planned survey for *Medieval American Art*, Caso reacted with great enthusiasm. But just as he was getting an idea of the project, he was interrupted by the telephone. He said he had told the telephone not to bother him. But seemingly it was an important personage who was calling because as we could understand from the dialogue that an employee, a political connection, was trying to place someone in the institute which Caso was just forming. From the ensuing defense that Caso was making, we could see that it was a hard knot. The discussion went on longer than was pleasant for him. Finally, he said that "As you may know, Sir, this is not a political organization. It is a scientific institution, and we can use only those who have the necessary preparation." When he put down the receiver, he realized that we had understood the whole conversation and covered it over as fast as possible. His opinion was that the book would be the first in any language where the arts and applied arts would be presented together. He was glad to see that the daily life of the pre-Columbian Indians would also be included, as folklore was beginning to attract his attention.

Caso said that he would telephone Diego Rivera and Miguel Covarrubias, both who had fine collections of pre-Columbian material, and this came after Pál told him that we already had about 80 percent of the photographs, and the illustrative material was almost ready to go to press. Caso knew not only North American

literature on the subject, but also European, and realized that Pál's was an aesthetic approach that had never been attempted previously. His enthusiasm was such that he promised to write a thorough review of the book when it appeared, and indeed, he wrote a praiseworthy and perceptive five-page essay on *Medieval American Art* for *American Antiquity* that was published both in English and Spanish.

Caso was a thoroughly civilized man who knew more than anthropology, and with his warmth and often-temperamental opinions, he quickly gained our trust. He told us, after we came to his office to thank him for the book review, to drop in whether we had something special to consult him on or not. There was a subject that Pál and he both wanted to warm up, the trans-Pacific influences on pre-Columbian art. Both the United States and Latin America were cursed by Central European scholars publishing fantastic theories. Caso always maintained that no boat, canoe, or even larger vessels could withstand a dangerous voyage over such tremendous distances. Indigenous American fruit and vegetables did appear in China, but only after contact with the Spanish galleons and the Philippines. Thorough Chinese investigations have established that these various products were never mentioned in any historical literature, text, or illustration. Pál and he repeatedly discussed the impossibility of trans-Pacific influences, and there were always other subjects that Caso brought up, because he realized our approach was not that of other American scholars. On account of Caso's inspiration, Pál wrote an article on the early appearance of American produce in Asia and in Europe, and also on the nomenclature, in some cases rather ridiculous, of pre-Columbian and Spanish colonial art that was appearing in Buenos Aires in Mario Buschiazzo's *Anales*.

The more we saw of pre-Columbian art, the more we realized that the Indians' taste and techniques resulted in a pungent and earthy artistic expression. H.H. Behrens, a prosperous businessman in Mexico City, was collecting pre-Columbian with an emphasis on work that showed the original native taste. Whether panel or sculpture, the pieces were characterized by a naive spirit and often executed using inventive and unusual techniques. When we asked him how he came by such unusual works, Behrens replied that he was well known by the Indians and smaller dealers for buying the "ugly things" that other buyers didn't want!

Caso's last position was head of the Mexican Folklore Institute; it was a long way from our first visit to his makeshift office. One Saturday morning, with our accustomed warmth and enthusiasm, we sat down together and rode our favorite hobbyhorse. Pál had his briefcase along, to show Caso a few clippings. But in response to a rising sound of voices outside in the corridor, he remarked that people were waiting for their paychecks. While that made us nervous, he himself showed no signs of urgency. But finally we told him that we had a luncheon engagement and made a hasty exit. We were already on the stairs of the building when Caso hastened after us with Pál's briefcase, saying, "Unless you want to leave it here and have us put it in the glass case!"

Latin American archaeology had become a subject for serious research and gained prestige among art historians. The 300 years of Spanish colonial art, architecture, and art history in the Spanish-speaking colonies, however, was still deprecated and almost ignored. The Central European refugees teaching in the United States moved in a circle from Michelangelo and Raphael to Rembrandt and Dürer, and constantly re-worked the Renaissance, ancient Greece, and Gothic art. The native churches in Mexico and the Andean highlands were more than they could fathom, and they never were able to grasp the humus on which those churches had risen. Even the Central European art historians whom we encountered in Latin America were so overcome by the shock of being out of their native habitat and speaking a different language, that they often approached New World art using pre-conceived notions and a pedantic and pompous vocabulary. Most of them never had the chance to see and study the actual works of art. As a result, when one student from Texas went to the Harvard art historians and proposed making his doctorate on Texas mission churches, the professor replied, "That is no subject for a thesis."

Fortunately, more perceptive investigations were taking place in Mexico. For our study of colonial art, the most important resource was the branch of the Institute of Anthropology and History devoted to aesthetic investigations at the National University, still referred to as "Esthéticas." Its main emphasis was the art and architecture of the Spanish colonial epoch, but nineteenth century and later modern art also found a place within the framework. Its director

was Manuel Toussaint y Ritter. He had been the secretary to José Vasconcelos, Rector of the University, who made it possible for him to travel to Spain as a young man, in 1921. Particularly impressed by Burgos and Seville, Toussaint returned to Mexico with the realization that his own country also had a number of monuments and objects from a great artistic past that needed to be better known. He was already familiar with many monuments standing forgotten and untended that spoke their own Mexican language, as while only a clerk at the Department of the Interior, Toussaint had traveled in the countryside with another enthusiast, Jorge Enciso. Their trips by train, by rickety rural buses, on horseback, and on foot, often short of food, sometimes required days before a treasure was discovered. Whenever possible, they bought black and white picture postcards or the work of some local photographer, to be added to their unique collection of visual materials. Toussaint gathered the newspaper articles about their exciting discoveries into the delightful book *Paseos Coloniales*, as fresh today as when the enthusiastic explorers roamed the provinces on horseback. It included the monumental sixteenth-century monasteries, an important style in themselves, as well as many of the highly original, charming folkloric buildings strewn far and wide over the landscape.

Toussaint and the institute became a magnet for many art historians, Mexican and foreign. The postcards and small photographs, which he so carefully collected, were pasted in large albums, providing a visual record for generations of scholars, including the Kelemens. We were able to peel out from those albums a structure of names and places from which, after consulting other historians and *aficionados*, we were able to assemble the illustrative material for *Baroque and Rococo in Latin America*, a project that took years to carry out. Manuel Toussaint's collection of photographs opened our eyes to a tantalizing world, and he inspired the first specialists who became teachers of Mexican colonial art, including the great Mexican scholars Justino Fernandez and Francisco de la Maza. Justino, with his knowledge of the United States and many lectures in English, created good publicity for the institute. Blessed by unusually lively visual talent and a capacity to discover unknown churches and describe them poetically, de la Maza gained acknowledgment for the institute and also broadened its horizons. Toussaint's

most ambitious book, *Mexican Colonial Art*, was the first great survey on the subject, and the relentless way Toussaint drove it to publication was characteristic of his manner of working. The book was translated into English by the prominent American art historian, Elizabeth Wilder Weismann, another who traveled with him in the Mexican countryside. Today the book has a status that no other volume on this subject enjoys. It is not only a translation; there are corrections, revisions, amendments, and additional illustrative materials that give the book a double value.

It was much more difficult for Toussaint than for Alfonso Caso to get a budget for his Instituto de Investigaciones, because archaeology had the priority, and provincial churches belonged in a different category. But when other countries to the south, and especially the Argentines, began publishing monographs of South American colonial monuments and bringing out their own *Anales*, Toussaint realized that the other countries also had people working along the same lines. In 1945, upon our return from South American, as we discussed various issues with Don Manuel, Pál suggested that he create a *mesa redondo* and invite the prominent art historians from the rest of Latin America to discuss their various monuments. He was quite enthusiastic about the idea, exclaiming, "And then they will see how great Mexico is!" He gave the younger generations a track to follow, and the publications that appeared every year were rich and varied, gradually illuminating the magnificent colonial treasures of Mexico. The man who inspired it all, the great pioneer Manuel Toussaint, on the way home after a stimulating but tiring European trip, unexpectedly, and much too early, fell victim to a mortal heart attack in New York City before he could reach home.

We also renewed our acquaintance with Robert Weitlaner, who was the best type of cultured Austrian and possessed a great deal of charm. He had worked for Ford Motors in Detroit, and was then sent down to Mexico City as one of the chief engineers of the Ford assembly plant. We had met him on our previous visit, and shortly after our arrival in 1940, happily accepted an invitation for dinner at his home in a suburb of the city. After the meal, he took us into the cellar, where, lit by a dim electric bulb, three shoeboxes full of clay spinning whorls lay on a high table. For Weitlander was another one

PÁL AND ELISABETH WITH ROBERT WEITLANER AT
PRE-COLUMBIAN RUINS AT MALINALCO, MEXICO.

church and convent. We made the trip the next Sunday. As we neared Toluca, we encountered a man going to market with a load of big woven baskets on his back. One was nearly a yard high, just right to hold our tall Puebla jar that a few days before was delivered to the hotel. Weitlaner bargained for the basket in Otomí and packed it into the trunk of his Ford.

At Tenancingo, we took the local taxi into a landscape that looked like the setting of a Verdi opera. The way lay along the bed of a rocky mountain stream, and over the steep shoulder of a barren hill. The road ended at a small village at the foot of the pass, and there was nowhere to proceed. We walked up through a deep gorge in the heavy heat. Turning a sharp corner, we came upon the ruins. The main stairway with its low balustrade and shallow steps leading to the temple was carved out of the hillside. The rock had weathered to a golden brown, and traces of color and plaster were still visible. The temple itself stood on a small plaza, facing a steep precipice. Its walls were cut to resemble a sub-structure with two terraces; we entered its semi-circular chamber by passing through the jaws of a giant serpent at the entrance. On the floor lay a huge eagle with spread wings and a raised head, and two more eagles lay on the broad, low bench that extended around the inner wall. Between them was a jaguar flattened out like a rug, its furry head and big paws carved in the round and its tail extending up the wall. Shattered statues guarded the entrance door. One suggested the legs of a jaguar, the other a human, perhaps a warrior. An indecipherable lump on the stairway possibly indicated a seated figure.

The fact that some of the huge boulders of the mountainside were left on the plaza and were also breaking through the balustrades of the stairs emphasized that Malinalco was one of the very few pre-Columbian sites where buildings were hewn from the living rock. The eagle was featured here (as well as the snake and the jaguar to a lesser degree), just as in Mexican heraldry today. An Aztec building of the usual rubble and plaster construction covered the temple, dating from pre-Aztec times. The slanting rays of the afternoon sun were scorching us. Down where the Ford was parked, a vendor of iced drinks was making a sherbet from the tiny local limes, stirring the juice with a wooden paddle in a shallow enamel bowl set into a washtub full of ice cubes. We bought all he had, undeterred by the less-than-hygienic preparation, and it was wonderfully thirst quenching.

who spent every spare minute collecting ethnographic material wherever he went, often in the territory of the Otomí Indians around Toluca. He had learned to speak their tongue; indeed, one Otomí had assured him that if he wished to start a revolution, they would follow his lead! These ancient implements for spinning thread varied according to age, shape, incised patterns, size, and weight. While we could simply admire those simple implements, Weitlaner understood them as individual pieces.

On our way back to the hotel, he mentioned that some 20 miles from Toluca, an old pre-Aztec cave temple had recently been cleared and could be visited. We could drive to Tenancingo in his new Ford, where he would arrange for a local taxi to take us over a poor road to the town of Malinalco, where there was also an early colonial

On our first visit to Mexico, Weitlaner had invited Pál to give a talk to the Austrian Club. It was held in a special room in a colorful beer restaurant, and over a dozen Austrians attended. He had passed around enlarged photographs of Mexico, Chichén Itzá, and Uxmal. Again an invitation was transmitted through Weitlaner for a talk to the Humboldt Club, which originally was a German group but (as Weitlaner ironically put it), "We have now all returned to the homeland." The Humboldt Club was located in a good section of the city, a spacious locale with nice furniture. The assembly room boasted a huge crystal chandelier and a concert grand piano; the lectern was at one end before a large screen. There were not more than twenty people in the hall when Pál started, but as the official introduction took place, more club members, who had been reading in another room, joined us. They all came up to the projector, raised a stiff right arm in the Nazi salute, and called out, "Heil Hitler!" When this scene was repeated by two or three latecomers, Pál changed his hitherto all-German text into English, stating, "I know the archaeological expressions better in English, as I learned them at Harvard University." But the audience listened attentively, and was attracted by the pictures enough not to notice their Hungarian lecturer's annoyance.

A few weeks before finishing up our work at the museum, we spent a week in Oaxaca, visiting the famous sites of Monte Albán and Mitla, and the wonderful local marketplaces. Mexico was fast losing its folk arts, and in this aspect of its native cultures, was drab when compared to Guatemala. The Mexicans seemed more dirty and restless than the Guatemalans did, as well, but also jolly and full of pep. Our last days in Mexico were occupied getting together the photographs and our other acquisitions, and then we took the fastest train we could get, which was from Mexico to New Orleans. At the station, many European visitors were leaving hurriedly.

Our stay in the sweet town of New Orleans was delightful. We arrived with two large baskets full of fine Puebla pottery and large garden vases for our laurel, apple blossoms, and other long-stemmed flowers. It seemed a lot of trouble at the time, but later we were glad we managed to bring them. Only a few days were needed to discuss our experiences with our friends at Tulane, and arrange for the baggage that had come by ship to be forwarded to our home in Norfolk. One evening, we dined with Professor Hermann Beyer,

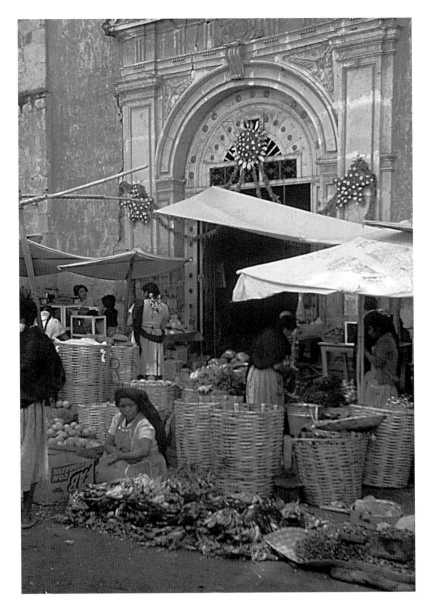

MARKET IN OAXACA.

whose advice and contacts had served us so well. En route to the restaurant, going through rather heavy traffic in a taxi, he asked the driver to pull over at a newsstand. Elisabeth said, "Not in this crowd. Let's wait until we come back." But at the next corner Beyer insisted again, murmuring, "I want to see what my Führer did today." That took place on Thursday, May 9th. We left for New York two days later, on the weekend that Hitler's Brownshirts marched into Holland. On the train to New York, an elegant young woman was anxiously pacing the corridor outside our compartment, as if the train could not carry her forward fast enough. She told us that she was Dutch, and had been visiting friends in New Orleans. Her whole family was in Holland, and she wanted to get back at once. Luckily, friends were to meet her in New York and, hopefully would keep her there. How fortunate we were to be out of Europe!

Once in New York, Elisabeth went right up to the house in Norfolk, unpacked our new articles, directed the girls to take down the storm windows, and then returned to the city. Pál had stayed in New York to finish up some things connected with his work. Together, we saw the Persian exhibit, which was magnificent, as well as the Mexican show that was being sent off when we were working in the museum in Mexico. The latter exhibit would be better called a "fair." It contained a lot of light and fanciful, decorative but not deep work distributed over too large a space, and the display of some rather vapid paintings on an immense wall made them look weaker and emptier still. The excellent pre-Columbian material was unfortunately crowded onto the ground floor, where it could only be seen by artificial light.

The increasingly terrible events of the war, and the hysterical and sensational reporting in the newspapers, drove us to the country as quickly as we could get there. We were both in good shape, looking forward to being home, and tackling the writing job. There was a great deal to be done, but the winter was so severe that thawing had scarcely begun, and we were sorry that the storm windows were down. Many trees were barely budding, and it rained uninterruptedly for a week. Then came three beautiful, sunny days, ending in real summer heat, and our first violent thunderstorm! It was so sweet and lovely that we instantly felt the soothing effects of being in our own home. Lilacs and apples began to bloom, and the charming little bluets popped up through the grass. Pál soon got his work organized and was dictating to a stenographer every afternoon. We began the task of checking and sorting photographs; it was nice to have such work to do when the rest of the world looked so gloomy.

THE YEARS OF WORLD WAR II:
NEW YORK, NORFOLK, AND EUROPE

OUR LIGHT-HEARTED DAYS—filled with music, flowers, ski trips, beautiful cities, museums, friends, and research—as we moved between Europe and America, ended during the winter of 1938 (which we spent in Budapest) when Hitler marched on Vienna. After a nightmarish drive through Nazi Germany, we finally reached New York by ship on a mild spring day. We collected our possessions stored in Italy, Hungary, and New York, and built our house in Norfolk, in the foothills of the Berkshires of northwest Connecticut, calling it "The Ark." Over the next few years, we finished the preparation of *Medieval American Art*, published by Macmillan in 1943. It was good to have a positive job to do in safety and comfort, finalizing the text, planning the layout, selecting the illustrations, and proofreading. Our work was enlivened by trips to New York for research, to attend musical events, and the theatre. We had many visitors at home, and Elisabeth continued her music with friends who lived in the area.

When the United States entered the war, it became evident that the American bomber pilots would need maps marked with the locations of historically and artistically valuable towns and cities, museums, monasteries, and libraries, to avoid destroying them if possible. Early missions over the European continent were carried out by English pilots with maps different from those the U.S. Government had at their disposal. The American Council of Learned Societies issued an appeal to its members, including antiquarians, archeologists, art historians, anthropologists, architectural

KELEMEN HOUSE, "THE ARK"
IN NORFOLK, CONNECTICUT, 1945.

historians, and others, who could provide the expertise. Italians, French, Dutch, Belgians, Austrians, Hungarians, and Americans were assembled as the Committee for the Preservation of Artistic Monuments. Pál was invited, and he was honored to be on the committee. There were also a number of other scholars who offered their services for one or two days, filling in information about lesser-known sites where there might be a building worth saving.

The Frick Reference Library became the headquarters of the mapmakers. It was housed in a building at Fifth Avenue and Seventy-first Street, north of the Frick Collection. (Donated by Henry Clay Frick, a wealthy businessman, the private collection was one of the finest in New York and displayed in his elegant residence on New York's most elegant street.) The reference library, a very valuable research center on principally American and European

works of art, was closed for the duration of the project. The map committee had to enter by the service entrance in the basement, go through a corridor, and up the elevator to the big reading room, a very pleasant place in those days. The handsome carved tables, larger than any refrectory table one could find in Europe, bore little, flag-like labels, where the experts were grouped according to country, and the books and photographs were laid out.

All kinds of guidebooks and information were collected, but sometimes it was necessary to turn to other sources, even church communities, to find tourists who had returned home with maps, booklets, and other up-to-date information that could be used to pinpoint exact locations. Washington had issued instructions not to clutter the maps too much, since the bombers needed space to bomb the sites, and frequent discussions took place about whether such-and-such a site was of prime importance or not. Sometimes a committee member, wanting to acknowledge his gratitude to whoever put him on the committee, or out of patriotism, or partiality to a specific location, argued vehemently with supporters of competing sites. Some of these matters could not be decided and were sent to the supervisors, university professors, for resolution.

In 1943, another front in the war was under preparation. More and more airplanes were made ready, and Washington sent word about certain maps that were needed without delay. When the Churchill Plan to attack the soft belly of the European continent was contemplated (which would have been a very good idea), the allies urged the cooperation of Greece, and neighboring countries, to save the huge number of priceless monuments in the region. When that plan was dropped in favor of the invasion of the French coast, the matter became increasingly urgent, as the American troops under General Eisenhower were already gathering in England.

The people who were unpleasant, or asked for too much to be protected on the maps, were gradually eliminated, and a working group was created that delivered the material in an organized fashion. Near the date of the landing in Europe, there was only one member of the group who did not seem to detect any urgency. She was a French lady who did not speak English, the wife of a refugee art critic, and evidently she did not realize these were preparations for an invasion. She worked at the tempo of a civil employee and was the only person who got a salary, because of her financial need. She was seriously holding up the work, so a gentleman who spoke French explained to the lady that an invasion was in preparation and the work had to be done without delay. Then she was heard telephoning friends that the invasion was soon to take place, and she had to be chastised even more forcefully! By the end of 1943, the committee was able to deliver all the needed maps to the military in Washington, although sometimes the locations were not exact. Nevertheless, it was a great satisfaction to have contributed toward the preservation of the cultural legacy of Europe at that terrible time in history.

ELISABETH ENJOYING THE LOCAL CHILDREN AT LA LEIVA, COLOMBIA, 1945.

SOUTH AMERICA, 1945:

BOGOTÁ AND TUNJA

AFTER PÁL HAD COMPLETED HIS WORK at the Frick for the Committee for the Preservation of Artistic Monuments, we gave up our rented apartment in New York and went to Washington. At that time, Pál was a Senior Trustee of the Textile Museum of the Smithsonian and tried to attend every annual meeting, usually held before Christmas. But most of our time was spent at the Hispanic Foundation of the Library of Congress, whose director Pál knew from Harvard, the distinguished scholar Lewis Ulysses Hanke. He had done a lot to promote *Medieval American Art* and helped to make it a success. Macmillan was considering another edition, but Pál did not feel entirely pleased with certain chapters. Some of the remoter countries had recently sent us a lot of new material, and Wendell C. Bennett at the American Museum of Natural History in New York had gone over the manuscript and given his approval. But it made a great difference in the aesthetic and cultural evaluation of a subject, whether it was derived from a photograph taken of an object on a shelf in some institution, as if in a lost-and-found department store, or whether we had seen the actual piece.

The American Association of Librarians and the Hispanic Foundation at the Library of Congress had sent a number of copies of *Medieval American Art* to libraries both in and out of the country, and the State Department had supplied its embassies in Latin American with copies. Hanke mentioned to the Director of the Pan-American Union, Dr. Rowe, that Pál would like to visit certain South American countries to determine if we had adequately

covered the ground. Dr. Rowe knew Pal's work; several articles, both on pre-Columbian and Spanish colonial art, had been handsomely published by the Pan American Union's Bulletin. Dr. Hanke and Dr. Rowe felt assured that such a trip would be successful, both diplomatically and personally. It could be a good follow-up of the favorable impressions left by visits of two distinguished scholars in the art field, Henry Francis Taylor, Director of the Metropolitan Museum in New York, and Daniel Cotton Rich, Director of the Art Institute of Chicago. With Hanke's and Rowe's support, it was easy to go over to the State Department with our project. When we mentioned the countries, where we would like to go, namely Colombia, Ecuador, Peru, and Bolivia, we were told that the four U.S. embassies would be alerted. Dr. Rowe gave us a letter describing our activities and the purpose of our visit. Pál corresponded with George Valiant, a good friend who was the American Cultural Attaché in Lima, and also several other U.S. representatives in South America, whom Pál knew from Europe. An excellent book had just come out, called the *Chanson Guide*, edited by Dr. Robert C. Smith, another Harvard friend. It had up-to-date information and included Smith's essays on the art and archaeology of each country. So the trip was on!

Elisabeth took care of photographic matters. Film purchases were restricted, and she had to apply directly to the government to get any at all. She was told to strip the request down to the least possible amount of film necessary, and then submit it for censoring. The young man who attended her asked a number of questions, took a few notes, read the request and said, smiling, "I'll put this through as fast as I can, and you can expect about half." Elisabeth almost went through the ceiling. She protested that we were told to cut the

request down to what was absolutely needed. If we got only half, there was no use going at all, as the photographs were needed as illustrations for the book, and without them the whole trip was for nothing. Her outburst had the desired effect, and we got all the film we needed, as well as a booklet issued by the Navy for their photographers, which gave the light speed at various latitudes and instructions on the "black spot technique." The latter showed how, by manipulating the lens diaphragm and calculating from the film speeds, one could calculate the clarity of time exposures correctly. The method proved to be very effective for interior shots, and saved a lot of film ordinarily wasted by repeated exposures. Elisabeth was still using the big, folding Zeiss camera she had traded for with the Park Service forester on Mesa Verde in 1936. She employed 4 x 5 Verichrome and Panchromatic film available in pack film and rolls. A little folding pocket Kodak was also taken along for candids and incidental photographs, and about 1,000 feet of 16 mm film for the Bausch & Lomb camera. All this was packed into a handbag, taken down to Battery Park, and put through customs, where it was sealed up with big yellow tapes marked "Passed by Customs" and became part of our baggage. Later on, such restrictions were lifted, and our secretary was able to send film through the mail to Lima.

It seemed impossible to buy train tickets to Miami, until the head porter at our hotel was able to get some for a drawing room, and we left New York on January 12, 1945. Miami was a quiet spot during the war, with the hotels being used mainly as convalescence hospitals. German submarines were known to be in the Gulf and around the off-islands, so the only safe way to travel to Latin America was by plane. We went down at once to the Customs Office, near a short pier, with a hydroplane floating alongside. Our luggage was inspected and every piece pasted over with official labels, until it looked like diplomatic luggage or a circus trunk! Early the next morning we returned to the hydroplane, where the stewardess and the luggage were already aboard. The forward section, just behind the pilot, was packed with strapped-in containers, and seats for twelve passengers faced one another as in a Pullman car. There were only two other passengers, a Cuban and an Englishman, the latter in a very nervous state, pale and shivering. As the hydroplane rose, it threw out huge wings of water like a fast motorboat. The windows got wet, and we could feel the tremendous effort that was required to pull free from the water. Everything in the plane was shaking! The metal ashtrays rattled, and every seam seemed to creak. It was Elisabeth's first flight ever, and Pál's first in a hydroplane.

The ride to Colombia was sensational, zooming to 9,000 feet above clouds and water three successive times, and swooping down again into tropical heat at Cienfuego, Cuba, Jamaica, and finally Baranquilla, leaving us both pretty altitude-groggy. On the descents, we felt as though we were diving into the sea. We ran into rough weather several times and just bucked along over Jamaica, but the tufted hills and the streams bordered with palms were so charming to watch that we forgot our discomfort. It was marvelous to behold how beautifully the enormous, four-motored machine was handled. When we landed, very gently but amid dashing spray in Jamaica, we were received at the dock by a tall sergeant in a handsome border guard uniform who served us Planters Punch, a most welcome treat.

After a few more rough hours heading for Baranquilla, the plane made its usual dive and taxied up to a small pier in a quiet lagoon. Landing in Latin America always seemed like dropping out of the sky into another world. A waste of swirling brown water with floating leaves, rotting fruit, and mud flats identified the mouth of the Magdalena River, along with a few sun-bleached sheds, trees all one-sided from leaning with the trade winds, and a dozen *zopilotes* (turkey buzzards) flopping and pecking greedily about the water's edge. The walk to the plaza was only a short distance, and it was a relief to be on land. Although the guidebook said that Baranquilla was "discovered" only in the early eighteenth century, it had grown quickly into a thriving commercial harbor, especially since the war, and was one of the most convenient gates to South America. We spent the night at the fashionable resort hotel, El Prado, overcrowded with vacationing businessmen and diplomats escaping from the high altitude of Bogotá, the capital. We were given the room reserved for the British Consul, who hadn't turned up. It was rather stark but had tropical luxuries: cold, running water, a thin pallet on the bed, and gorgeous gardens outside the window. A slim trail of tiny white ants going down one wall and across the other caused Elisabeth to hastily hide what remained of our New York chocolates in the bureau.

We were awakened at 4:00 A.M. for breakfast, and then came a 25-mile bus drive to the Avianca airfield. The place was crowded with people seeing off the passengers. One homely old gentleman carrying a little box with some baby chicks dyed red and blue in it, was surrounded by half a dozen pretty young women and at least a dozen children. The whole bunch was taking a private plane. When his hat blew off he never even turned his head but left it for someone else to rescue, like some sort of prince. It flew at Elisabeth, so she caught it and was cheered by the crowd! Our plane took off in the starlit night with dawn just edging the horizon, and flew over the low plains around the Magdalena River, its lakes, marshes, horseshoe curves, and jungle growth. Next, we seemed to be spiraling straight up next to a green mountain wall. Soon the rising sun illuminated so many clouds that the land was no longer visible; the fascinating cloud formations seemed to be chasing after us. It was a rough half-hour, as the plane flew above the mountain range and came into the high valley of Bogotá, some 8,700 feet above sea level. Once in our comfortable rooms at the Hotel Granada in the capital, we mused that in three nights we had journeyed all the way from Connecticut, and suddenly we felt exhausted. Surely, food would help! In the dining room we were introduced to the famous Colombian soup, hearty and rich, thick with beef and a variety of vegetables, including tiny green corn on the cob.

Even after resting for a week at the hotel, Elisabeth was suffering from indigestion and a cold. We had not answered a welcoming message from the American Embassy immediately, being much too tired to start any kind of a program. Finally, one morning we took a walk in the chilly air. The quiet grew on us as we approached the open main plaza, surprisingly framed on two sides merely by low and unpretentious buildings. The plain, insignificant facades added to the coolness that pressed on us under cloudy skies. Accustomed as we were to busy, rather boisterous main plazas and sunshine, it could have been scenery made for an austere early Shakespeare tragedy.

Later in the afternoon, we strolled a bit about the city. It seemed to be a pleasant mixture of modern culture and old traditions, with good bookstores in abundance. A number of buildings in the heart of town were being torn down, probably to be replaced with more modern commercial structures. The ancient manner of building for that earthquake-endangered region was visible in the cross sections. Although the roofs were often made of heavy tile, the ceilings consisted of a mixture of straw and cloth. The outside walls were thick and sturdy, while the inside floors and partitions were surprisingly light and flimsy.

We happened upon the modest facade of a church on a busy corner, and entered to behold the nearly untouched splendor of the early seventeenth century. Beyond the triumphal arch, the whole sanctuary was sheathed in polychrome and gilded woodcarving, amazingly well preserved under the patina of age. It had a brilliant glow and color that we had not seen either in Mexico or Central America. Biblical scenes were carved in high relief, and a series of statues, including a number of female saints, was laid out in an almost Renaissance clarity of sequence. It was a startling example of the blending of European and New World talent that made Hispanic colonial art unique. As we later learned, the vast work was contracted in 1623, after the design of Ignacio García de Ascuch, a native of Astúrias, Spain, and carried out partly under his supervision by *mestizo* assistants and slaves. The use of two pulpits on either side of the sanctuary was rare. The heavily domed *portavoz* was surmounted by two lifesize, polychromed, gilded figures of saints. The decoration was rich with the *mudéjar* influence prevalent in Colombia. The ceiling over the nave still retained the skeleton of a fine tray ceiling, with a gilded, honeycomb pendant hanging from the center, and beams with fine *mudéjar* tracery.

At the U.S. Embassy the next morning, we met the Cultural Attaché, Dr. Albert Gerberich, who welcomed Pál with a few words in Hungarian. Although he was born in Philadelphia, he had learned them from his wife, who was a second-generation Hungarian. Gerberich was a tall, polite, and good-looking professional, who remained a valuable friend until his retirement years, first in Bogotá and later at the Colombia desk at the State Department in Washington. He asked us pertinent questions, made suggestions, and warned that Pál might be asked to give an interview on a dispute just then going on in Bogotá. Supposedly, it would be good publicity and give Pál a "cultural profile." The matter had to do with the colonial church of San Francisco on Calle Septima, one of the oldest churches in Bogotá. Opposite the church was a much later building, where the

businessmen said, "Move the church, of course, as it can be turned into a museum somewhere else." A more conservative faction, proud of the city's heritage, was protesting that it would be far simpler to move the Jockey Club somewhere else!

While we were still at the embassy, a newspaperman arrived with a photographer. They took our pictures, heard our story, and asked Pál about his opinion on the issue of the Calle Septima. Pál replied that as much as he liked riding, having been a cavalry officer in the Austro-Hungarian Army, nevertheless, he could in no way recommend moving the Church of San Francisco. He related how, while in California, we had the pleasure of first seeing the Mission Church of Santa Barbara replete with the patina of age, and later after it had been shaken by an earthquake and repaired. Apparently, the job had been given to a contractor, who told his workmen to put the stones together using plenty of cement, placing solidity above all. The reconstructed mission stood in the same place as the original and had exactly the same dimensions, but it was a very different building! Anyone who knew it from an earlier time, could tell that it had been reconstructed. A whole building could not be moved without losing its character, as well as the inimitable stamp of human hands and natural aging. "Furthermore," Pál continued, "to tear an essential element, such as the altars of the sanctuary out of that warm, living, harmonious building, would be to ruin a priceless work of art."

The next morning, we were called on by two brothers, Guillermo and Gregorio Hernández de Alba, members of an old Bogotá family. Gregorio was an archaeologist, the man who had excavated the pre-Columbian site of San Agustín, and his brother was a history professor at the Jesuit College. They had come to ask Pál to evaluate a portrait of an early Jesuit Father connected with the college. Pál did so on one of our last days in the city, after learning more about its art, and wrote an article that the college later published.

One of our first visits was to the highly recommended collection of pre-Columbian gold in the National Bank. For a number of years, the enlightened officials there had persuaded farmers and laborers, mainly on the coffee plantations, to bring in the gold objects they found in ancient tombs, as they dug around the coffee. The bank paid them the current price for the metal, which had previously been melted down by jewelers and dentists. On the second floor of the

CHURCH OF SAN FRANCISCO IN BOGOTÁ, COLOMBIA.

Jockey Club had its luxurious quarters. As the city was going through pronounced modernization and the destruction of many colonial buildings, it was clear that some of the narrow streets would have to be widened. The dispute was about which building should be demolished. Members of the Jockey Club and "progressive"

bank was a big meeting hall for the trustees. It was lined with glass cases, where hundreds of gold objects in the form of headdresses, breastplates, nose-rings, earrings, mantel pins and other such ornaments from the various ancient tribes, the Quimbaya, Chiriquí, Chibcha, and Sinú, were tastefully displayed with excellent, modern illumination. Some types we had never seen before, and of the more familiar, those were the best specimens that we knew of. As Pál said in his first newspaper interview shortly afterwards, that one museum was worth the whole trip! We began working there the next day and spent most of the week at it. What a challenge it was photographing those small, fine objects, as we balanced a small table on top of a chair and rigged up a towel and sheet for background and bounced light! A group of bank officials and employees gathered about us, eager to help, and carried the gold pieces back and forth from the cases. We took twenty-five to thirty sensational objects, some of them never photographed before, and the pictures came out very well, in spite of trouble during developing. It was the end of the dry season, and water was in short supply. We had to hunt for a photographer conscientious enough to guarantee a satisfactory washing of the films, as in most private houses the water was turned on only in the mornings. Fortunately, at the hotel we lived in luxury, with ample hot water both at night and morning.

Dr. Gerberich arranged a trip for us to Tunja, founded (as was Bogotá) in 1539 by one of the Spanish Conquerors. Tunja figured importantly in the wars of liberation of the early nineteenth century, and was a treasure trove of colonial art. Gregorio Hernández de Alba accompanied us there and proved to be very knowledgeable about the history of the place, as well as a delightful companion. We started our trip on the train toward the northwest, and by mid-afternoon we reached the city of Chiquinquirá, considerably smaller than the present capital, but important because of the mines in the vicinity, and as a pilgrimage center. Nevertheless, it was clear that the hotel was not organized for tourists of grand style. The four of us, including our driver, were shown into a large room with a bed in each corner, consisting of planks hammered together and with a coverless pillow at one end. It seemed that Latin American travelers were not accustomed to lie down and sleep between sheets in a room with a bathroom, but just to lounge about through the night smoking,

drinking, talking, and maybe dozing. Fortunately, our host could provide other rooms, as the place was practically empty.

In the dining room, we were given a table by the window. Across the plaza stood a large, rather classic church with a long, broad stairway against one massive wall. We were well into the middle course, when, in the slight rain falling through the twilight, a small group of Indians appeared carrying a litter and setting it down at the foot of the stairs. A man and woman left the group and went up the stairs. A few minutes later, a fellow came out carrying a processional cross, and behind him the priest in his long cassock, with a glimpse of white lace peeping out from under an overcoat thrown over his shoulders. The priest spent only a few minutes ministering to the motionless figure on the litter before going back up the steps, and the tragic party moved off with its sad burden. Mist enveloped the plaza, and rain pelted the cobblestones. Somewhere at the other end of the plaza, a single light went on. Don Gregorio said that was the cheapest way for the Indians to receive extreme unction. If the litter were taken to the main entrance, it could cost more, and still more if carried inside to an altar.

The war was raging on all fronts, and the region was thrown entirely on its own resources. Don Gregorio managed to acquire a car for the trip to Tunja the next morning, but the driver was not very reassuring, as he complained about his bad tires. The car was indeed a rattletrap, with its tires ingeniously patched up, and we were twice slowed down by blowouts on the high, barren, windblown road. It was mid-day when we reached the large village of La Leiva, where the market was just breaking up. Men in heavy ponchos of natural gray wool and round felt hats were packing sacks of their purchases on burros. One had a goat with its feet tied together, and several others hoisted up squawking chickens.

Although La Leiva had a distinguished history due to its participation in the early nineteenth century Wars of Independence and looked very quiet, in fact practically asleep, it was a much-frequented gathering place for merchants and business folk. The houses were small, but well kept, and the streets were busier than in other towns we had driven through. On one side, a low colonnade offered shade and protection in front of a row of shops and offices. At right angles was the parish church, simple, practically without

"FIRST PUNCTURE" ON THE PASS TO LA LEIVA WITH
DON GREGORIO HERNÁNDEZ DE ALBA, ELISABETH, PÁL.

ornamentation, and with a massive tower on the left side. It was cross-shaped, but the transepts were shallow, like two deep chapels. The low dome over the crossing was flanked by half-domes in the Byzantine manner, constructed of wattle and daub. The chronology of these churches was uncertain. In Spanish colonial America, the early churches, erected with a great deal of effort and sacrifice, required multiple alterations through the ages. Usually, work was avoided on a cupola or apse, unless they were severely damaged. That might explain why the body of the church at Monguel, in a neighboring valley, resembled the one at La Leiva, boasting an elaborate facade with two towers from the eighteenth century. While taking photographs, we heard some explosions. Our tires had burst again, because of the change of altitude! Don Gregorio was having a loud argument with our driver, who was refusing to go on to Tunja. To an impatient remark from Pál, Don Gregorio remarked that travelers should be ready to take unexpected incidents in stride, as he marched off to telephone for help in Tunja. It was not the price, but the unavailability of vehicles that was the problem, but a promise that a car would soon come reassured us. Luckily, one of the doors off the colonnade opened to a friendly little inn, where we lunched in the patio, in the center of a bright, blooming garden with

an icy mountain stream rollicking along one side. It was late afternoon when the car finally came from Tunja, and we arrived there in darkness.

Although we did not realize it at the time, Tunja would become an important key to the rest of our investigations, because it had probably the most extensive documented continuity that we were to encounter in South America. Since time immemorial it had been an important city. In pre-Columbian times, it was the capital of one of the three great chiefs of the Chibcha people, rich in gold and silver, and surrounded by abundant agricultural valleys. The Spanish city was founded by the *Conquistador* Gonzalo Suárez Rendón in 1539, and soon became prominent on account of mining and its intellectual life. Slumbering since the fierce fighting of the War of Independence from Spain, it benefited from a languorous pace and hence had preserved its original historic atmosphere, buildings, and furnishings to a refreshing degree. During World War II, no manpower was sapped there, but nevertheless, a standstill occurred in the life of the city, imports were disrupted, and there was little new construction or reconstruction of the historic buildings. Many small cities in Latin American countries boasted more elaborate exteriors, but the lavish use of red and gold in Tunja's church interiors preserved an opulence of gilded, polychrome woodwork that was blended in highly original ways, and remained almost undisturbed by modernization. There were abundant examples of the beginnings of the translation of Spanish architecture, life, and art into the exigencies of the New World, with its special landscapes, light, climates, and the extraordinary artistic ingenuity of its native peoples.

Some 9,250 feet above sea level, Tunja overlooked a bleak, treeless, and mountainous landscape, swept year-round by cold, harsh winds. Emerging from the hotel early the next morning, we viewed what seemed to be an old, dead city. On one side of the unusually large plaza were the cathedral, the church of Santo Domingo, with its austere, Renaissance-like facade, and an adjacent row of dwellings that once housed the bishop, the *Conquistador*, and other high officials of early colonial days. Other important dwellings from the sixteenth and seventeenth centuries, with wooden balconies and stone portals, flanked the plaza's other sides. The buildings were raised on a broad platform, eight or ten steps above the main floor of the

GATHERING FOR THE MARKET AT THE PARISH CHURCH IN LA LEIVA, COLOMBIA.

EDUARDO, FAITHFUL HELPER FOR TWO DAYS IN TUNJA, COLOMBIA.

great plaza. We found the *mudéjar* influence notable, both outside in the pointed arches of some of the colonnades, and also in the interiors, as well as in the varied, fanciful decorations. This was evidence that a number of Muslim converts remained in Spain after the Expulsion, and a number of them were among the early settlers in the Americas, where there was a great need for artists and craftsmen. Shortly after the Conquest, the Spanish soldiery was reported to include many converted Muslims, and some of them may have been craftsmen. Every master carpenter in Spain, whether he was a born Christian or a Muslim convert, had to be as familiar with the *mudéjar* joinery as he was with the coffered wooden ceilings of the Renaissance. Tunja, on account of its isolation, had well-preserved examples of the very early styles. The imported architectural influences achieved distinction through the employment of local labor and raw materials.

As we moved along the plaza, listening to the history of the place related by one of the town historians, peering into the flowery patios of the ancient houses and photographing the pointed, Byzantine-like arches of the colonnades, a giggling crowd of ragged urchins began to gather. We selected one of the boys to carry the cumbersome photographic equipment. His name was Eduardo, and although he looked about eight years old, he said that he was twelve. Our destination was a house that stood at right angles to the long row next to the cathedral, built by Juan de Vargas, Royal Scribe in the city from 1592, for almost thirty years. As the great door to the house opened with a clatter of

bolts, we were anxious not to be burdened with our Pied Piper urchin entourage and entered hastily, Eduardo skipping along close by. We gazed in wonder at the whitewashed surfaces of the walls in the main rooms, covered with superb classical compositions featuring Jupiter, Minerva, and other mythological figures amid spirals and floral arches. There were also pictures of rare, exotic animals, including a rhinoceros and an elephant, as well as allegories and the coat-of-arms of the original residents. The designs were well-spaced and revealed an amazing knowledge of the classic and zoological worlds. This was the region where the Chibchas mined salt and coal from small, scattered pits, and marketed it in Bogotá. Tragically, because the house had been used for the storage of coal for a long time, the walls were stained and the paintings dulled from an overlay of black dust. The subject matter on the walls of the Vargas house was clearly derived (as was common in the New World, particularly in the sixteenth century) from books with Flemish engravings. It took a superb artistic eye to adapt such models with such graceful balance to the walls of a large room.

The placid austerity of Tunja's house exteriors was mitigated by the potted greenery and cascading flowers in the patios and galleries inside, where the descendants of some the earliest settlers still lived. But the city was most remarkable because of the interiors of the churches. The Franciscans and Dominican Friars reached the New World with the *Conquistadors* and set about their task of converting the natives with great zeal. Monasteries and churches were already well established by the middle of the sixteenth century, and embellished well into the mid-seventeenth. Although the first Franciscan establishment collapsed, and a new one was not finished until nearly the next century, its interior was the most serene of all those we saw. The walls were only whitewashed, giving prominence to the five-sectioned, carved main altarpiece with a series of sculpted saints and an impressive pulpit. A huge gilded ring studded with golden rays, with a crucifix in the center topped the portavoz over the pulpit. On the wall behind, a sculpture of a golden sun with a face of Indian cast was placed so that seen from the floor of the church its beneficent smile shone down over the worshippers.

The Dominican monastery's church of Santo Domingo had a more glorious fate. Only two decades after its founding, it received a

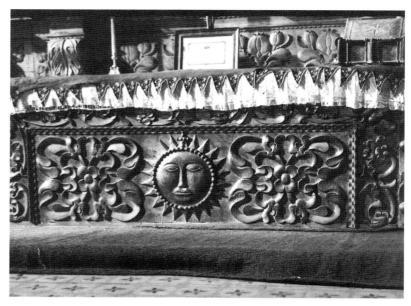

RIGHT NAVE OF THE CHIBCHA SUN ALTAR AT THE CATHEDRAL SANTO DOMINGO IN TUNJA, COLOMBIA.

bequest from the Captain General, the *Conquistador* García Arias Maldonado, for a chapel dedicated to the Virgin of the Rosary, patroness of the Dominicans. The chapel received many other such gifts and embellishments during the ensuing centuries. The main *retable*, perhaps a replacement, was finished towards the end of the seventeenth century. During the seventeenth and eighteenth centuries, so many alterations occurred in various Tunja churches that the Santo Domingo altarpiece was in our time particularly valuable, due to its antiquity. While elsewhere bas-reliefs had often replaced painted canvasses, in Santo Domingo the entire display was preserved as originally installed. Handsomely designed, high wood reliefs, polychromed and gilded, portrayed scenes from the life of the Virgin. The introduction of slender caryatids separating the panels was a particularly attractive invention. In the center was the *camarín* or Virgin's chamber, which guarded a statue of the Virgin of the Rosary. As frequently took place in South America, the *camarín* was recessed like a bay window, to be dramatically illuminated by natural light.

Among the decorative elements adding to the rich impression were ceramic bowls inserted in the gilded surfaces, which produced

a contrast of color and material. We had seen the same type of ceramic bowl in the Dominican church in Bogotá, inserted into a large golden palm leaf in a composition that appeared all of one piece. The Viceroy Marqués de Solís y Folch de Cardona made an extravagant bequest to the Dominican monastery of Bogotá, including his collection of porcelains, and the bowls may have been part of it. In both churches, the bowls were reportedly pieces of Spanish Royal Talavera ware. Doubting this, we photographed the pieces both front and back, and after considerable research with no satisfactory results, consulted the respected ceramic specialist, Bernhard Rackham. He determined that the bowls in the Colombian churches were tin-glazed Delft, only an average export ware. The answer to the riddle was possibly at hand! The Spanish Viceregal administration and the Council of the Indies in Seville recognized the value of permitting other colonial powers, such as England and the Netherlands, to sell needed goods from time to time to the Spanish colonies. The foreign ships might be replenished by additional vessels in hiding, possibly with the cooperation of corrupt harbormasters, thus multiplying the foreign merchants' profits! Nuevo Granada, as Colombia was then called, had an important harbor on the Atlantic, Cartagena, and by the time the Delft export ware that originally served as ballast reached Tunja and Bogotá on the high plateau, it had considerably increased in value.

The Church of Santa Clara was constructed with a pointed triumphal arch, sheathed in gilded wood, producing an effect that was *mudéjar*, rather than Gothic. Large paintings in heavy frames completely covered the walls, and the ceiling of the nave was studded with gilded medallions and painted stars. In the center of the ceiling of Santa Clara, probably on wood, was a large painting of the smiling sun, surrounded by winged seraphim. The piers of the triumphal arch at Santa Barbara were sheathed with gilded wood divided into sections, each with its own motif. In one case, spiraling lines indicated a column, and curling, three-dimensional, golden leaves suggested the capital at the top. In another case, the entire square pillar or pilaster was decorated with a fanciful, lacy, flowering garland. The triple columns of the altar were Baroque, but otherwise its general spirit was a frozen Renaissance. The church was evidently well kept, and showed the attention of the distinguished citizens of the town.

Elisabeth prepared to shoot the interesting details, and by this time Eduardo knew her needs exactly, first carefully handing her the tripod, next the black cloth, then the light meter, and lastly the film pack.

Later we visited the Historical Society, accompanied by some local dignitaries. Various objects were on display in the large, comfortable rooms, and in a large, glass-covered exhibition table lay documents, maps, and other small objects of special interest. A number of these were lifted out and salient facts were pointed out to us. As we stood there, the pages being reverently turned by Don Gregorio, a little dark head suddenly appeared between the two authorities; it was Eduardo peering in with a rapt expression. The morning we left, on seeing Eduardo lying on the grass faithfully waiting for us, Elisabeth said, "I've taken several candid shots of him and would like to send him the best one." Don Gregorio replied, "But you would have to address it to "Eduardo, Streets of Tunja!"

Returning to Bogotá, we found that we had missed our Ambassador's invitation to luncheon, but we were compensated by a reception at the house of the Cultural Attaché. Besides U.S. and Latin American diplomats, there were a number of Spanish Republican refugees, writers, and professors, all energetic, charming, and singularly free of the condescensions notable in Germans and the French. The citizens of Bogotá were very different from the people we had met in Mexico and Central America. They had a less broken intellectual tradition of liberalism than most of their neighbors—the local newspapers discussed cultural, intellectual, economic, and social problems regularly and carried excellent, sober coverage of the war. If we were to get as much cooperation elsewhere in South America, the trip would certainly be a success! We had such a good time and so much to do that we decided not go to Popayán until around the twentieth, and not to arrive in Quito until the first of March.

At the party we ran into Dr. Martín Soria again, who had moved to Madrid from Berlin with his parents, where his father, an electronics expert, found a very good job. Martín had studied Spanish art and acquired a degree in law. Later on, his father obtained a position in New York, and Martín went to Harvard for a Ph.D. in art history. His thesis was the first in English that was thoroughly researched on the Spanish painter Zubarán. Martín's first visit to Mexico and review of Toussaint's collection of Spanish colonial

photographs coincided with our trip. We became friends, and were very appreciative of his Central European and Spanish experience; he was probably able to ascertain the fascinating originality of Spanish-American Baroque. Soria soon became an enthusiastic proponent of Latin American colonial art with a connoisseur's eye. He won a Guggenheim Fellowship for travel in South America and came to visit us in Norfolk. Pál related the stories of our travels and gave him advice that he used to great advantage. Pál had put special emphasis on the importance of Tunja and especially the Casa de Vargas, the house with the wonderful murals covered in coal dust. Due to the coal lying around, the whole house in disrepair, and our having so much to cover in Tunja, we only had time to take a few photographs. Pál urged Soria to do some work on the house, important also for its early date and provenance. After our visit, the building was declared a national monument, and Soria spent lot of time researching and publishing articles about it. He was one of the potentially great scholars in the field of Spanish colonial art and architecture, and his early death in an airplane crash was a great loss to the field. (It happened when he was en route to locate more resources in prints and engravings in Brussels and Antwerp.)

At the same party, we also became better acquainted with Don Gregorio's brother, the historian, who later took us through colonial Bogotá. He took us to a number of the better-preserved churches that we had not visited. As in Mexico and other Latin American countries, revolutions and cosmic catastrophes had ruined many of the earlier works, but the documentation was notable: clear and almost complete through the years. The city was important for its well-preserved church interiors, with structural details and *retables* dating from late sixteenth and early seventeenth centuries. Also striking were the many large, life-size, well-executed woodcarvings of groups, perhaps best exemplified by a side altar of the richly endowed Church of St. Ignacio, depicting *El Transito* (the transition to heaven of St. Ignatius). A veritable religious diorama, the life-size saint lay in a trance, with his head supported in the arms of an angel, whose upward look seemed to commit him to heaven. The scene took place in the hallway or entrance of a church, for in the background an altar was depicted, and a door opened on a flowing river and some greenery. A little angel stood at the saint's feet, holding his Cardinal's hat, while in the background a youth held his cloak. In the center at the back, an archangel with splendid wings held up an open book, as in a testimonial. In the upper third of the scene, a floating crowd of angels and putti swirled about a great sunburst of golden rays that emanated from a symbol of the Trinity.

Through Dr. Gerberich we were invited to visit the Ambassador of Belgium, Baron Van Merbecke, who was a noted collector and art historian. His special interest in this outpost (as the diplomats referred to it) was crèche figures, the nativity groups displayed throughout the Christian world at Christmas time. They depicted, in statuary and in painting, not only the birth of Christ with the Virgin Mary and St. Joseph, but also the adoration of the Three Kings and the shepherds and their animals, with all the lyric possibilities allowed by the plastic and painted arts. Baron Van Merbecke's collection was remarkable, as he had gathered it over many years and arranged it about his home very tastefully. Elisabeth's special delight was the Three Kings, dressed in antique velvet with tinseled gold lace, one riding a mighty charger, another a graceful Arabian horse, and the third a burro, accompanied by two long-necked little animals, supposed to be camels, but looking much more like llamas!

Dr. Gerberich announced we had one more official visit to make before we left for the southern part of Colombia. The Ambassador of Ecuador, on reading about us in the newspaper, wished to meet us in preparation for what we would see in his country. At the appointed hour, we took a car to a villa at the edge of town, where a large shield announced the "Embajada de Ecuador." We were taken to the Ambassador, went through the usual rigmarole about it being such a pleasure that we spoke Spanish, and then sat down. And as usual, we wondered once again what such an Ambassador does the whole day! We told him of our intention to prepare a survey similar to the one on pre-Columbian masterpieces, but on masterpieces of colonial art. We related that Gabriel Navarro, a famous artist and historian from Ecuador, had been in New York just before we left, as a guest at the Metropolitan Museum of Art. We had been very impressed with two bulletins on the art of Ecuador, which Henry Francis Taylor, the museum's director, published to educate New Yorkers about the art of colonial Ecuador.

As we were leaving, the Ambassador asked, "Do you have your passports with you?" When Pál said, "yes," and gave him our passports, he called in his secretary and gave elaborate instructions. Returning the passports, he said, "These are courtesy visas. It does not cost anything, and I am very glad that you are prepared to visit and become friends of my country." When Pál grumbled to our Cultural Attaché that he didn't think the morning would bring us very much, Gerberich replied that there were certain things one simply had to do. And later, when the Secretary of Education also expressed a desire to meet us, Gerberich went with us. The Secretary of Education was a burly gentleman, very happy that he could speak Italian with us. He took a copy of *Medieval American Art* from a glass bookcase and laid it on the table with a complimentary flourish. He said he greatly appreciated how so much was included about all Latin America, because he was not only interested in his own country, but also the others. After talking in general about what we had seen and what we would try to do in the future, a secretary came in and called him away. Pál looked inside the books and observed that nothing had been touched. He closed it and let it fall open. It opened on Colombia. He did it again, and it opened on Colombia once more. The book was not even paged through, neither pictures nor text. Later, Pál mentioned to the Secretary how impressed he was by the number of bookstores along the streets and the quality of the titles they carried, but brought up the lack of publications on archaeology and art history to illuminate local works of art. The gentleman defended the Secretariat, by saying that for years it had published books on a wide range of subjects. To our delighted surprise, an employee of his came to our hotel room later with two big packages. They contained more than 100 small paperback books about the rivers, animal life, mineral resources, legends, ballet, poetry, local customs, and more, although not much colonial history. Somewhat embarrassed, we sent profuse thanks to the Secretary. Afterwards, Pál telephoned Gerberich and asked him what to do about the books, as our room was full of them! He said that he would send the ones we wanted to keep to our place in Connecticut, and the rest to the United States, preferably to the Hispanic Foundation at the Library of Congress.

Our days continued to be very full. We had taken nearly 200 pictures of our own, and most of them were fine. They were divided about half-and-half between colonial and church architecture and interiors (which unexpectedly came out very well, although problematic, because of the darkness), and archaeological objects, mainly gold from the Banco de la Republica. We gave the bank a selection of Elisabeth's enlarged photographs in an album, and sent our harvest of photographs and films off to Dr. Robert Smith in Washington.

One morning, shortly before we left Bogotá, two young men in black suits and ties, answering to the noble names of Nariño and Barriga, came ceremoniously into our room. One of them was familiar, because he had helped us when we photographed at the bank. They came with the news that the bank was planning to create a museum for the gold pieces. They expressed their gratitude for our visit to the Museo de Oro and handed Pál a package and a letter on bank stationary. The letter thanked us for the evaluation that Pál had given of the museum's collection, and for the copies of the photographs that Elisabeth had taken, extending cordial good wishes for the success of our journey in South America. It was a very gracious letter from Julio Caro, Director General of the bank.

We opened the jeweler's box, about 3 by 5 inches and lined with white silk, and found two *tumbaga* (gold-copper alloy) Chibcha figurines that could be adapted as brooches, a man and woman about 4 inches high. He was carrying what appeared to be a spear thrower and the woman a long bar, perhaps the spear. Perfect in shape, with the hands, features, and other details indicated clearly in what is generally called "wire work," but is believed to be only possible to cast in the lost wax process. They had the faint glow of old gold. There was also the port permit (to enable us to take them out of the country), from the Minister of Education. Thus, our rewards were already coming in, partly in pre-Columbian gold and official permits, and partly in presents of books and orchids! A few years later, the new director of the new Museo de Oro got in touch with us in New York, where we helped him acquire exhibition cases to display the fabulous collection.

We sent four packages to Norfolk containing a large number of books and pamphlets, and wrote to Helen to have our housekeeper expect them in six to eight weeks and take care of any Customs duty. The book collection was partly modern, well gotten up monographs, and partly antiquated brochures that their authors gave

us as a respectful gesture. We would certainly have to rearrange our library if the manna was to continue to fall in such abundance in the other countries (admittedly, a few were left for some friends at the embassy)! Although Pál requested only one book on the colonial city of Cartagena from the director of the Cultural Extension Division of the Ministry of Education, he sent twenty-eight volumes of literature and history about a variety of places in Colombia! The wife of the Minister of Education presented us with one of the most beautiful books, a monograph on Vásquez, a great Colombian colonial painter. We had a very interesting meeting with the Rector of the Jesuit Colegio de Rosario, a man of great suavity and knowledge of the arts, and a bibliophile as well. Yesterday we visited the city's leading artist and Director of the School of Fine Arts in his somewhat crowded quarters full of old books and woodcarvings, along with his own work.

Pál's second and final interview was published in *El Tiempo*, Bogotá's leading newspaper, and one with remarkably high standards. Pál called attention to the great danger in tearing down the old sections of the town, without preserving anything for the pride of citizens and the wonder of travelers. While people in Bogotá were very proud of their history and achievements in literature, they were also amazingly unaware of the artistic treasures, mistreated on a daily basis. The ample newspaper publicity was helpful, as the paper was widely read (with a circulation of about 12,000), so Pál had a good audience for his opinions. On our farewell visit to the Minister of Education, he showed us a proposed law for the creation of a committee for the preservation of national monuments, and we proposed the creation of an archive of photographs as well.

On the 8th of February, we sent the following note to Helen: "Lima arrival not before April 4th. Need only thirty more filmpacks. If larger size unavailable, send 4 x 5s." That was probably self-explanatory; we had been able to buy twenty-four of the 4 x 5 size here, albeit at a monstrous price. In the meantime, Elisabeth tried the 4 x 5s out thoroughly, photographing at the Museo de Oro. In some ways, those were better for small objects, as the pictures centered up more neatly. It remained to be seen how well the size could be adapted for landscapes and architecture, but that would doubtless work out with practice. The filmpack holder was neatly adjusted to the smaller size, with a bit of hand-polished woodwork done at the embassy. Elisabeth saved some of the bigger size until we would hear how Helen got along with our order to Eastman. At the National Library, a special showing was arranged of a film about San Augustín, where we had decided not to go because of the difficult terrain. The trip required three to four hours on horseback after a full day on the bus, and we already had enough photographs of the monuments. The carvings were flat and dimensionally undeveloped. The local people were very proud of them, but we had seen nothing so far to surpass the work of the Mayans. More interesting would be the vast, frescoed tombs of Tierradentro, still more difficult to reach.

We received too many invitations to accept, but had a splendid tea at the colonial home of an interesting woman, the head of the colonial museum. It had more of the Guy de Maupassant atmosphere than of the cocktail parties at home. Chinese antiques blended extremely well with the gilded remnants from colonial churches, and we ate from silver plates and drank from lacquered cups. With the exception of our Cultural Attaché and Pál, there were otherwise only women, at least twenty-five of them, including seven daughters of the house!

CALÍ AND POPAYÁN

OUR PLANS WERE AS FOLLOWS: to leave Bogotá on February 21st, arrive in Calí two hours later, photograph some colonial churches that afternoon, and then visit the city's only private museum. The next day, we would travel by *autoferro* to Popayán. In that old university town we intended to stay until March 2nd, and fly by way of Ipiales to Quito, Ecuador, arriving the same day after a two and a half hour flight. Popayán was only about 5,000 feet high, and we thought to recover there from the altitude of Bogotá, before confronting the altitude of Quito.

We made the flight to Calí in a very small Boeing, one of those little dragonfly planes, which drifted down from 9,000 feet in corkscrew curves to the 900-foot elevation of the Caucá Valley. We were only six passengers, including a child. The planes were usually

nearly half-empty, although one had to reserve places far ahead, as they carried more priority freight and mail than people, to maximize the profits. We had a rough takeoff, going straight up into the air to cross the mountains protecting Bogotá. From there, we sailed over a sea of clouds above the great Magellan Valley, and suddenly found ourselves amid the mountain peaks of the Cordillera Central that rises to over 12,000 feet. Then the plane circled downward through cloud banks, until we could see palm trees along waterways, and finally landed at Calí in the beautiful Caucá Valley, quite close to the Pacific, but separated from it by another formidable range. It began to dawn on us why South America, especially Colombia with all its vast wealth, did not open up sooner to the rest of the world.

This valley was a blessing for an entire section of southwest Colombia. Its rich and well-kept plantations raised nearly every crop that a semi-tropical climate can produce. Colombia was actually the only South American country with coasts both on the Atlantic and the Pacific. The city of Calí was only a market town in colonial days, a stopover, as traffic swept from the sea to the mansions above the clouds. It had grown into a busy, wealthy, modern town with good railroad and shipping connections in all directions. It seemed especially lush and green to us after the savanna of Bogotá, which was suffering from the worst drought in its history! Two big rivers swept through the fields, and cattle were grazing everywhere. We were met, quite unexpectedly, by the Secretary of Education in an official car, accompanied by a dear, eccentric old gentleman who owned a famous private collection. We were shown the whole town, from the few remaining colonial monuments to the new 100-bed hospital, almost completed. It was very nice to have a car at our disposal and two guides so enthusiastic about their city. We drove down to look at the famous Caucá River, a turbulent stream of the muddy color of all great agricultural rivers. Big bamboo rafts loaded with vegetables were just landing. The banks were lined with the houses of the black population, considerable in this region of sugarcane and cotton. The village was remarkably clean, the citizens courteous and proudly independent. In their backyards grew banana trees, cocoa, coffee, and pineapples. The flowers were riotous, and to cap it all, even the birds were brilliantly colored. Calí was a lively city and after the high altitude, the many interviews, and so much photography, it was a very

pleasant recovery place for a few days. Walking in the park in the evenings, we were intrigued by the word *platinos* we heard so often, until we realized that the passersby were referring to our silver hair!

We traveled the 100 miles to Popayán by *autoferro*, a long, bus-like car, set on a narrow gauge railroad track that beat the train by several hours. It was a delightfully clean and smooth ride, with bucolic scenes along the valley and tantalizing vistas of the mountains. Then the tracks rose sharply into a new valley 1,000 feet higher, just as green, almost as rich, and with considerably fresher air. The Caucá River certainly rose; how it got down to where we first saw it without a Niagara Falls was a mystery!

Popayán was a university town, still occupied by descendants of its *Conquistadores*. It was far more isolated and remote than even Tunja, although it was formerly on one of the great traffic arteries to Quito and Peru. Being so distant from Bogotá, it had gained a kind of independence from the capital. Greatly torn by the Revolution, because it was dominated by Conservatives, the city's power waned with the opening of other land and sea routes. The final blow was a civil war, involving a party that wanted to secede to Ecuador, to which it was actually geographically closer than Bogotá. Intellectuals, poets, statesmen, and retired people had established themselves in Popayán to partake of its delightful atmosphere. The colonial architecture was different from what we had seen in Tunja and Bogotá, where it was sturdy and severe by comparison to Popayán's charming houses and lush vegetation. Our hotel was primitive and noisy, with students arguing beneath our window at early dawn, and once performing a serenade with a drum! We became very good-natured, lazing about during the hours of hot sunshine between violent thunderstorms, and had a wonderful rest from the high altitudes.

We met up again with Dr. Henri Lehmann, a German refugee whom we first knew in Paris, where he was involved with the conversion of the old Trocadero Museum into the Musée de L'Homme. After fighting in the French army, Lehmann was able to get to Colombia to do some ethnological work on a grant. He organized a collection for the university by excavating much of the material himself, but had recently been called to Mexico by the French Institute, and was leaving in a few days. We attended the big

send-off, and put in some words of praise at a meeting of the Friends of the Archaeological Museum of the University of Caucá. Pál made a speech in Spanish about the importance of pre-Columbian art, and we were elected corresponding members of the organization.

We always visited the highest ecclesiastical authorities of a town, whenever we wished to photograph the interior of a church and its furnishings. That was how we met the Archbishop of Popayán, an unusually tall, robust man, friendly from the first moment, and very proud of his diocese. He smilingly showed us a chapel that he had designed, unfortunately with a rather commonplace interior, which might have been done by a contractor, whose taste was developed constructing modern bathrooms. But seeing our interest in whatever he had to show us, he guided us toward a long, dusty, neglected reception hall, with the usual canopied papal throne looking rather empty and forlorn. At the far end, in semi-darkness, stood a half-life-size statue of the Virgin Mary, poised on her crescent moon on top of a great silver globe. In her hand, raised high, a

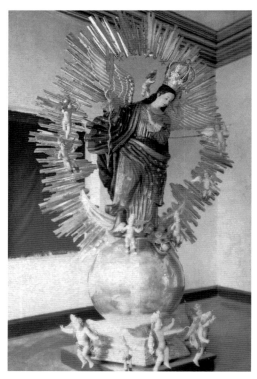

VIRGIN MARY ON CRESCENT MOON IN THE ARCHBISHOP'S CHAPEL AT POPAYÁN, COLOMBIA.

VIRGIN OF THE FIFTH SEAL, IN THE CHURCH OF SAN FRANCISCO AT POPAYÁN, COLOMBIA.

javelin zigzagged like a bolt of lightning. An immense aureole of silver rays surrounded her figure. That the costume had been touched up a bit with fresh paint, and a scattering of gauze-draped, newer, tinseled little angels was fluttering about her did not diminish the startling vision. It was a representation of the Virgin that we had never seen before! When he saw our excitement, the Archbishop said that he would be glad to have us photograph the figure, but that we should wait until Monday, when they could bring her crown, kept in storage at the bank. When we went out strolling, Elisabeth very often did not take along her camera, but fortunately, on this occasion, she had done so, and we could take a picture without the crown. When we returned that Monday, she was wearing a high, golden crown of very fine workmanship studded with semi-precious stones. A space in the aureole accommodated the crown's place in the composition.

Late that first Saturday afternoon, we wandered about the town and stopped at the Church of San Francisco, which was dedicated to San Bernardino. After the glare of the plaza, its spacious interior breathed coolness and quiet. The faded splendor of the gold and the colors on the side altars glimmered softly, their ancient patina untouched. On the walls hung paintings in Baroque frames. The main altar spread across the entire end wall of the nave. Toward the top, a rough tarpaulin curtain closed off an arched recess. The pulpit was a masterpiece of intricate carving. Its newel post was a figure in an elaborate costume, balancing a basket of exotic fruits on its head. The place was empty as though abandoned, but we found a priest to show us about. When, still full of the excitement of the previous morning, we spoke of the Archbishop's statue of Mary, he said quietly, "Wait until you see mine." He led us back into the apse and

up a narrow flight of winding stairs. High in the curtained niche just above the main altar, lit by the windows of a lantern in the turret, stood a life-size statue of the same Madonna in pristine glory. Upheld by the crescent moon, she was poised above a silver lily that sprouted from the base of a silver globe about 3 feet in diameter and was bound with gilded, lace-like bands. A serpent wound around the moon. One foot of the Madonna rested on its body, with the other poised to step on its neck. With her right hand, she aimed a golden javelin at the serpent's head, her left arm and cloak swinging outward with the movement. Heavy, star-shaped earrings hung from her ears, and a silver, filigreed crown rested on her inclined head. The statue appeared to be encased in gold leaf, which glinted through the brilliant patterns of *estofado* painted on the gown. Each symbolic garment, robe, surplus, and mantel were

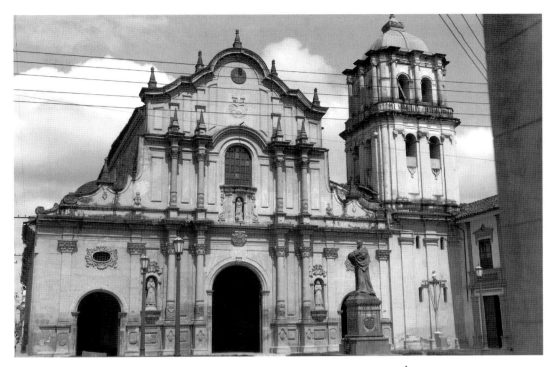

FACADE OF THE CHURCH OF SAN FRANCISCO, POPAYÁN, COLOMBIA.

clearly defined by a different manner of tooling. The robe, in contrast, was in a mild blue with gold ornamentation.

The priest told us that the splendid figure was shown only on special occasions, and that many people outside Popayán did not even know she existed. She was very much beloved by the faithful, who call her the *Immaculada*, the Immaculate Conception. But she was not the Immaculate Conception, instead she was an iconographic representation that was entirely new to us, and the search for her identification would take us many years. During Holy Week, both that Madonna and the one in the Archbishop's mansion were displayed to the public, and one of them was carried in a procession around the town. Thus, our friend Dr. Lehmann must have seen it at least four times, and doubtless on other special occasions. But he never wrote about it in his article on the holy statues in Colombia in the *Gazette de Beaux Artes*. Pál remembered that Dr. Lehmann had published an article in the *New Yorker* magazine on the colonial treasures of Popayán, but he did not draw attention to the two beautiful

Virgins. Noting our amazement, the priest asked if we would like to photograph the figure, as no one ever had. Alas, that time Elisabeth was not carrying a camera. In any case, it was late in the afternoon, and the light would soon grow dim.

When we came back prepared to take photographs, the Archbishop's statue was wearing her crown, and we worked for several hours. It was late in the morning, when we reached the Church of San Francisco. The priest eagerly received us and led us up to the little chamber so beautifully lit by several windows, artfully placed on the domed ceiling. A boundless sea had been painted there, with a little floating ark like the toys we used to play with. The shimmering silver Madonna seemed to float in space. Elisabeth photographed her from numerous angles, and the priest even convinced her to stand on an undecorated altar in the nave, to get the view that one would get from below. As the session neared its end, the sun reached its zenith, and a ray directly struck the golden javelin, illuminating it with startling brilliance. Remembering the

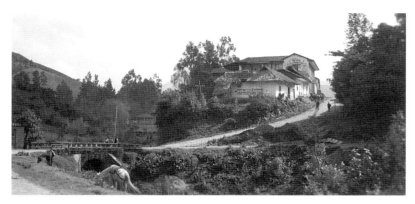

ON THE ROAD TO THE VILLAGE OF SILVA, COLOMBIA.

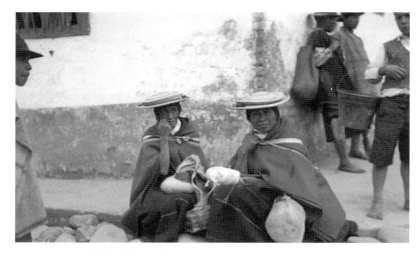

MOUNTAIN AND FIELD WOMEN AT MARKET
IN SILVA, COLOMBIA.

sun behind the crucifix at Tunja, the significance was clear. It was a most convincing bolt from Heaven!

As we stood in the church with the Monsignor, we realized that he could not understand our excitement. He said that the figure was also visible in other places. Our experience had been that in Mexico and Central America, and in the churches we had seen previously in South America, no such representations of the Virgin Mary existed. Her appearance in Popayán, with wings, standing on the new moon, with the lily and globe, and, with the very unusual feature of directing the golden javelin at the beast, was magnificently original. And there we were with her, halfway to Heaven!

On one of Dr. Lehmann's last mornings in Popayán, we rose at 5:00 to accompany him to the Indian market at Silva, a village about 40 miles away. We got off in good time, as did the Avianca pilot, who breakfasted with us. He had been contracted to go to Ipiales on the Ecuadorian border, with a special plane, to rescue a Russian ballet troupe that was late to start a season in Bogotá. Some job to move fifty people en masse through that country! Our route wound up toward the mountains into a lovely village on another high plateau. The Indians were coming down from the far hills to market, some on horseback and others on foot. So many languages were spoken in the region that they had to resort to Spanish to understand one another. They all wore dark clothes, not as attractive as the bright colors of the Guatemalans, but very picturesque. Both the men and women had carefully made, round straw hats, rather Chinese looking, which were woven by the men with colored patterns throughout.

Most of the women wore cerise blouses and black skirts gathered around the waist by wide belts, with a brilliant blue blanket over the shoulders, held by a big safety pin. It took an Indian to appreciate the esthetic qualities of a shining safety pin, just as it did to see the value of a thick, terry-cloth bath mat as a saddle blanket! Multiple strands of white beads and silver filigree earrings completed the costume. The men wore several *ruanas* or short ponchos, nicely fitted, so that their contrasting colors showed at the edges: pink and gray, with black or dark gray on top, and expertly woven with an occasional, narrow, brightly colored stripe. Their shirts were the usual white cotton, plus short pants, but they had adopted a kilt of the same brilliant blue their wives wore, which made them look like Mongolians. These were very friendly people among whom Lehmann had lived for months. They were not used to tourists, and consequently they were not reluctant to be photographed, especially after Lehmann passed around a few pictures of them that he had taken on his last visit.

The usual market produce was being sold; stacks of green bananas and blocks of dark brown sugar, frequently drunk with water throughout the day, and also used to make the native beer. The rest was bazaar junk: mirrors, bright ribbons, and cheap jewelry, plus lots of sturdy rope and carrying bags fashioned of the same fiber. All the women were spinning, twirling the old-fashioned spindle as they walked, or plaiting

fiber bags. We had time to see the old church before we ate lunch, and to climb up to the chapel on the hill for a truly enchanting view. From Popayán it was a day's horseback ride to the strange, frescoed tombs of Tierradentro. Had we had more time and being that close, we would have been very tempted to make the arduous excursion.

Lunch was plentiful and certainly exotic. It consisted of fresh pineapple, a soup of liver and potatoes, small new potatoes stuffed with a highly spiced hash, baked and served with rice, some very tough chicken, a delicious egg pancake, an excellent spoon bread made of fermented cornmeal mush, a salad of chopped egg, onion, and tomato, and for dessert a spoonful of rich caramel, served with a glass of milk. All that plus soft wheat rolls (cake flour to us), and gorgeous, sweet butter, finished by very strong, very good Colombian coffee, was almost more than we could handle. Dr. Lehmann left for Bogotá in the little Boeing that had brought us to Calí, and we waved him off.

ECUADOR

QUITO WAS OUR NEXT DESTINATION, two and a half hours away by plane. We left Popayán on a Friday, sitting around the airport for some time before our plane came in. The flight was rough and led over the most broken-up country we had ever crossed, like choppy waves in *terra firma*. Far below, a tiny road with serpentine curves indicated why the trip by car would have taken three days. Arriving in Ipiales on the Colombian border, we learned that the plane from Quito had been canceled because of poor visibility. We jumped at the chance to hire a car and left the other passengers heading toward a primitive hotel in a cold and dirty town. Our drive's name was Montenegro, and the young fellow with him was Jorge, his mechanic; evidently, it was good practice to bring one along! We got through the Colombian border without any fuss and reached the small town of Tulcan, on the Ecuadorian side.

We spent a half-hour changing our money into *sucres*, while the Immigration Officer went off with our passports. He returned with a worried expression, because we had two visas for Ecuador, one acquired in New York and the other given to us by the Ambassador of Ecuador in Bogotá. The dilemma was that the colonel, who commanded this border office, was having lunch, and the standard tourist visa required a payment of ten *sucres* per person (about $1.60), while our courtesy visa was gratis. When we offered to pay the $1.60, the official replied that he could not accept it, and that we should go to a nearby restaurant, have our lunch, and wait until the Colonel finished his *siesta*. Both Customs and the restaurant were located in a large, rather pompous Victorian building, probably constructed for some border conference, with an elaborate meeting hall, a broad staircase, and other ostentatious features. We sat and gazed through the dusty windows at a disheveled, barren landscape. Two hours passed before someone came to lead us into the office of the Colonel, who had a spreading figure and an expressionless face. Right and left of him stood half a dozen border guards, looking at him as if he were Solomon himself. It transpired that they would be unable to accept the money because of our also having a courtesy visa. Since the visa from Bogotá was dated two and a half months later than the visa from New York, we could pass free. Worries about making a diplomatic blunder evaporated, the officials apologized profusely, and finally we were on our way.

The roads were better than on the Colombian side of the border, made of mostly hard dirt, but sometimes of cobbles from colonial days. Some time later, we arrived at a vast, treeless plain with endless fields of yucca and cactus, 12,000 feet high. The clouds lay so low and so thick on the jagged mountain peaks that we were very glad we weren't traveling by plane. After a good two hours, we began to descend a winding road into a beautiful, tropical landscape, completely different from Colombia. Ecuador was the land of eternal spring, and everything by the roadside was blooming. The mountains sloped away in great shoulders, cut by deep canyons, with the fields shaped into terraces to facilitate irrigation and cultivation. Apparently, the natives were all full-blooded Indians.

The planted sections were marvelously rich and varied, as in no other land we had ever seen. Tall eucalyptus trees cast long shadows, and the emerald green of the fields created a more intense and vibrant landscape than any painter could hope to put on canvas. Then it was over another pass and into a genuine desert, with a glacier

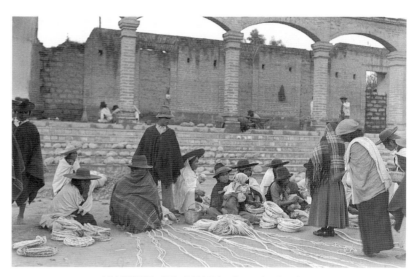

MARKET AT OTAVALO, ECUADOR.

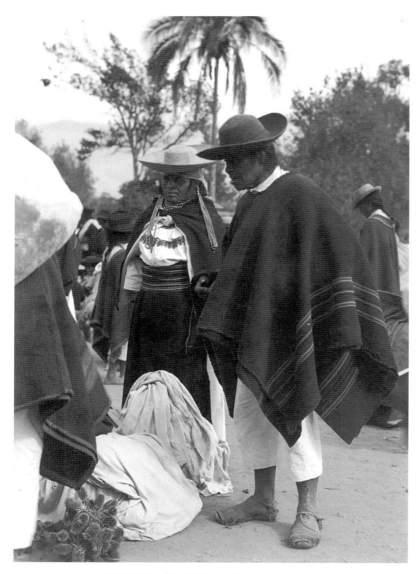

MARKET AT OTAVALO, ECUADOR.

running through it. At the bottom of the valley lay a little Negro village, adrift in dust. The story went that some black slaves escaped their colonial masters while on a journey, hid in the rocks, and stayed there. It was one of the hottest villages in the region, and no one knew what these people did for a living. We reached there about dark, and the fantastic shapes of the desert rocks and thatched roof hovels looked ominously weird by the light of a few fires. A chain was stretched across the road. An official politely asked for our passports and went off with them for a quarter of an hour, seemingly fascinated by such rarely seen documents. This happened to us several times and was most irritating; apparently, it was a holdover from the days when a great deal of smuggling took place.

By this time it was clear we could not arrive in Quito by midnight, and the road was continually spiraling dangerously up and down. We stopped for the night in Ibarra. The city had electricity, but such a weak plant that the lamps looked like small candle flames. Our hotel, the "Victoria," was a low building with the usual central patio; only the front rooms had windows, and the others had doors opening into the courtyard. Ours boasted a ceiling at least 12 feet high, and a number of pretty little chromes on the walls of flower-framed cottages and children playing with dogs, hung up high, probably to keep them away from covetous hands. Our driver took us to a restaurant run by an American from Michigan married to an Ecuadorian, and we hungrily gobbled up very good beef steaks, with lots of vegetables and apple pie. The hotel was remarkably pleasant, aside from the drivers, who pounded and shouted at the door in the wee hours of the morning, with groups of late passengers, and the policemen who blew whistles every ten minutes all night.

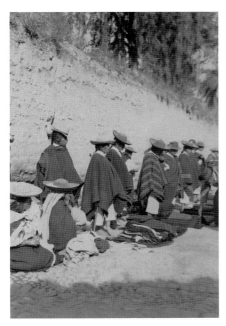

TEXTILE VENDORS AT
OTAVALO MARKET IN EQUADOR.

FORMER BISHOP'S PALACE AT CAJAMBE, EQUADOR.

We got up at 5:30 and were off by sunrise to reach the next big town of Otavalo, one of the most famous Indian markets in the country. The fair started about 4:00 A.M. We arrived a little after 7:00, and everything was in full swing. As usual, the market was held in several different squares. The food was sold in one, textiles, ropes, leather goods, and such sold elsewhere. Several different tribes of Indians were there in their traditional dress. The Otavalo natives wore a big, reddish felt hat, while others had on immense white ones, turned up all around. Still others wore black or blue; all had heavy woolen ponchos. Some of the women were decked out with beads and silver, while others looked more demure with straight-falling, black and white costumes echoing those of Benedictine nuns. They were a handsome, graceful people and very friendly. They did not make any fuss about being photographed, although some were so shy that they ducked their heads and ran away. Elisabeth took two dozen stills, as well as a reel of movie film. The sun finally appeared over the high volcanic cones, and the light was perfect. The brilliant square with its background of eucalyptus, the

long, sloping fields and wild sky above, were sights we probably would not find again.

The deeper we went into the country, the more apparent became its terrible poverty and the lack of hygiene, in spite of the richness of the land. After crossing another desert, we had lunch in a village called Cajambe, with a population completely in rags and tatters. In stark contrast was an opulent, colonial Archbishop's palace, then the property of a rich landowner, who seldom used it. We came to another *paramo* (what the natives call the high, bare, and cold regions), and descended into a deep valley. Next to it was a tremendously steep rise that made the radiator boil over for the first time on the trip, and we came to the high plateau, where lay the capital of Quito. No peasant carts were visible, as all transport went by mule train or human carrier, and once in a while by truck or bus. Even about 20 miles north of Quito, there was no sign of any improvement, either in the condition of the road or the villages. About ten minutes before we reached the outskirts of the city, we saw our first snow-covered volcano, Cotopaxi, jutting up 16,000 feet into the sky.

To compound things, the shouts of street vendors started at 6:00 A.M., and the church bells began tolling at 4:00! As much as we wanted to stay in the heart of the town, the noise forced us to move farther away from the center of the city. The second hotel was a large, formerly private villa in the midst of a tropical garden. The only other guests were some American army officers there on a mission, and a scattering of American engineers enjoying a short respite from work in the steaming jungles. The center of town was only eight minutes away by taxi, so we went there in the mornings on our various errands, ate lunch in the "Ristorante Cristal" (Hungarian owned and serving chicken paprika), and returned late in the afternoon to our quiet, spacious quarters to revitalize.

It took longer to get connected than in Bogotá, but luckily, because of newspaper publicity (five articles about us appeared right after our arrival), we were soon going strong. The study of colonial art had become increasingly more important to us than archaeological material, and colonial Quito, although backward and poor, was without a doubt the best preserved architectural monument we had encountered. Its historic plan and stylistic unity were amazingly intact. There was a special harmony of vista in the various streets, as the buildings were more or less the same height and the facades fairly evenly aligned. Lush vegetation, visible in the patios, gardens, and surroundings gave a mild and friendly tone to the total picture. The exterior details ranged in style from late Renaissance to filigree rococo. The interiors were veritable museums, with a richness of gilding, columns, mirrors, reliefs, and statuary that even Mexico no longer preserved, due to centuries of earthquakes, fires, revolutions, and extended contact with the outside world. The preservation of colonial art in Quito was partly attributable to the fact that in 1945 the best connection with the capital was still via a one-track, narrow gauge railway from the Pacific harbor city of Guayaquil. It was constructed by American engineers in the last decade of the nineteenth century and was considered to be one of the engineering feats of the world. The ride took at least two days and was often interrupted by landslides and other natural occurrences. Quito was so hilly that in colonial days the bishop and the president of the Audiencia drove about in carriages, while the rest of the population, gentry or Indians, went about on foot or by horse.

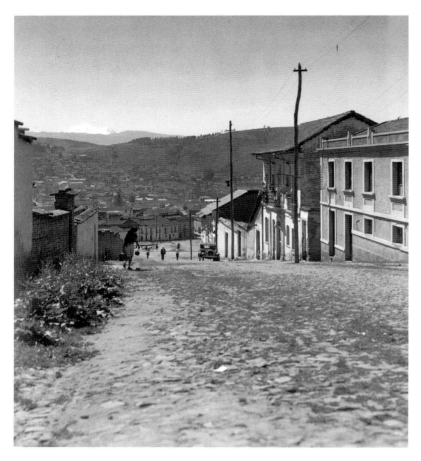

STREET SCENE WITH SNOW-COVERED COTOPAXI VOLCANO
IN THE DISTANCE, AT QUITO, EQUADOR.

And on the right, lower mountain peaks rimmed the horizon. Below them, on the shoulder of Volcano Pichincha, spread the enchanting old capital, with its church domes shimmering in the sunshine. It was mid-afternoon and ferociously hot, for the city is nearly on the equator, where the sun shines the strongest. The climate was actually quite temperate, however, because of the high altitude, with a light coat sufficient for daytime but two heavy blankets needed at night.

Unfortunately, our hotel was on a corner of the main plaza. Although it was architecturally beautiful, with a cathedral and colonnaded colonial buildings all around, the plaza was full of traffic.

STREET SCENE NEAR SAN LAZARO HOSPITAL
IN QUITO, EQUADOR.

Since becoming a Spanish city, Quito had been a religious center full of churches, convents, and monasteries. An amazing number of them survived, and in spite of numerous tasteless nineteenth-century changes, they housed many treasures, particularly sculpture. Ecuador was still very much in the hands of the clergy, and priests and monks thronged the streets. Nevertheless, the impact of modern civilization on a crumbling and reactionary system was obvious. Under the farsighted regime of President Gallo Plaza, Ecuador was one of the last

Latin American countries to close its doors to refugee immigrants, who brought some of the amenities of the outside world. One enterprising foreigner opened a tea dance parlor, which some of the old citizens feared would loosen morals. The hospital had been upgraded by a skilled administrator and a doctor, once prominent in Budapest, and a well-known designer was making use of the weaving skill of the Indians to create carpets for the new United Nations headquarters in New York. We heard an inspiring report about a project on childcare and elementary sanitation that was being given free throughout the country; unfortunately it was being received with apathy. Elisabeth took amazing shots of sculptures inside half-dark churches, and we bought more than 100 photographs from Bodo Wuth and another professional photographer, mainly of the interiors of La Compañía and San Francisco. We also met important local officials, churchmen, collectors, and historians, through introductions and at a reception held by the vice president of the Casa de la Cultura, Jacinto Jijón y Caomaño. Pál was invited to give a talk (called a *charla*), and he once again spoke about the importance of preserving pre-Columbian and colonial art, sitting in a large, gilded chair at a velvet-covered, antique table. In spite of his often ungrammatical Spanish, the audience seemed to like it, and the newspaper filled in the incomplete verbs in a good article the next day!

We visited several homes of local aristocrats, some of them tasteful, and with their treasures agreeably displayed, and others like archaeological bazaars, with more pretense than value. Of the local people, the director of the museum was our favorite: Nicolás Delgado, a much-traveled, older man, with the soul of an artist and a true liberal among so many reactionaries. It was a shock to learn that there was no public archaeological museum in Ecuador except in Guayaquil, because one of the richest men, the owner of a barn full of pre-Hispanic and colonial tidbits, squelched any action in that direction. (We later met this man and were invited to see his collection, which is subsequently related.)

Some special places both in Europe and in America have an atmosphere of sanctity, perhaps because of their structure and interior decorations, or because in ancient times a certain event, or holy festival, took place there. Quito's church of San Francisco emitted an air of sanctity with remarkable force. We first saw it as the day

darkened into night, standing formidably on a large, stone platform above a sloping plaza, and approached by a sweeping, semicircular stairway. The facade was of local gray stone, heavy and severe, in a late Renaissance design with Baroque touches that gave no hint of the glorious interior. Suddenly the huge doors opened for mass, and Heaven burst into view, recreated on earth by the blazing red and gold nave! At that moment we were struck dumb, and once and for all comprehended the hope of the Indians for eternity in Glory, as embodied by the church.

Three Franciscan friars founded the establishment in the early 1530s, led by Friar Jodoco Ricke de Maselear, a Fleming from Ghent. They received a grant of Indian laborers and set about at once to teach them how to plow with oxen, build roads, count in Spanish, read, write, and bind books. They founded the Colégio de San Andrés for religious instruction, and taught the Indians to play musical instruments and create paintings and sculpture. (The first painting instructor was Pedro Gosseal, a native of Mechlin, halfway between Antwerp and Brussels. Friar Ricke also founded the Franciscan Monastery of San Bernardino in Popayán, Colombia, and died there in 1574.) Thus began the development of the great artistic life of colonial Quito.

By the end of the sixteenth century, the Franciscan complex covered four city blocks and had four cloisters, as well as the church. Spanish aristocrats endowed private chapels, and artworks from the Quito workshops were exported all over the Hispanic colonial world. Art and faith united to spread the Word of God across the ancient, rugged kingdom, once an important part of the Inca Empire. In Ecuador's high valleys and plateaus, at the eastern slopes of the volcanoes at the headlands of the Amazon, and deep in the jungle lived innumerable Indian tribes, who knew nothing of Christianity. The missionaries endured wild animals, unknown diseases, and terrible journeys and living conditions. But they erected large churches from timber, converted neophytes to pray to a new God, and taught them to play holy music on instruments that they made themselves. It was a conversion that invented its own methods, in a heroic epic. The impressive monastic establishments, still standing in Quito, spoke volumes about the remarkable success of those early friars, and the faith and loyalty of their Indian converts.

In 1755, a disastrous earthquake destroyed much of San Francisco's nave, but the interior still shimmered in golden harmony. The priest in charge permitted us to be locked in, undisturbed during the mid-day closing, and leave by a door in a side wall. As we sat on a bench enveloped by an odor of incense and candle wax, trying to absorb the riches of that astounding interior, we were overwhelmed by emotion. Perhaps we even felt something of the religious inspiration that sent the early missionaries into the mountain valleys far to the east, and down to the edge of the jungle. The nave was sheathed in wood paneling with a delicate but dense carving of flowering vines that served to lead the eye forward toward the sanctuary. Life-size figures of saints were mounted on the cornices. Large oil paintings at the base of the huge, square pillars gave the eye a rest from the elaborate decorations above. The dome over the crossing of the nave and transept was mounted, in the *mudéjar* manner on squinches, and apparently was not greatly injured in the earthquake. A frieze of panels painted with images of various saints recalled the Byzantine. The main altar was very elaborate with both sculpture and painting, caryatids bearing baskets of flowers, stately columns, and heavy cornices. It was all exquisitely lit by daylight from a turret in the roof, invisible from the nave.

In a niche at the center of the main altar, in a silver, embossed frame, was the same Madonna we encountered in the Franciscan church in Popayán, also winged and poised to hurl a golden javelin. The weapon was missing, but she stood on the new moon and looked down at the serpent's head. This time her provenance was clear. She was carved by Bernardo Legarda, a local *mestizo* sculptor of the early eighteenth century, who tradition tells lived on the plaza opposite the church, where his studio turned out many important sculptures. He was a master of the techniques of the enamel-like *encarnación* and *estofado*, the former used to render glowing and lifelike faces and hands; the latter a technique employed on the surface of the garments, which overlaid gold leaf and paint, then was incised to indicate patterns. The heads and hands of the images were made separately, for the better application of the *encarnación*, and then fitted to the body. The hands of the Virgin on the San Francisco altarpiece can still be taken from their sockets, and on the tenons were two inscriptions, placed as if on medallions, "Bernardo Legarda" on one and the date of 1734 on the other.

Another Quito sculptor of outstanding talent was Manuel Chili (or Chill), nicknamed Caspicara. It was characteristic of conditions in Quito that, with the exception of one date in a document that mentioned him as a "contemporary" in 1792, almost nothing biographical was known about the artist. He was born of Indian parents, generally known by his nickname, meaning "rough face" (scarred from smallpox), and admired for his ability to imitate Spanish sculptors. His work had an uncanny feeling for wood and exhibited not only technical virtuosity, but also was embued with warmth and humane sensitivity. Caspicara's only known signed work was a small, exquisite, polychrome figure of the sleeping Christ child, probably from a manger group. (The authorship of his other works was usually determined from documents.) Caspicara lived in the Rococo period, when porcelain and ivory figurines were cherished possessions in many a household. Most of his statues were only half life-size, in contrast to those of Legarda's era. Also of significance were his group compositions, for apparently before his time, the artisans in Quito produced only single statues. In Quito, whether it was in a church, a chapel, or a private salon, one could find outstanding works of art by a known master or an anonymous one, both indicative of the high standards and individuality of the best years of the colony.

Two smaller churches were also connected with the massive complex of the Franciscans, San Bonaventura standing on what was believed to be the site of the first church erected by Friar Ricke, and the Catuña Chapel. The latter was named for a wealthy Indian, whose bequest paid for its erection in the mid-seventeenth century. When the painters' guild took it over in 1781, it was redecorated and made the center of their religious festivities, involving Caspicara and other notable artists of the epoch.

We had been more than three weeks in Ecuador, and we were very tired from so many activities at that high altitude. At the embassy, we heard of a resort with hot springs, not too far away at a lower altitude, called Baños, "the Baths." A recently re-opened old hotel there, with a nice restaurant and sweet shop, was being run by a man from Cologne and his wife. It sounded like a pleasant place to relax, so early one morning we started off. The route lay along the backbone of the Andes to Ambato, known as "the garden spot of Ecuador." We were nearly freezing in our heavy coats, until the sun

came up and shone into the car. The morning mists had not yet gathered, and there was a clear view of the beautiful, snow-capped volcano Cotopaxi. A little later, the wild crag of Tungurahua came into view. The high valley, dominated by the town of Ambato, was rather reminiscent of Mexico, and terribly dry and dusty. The Indians on the road and in the market were streaked with dirt, and so were we; but a hearty meal prepared by the proprietor of a small inn, a Czechoslovakian woman born in Hungary, completely restored us. After a short nap, we were on our way again.

Turning east through a marvelous lane of eucalyptus trees, the road began to fall rapidly in a succession of wide serpentine curves around the shoulders of the mountain. It was terribly dangerous, if not impossible, for vehicles to pass on the tight curves, but although we met a number of jammed-full buses, it was always on straight stretches. The scenery was fascinating, featuring great, powdery wastes and contrasting displays of irrigated land in vibrant green. Water gushed and tumbled through the gorges cut by melt from the volcano's everlasting snow. We crossed a little bridge, guarded by a cross and a statue of a saint, and entered the narrow valley of the famous Baños hot springs. The sulfurous, volcanic waters were reputed to have spawned a watering place in pre-Columbian times that had become a large, sprawling village. Among dreary, scattered hotels and *pensiones*, many of them falling to pieces, we finally came upon the tiny Villa Gertrudis, a neat, bright, little tearoom and restaurant, with only two rooms to rent. A group of guests was having afternoon coffee and cakes at tables in the tearoom and on the terrace, in city clothes, hats, and parasols. What could be more incongruous in that wild and tropical landscape! Our room could have been in some pleasant inn in Tyrol, with its carved bedsteads and cane-work on the wardrobe doors, but when we threw open the shutters, a huge banana tree waved in the breeze.

Our host, Mr. Heller, was a German refugee Jew from Berlin, and his wife a blond Christian, also from Germany. Both of them were full of optimism and energy. After a delicious hot supper, we discussed the troubles in Europe, and Heller related his adventures during his flight to Ecuador. He could not take the altitude of Quito, so they moved to Baños and installed themselves as comfortably as possible, without the benefit of money. Heller built

all the furniture with the help of a native carpenter, and was then putting a wing on the house. He also installed the electricity and built his wife a stove out of cement in the local style, with a good oven and half an oil drum on top as a water heater. We lived extremely high for a few days, with sweet butter made to order daily (for there was no refrigeration), and all kinds of fancy fruits and pastries. We rested better there at night than on the whole remainder of the trip. After a sumptuous breakfast of fresh orange juice, homemade bread, and native honey, we wandered about the village in the cool of the morning. A big, new, wooden shed had been erected as the bathhouse. The hot volcanic waters were guided into pools next to the dressing rooms, and everything was spick and span. Indian women were bathing in the steaming waters of the ancient pool, which was reputed to effect miracles for rheumatism and other ailments. Any increase in commercial development was doubtful, however, as the church intended to make it a pilgrimage site to celebrate some miracles of its own. Thus the charming little parish church was falling to pieces; while at the other end of town was rising an enormous, stone pseudo-Gothic structure, decorated with huge, hideous paintings of aforesaid miracles among sugary plaster statues.

We had heard that beyond Baños, far down the eastern slope of the Andes, the Shell Oil Corporation was digging for oil in a small village. In Quito we had met some of the engineers who had come up from the rainforest for a rest, all sweated out from the sunless dampness of the jungle. Always hungry for diversion, they urged us to come down and visit them, as American strangers were particularly welcome. So on our last afternoon at Baños, we followed the road farther east winding around the barren base of the volcano, scattered with rocks from a lava flow. The mountains were cut by great cliffs, and almost every one had its own sensational waterfall. Below the Rio Baños, the road wound through a narrow gorge with big trees suddenly thrusting up on all sides. The sun illuminated the dark wall of the rain forest, with orchids in many different colors hanging from the trees. The river was on its way to join the Amazon deep in the forest. At that longitude so near the equator the afternoons always seemed very short, and at sunset, the golden globe from the sky almost tumbled into the sea.

After only a short distance, our driver suddenly stopped the car. He announced, "I don't want to go farther. It will soon be dark down there, and the Jivaros might attack." The Jivaros were a tribe once noted as headhunters, the shrunken heads of their enemies were exhibited in a number of classy museums and were for sale to tourists. (Fortunately, nobody offered any to us!) Jivaros had recently murdered some American Protestant missionaries, reason enough to avoid an encounter! To further dissuade us, the guidebook said that after the oil camp, all traces of civilization disappeared, and the traveler proceeded at his own risk. We realized that we would have to spend the night at the camp, and it was very hot. So we turned around, where a signpost announced that it was 200 kilometers to Quito. Along the way Elisabeth gathered a sheath of ground orchids, growing out of the cliff on long stems like lilies, but they quickly wilted in spite of all the care we gave them.

Twilight was settling on Baños, when we returned. The Indians, who had been soaking themselves in the open pool behind the bathing house were trotting along the dusty road back to their villages. The plaza was deserted, and the guests from other hotels had gone home for their evening meal. We reached the inn of the Hellers in time to freshen up for another delicious dinner and evening on the terrace, chatting with our hosts about the war and Europe's doubtful future. Above, the sky was a deep velvet blue, studded with brilliant gold stars in constellations that we had never seen before, at least in Connecticut! On the return drive to Quito, we lunched again with the Czech lady. She fed us real Hungarian *gulyas*, not to be confused with European and American goulash! She also gave us plum dumplings and introduced us to the famous local *naranjillas*, small oranges with a distinctive, spicy flavor.

A few days after we returned to Quito, we had a strange visitor. Emerging from our bedroom one morning to have breakfast, a somber figure in the anteroom stood up and introduced himself. He wore a dark suit, black shoes, a white shirt, and a black necktie, as if dressed for a funeral. He was a Senator from the Province of Esmeraldas on the Pacific Coast, which had been noted for its gold and emeralds since ancient times. The Senator had come to express his hope that we might intervene to stop the looting and destruction of pre-Columbian sites. A European company had permission to

build a road, and the bulldozers had opened ancient tombs in the cliffs along the coast. They were constantly uncovering valuable funerary vessels, gold, and even platinum objects that the workmen were looting, breaking the pottery, and burying it again to hide the evidence. Everything valuable was carted off, and perishable objects, such as textiles, were buried again with the pots. As long as the bulldozers continued their work, there was no opportunity to secure any scientific evidence, and thus the sites no longer had any archaeological value. Pál answered him regretfully that we had only a short time left in Ecuador and were going on to Peru and Bolivia for several months, which would make it impossible to present his case in Washington until July.

As we discussed the Senator's plea over breakfast, Pál recalled the work of Marshall Saville, one of the pioneers in American archaeology. His patron was George Heye, who had founded the Museum of the American Indian in New York. Saville had regularly published his findings from 1900 to 1929, and he had worked on the Ecuadorian coast at Manabí and Sigsig and was said to have a phenomenal memory of publications and objects, handling his knowledge with such ease and charm that he not only presented facts, but also offered suggestions for the scholars of the future. Projects for Esmeraldas were proposed in American archaeological circles in subsequent years, but unfortunately it took decades until something was really done. By that time, the sites in the Senator's province, like many others in Latin American, had been badly pillaged.

Another of our visitors was Edwin Ferdon, who was doing excavation and research for the Museum of Santa Fe, New Mexico. He was a disciple of Dr. Edgar Hewett, Director of the Museum of New Mexico, who had been such a help to us in his home state. Ferdon told us that he had finished his collection, amounting to almost sixteen boxes of archaeological objects, and we mentioned our visit from the Senator from Esmeraldas. Ferdon replied that he had seen the destruction on the coast. He said that the road reported by the Senator cut through the cliff in such a way that it left a stratified cross section of the mound, a perfect site for archaeologists. He had been warned that he might have difficulties sending his boxes to the United States. Having read in the newspaper about Pál's lecture at the Casa de la Cultura and reception hosted by Jacinto Jijón y Coamaño,

Ferdon hoped that Pál's influence might help him to export his archaeological materials. Jijón had to give the permission, and his reputation was that of a hard nut, very jealously guarding his country's archaeological treasures, the man who reportedly had squelched the creation of a public museum. Surprisingly, he was very receptive to meeting us, and we drove the next day to his estate outside the city, where he had a barn full of archaeological and colonial tidbits of his own. Ferdon presented his case with considerable humility and said that the objects had already been inspected and were ready to be shipped. The boxes were outside in the car, with an export permit, which had only to be signed by our host. Jijón cooperated, and Ferdon successfully delivered the material to the Museum of Santa Fe. Subsequently, his report was published in an issue of *El Palacio* that also had an article by Pál, a happy coincidence! Our own collection of books and some 400 photographs and films were sent off to Norfolk about then, as well. It had been hard to find as many books as in Colombia; the Ecuadorians seemed to write less, and the few authoritative works came out in editions of only a few hundred copies, to be given immediately to friends.

Another town reportedly worth visiting was Cuenca, at an altitude of 18,400 feet and surrounded by a chain of high mountain peaks, which made flying quite hazardous. We were advised that it would be safer to go down to Guayaquil, Ecuador's harbor on the Pacific Ocean, and fly to Cuenca from there; the planes maneuvered through the only opening in the chain of mountains, where this was possible without instruments. Most of the flight was over dense banks of clouds, but at the right moment, a miraculous hole appeared, and suddenly we were there! The valley, where the city was located, was sweet and friendly, with a relaxing climate similar to Popayán's. We had an introduction to a young American geographer named Besile, and his wife, who had actively searched for quinine during the war. Since prehistoric times, Ecuador (and especially Cuenca) exported quinine. (Later, another export was coca leaves, and we saw Indians and *cholos*, as the *mestizos* were called in certain parts of South America, constantly chewing them, to relieve hunger and fatigue. It was a practice that would be very difficult to eradicate, because the leaves could be smuggled so easily that it would be hard to establish any effective control over the commerce.)

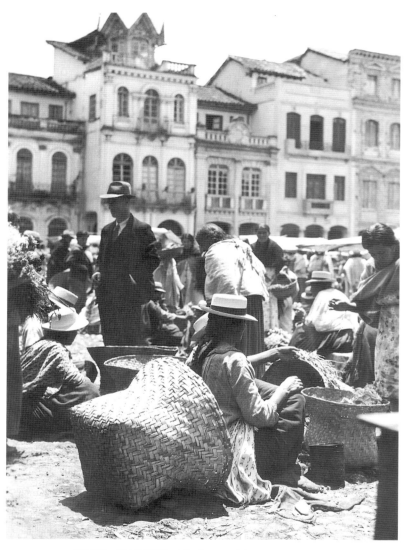

FOOD MARKET AT CUENCA, EQUADOR.

ROCOCO ORGAN (CIRCA 1739)
AT THE CUENCA CATHEDRAL.

and work could be done only when the air was damp. The rims of the hat were often left unfinished until after purchase by the dealer, who had his factory workers block and decorate them. The women's costumes were charming and colorful. They wore two skirts of different colors, the lower one embroidered at the edge, the upper one slightly shorter and tucked, sometimes gathered up in *pañeras* in the eighteenth-century manner. A tie-dye blue and white shawl was worn, with heavy lace on the ends obligatory, and over that a bright wool shawl. A Panama hat went on the head, without a band or a blocked shape. The babies were wrapped in white wool shawls with flowered edges that hung below the mother's "carrying cloth." Although it was Easter time, we only saw one desultory procession. But the *santos* were all decked out in miniature Panama hats, which gave them a very perky appearance!

In the early seventeenth century, Cuenca had 500 Spanish inhabitants, attended by countless mulattos, Negroes, and Indians. It was known as a city proud of its Spanish heritage. As was customary in other cities, when there were too many girls in a family to find the right kind of husbands, some of them became nuns. Young widows would enter the convents as well, and the Prioress was happy to welcome them as lay sisters, when they had enough money to contribute. The ladies were adept in the creation of artificial flowers, embroidery, delicious chocolate, and other delicacies. Parents were happy to see their daughters well taken care of, without the troubles

The Besiles hosted us for the weekend, and we explored the town and environs in their jeep, ending up on a nearby hill to get the lay of the land. The small city preserved enough of its rococo charm to be well worth the trip. Almost the first thing we saw was a native woman carrying a large package of elastic, undulating toquilla straw, which was kept moist in a special broth, to be woven into the hats that we call Panamas. The fine hats took over three months to weave,

of a household. The girls were not always on their knees or slaving in the kitchen, however, for the convents hosted receptions, where the visitors brought news of happenings in their families and the outside world.

A Jesuit chronicle, published in Europe in 1773, praised the musical talent of the Ecuadorian natives and related how many churches had their own organs and orchestras. We knew the great rococo organ in Cuenca's cathedral from a photograph. Built in 1739, and refurbished in 1925, its blue and gold paint and

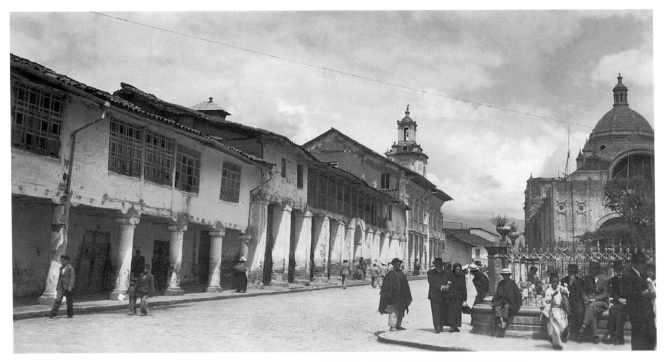

EASTER SATURDAY, 1945. STREET AND MAIN PLAZA WITH OLD MUNICIPALITY AND NEW CATHEDRAL IN CUENCA, ECUADOR.

silvery finish still enhanced the handsome interior. The organ occupied the center of a deep, wide loft, and its elaborate form and decoration suggested that it had been especially designed for that space. The only documentation referring to the organ was written in 1739 by the director of the church, a resident of Cuenca, and supposedly the designer of the organ. It still had more than 100 pipes. Small pictures of early instruments decorated the pipes, as well as painted and carved figures blowing little trumpets. Four large bellows fed it, two on either side, so that one man could work each pair. Its single manual had only two and a half octaves, but we heard it played, and its performance greatly pleased the audience, for despite its dreary, sleepy pace, the music filled the church with a resounding echo. This was only the second really old organ we had seen in South America; the other was in the church of La Merced, in Quito. Church music in the region usually consisted of a chorus and orchestra, rather than organs.

The grand finale of our long weekend was a visit to the Easter market. There was a great trading of Panama hat material and a large general market with food and such, but the textiles were the most interesting part. We bought a shawl with a white background; the main section was dotted with stylized corn motifs in indigo blue and edged with a line of women holding hands against an indigo background. Especially impressive was the long section at the end, the long warp threads intertwined into a sort of a lace with flowers and birds and ending in long fringes. The evolution of the almost universal women's shawl in Latin America indicated various changes in the last decades. In Guatemala we had found a shawl in warp ikat technique fashioned on a dark blue background. Again, the popular corn motif, with dots for the pollen, alternated with women's figures wearing typical wide skirts. The motifs were very large and the warp ends knotted into triangular scallops. They were very bold in contrast to the much more elegant work from Ecuador, but both were handsome in

their own way. Chronicles from the colonial epoch related that the Indian weavers often imitated fabrics worn by the Spaniards. Very happy with our purchases in Cuenca, we were ready to leave for the busy harbor city of Guayaquil.

We could gauge our departure by the fact that the plane flew over to the next station, at Loja, three-quarters of an hour before we had to leave for the airport, to make its return flight. This eliminated the sitting around at hotels and airports that we usually endured, waiting for the right flight and favorable weather reports. The landing in Guayaquil was quite perilous. The plane came in between two high slopes, over a deep gorge, and had to land at the very edge of the precipice, because the landing field was so short. Indeed, shortly after our visit, a private plane had been pulled into the gorge by an unexpected down draft, killing all its occupants!

The whole coastal line seemed to be one tremendous delta formed by the water that was coming down from the mountains. Looking out of the plane window, one saw ribbons and patches of water that seemed to have no beginning or end, deadly breeders of illness. Stepping off the plane, we felt as if we had walked into a furnace. Guayaquil was a pesthole until the 1920s, with malaria, yellow fever, and bubonic plague so prevalent that ships refused to put into port there. It was cleaned up by a Dr. Gorgas and his successors, supported by the Rockefeller Institution, and had become a sprawling, picturesque town, the largest in Ecuador. The houses were all two storied, with the upper one protruding to form arcades over the sidewalks. The whole upper walls usually consisted of windows, shuttered with wood but without any glass. The waterfront was in part a pretty park. The river flowed out with the tide and backed up as the tide came in, and on the surface, great masses of water hyacinths moved out and back, blooming with pretty lavender-blue flowers. The humidity seemed at saturation point all the time, including at night, and the thunderstorms from the mountain every afternoon cooled off nothing, but sent water vapor up from the sidewalks. Our salvation was a modern, well-run hotel full of tall electric fans, kept by an Englishman from Gibraltar.

We started right out the next morning, and obtained the address of a Swiss merchant who had lived there since 1912, and collected an unusually rich and important variety of archaeological materials. He invited us to see his collection in the cool of the evening, and in the afternoon we went to photograph specimens in the archaeological museum. There we were sought out by another Swiss, an oil engineer, an amazing and hearty fellow, who swept us into his truck and took us out to his apartment, where he showed us the most extraordinary pieces. In fact, a view of the fine figurines quite changed our idea of the artistic value of coastal archaeological remains. Most of these were from Esmeraldas and Manabí. In the evening visit, we again saw some gems, above all a breastplate about $3 \frac{1}{2}$ inches in diameter, depicting a great circle in filigree, with a human head at the top. It was made of a combination of platinum and gold, so fine that the technical break could not be detected. In addition, there were other platinum and gold combinations, including one with a lovely, interlocking step design in two colors. There were also two tiny clay figurines of men paddling a canoe, enchantingly full of movement, and a whole sequence of little heads, monsters, and interestingly shaped pots. We made arrangements to photograph practically everything all of the next day, but it was not to be.

At 10:00 the next morning, we received an announcement from the Pan American office that they could not take us on the plane the next day, but they had made reservations for us a week later. We went to the office to protest but found no one there but clerks, who said all orders came from Lima. Finally, an assistant manager gave us the tip that, if we could be packed and ready within the hour, we could board a special plane coming through late from Calí. We both were quite ill from the sudden drop from the high altitudes to the muggy coast and realized that we could not wait so long. It was a tremendous scramble packing up everything, but the plane waited for us. We climbed up the emergency hatch, and the instant the door was closed, the motor flared, and off we went. It was a most beautiful flight. The Ecuadorian jungle was left behind, as we swung out over the sea. When we saw land again, it was the Peruvian coast, at the northern limits of the Chimú kingdom, dry and barren. A river wound down from the highlands, invisible through the boiling clouds. The land was green and fertile, and dotted with charming villages. We could immediately comprehend the cultures of the river valleys, as they developed in relative isolation from one another. We made only one landing, in an oil field, with an impressive length of

asphalt pavement leading to nothing but a few sheds. As the afternoon went on, we flew along the coast, over a strange strata of fog and clouds that was constantly changing form. Sometimes in the distance, at an incredible height on the horizon, we glimpsed snow peaks and the 12,000-foot highlands. The drifting sand along the coast also looked like snow. Half an hour before Lima, the landscape turned green again, due to intensive irrigation, and red hills were piled up against a horizon studded with silver clouds.

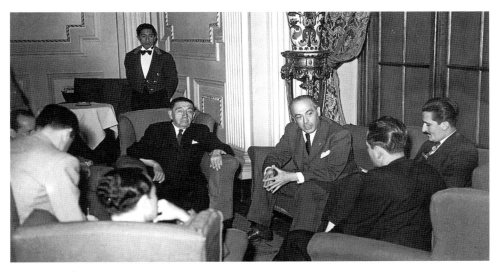

PÁL, SEATED THIRD FROM RIGHT AT A PRESS RECEPTION AT THE HOTEL BOLÍVAR IN LIMA, PERU, ON JUNE 20, 1945.

LIMA, THE PACIFIC COAST, AND AREQUIPA

UPON OUR ARRIVAL in Limatambo, Panagra's publicity director, Dr. Quimper, was waiting. He escorted us to the Hotel Bolívar, which turned out to be one of the best hotels on our whole trip. Dr. Quimper announced that he had set up a reception the next day to introduce us to a group of Peruvian archaeologists, art historians, and embassy people. But Pál had not weathered the trip very well, so he went to bed at once, and did not make it down to the street for five days. His stomach was so upset from all the activities and changes of altitude that he couldn't even eat the mildest food from the hotel kitchen. In desperation, Elisabeth went out to a delicatessen and bought American canned goods, such as creamed soup in a can, salt crackers, cocoa mix, and canned fruit. Meanwhile, the American Embassy sent people to meet us in a room off the lobby, so Pál dressed up and went down, but returned to bed with shaking knees immediately afterwards.

The hotel faced a large plaza dedicated to the revolutionary hero, San Martín, whose statue stood in the middle of an elegant garden. He sat on his stalwart horse, crossing the Andes to join up with Simón Bolívar. One of our first visits was to the Council for the Preservation of Spanish Colonial Art, located on the same park. The Council had booklets and photographs aplenty, but mainly of the area around Lima

and the coast, rather than what was in the mountains, which was more interesting to us. Soon we realized that the material we had already accumulated for the two-volume survey, *Medieval American Art*, had covered all of the important pre-Colombian sites in the coastal region. The Peruvian capital was one of the places most prone to earthquakes, and their ravages showed all along the coast. It was depressing to go along the coastal towns and encounter either fallen roofs, with the sky looking into the structures, or recently restored buildings that were overdone and had lost their artistic integrity.

Lima was an extremely important city because of its harbor, Callao, where much of the silver, mined in the high Andes, arrived to be loaded into whole convoys of ships. Ship captains who were lucky enough to have been there more than once, carried commissions from monasteries and nunneries back to Spain for church furniture, art work, and vestments for the growing number of wealthy churches in South America. An example of the works that were sent from Spain are listed in documents in the archives of the Hispanic Society in New York; they show that in 1598, King Philip II sent carved, gilded, and polychrome wooden tabernacles by Juan Martínez Montañes for the South America Dominican monasteries. Similar documentation covered all the imports, but after the

Revolution that swept Peru in the early nineteenth century, such reorganization took place that the local documents were, in most cases, not indexed or available to investigators.

Lima was called the City of Kings, and as such received all the privileges that kings, viceroys, bishops, and cardinals were entitled to. At the beginning of the colonial period in Lima, the Dominicans, Jesuits, and Franciscans vied with each other to spread the new religion. Lima was a walled city planned by the architects of Charles V, and the principal streets led off the Plaza Major. When we were there, a few city blocks still preserved the original city plan, and many shops stood in their old locations. Some buildings had been restored and others reconstructed, and we could easily imagine the atmosphere of the epoch. During our visit to Lima, we were presented with a luxuriously printed guide enumerating fourteen banks in Peru, in the year of 1937. That impressively large number illuminated the fact that three oligarchies controlled the economic life: the sugar planters, the banks, and the newspapers. Peru, at least during World War II, tried to appear very civilized and under control, and its leading citizens wanted to make a dignified, cultured impression. What was behind the official scene was not acknowledged.

In a number of places in South America, an ingenious way had been found to roof the churches that had been damaged by earthquakes. A type of reed with a tough exterior was strung in bunches, like the curtains used in tropical countries. It was elastic and yet solid; first it was stretched and covered with a woven material, then it was whitewashed to give the effect of plaster. When an earthquake tore the fabric on one edge, it hung down and allowed a view of the construction methods. It was a pathetic and common sight, for Lima suffered from ever-recurring earthquakes. Only a few of the original religious and civic buildings were left, as the colonial style did not survive later European influences. Lima tried to be a City of Kings and copied European metropolitan capitals; a dominant minority tried to degrade what the colony had produced. We were able to envision the attractive, earlier city from engravings, woodcuts, and other pre-photography era pictures. Cuzco had suffered the same kind of tasteless, even poisonous restoration after an earthquake, and North Americans who were involved deserved some of the blame.

Our days in Lima were extremely full and enjoyable. The climate was simply strange: aside from an occasional morning fog, there was brilliant sunshine, and the temperature was like that of a warm September day at home. It was extremely damp, and whenever we got out of the breeze or into a closed room, it was steamy hot. But the nights were chill and even the shady side of the street made us shivery. People told us that, when we returned from the highlands in June, there wouldn't be any sun at all, but fog all day long. Then, people wear coats to formal dinners, and all the closets mildew! Yet, only an hour away by car on the side of the mountain, the sun would be shining. The suburbs of San Isidro and Miraflores were charming, with each house in its own big garden. The poinsettia trees were in bloom and the geraniums were set out for winter bloom, as they like dampness. At the foot of some streets, we caught a glimpse of the blue Pacific. As elsewhere along the coast, bathing was limited to specified beaches, because of the dangerous seas. Life in Lima still kept its colonial formality, so the season closed on a definite day, regardless of the weather. But during the heat, the stores all closed for three hours over noon, to give everyone a chance to go to the beach.

The Committee for the Preservation of National Monuments in Lima was refreshingly active. When the great earthquake of 1940 destroyed so many of the old buildings, a photographic archive of the Lima churches had just been started, and with the help of the photographs the most important ones could be restored. Although the restorers were somewhat given to "cementization," as Pál called it, they had a strong feeling for their colonial art, and also applied this developed taste effectively to their modern buildings. We collected a vast amount of photographs, especially of places we could not visit. Peru had been much photographed, but many gaps still awaited attention, and Elisabeth was anxious to turn her own lens on some of the provincial churches. Dr. Julio Tello was rearranging the archaeological museums, so we were not able to see as much of the material as we would have wished. We hoped to see more on our return from Trujillo and the highlands, at which point we would know better what we were lacking. The best colonial material, aside from altarpieces, seemed to be in private homes. Through the preservation committee and our special American friends from the embassy, the Marvin Patersons, we had several invitations to visit

HACIENDA MARANGA (PRIVATE HOUSE)
IN LIMA VALLEY, PERU.

The unsung hero of Hispanic colonial art in the New World was the excellent scholar and teacher from the University of Michigan, Harold E. Wethey. His career was dwarfed by the German refugees, who had decided that Michelangelo, Rembrandt, and the masters in other threshed-out chapters of art history were more important than the art and architecture of the once-glorious Holy Roman Empire of the German Nations. The Empire was so wide and famous that it was called "a world where the sun never set." One refugee admitted that for him Hispanic art was "peripheral," and he had never visited the Iberian Peninsula. Some contemporary U.S. academicians even attacked the use of the term *mestizo* art, a widely used expression for the blending of Spanish styles with native sensibilities. After the resignation of Professor Pope at Harvard, who had published fifteen books on Spanish art, the University's Department of Humanities dropped the art of the Iberian Peninsula, which had influenced many other European countries but was seldom credited. While visiting various buildings whose reconstruction was paid for by living people (some we knew), we were impressed by the lack of colonial flavor, delightfully evident in more northern countries. The condition of those so-called Peruvian colonial buildings was deplorable. A typical sight was the center of the room swept clean, and against the walls an inharmonious arrangement of fragments from choir stalls and other ecclesiastic furniture. Some of the fragments were not even colonial! Nevertheless, Wethey's inspired book on Peruvian painting, architecture, and sculpture showed the great patience he applied to work in the archives and with local historians, to search out and recount the long, tedious story.

Lima still had two buildings that gave a glimpse of the magnificence of the colonial city. One was the Torre Tagle Palace, built by the family whose name it bore, in the early eighteenth century. It still emitted the flavor of the epoch, an elegant building that never became a religious establishment, which was unusual. The owner, a Spanish knight, who was Captain of the Lancers, after successful exploits in Chile, was given the highly lucrative position of Permanent Paymaster of the Royal Armada of the South Sea. The family was granted the hereditary title of Marqués, and their high standing and wealth permitted the rich embellishment of their home, in a delayed baroque style at a time, when the rococo was

some of them. There was more international commerce in books than we had encountered elsewhere; we were constantly hunting for publications and collected some very enticing titles. Elisabeth wrote to our secretary to compare prices in Lima with those at Wittenborn and Company in New York, namely for Angel Guido's *Redescubrimiento de América en el arte*, Buenos Aires, 1944, and the *Historia del arte hispánico*, Barcelona, 1931–45, by the Marqués de Lozoya (Juan de Contreras).

already in fashion. There were even *mudéjar* influences to be seen in the galleries, and the facade had marvelously carved, closed, wooden balconies, once popular in much of Lima. The brackets and balustrades also showed the influence of the Muslim carvers, who left their style and traditions stamped on Spain and its colonies. Luckily, the earthquake of 1746 did not wreck the Torre Tagle's exquisite ensemble. The edifice served as the presidential residence and, at the time of our visit, housed the Ministry of Foreign Affairs.

The other building of special interest was the Quinta Presa, farther out from the congested downtown. It also had a strong *mudéjar* influence, especially in the garden, which offered an expansive panorama with its open arches, balconies, and wooden railings. Once water flowed through open stone basins in front of the house, making the walks into little bridges. Originally, the house was built of brick and adobe faced with stone, and decorated with stone, fine woods, and tile. Large bay windows with dark frames were remarkably effective against the pink and white plaster walls. The interior of the house was equally as elegant and complex in its architectural decoration. Mirrors and fine paintings decorated the walls, and the furniture was so well designed that it would serve handsomely in any salon of today. The great reception room on the second floor had undulating moldings, paneled doors, and gilded ornaments, which produced a rococo effect.

At the back of the villa was a covered verandah almost as spacious as the interior, with a charming view of the garden. It made us think of a sixteenth-century Persian pavilion. Wonderful parties must have taken place there! The property was built in 1766–1767 and owned by Count Fernando Carillo y Albornóz. It was the setting of a romance between Viceroy Manuel Amat y Juyent Planella Saymerich y Santa Pau, reputed to have drawn up the plans for the house, and the seductive dancer and actress, Micaela Villegas, better known as "La Périchole." The affair was immortalized in popular literature, and Offenbach composed one of his light operas around her life, called *La Périchole*. The actual amorous affair of the viceroy and the actress, and how large a role the house played, perhaps was embellished by legend. But standing in the garden with its musical, flowing water, we could readily imagine the scene by candlelight and believe in the love affair between the *mestizo* actress

and the Spanish aristocrat. The lovely house preserved one of the last flourishes of viceregal Peru.

The notices that we got in the newspaper brought us visits from Lima's authorities on archaeology and art. The Swiss concierge in the Hotel Bolívar handled the visits, and on the third day he asked our permission to send up some dealers. Among them was an especially well-informed Polish dealer. He brought some interesting metal pieces and another time a red seashell with a carved human figure on the inside. It had a square head, slit eyes, and crossed arms holding what looked like a chair. The dealer said that he had a whole bag of such shells carved with figures, and had sent them to Sam Lothrop at Harvard, who said they were fakes. The dealer argued that they could not be fakes, because he paid the equivalent of ten dollars for the whole bag! Notwithstanding the low price, the virtuoso carving and remarkable visual effect showed that the carver knew exactly how to achieve his desired effect. The lines were without any hesitation, and the coloring was well done. Proving that the pieces were not fakes, some time later a cache of the same type of object was found on the southern coast. Most of the collection landed in the United States, and the Museum of the American Indian owned a similar object from the Pacific Coast.

After we had been ten days in Lima, Rafael Larco Hoyle, one of the most important sugarcane plantation owners, came to visit and invited us to visit his home in Chiclín for three or four days. He said that he had also invited the architect Rafael Marquina y Bueno, President of the National Council of the Restoration of Historic Monuments, thus adding to our anticipation. We made the trip in early May, after the concierge got us a car. Gasoline was obtainable, but tires and spare parts were miserably scarce, due to the impossibility of importing anything during the war. But we started off cheerfully and went to pick up Marquina. He stood in the gateway of his residence on the west side of the city with his little satchel, like a soldier getting ready to march. Pál sat beside the chauffeur to have a better view, and Marquina sat with Elisabeth in the back. He turned out to be a very delightful and energetic fellow, probably in his late fifties. As the car rolled on, Marquina told us he that he had earned an American diploma in architecture and had also visited Europe, mentioning especially that he had lived in Paris. He

suggested that we speak Spanish and English for alternate hours, a good exercise for him as well as us, because his English had become rusty. He was a tremendous asset on the trip, sharing our taste and showing us remote, unknown spots and fine details that we would have missed otherwise.

The Pan American Highway ran straight as a die for miles along the coast, and in spots the sand had drifted high over the road and beyond. An American snowplow was moving along the road to keep it passable. Our driver stopped every hour to check the condition of the car's worn, old tires, as the hot air and the burning sand could put too much pressure on them. The route was broken by a succession of deep valleys, carved by the melting water from the Andean snows. In the background, four and five tiers of hills piled up, one behind the other, until the top one was lost in the clouds. There was a lot of trucking, with people flapping about on top, also many buses, carrying both passengers and freight, and some speedier ones known as "expresses." In a land where there was practically no rain, the valleys were surprisingly beautiful and green, each with its isolated villages and farmlands. At first there were cotton plantations, and rough bales of cotton lying near the shore to be picked up by barges, without any fear of spoilage, since there wasn't any rain. Later came the juicy green of the sugarcane fields on the huge Grace Line plantation. Since it never rained, there was no rush to cut the cane at any given season, and the even temperature allowed new crops to be planted at any time of year. The hotel had furnished us with a lunch, and when we reached the village of Chimbote, Marquina recommended stopping there. We went into a little inn by the wayside to get out of the burning sun. The air was stuffy, and there were so many flies that they even crawled under our glasses and into our eyes! The noise of a Wurlitzer added to the discomfort, but we unpacked our sandwiches. Elisabeth waved a handkerchief with one hand and grabbed a sandwich with the other, drinking her coffee from the back end of the cup. We wondered when the poison would take effect!

The journey continued under a gray blanket of sky, and then there was a split in the clouds, and sunshine illuminated an area to the north. Suddenly, a pile of golden terraces loomed against the sky, and we both shrieked joyfully, "Paramonga!" It was the famous ruin, also known as "La Fortaleza." This was the fortress that defended the southern frontier of the Chimú kingdom. As we came nearer, the outline of the fortress, the straight lines of the construction, and the four lines of defense could be clearly observed. We recognized the advanced type of construction, and later agreed with our friend Marvin Patterson, the U.S. Military Attaché, that if it had not been built of adobe, the fortress would have been an impregnable bastion of defense, at least until the First World War. We piled out of the car and circled the ruin, and Elisabeth immediately took at least a dozen pictures. The shadows were grand and dramatic. The three terraces once were each painted a different color, red, blue, and yellow, of which traces still remained. In the mid-day light the colors still created a harmonious total, emanating a magical spirit over the place. There were remnants of fortifications all the way from the mountain wall to the sea, about half a mile away, and the great fortress dominated the valley. It was placed for the best possible defense, even according to modern military strategy. When we returned in the afternoon a few days later, we were able to shoot views of the whole structure. It was, without any doubt, the most impressive pre-Columbian ruin that we saw on the coast.

We reached the noble town of Trujillo about 6:00 that evening. It was named for Pizarro's birthplace and synonymous with pride. Most of Peru's aristocratic families first lived there, as the climate was better than Lima, milder, and less foggy. Characteristic were the señorial houses, each with its great, rather severe portal, flanked by windows with grilles on each side. Inside were a patio, and a charming, columned portico leading into the house proper. The churches also had many treasures, namely San Francisco, with two side altars of bas-reliefs, much like the famous St. Francis in Bogotá. However, the Trujillo altarpieces were without gilding or polychrome, but were remarkably well organized, and effective in plain wood. One was dedicated to the Virgin, and the other to the life of Jesus. The next morning, we went about taking as many photographs as we could. A little before noon, we picked up Dr. Horkheimer, a German archaeologist and head of the local museum, who took us to Chan Chan, just beyond the city. The site was terribly ruined, not only by an unprecedented rain about twenty years before, but also because it was literally being turned over by treasure hunters. The site was so vast that it was impossible to keep it guarded, so nobody tried;

PÁL AND FRIENDS POSING
AT CHAN CHAN, PERU.

someone had counted thirty men digging there in bright daylight. When we remarked about the blatant pillage, Dr. Horkheimer said that Peru did not have enough soldiers and policemen to guard such ruins, and, "if we run them off, they will simply come back at night." A number of open spaces we passed were almost covered by scattered bones and broken pottery! But with the help of our expert guide, we were able to visualize the great city of the Chimú in full flower. We took in the various bas-relief arabesques, the vast proportions of the so-called throne room, the ingenious manner of laying adobe blocks, and the construction of storage rooms to withstand the all-pervading dampness.

Late that afternoon, we drove another half-hour north to Chiclín in the Chicama Valley, where we were cordially received at the hacienda of Rafael Larco Hoyle. Instead of a great hacienda house, as we would have expected, we were shown to the verandah of a one-story house in a row of identical dwellings. Each member of the family had his own home, for Larco Hoyle had turned the hacienda over to his three sons. We were served a delicious "lemonade" from the juice of a melon called "tumbo," and then shown to our apartment. Because of mosquitoes, and the dust that came straight from the Pacific dunes, there were no windows, only doors leading from one room into the other. Each room was lighted by a glass turret, opened and closed by cords. Our furniture had belonged to the Sultan of Morocco, and was made of variously colored woods with extravagant inlays of ivory, perfect for that exotic setting. It must have been a souvenir from an African cruise, when our host went traveling with his young wife.

The arrangement and classification of the pre-Columbian collection was entirely the work of the eldest son, Rafael Jr., an able archaeologist. He was a graduate of Cornell in agronomy, and his great knowledge of the flora and fauna of the district helped his work considerably. Their mother had died when the three boys were very young, and they were all unmarried, with their father making up a male quartet of unusual intelligence, good manners, and pronounced consideration for one another. Besides being Director of the Larco Hoyle Archaeological Museum, Rafael Jr. had his share in the running of the farm, a huge sugarcane plantation with cattle, horses, and pigs. It employed 3,500 workers, whose village we had passed through, as we drove to the hacienda. The hacienda had running water, and there were football and other playing fields, as well as a school, hospital, a hall where movies could be run, and a company store, selling its goods at cost. As a logical result, the Larco Hoyle workers were contented and remained on the place.

The museum was the main reason for our invitation. Larco Hoyle Sr. had given his workers orders, many years before, to bring in what they uncovered, while working in the fields, just as had the State Bank in Bogotá for their Museo de Oro. But Larco's men were instructed to bring in *everything* that was found. He paid good prices not only for pottery, but also for textiles, metal, and objects in wood, bone, and shell: the whole range of excavated materials. He not only bought what came from the hacienda, but also pieces from sites farther north; thus, it was quite a varied collection. The museum stood on the main plaza of the village, and its decoration was inspired from various Chimú and Mochica vases, both inside and out. It did not have any windows, and skylights lighted everything from above. The main part of the collection consisted of ceramics, well-kept and arranged by type. There were also a great many rare Chimú textiles, objects of wood, bone, and turquoise, and a big safe full of gold. A display of the ceremonial regalia of the Chimú kings was stunning; the pieces had been excavated mostly by treasure-

hunters around Chan Chan. While our appreciation of North Coast Peruvian art got a definite boost, we could still not work up the same enthusiasm as for a single good Maya jade! The Peruvian was an impersonal art, more craft raised to the nth degree, than high art, and we missed the particular spark of many Maya and Mexican pieces. Elisabeth took a number of pictures that evening and the next day, assisted by the in-house Japanese photographer and the caretaker, who changed backgrounds and arranged reflections and shadows as needed.

Rafael Jr. invited us to spend an evening with him, and hear his opinion about the pieces in *Medieval American Art* that he thought belonged to a different culture than we had indicated. That evening, we went to his well-furnished house with its large library. He had some amazing theories concerning the Moche and Chimú cultures, but his vast knowledge was based on a real talent for observation, and linking objects and ideas. He pointed out a number of pieces in our book that were identified as Chimú, and remarked, "these belong to another northern culture, called Cupisnique." Larco Hoyle explained that this region had been very little explored, and no systematic archaeological work had taken place. Pál made note of the plate numbers of the pieces in question and acted as though he accepted everything Rafael Jr. said, because it was after eleven o'clock. Our host had a different lifestyle than we did, and hadn't been running all over Colombia and Ecuador, absorbing new impressions! We were relieved, when he closed the book and said, "I will go to Harvard myself and will tell them what I have told you." Indeed, he went up to the Peabody Museum at Harvard and presented his case, and his new nomenclature was accepted.

Our host remarked on one of the pleasant evenings during our visit, that, while it might be very pleasant to give hospitality to knowledgeable people, when the collection became better known, it would bring tourists, and a wider range of visitors, than could be welcomed at the hacienda. In later years, the Larco Hoyles built a museum in Lima and transferred their entire collection. What made the greatest impression on us at their hacienda at Chiclín was the humanistic spirit, which the distinguished head of the family had implanted in his three sons. The experience was the second high peak in our journey, the first having been the Museo de Oro in

Bogotá. We left with five pounds of books, all publications of Rafael's, and a basket of lunch for the trip back, which we enjoyed eating at the harbor of Chimbote, about halfway back to Lima.

We had heard about an extraordinary collection of paintings in Lima that was not to be missed, and we were pleased to be invited to tea by its owner. Pedro Osuna, a pleasant, unassuming young man in his mid-30s, was considered to be Lima's most eligible bachelor. He called himself just a simple *minero*, or miner, but we found out there was a street named after his father, an owner of valuable lead mines! We arrived at Osuna's to find a manservant waiting at the gate. As it never rained in Lima, people did not drive to the front door of the houses, but got out and walked through the gardens. We entered a large Italianate villa, but like most of the mansions in Lima, definitely not a grand palace. The picture collection began right in the front hall and was a bit overwhelming for its lack of organization, as the paintings were apparently hung up just as the collection grew. Pedro had assured us that he would not invite "anybody," and let us browse about at will. But by the time we reached the fourth hall, we were joined by his sister and his aunt, a delightful, energetic old soul in the best Victorian tradition, the founder of a very active women's club. Then appeared a newspaper friend and a belle from Argentina, the latter very ill at ease among all the art. Marvin Patterson and his wife were also there, and a snappy, elderly lady connoisseur, together with a few more of Pedro's friends. The connoisseur commented to Pál, "You know, one of the things about Pedro's collection is the way it is beginning to cover up the house." Perhaps all the friends were needed, as well, to fill those pompous halls!

The house opened onto a large, square garden with many palms. Along one side ran a row of shuttered rooms, perhaps bedrooms, all on one story. At the far end was a pretty pavilion, reached by a large double stairway. Through the tall windows we could see the servants moving about the dining room. About 7:00, we all made our way amid the palms and floodlights to an enormous oval table laid out for tea, with a lace tablecloth and silver. Elisabeth counted sixteen beautiful platters of different Peruvian sweets. There were miniature sugar cookies stuck together with chocolate and jam, a rum soufflé inside a flaky crust, and the best was a nut paste rolled in dough forming tiny crescents, dotted with burnt sugar. After much feasting

and considerable chatter, Pedro suddenly leaped to his feet and announced, "Now we are going to see the underground passage." There really was one, at the foot of the garden, beyond the tennis courts. It led to a small, charming guesthouse in the most modern style, with rooms flowing into one another, and an outdoor living room facing a small patio, replete with fountains. It had its own gate to the street but no connection to the big house, except the underground passage. The walls were decorated with only modern paintings. It was a very worthwhile experience. After that first ceremonial visit, we returned when we could be alone. We selected what to photograph, and Pedro acted as Elisabeth's helper, setting the paintings in the good light out in the garden.

A few days later, we had a long ride into the hills with Dr. Howard Nostrand, the U.S. Cultural Attaché, and his wife. It was a strange but beautiful landscape. We followed the turbulent river up a slanting, narrow valley that soon became a gorge, to a height of over 8,000 feet in less than 75 miles! It was fascinating to see the demarcation line between fertility and barrenness, where the irrigation canals were led along the side of the hills. Later we ran into clouds, more dampness, greenery, and terraces constructed in the ancient manner along the sides of the hills.

One day, we enjoyed more of Lima's sharp contrasts, with tea on the vast sofas of the National Club, and then rum at the artists' hangout, named for Peña Pancho Fierro, the nineteenth-century caricaturist who worked in the style of the French artist Daumier. There we met a group of pleasant and serious people, far less self-conscious than their Mexican counterparts. There was a fine collection of ethnological objects: animals, figurines, gourds, and woodcarvings from various parts of the highlands.

By then we had been in Lima and its environs for more than a month, and had seen the public collections, as well as many in private hands. Compared with Middle American pottery, the Peruvian material made a strong impression on us. In Peru, there were also forms executed without the wheel that represented people, fish, cats, and vegetables, including potatoes and corn, as well as other commonplace subjects. Some pottery was painted, but a less personal involvement by the artist contrasted with the beautifully painted or engraved (some even in relief), cylindrical Maya vases. The latter illustrated the story of religious ceremonies and gripping dramas with eloquent, fluent lines and gestures. The Peruvians' imagination and artistic ability reflected very different traditions. Some pieces were very poignant, and their observation of nature was amazing. Both the scenes of the Maya and the sculpted pottery of Peru presented a realism all their own.

The colonial sculpture in Peru was quite dull compared to the inspired work in Quito. On the other hand, the paintings demanded more and more of our attention. They were mostly of saints and Holy Families, in a strange mixture of "sophisticated realism," with sparkling eyes and carefully foreshortened hands. The costumes were encrusted with gold and jewelry until they literally stood out from the canvas. Some of these were brought enchantingly up to date, such as a figure of Santiago Matamoros killing the Turks, in a powdered wig and cocked hat. There were a few interesting portraits as well, and the colonial silver had great charm. Every imaginable household article was made out of silver. Special filigreed religious incense burners depicting fantastic figures of deer and turkeys were carried in processions by the lady of the house and the servants. The men carried enormous flower-painted trays heaped with flowers, to strew over holy images as they passed by. Horse trappings were also elaborately decorated with silver, from bridles and stirrups (the lady's often in the shape of a silver shoe), to saddles and the horsemen's costumes.

Dealing with less artistic concerns, our on-going correspondence took a few days to settle. Macmillan wrote Pál all kinds of pleasant things, but still had not answered his refusal to accept their proposition for the third printing of *Medieval American Art*, for which we had requested more money for the plates. We sent off our first crop of over 400 photographs of Peru by embassy pouch, and twenty-five pounds of books by parcel post. Our eighty-four photographs from the trip to Trujillo included some wonderful shots, among them very difficult church interiors, and archaeological material. And we still had not seen the most interesting regions! Fortunately, we had bought many photographs of the most important sites, in anticipation of our trips there.

Our journey was moving toward its climax. Since we were planning to spend several weeks at the high altitudes of Cuzco and

La Paz, we followed good advice to spend a few days in Arequipa. What a magnificent view on that plane ride! If an artist were to paint that country, he might fill a canvas the size of a wall with enormous mountains, gray, yellow, and purple, with eroded slopes, a frill of sea in the foreground, and a dash of snow along the top. Then he would paint a miniature bright green oasis, with a stream fed by melted snow running through it, animals, tiny people and houses, and a frosty-white, carved stone church. Arequipa was one of the most enchanting places we had ever seen, and our first impression from the air was borne out by the five-day visit.

About 8,000 feet high, Arequipa enjoyed the brilliant sunshine and translucent colors of Lake Atitlán in Guatemala. It lay in the lap of three great mountains, the nearest a beautiful, snow-capped volcano 19,200 feet high, called "El Misti." From there, the earth slanted away to eventually reach the sea, so that Arequipa was not in a valley, but in a serene, wide-open landscape. We found the dry air and sunshine most welcome after the dampness and fogs of Lima. The city was a stopover for travelers headed for higher altitudes, and an ideal vacation spot. Founded soon after the Spanish Conquest in 1540, but isolated for centuries, Arequipa developed a distinct intellectual life and traditions. At the end of the last century, an English company put a railroad through from the port of Mollendo, but until the airplane arrived, the trip by train from Lima took two days.

The mountains in the area had quarries of white and grayish-pink volcanic rock that furnished building materials. Arequipa was dignified architecturally, but its general impression was not overly somber, because of the many gardens that bloomed all year. Despite the restoration that was necessary after major volcanic earthquakes in 1600, 1687, and 1868, the city retained much of its colonial character. Enlightened local businessmen had seen to the preservation of the old buildings and used them as offices, as well as residences. The intricate and delicate stonework that adorned the buildings was facilitated by use of the local soft volcanic stone. The Indian artisans translated designs from ornate silver work into architectural decoration, a style known as plateresque. The leafy scrolls and grotesque figures, thickly intertwined with open flowers and lacy frills around the edges, was a recognizably distinct and truly *mestizo* style.

We settled happily into the government tourist hotel on the edge of the city, with a wonderful view of El Misti's perfect cone. Soon after arrival, we met a Mercederian monk, the editor of Arequipa's Catholic newspaper, and a knowledgeable and enthusiastic historian. He was transcribing the ancient documents of his Order to furnish data on the colonial period. He took us around to see many things that we would have missed. Eight great, seismic catastrophes had left their mark on Arequipa. Of the churches, only the Jesuit's La Compañía, established in 1698, and known also as Santo Domingo, retained some of its colonial vestiges. Fortunately, the main facade had been so well restored that it did not even show any cracks. The elaborate stonework flowed together as though made of a single stone, for the soft volcanic stone hardened with the ages. Atypically, the main portal faced a narrow street and was notable for its pediment with a bold carving of Santiago Matamoros. Also striking were two mermaids playing the native *charango*, the small, banjo-shaped string instrument, still encountered in the high Andes today. The side portal faced a larger atrium, actually a small plaza, and was even more prominent and ornate. The stone carving showed great vitality and contained numerous decorative motifs of the *mestizo* genre in the Andean area, repeated in stone, wood, silver, and textiles. On either side of the portal, the date 1698 was inscribed on fancy framed medallions.

The church roof was distinguished by a sturdy row of domes that covered separate little chapels, and a staunch barrel vault (typical of the Andean region) was still intact, although the adjacent cloister was in ruins. To get as full a photograph as possible of the strikingly beautiful and original facade, Elisabeth decided that she would have to climb to the roof of the opposite building. She called for a ladder and was able to get a favorable position. The result was valuable, because not many years later, another violent earthquake took down the two sides of the church, leaving only the central portion of the facade intact. By the second half of the nineteenth century, Arequipa had become a well-known showcase. The colonial residences preserved the reconstructed, embroidered stone facades, walls, and gates, thus perpetuating the harmonious beauty of the city. Tragically, major earthquakes struck the city again in 1958 and 1960, causing severe damage, but each time Arequipa was restored.

CUZCO AND MACHU PICCHU

FROM AREQUIPA WE WENT TO CUZCO, the ancient capital of the vast Inca Empire and the first capital of the Spaniards, high up in the Andes at 11,000 feet. Fertile agricultural valleys and frequent caravans carrying minerals from the Andes to Lima maintained the city's prominence all through the colonial era. We made the trip by night, having been told that the narrow gauge railway had to cross a 15,000-foot pass on the way to Juliaca, and we might get mountain sickness. In a compartment in an almost miniature Pullman car, we slept like logs and crossed the pass without even realizing it. At 7:00 in the morning, there was hot water and breakfast on a tray. Ice lay in spots on the ground at the Juliaca station, very cold at 13,000 feet high. Indian women were selling fruit and hot dishes, but their most attractive wares were little pottery bulls, famous to the region. On the other side of the tracks, a blindfolded donkey was pacing around and around on an old-fashioned threshing floor. On that high, treeless plain, rimmed by higher peaks on the horizon, we felt as though we were in Tibet. The Titicaca landscape's beauty is the crystalline light, which makes all distances evaporate. We wandered down the street to the parish church, to admire the handsome tower, tremendous, arched portico characteristic of the region, with flame-like finials sticking up all over the massive building, including the dome. Splendid stone barrel vaulting roofed the nave. The church was dated 1774 on the facade and dedicated to St. Catherine.

About 9:00, we went on to Cuzco in a "salon" car, enjoying the leather chairs and a hot lunch. Each station stop was as picturesque as in Mexico, with different native costumes. At one, the Indians were selling figurines of animals that harked back to a pagan fertility cult; they resembled ones we later recognized in Lima's archaeological museum. About halfway to Cuzco the landscape began to change, and we rolled through more fertile valleys. Looking up, we saw our first Inca terraces, and it dawned on us that the Inca land was orientated not toward the bleak south, from which we had come, but toward the north and the rich "Oriente," the slopes of the Amazon. The farms were not the barren fields of a folk barely scraping by, but were rich and cultivated with obvious care. Elisabeth said that it reminded her of Switzerland.

On the way from the Cuzco railroad station, which was rather removed from the center of the city and the tourist hotel, we had an overview of six centuries of architecture. A number of buildings stood on Inca foundations that consisted of irregular stones cut into roughly cubic shapes, some with sharply slanting sides. They presented a mosaic that seemed to have no system, not even ordered horizontal or vertical lines. It was a unique invention in building construction, the stone set without mortar, yet forming a tight, solid wall. On top of the base were adobe walls often covered with plaster and cracked open due to earthquakes. The roofs were thatched, tiled, or covered with modern tarpaper. The irregular streets, some cobbled, were far from clean. Soon we reached the lobby of the recently opened tourist hotel. The elevator had not yet arrived, and we had to be careful climbing the flight of stairs. The place was empty except for some Peruvian army officers, and the Swiss-Argentine hotel manager went out of his way to make us comfortable.

Since the automobile had only recently arrived in Cuzco, things were very quiet in the side streets, where we found some intriguing sixteenth-century palaces. They resembled the Pizzaro and other *Conquistadores'* homes in Trujillo, Estremadura, Spain, which were built from the riches of Peru. The Cuzco portals were decorated with Spanish coats-of-arms, and dragons and snakes probably of Inca origin. Near our hotel was a house connected in legends to the descendants of a noble Inca mother and a Spanish *Conquistador* father, Garcilaso de la Vega, who wrote *The First Part of the Royal Commentaries of the Yncas*. Earthquakes had loosened the bind between the stones of its outer walls. Inside was a large, open courtyard, with a restless mule on a chain and a few potted plants. A rickety wooden stairway led to the upper story, where laundry was strung up.

There was not much life to be seen that cold morning in the huge Plaza de Armas that once pulsed with ceremony and commerce. A mood of medieval abandonment emanated from the scene. We got directions to the office of the Archbishop and paid him a visit. He received us kindly, and gave us a pass that allowed us to photograph anything we wished in the churches, and we began using the camera immediately. Our only limitations were those of the altitude, and we had to rest every morning and afternoon. The

PANORAMA OF CATHEDRAL COMPLEX (1543) IN CUZCO, PERU.

brown andesite stone facade was restored after a quake in 1940, and in 1950, one of the towers collapsed. The cathedral complex included the connecting, smaller, eighteenth-century churches of El Sagrario (also called El Triunfo) and La Sagrada Familia (the Sacred Family). Inside supposedly lay the body of Peru's Conqueror, Francisco Pizarro, who was murdered in his palace on the square. Monumental, cruciform stone pillars sustained Gothic brick vaulting. In the afternoon, the slanting rays of the sun penetrated the upper sections, and a golden dust seemed to vibrate through the arches and fall over the polychrome statues, faded paintings, and bizarre wooden decorations,

churches were built of square stones, often Inca-cut, with square towers and twisted columns. Many were basilicas and, instead of ornate side altars, they had two rows of enormous canvas paintings down the side walls in heavy gold frames, with overhanging cornices and jutting candelabra in front that must have meant for very effective lighting.

On one side of the plaza stood the noble, weather-beaten cathedral, begun in 1543, on top of a low platform over the ruins of the temple of the Inca creator god, Viracocha. The imposing church was a source of inspiration for the entire region all through the colonial period, and was rebuilt numerous times due to earthquake destruction. The version completed after the especially destructive shock of 1650 cost the equivalent of two million dollars! The rich

carved by Indian and *mestizo* craftsmen. Especially notable were the finely worked, tall iron grilles closing off the side chapels. An ancient colonial altarpiece set up at the end wall was unusually rich, with multiple niches and caryatids. Its elaborate wooden scrollwork was doubtless of local origin. With the Archbishop's permit and long ladders, we took down several large canvases to photograph them in better light. One Madonna especially took our fancy, since she was in the orthodox dress of the Immaculate Conception, but her facial expression was more on the piquant than the holy side! The cathedral boasted two early organs, one a gift from the Spanish Royal Family in Flemish style, and probably constructed in Europe; the other was of local construction, and one more proof of the advanced skills of the native craftsmen.

One of the most intriguing works of art in the cathedral stood in a special chapel, a statue called the "Christ of the Earthquakes" that was believed to have miraculous powers. It reportedly was taken out of the church during the terrible 1650 earthquake, and caused the temblor to subside. It survived the quake of 1950 and was placed in the center of the main plaza, and was still carried in religious processions on men's shoulders. Prayers are said before the statue whenever an earthquake threatens. It had the marks of a colonial work, although tradition told that it came from Spain. Usually it was clothed in a short lace garment, but during holy festivals a long satin one was substituted. Many paintings were made of the image as it stood in the cathedral, amid flowers, candles, hanging candelabra, and mirrors. The paintings were distributed far and wide for local earthquake relief, since the statue could not travel to all the places where it was needed.

Across the plaza was the massive building of the Jesuits, La Compañía, completed in 1668, and connected to their former college and living quarters. It was one of the most artistic and impressive churches in Peru. The harmonious design of the facade, in spite of heavy decoration, unified the entire structure. The windows had cornices like eyebrows, and the two towers had small finials that lightened its weighty appearance. The massive cupola had been constructed with the same dignity permeating the rest of the building. The wear of centuries was very evident in the interior, but some of the side altars, gilded and finely carved, still retained their ancient splendor. Coats of arms and other emblems, elaborately carved and colored, recalled the Peruvian aristocratic residences in the city, such as the Casa del Almirante, the "Palace of the Admiral" (although it was certainly far from any sea). The pendentives of the dome were enriched with carvings and emblems of the Jesuit Order, with the four Evangelists just below, comfortably seated in niches, as if supporting the dome.

The sumptuous main altar set a tone of great elegance. At the top of the altar screen, a figure of God the Father held the globe of the world, his right hand raised in blessing. As in Quito, no restoration or reconstruction disturbed the total effect of the harmonious work, apparently designed for the exact place where it stood. The Jesuit establishment had considerable land in the center of the town, and when secularization made a university out of the seminar, it was donated to the community with pride. The rector of the university recommended a young guide to us, who was the best historian on his staff. He was not only born in Cuzco, but also may have been its most patriotic and best-informed citizen! More than *Cuzcenimo*, the young fellow was *Cuzcenissimo!* He gave us very good advice about a number of significant places, which we followed up to good advantage.

One of the many charming incidents we experienced in Cuzco had to do with the nunnery of Santa Catalina. The nunneries were required by law to be open to the public, as were most churches in South America. A number of cloistered nunneries got around this gracefully by opening their churches for Mass at 4:00 in the morning, and then closing up about the time a stranger might wander in. We passed by Santa Catalina rather early one morning, and noticed a man getting part of a sheep's carcass out of a cart, and taking it through the open door. We looked in and saw two entrances, the right one opening on a small vestibule with a wall pierced by a turntable. On the left was the church, a long, narrow hall with all its altarpieces along the side of the wall toward the cloister. The interior had a soft, dusky atmosphere with its tones of gold and silver blending with a creamy white. We were greatly impressed and asked the *sacristán* if we could come in and take photographs. He said that he had to ask the Abbess and disappeared, then came back and led us up a narrow stair into a room with three chairs set out. A black grille of heavy, interlacing iron pipes, as big as a man's wrist, closed off the opposite wall. Six feet back of that was another heavy grille, and beyond that, a faded green curtain from floor to ceiling. We could hear the Abbess's voice, with a fine Castilian pronunciation, inquiring about our purpose. She evidently could see Elisabeth with the camera through the fabric, and asked whether she would take the pictures. The fact that we both spoke Spanish and assured her about our devotion won our case, and she granted us permission.

The next morning, armed with all our equipment, we were led into the church by the *sacristán*. The quiet and the early light gave the place a tranquil mood. As we prepared to photograph the first *retable*, there was a soft rustling behind the choir screen. Realizing that we were being observed, we spoke admiringly about the altarpiece. A carved wooden grille painted red and gilded closed off the elevated choir, from where the nuns observed the Mass. The scrollwork and

rosettes made it very rococo. The same daintiness that was observable on the choir was also present on the altarpiece. Beside sculptures of saints and paintings, it had a relief of the Annunciation and, over the whole altar, the patina of centuries. The entire building had been rebuilt after the devastating 1650 earthquake. No records existed to say how accurately it had been restored, only that it went up almost immediately. A number of carved little angel figures were scattered about, and a long frieze, painted with women saints, decorated the length of the nave.

Although we had taken all the pictures that we wanted, we tore ourselves away reluctantly from that lovely sanctuary. The *sacristán* reappeared, and we expressed our desire to make a donation to the cloister. He disappeared, then returned, and told us to go into the small room at the right and wait. Our donation was placed on the turntable, a voice said "*un momento*," and the turntable spun back around with a white box containing two small dolls, a Quechua man and woman in native dress. They were knitted of fine thread, probably done with darning needles. The man wore a scarlet coat with tarnished gilt spangles as buttons, a wide belt with a blue design, embroidered, knee-length trousers, and sandals with pink pompons. The familiar Quechua cap with earflaps was on his head, made of pink wool with dark blue ornaments, and a straw hat hung on his back. A fringed coca bag was slung over his shoulders. The little man's features were delineated in embroidery, and his hands held a long, wooden pipe to his mouth. The tiny woman wore a pink jacket and blouse embroidered in black and red. Her skirt was in turquoise wool, enhanced by horizontal strips of scarlet with white, lace-like edging and pink and red stripes around the waist. Her shawl was fashioned in stripes of orchid pink, white, and scarlet, and embroidered in green, black, and white. Her long black hair was tied with white ribbons, her red hat embroidered in turquoise, and she was spinning wool onto a delicate wooden spindle. Below the swinging skirt, we caught a glimpse of a pink petticoat. As we left the convent with our charming little present, half a sheep was going through the turntable in the wall: dinner for the nuns!

Another very busy day was spent at the Santo Domingo convent, built on the foundations of the Inca Temple of the Sun. We photographed some interesting sculpture along with the lively ceiling over the reception hall, decorated with the coat of arms of the Dominicans and angel heads in octagonal medallions, all modeled in stucco, and finely painted. We also visited the churches of San Antonio Abad and Santiago. The latter had a painting of the image in the cathedral called the "Christ of the Earthquakes." We saw such paintings far and wide in earthquake zones, and even in Guayaquil. Another very interesting image was in the church of San Sebastian, which was founded in 1572, and stood in an Indian *barrio* about 3 miles out of Cuzco. The village was reputed to be inhabited by descendants of families of Inca blood, who moved there from Cuzco after the Conquest. The interesting image was the "Christ of the Globe." The tortured figure of Christ, with his wounds clearly delineated, even to the nail punctures and the spear wound, knelt on a flattened sphere, representing the world. From the sphere grew the Tree of Paradise, with Eve offering Adam the apple. Christ's hands were upraised and his eyes turned toward Heaven, as if offering himself in redemption. The whole concept was very powerful and imaginative, a version rarely encountered in European or even Latin American art. Such surprising "discoveries" kept us taking pictures continually, somewhat frustrated by the sheer quantity of wonderful subjects. No region of the Spanish colonies in South America was more densely populated by Indians articulate in the arts, than the area around Cuzco.

Whenever we visited a colonial church, we looked for the organ. Usually it was visible from below in the choir loft, or on the loft extensions along the side walls of the nave. Before the Conquest, the Indians had been accustomed only to instruments of clay, reed, and wood. They were very impressed by the European organs: monumental, built-in instruments, often covered by a case ornamented with paintings and other decorations. Since the Spanish King Charles V was Flemish-born and educated, it was logical that he influenced the import of Flemish style organs (and even donated at least one, that in the cathedral of Oaxaca in Mexico). The transportation of an organ from Madrid, Valladolid, or the Escorial was long and tedious. We never found any records of organs being shipped directly from Flanders to the New World, but this is not to say that instruments ceased to be imported from Spain, for sophisticated organs continued to be prized, and shipped to the colonies.

After an organ was imported and carried up to the Cuzco cathedral on the backs of the Indians, the Indian and *mestizo* populations learned to build their own organs, and other musical instruments. It was very revealing comparing the two organs in Cuzco's cathedral. One instrument was constructed in the Flemish manner with some colonial repairs, probably necessitated by the earthquake of 1650, while the other was typically American in its inner arrangement and apparently (according to the great expert on organs, Vente of Holland) an attempt to copy the first one. The construction of a 600-pipe organ for the Franciscan convent in Quito was considered an outstanding event of the time.

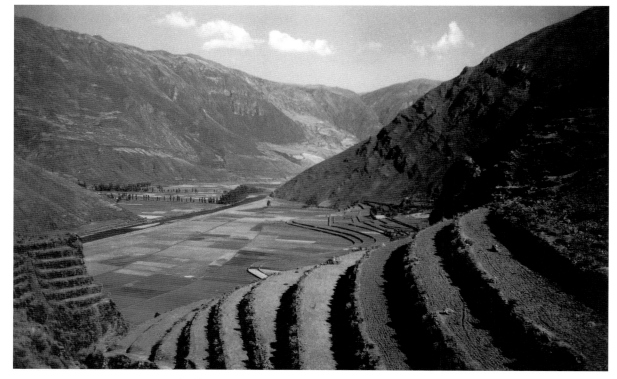

ANCIENT TERRACES ABOVE PISAC, PERU.

The records concerning imports to Quito, and also to Cuzco, of organs and other instruments of Flemish manufacture, were especially noteworthy, since the two South American cities played such an eminent role in the propagation of the faith in the High Andes.

On a visit to Pisac, about 40 miles across a mountain from Cuzco, we were able to get a fair idea of the development of organs from small, primitive organs that still existed in remote places. This Indian village thrived at the foot of ancient ruins in the sensationally beautiful, narrow valley of the Vilcanota River, which later joins with another river to form the Urubamba, which feeds the Amazon. We approached by way of a high pass, so that our first view was almost from above the ruins, with a sweeping view of the famous agricultural terraces. The ones near the river were still in use. The market was small, friendly, and unspoiled, and took place in the main plaza under three great tropical trees. Its colorful atmosphere and rhythm made us think of Guatemala! Although there were several cars of tourists, the natives did not pay much attention to us, prices were relatively low, and no one begged, except a few children. The church was on one side of the plaza, a drab, brown adobe structure with an earthen floor. It had a plastered, whitewashed porch and frescoed portal, and inside were some rather dusty, ancient pictures and a tiny, impossible-to-date organ, still very much in use. It was quite unusual, with characteristics suggesting it was made in the region. The few pipes were set in a chromatic sequence that resembled an upright harpsichord. The hand-pumped bellows were small, having only a few pipes to feed, and the "trackers," i.e., the key connections, were played in a manner very rare in Europe, but often utilized in the Americas.

Pál made friends with the priest, a Mercedarian friar, before the service, which began with a masked dance outside the door performed by dancers from a distant village, an annual performance. They probably represented devils that had, over time, turned into clowns. The chief dancers wore knitted false-faces that were very effective, as they were

masters of pantomime. The various officials of the villages, the *Alcaldes*, marched into the church bearing silver-headed staffs. The service was short, with an expressive sermon in Quechua. After that, the entire congregation sang hymns to Quechua tunes, accompanied by the wheezy little organ. When the bell tinkled for the Elevation of the Host, six or eight conch shells were blown, quite a pagan sound! After the service, the *Padre* arranged for a repetition of the dance, so that we could photograph it in the sunshine of his patio.

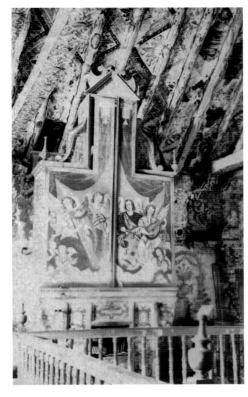

CHURCH ORGAN AT ANDAHUAYLILLAS.

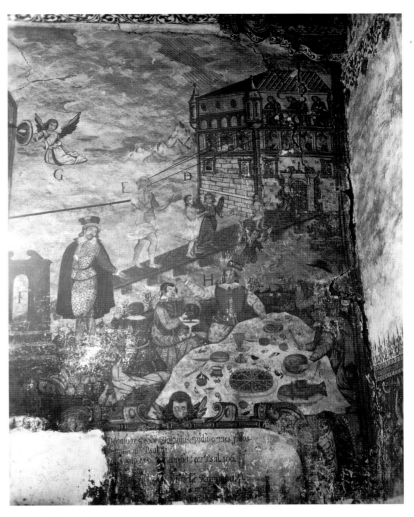

CHURCH FRESCO ON THE LEFT OF MAIN DOOR
AT ANDAHUAYLILLAS IN THE CUZCO VALLEY, PERU.

Later, when Pál asked about unknown villages, he took us to Taray in an adjacent valley, once a flourishing summer resort of the Cuzqueños, but then a sleepy, ramshackle village with a church that still had many of its treasures. We took some photographs and then had a picnic lunch by the Urubamba. At a distant hacienda we found some very good paintings of the Cuzco School, and an important panel from Catalania, which gave us physical proof of the long-suspected Catalan-Byzantoid influences that lingered in the region. We drove home by a longer road over a mountain pass, affording us with the sight of even more snow mountains and fertile valleys, than on any previous trip.

A few days later, we went church hunting alone in the opposite direction, up the Cuzco Valley. Our goal was Checacupe, a huge adobe church in a tiny village that was made a national monument. Its walls bore very old, fine frescoes, and the great gold frames and impressive altar that were common to the Cuzco style. In the early afternoon, we reached another village, Andahuaylillas, off the highway. Beside the usual woodcarvings and an interesting ceiling, very early fresco decorations in good Renaissance tradition absolutely charmed us (probably executed at least fifty years after the style was passé in Europe). Two antique organs with painted wings were a wonderful find. We photographed madly in practical darkness, surrounded by at least thirty village boys who were very well behaved! Sadly, only a

CLOSE-UP OF FRESCO IN CHURCH CHOIR
AT ANDAHUAYLILLAS IN THE CUZCO VALLEY, PERU.

survived from mid-sixteenth century Quito, in which the Franciscans described considerable progress in the musical development of the Indians and *mestizos* and their performances in the Franciscan establishments. The friars highly praised the Indians' talent to learn, read, write, and compose music, which was essential because of the difficulty of importing sheet music. Most of the music books for the choirs have been lost or pages torn out, but antiphonaries of fine design with color decorations still survive and deserve admiration.

Indian boys and girls, as well as the adults were eager to sing in church ceremonies. In Mexico the same desire was noted; in the early sixteenth century, one of the first twelve Franciscan friars, Motolinia, left a moving, personal account of his congregation of Indian converts at the Franciscan establishment of Tlayacapan, Morelos. He wrote about the wonderful music that resounded throughout the town, as the Indians competed with one another, practicing singing and playing their instruments in all the different neighborhoods. Perhaps they transformed the wrench of the loss of their old culture and religion into song!

few of the organs that we had encountered still sounded. The huge leather bellows usually went to pieces first. Necessary to feed the pipes and pumped by human hands, once they were cracked and broken, the tone of the instrument was destroyed. Many of the organs in Highland Peru had painted wings to close them off when not in use. In most cases, the working pipes were also visible in front of the organ, thrust out horizontally like the ones in Pisac, and possibly decorated with grotesque faces. Most of the ancient organs did not have pedals and often only one manual. Larger churches might have two instruments set opposite one another in the loft.

The Indians were enormously talented as musicians. In the first half of the sixteenth century, the Flemish friars taught them how to play European flutes, trumpets, and cornets, as well as organs, the science of mensural music, and the plain chant. Documents have

We soon had a personal demonstration of native musical talent that opened up the Quechua world for us. Although our hotel in Cuzco was practically empty, for a time there were three American couples there, and all the wives came from Indiana, including Elisabeth! One of the men was a professor at a Midwest college, in Peru to trace the biological history of corn; the second was a professor of botany with similar interests. We conferred on ways to withstand the rigors of the altitude, and the best suggestion seemed to be having a huge pot of tea from coca leaves on the table whenever we sat down for a meal! The director of the local university, Dr. Chaparro, arranged a special entertainment for us. It took place in the side chapel of the Jesuit church, then an empty hall, where chairs were brought in for the six Americans comprising the audience. The orchestra consisted of a little harp, a rather small base viola, and an

alto clarinet that was supposed to have an especially wide range. The musicians played a traditional melody of the villages behind the Andean peaks toward Bolivia and the eastern slopes. The melody was mournful, in deep, low tones, and although it had a fascinating rhythm, its melancholy was emphasized by the accompaniment and the run-down appearance of the performers. After a few numbers, and a little pause, they recited parts of the famous heroic epic, *Ollantaytambo.*

The story of the hero Ollantay and his rise and fall is the stuff of a dramatic opera. His fortress 30 miles northwest of Cuzco protected the Inca Empire from depredations of enemy tribes. He won great favor in the Inca court and fell in love with the Inca ruler's daughter, which doubtless was requited. A marriage was impossible, due to strict rules governing the Inca's family, since it would cause great complications in perpetuating the dynasty. Driven away in disgrace, Ollantay retired to his fortress and eventually joined the enemy in an attack on the Inca, but they were defeated, and he was killed in battle. A player emerged from the back of the hall, a small, older man who had helped carry in the musical instruments. He turned out to be the actor who would recite the famous epic that had come down through the centuries by tradition, and finally was written down and translated. Being familiar with the tale, it was doubly enjoyable to be able to follow it easily through the tones of his voice. He started in a slow, impersonal, narrative tone, as the action commenced, increasing the excitement for the hero's reception at the court of the Inca, and his awakening love for the princess. The battle was climactic, and afterward an apotheosis for the hero was declaimed with pride. It was a tragic manifestation of a people who had been under foreign domination for 400 years, but still kept their traditional language, allegedly spoken by two million Indians. As the performers gathered their instruments together and left the room, we Americans suddenly found ourselves sitting in an empty room, very moved by this intimate glimpse into their world. The dignity of elocution and the poise of the performers, undernourished and ragged as they were, was something that we would remember for a long time.

As everyone knows, any trip to Peru has to include a visit to the breathtaking, ancient city of Machu Picchu, in a remote part of the Andes. We departed from Cuzco at 8:00 one morning, aboard a small

auto set on the tracks just ahead of the train. After a strange series of zigzags, switching forward and then backward to head the car in the right direction, we rose quickly over the hills behind Cuzco, with a wonderful view of the town, and sailed down the valley of the Urubamba River. The terrain was at first very rich, with enormous haciendas, grazing cattle, and corn being harvested. We would pass a close spot in the overhanging hills and reach another rich

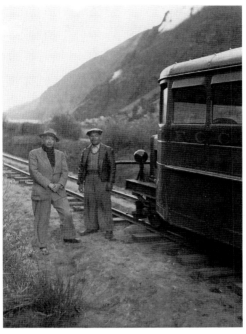

PÁL (ON LEFT),
RETURNING FROM MACHU PICCHU
NEAR OLLANTAYTAMBO, PERU.

valley, but then it turned into a gorge with narrow walls. Inca terraces were commonplace, with many of them still in use. In such a setting lay the fortress and town of Ollantaytambo. Although the average tourist was thrilled to see Machu Picchu, few visitors were also interested to visit the immense cliff wall that had been smoothed down to hold the great fortress of Ollantaytambo. The train stopped there, and we spent a wonderful hour at the ruin. Ollantay was the name of the famous Inca warrior whose legend we had seen performed, and Tambo means "resting place." The site of the fortress was particularly advantageous, as it closed off the valley from raiding enemies. The 1877 illustrated account by Ephraim George Squier, *Peru: Incidents of Travel and Exploration in the Land of the Incas,* showed the immense area covered by the fortifications. Not realizing what we were in for, we enthusiastically piled out and, taking a little boy to carry the cameras, started along the shady path toward the fortress on the slope. The terraces were beautiful, and all along the sides the water

for irrigation came rushing through the same channels that the ancients had used. The town was primitive but picturesque, with water running through the streets, as it is said to have done in all the Inca towns. We climbed to the fortress enthusiastically, somewhat tempered by the heat and altitude, and saw the two forts on the other side of the gorge, partially destroyed to clear the way for the train to go through. Although some towers had disappeared that were built with great geometric exactitude, the smooth faces of some walls were still standing. The faint green color of the stone and the evenness of the steps indicated the miracle of its many years of construction, without the use of metal tools. There were the usual Inca terraces for cultivation of corn and other crops, and from way up on the hill water gushed through expertly carved sluices, water that has run during all those centuries, and made the whole place seem alive. Only when we heard the train whistle did we realize how long we had stayed, and ran most of the way back, to whisk off in our little auto just as the train pulled in.

The landscape grew wilder and became very tropical. Little pink begonias grew along the cliffs, and lacy orchids, about as big as one's fist, were also a lovely pink. Large, spreading trees appeared that are typical of the jungle. Thus we passed several Inca bridgeheads, some still in use, and, stopping briefly, gazed up a wild gorge across a magnificent waterfall, to the towers of Phuyu Pata Marca. We reached the station of Machu Picchu around noon. It was a typical railroad-end, road-building town, dark and cold, in the shadow of the mountains. The keeper of the Ruins Hotel was there to meet us. In his little shack, Elisabeth put on the ski trousers that she had brought all the way from home for this occasion! Horses and mules were waiting for us. We walked up the gorge for half an hour, the horses and mules clumping along beside us, because the road was narrow and had too many trucks. We crossed the river, mounted up, and hit the steep and rocky trail. Fortunately, the horses seemed to know every stone. Elisabeth just hung on, while Pál, the expert cavalry officer, described the scenery. By the time we reached the top, we were in the midst of clouds and could see the train and the river, more than 1,000 feet below. The Urubamba River makes a horse-shoe curve 2,000 feet below the mountain, so the city had a river on three sides and snow-capped peaks beyond, as far as the eye could see.

After lunch, we put on our heaviest shoes and walked along the side of a terraced step, passing through a house where an old Indian woman kept the keys to the gate. Suddenly, we were standing on the rim of an amphitheater, with the whole complex of the great mysterious city spread before us! We were the only human beings there. It was smaller than we had expected, but also much more imposing. The lush flora and the incredible landscape would be gorgeous without any ruins at all! The tramping of eager but careless tourists had so damaged the once exquisitely laid stone walls and paths, that drastic reconstruction was undertaken. Machu Picchu was one of the main sources of hard-currency income for Peru. Edifices that were a miracle of Inca building, such as the semi-circular tower, were still in such good condition that the blade of a penknife would not fit between the stones. But a photograph made some twenty years after we were there showed that both the upper and lower sections had been grossly tampered with. Terraces that had been completely buried were freed of vegetation, and machine age uniformity invaded even the remotest corners. Large plazas had been "discovered," and there was even the suggestion of a pyramidal base, a fantasy, echoing the Maya builders. What we saw in our one day of solo exploring was a slumbering, pre-Columbian world, hundreds of years old. Machu Picchu has become a much-advertised place visited by hoards of people, and "preserved" as a cemented, open-air museum to withstand the onslaught.

Back in Cuzco, the U.S. Cultural Attaché and his wife, the Nostrands, joined us for a few days with one of their sons, as Nostrand wanted to check on the English program the United States was running. We did a good deal of sightseeing together. We visited the Archaeological Museum, which was not very large, but had some very good pieces, and bought picture postcards by two excellent local photographers. The next day, Dr. Pardo, the Director of the Archaeological Museum, escorted us all to the nearby ruins of Tampumachay, Kenko, and Sachsahuamán. Tampumachay was a bath in a charming, small, enclosed valley that apparently was used as a vacation spot by the Inca ruler, with a protecting citadel at a distance and quarters for attendants. The spring itself ran right out of the masonry against the hillside, crystal clear, and played into two basins. Kenko was a recently discovered Inca amphitheater, an admirably

ELISABETH AND PÁL WITH DR. NOSTRAND,
U.S. CULTURAL ATTACHÉ, AND DR. PARDO,
DIRECTOR OF THE ARCHAEOLOGICAL MUSEUM
AT THE SACHSAHUAMÁN RUINS IN CUZCO, PERU.

ELISABETH WITH DICK
NOSTRAND AT FOOT
OF THE ANDES NEAR
LIMA, PERU.

Cuzco. An imported style with European echoes established the profile of colonial Cuzco, the ever-recurring earthquakes gave the restorers the temptation to smooth over and replace walls. The original Quechua city was sinking into the waves of the past and had lost its character, lost its soul. A historian in Bolivia later told us that in Cuzco nearly every street corner was picturesque. But as strong as the photogenic details of the city still were, after every earthquake, something happened to diminish its historic appearance. The "restorers," whether from Spain or the United States, often visualized small, eighteenth-century cities in Spain and attempted to recreate them in Cuzco. There was an attitude that everything from Europe was superior. It ruined the pre-Columbian and colonial atmosphere of the cities and also the plazas of Cuzco. In Arequipa, not as touted as a tourist destination, there were more traces of how the colonial cities might have looked in the past. But in spite of earthquakes and neglect, Cuzco was the queen of colonial cities, to be compared only with Venice and Toledo: graceful, colorful, friendly, and the inhabitants relatively unspoiled. The Inca name for themselves, "Children of the Sun," had real meaning to us, after visiting their once magnificent capital that was transformed by the *Conquistadores* into one of the jewels of the Spanish Empire.

During our last week we mostly photographed paintings in private and public collections and rounded everything up in preparation for our departure. Thankfully, our contacts were all made early and everything was open to use, for in the last days the excitement about the presidential elections on June 10th made everyone practically headless! Thursday was Corpus Christi, a great holiday with extraordinary pageantry. It was celebrated with a procession in the Plaza de Armas. During the proceeding week, the images of saints were brought from all the villages around and kept in Cuzco

precise, semi-circular wall built around an enormous, natural projecting rock that may (with imagination) be in the shape of an animal, and was evidently an altar. The site was again so beautiful, with the mountainous landscape, sloping fields with grazing llamas, sheep, and flute-playing shepherds, that the trip would have been very rewarding, even without the archaeological remains. Beside the great altar, there was a huge volcanic boulder that had tunnels underneath, forming a mysterious labyrinth. On top it was shaped into animal forms and hollowed out places, for whatever unfathomable reason! Sachsahuamán was as magnificent as photographs had indicated, if not more so, especially because on top at the "reservoir," was a wonderful view to the right and left of a whole range of snow mountains, with Cuzco down below.

These sites were less trampled over, than Machu Picchu. What happened to Machu Picchu was observable also to a certain degree in

churches, with the local images serving as their hosts. For the procession, each church's image, gorgeously dressed and bejeweled among waving flags, was carried on a heavy silver litter on the backs of the Indians, headed for the cathedral. It was much more folkloric than the processions in Middle America. The litters were heaped with flowers, both natural and artificial. A gigantic St. Christopher, with the Baby Christ on his shoulder, moved along under a waving palm tree. The litter carrying the Virgin Mary swayed on the shoulders of her bearers, as if taking dignified steps. She was lavishly decorated and magnificently clothed. Her long silken train was held up by a little angel, suspended from a wire, bobbing along behind as though flying. A great crowd had gathered opposite our hotel window, and the white-clothed Mercedarian monks had put their chairs out on the overhanging cornice of the cathedral's main portal. As colorful as the procession was, according to historical accounts, it was much more elaborate during colonial days. As the plaza cleared out, leaving only a few scattered groups of Indians, we left. The majesty of the place was gone, and when the sun went down, the life and warmth drained out of the world as swiftly as the light!

FROM CUZCO AROUND
LAKE TITICACA TO BOLIVIA

SINCE LONG BEFORE THE CONQUEST, the Lake Titicaca region had been the heartland of the powerful Aymara Indians. The Spanish shunned it at first because of its cold climate and barren soil, but in 1660 exceptionally rich silver deposits were discovered. The ensuing rush brought in large numbers of Andalusians, Castillians, and Basques, whose squabbles put the region into such anarchy that the viceroy had to go there from Lima to settle things. Our route through the area, from Cuzco to Bolivia, was by train around the southern edge of Lake Titicaca. Times were peaceful, and we visited some colonial towns along the way. The startling vista of that wondrous lake was more than our eyes could take in, straining in vain to see the end of it. The water, the land, and the barren mountain wall with the expansive sky above it all flowed together, unbroken by grass, bushes, or woods; a breathtaking panorama that gave our trip an almost supernatural quality.

The first lap was an all-day drive to San Carlos de Puno, at the north end of Lake Titicaca, much more intriguing than the ride up to Cuzco from Juliaca, since we knew more about the country. Puno is 13,000 feet high, and we were a little dizzy as we got off the train in darkness. The town was founded in 1669, on the site of the pre-Columbian village of Laicacota, at the edge of the great lake. We took a little walk down to the water, but the chill drove us back to our quarters at the new government tourist hotel. We were discouraged to find out that at that season (South American winter) after sundown the temperature crashes to freezing or below! Since there was no wood or coal, the unfortunate residents only had llama dung for fuel, which didn't burn very well in the thin air.

After dinner, avoiding puddles all over the cobblestone streets, the owner of the hotel took us to call on a German living in the village. He was an illustrator for a magazine in Leipzig and suspected of being a German spy. The artist showed us some back numbers of the magazine and German newspapers, but none was dated as late as 1945, when the hardest fighting of the Second World War took place. The fellow was a bit stiff at first, but loosened up after hearing of Pál's experiences in the First World War. Pál asked him what he did the whole day, and he replied that the landscape and the folk, living ethnology, gave him enough inspiration for his studies and sketches. He said that he sometimes felt alone and wished that he had more frequent visitors; it seemed that our visit was very welcome. He escorted us to the door, carefully closing it so that his warm room would not lose any heat. As we stood outside, he pointed to a barrel-like construction of wood on the roof and said that was his radio antenna. It was a small affair, and as much as we could judge, would not have been able to send signals either to the Atlantic or the Pacific. It had considerable height, but with all the mountains in the immediate vicinity, not to speak of in the distance, it appeared to be a rather dilettante effort. Going back to the hotel, all the puddles on the road were frozen solid, and so, almost were we. We spent the night dressed just as we were, minus our shoes. In spite of heavy covers and warm sweaters, we could not work up enough internal heat to sleep comfortably.

PÁL WITH MECHANIC AND DRIVER ON THE BOLIVIAN BORDER
BETWEEN JULI AND POMATA.

decorative, brown-striped sacks made of their own wool. Suddenly, their herder rose up out of a bush-covered gully and gave a whistle. All the animals immediately gathered around him, fell into line, and hurried off.

Our first stop was Acora's church, dedicated to San Pedro, with an elaborately decorated sacristy doorway featuring angels and grape-entwined columns. Its naïve composition and lively use of color was undiluted folk art. The small town had several other colonial churches, but only San Pedro was kept up. Llave was somewhat farther out, another small town with a wealth of art in the churches that was rather overwhelming in the barren landscape. The next day we visited Juli, a town at about the center of the southern shore of the lake. Already by 1579, due to the proximity of copper and silver mines, Juli's population (with its outlying suburbs) numbered about 14,000. The village plaza was overgrown with weeds, showing what awful desolation had overtaken the formerly prosperous town. The monks, nuns, and priests, as well as the other residents, had once lived in a style that would astound modern visitors. In those days, Juli had five or six great churches; four remained. A priest guided us to the oldest church, dedicated to Saint Peter the Martyr and dating from the second half of the sixteenth century. There was a marked contrast between the unimposing adobe and rubble exterior, the facade white-washed only on the first story, and the sumptuous interior. This was a cruciform church, with a broad nave and side chapels set in bays. Pointed arches met at the crossing beneath a cupola constructed of reed and plaster, and the pendentives in the corners bore ancient statues of the Four Evangelists dressed in starched and painted actual textiles!

The manager of the hotel arranged for rental of a car, to enable us to reach some towns within a radius of about 50 miles. The next day out in the car was spectacular. First came great cliffs, worn into weird shapes by the wind; then a great stretch of plains that was once lake bed, tufted with gray grass and pasture for herds of sheep and llamas. Graceful dignified creatures, they came in various shades from dark brown to white and were often striped and spotted. The alpacas were so fat with their heavy wool, that one would not expect them to move very well, but they could jump and climb as well as the others! We even saw a few vicuñas, reportedly difficult to domesticate, small with very silky, fawn-colored hair, and fine bodies, like deer. We came upon a train of llamas grazing on a hillside, and stopped for photographs. They were loaded with 50-pound, very

native *charango*, an instrument resembling a small ukulele that was still used. The rug was so ancient and original that we were tempted to try to buy it, but took a photograph instead as a memento. The piece was an exquisite colonial textile; we seldom encountered its quality of design and motifs even in fragments, in our later studies of Peruvian textiles.

The church of San Juan was built somewhat later, from early to mid-seventeenth century. The first church had been built by the Dominican Order (about 1590) of adobe, rubble, and wood, but the Jesuits took it over and greatly transformed it. The exterior was modest, with the underlying construction showing through where the whitewash had vanished. Only the side entrance still had any visible elaboration. The church was an unusually long, large building with a transept aisle. Somewhat puzzling were the traces of walled-in archways, once perhaps a half-open colonnade or serving as a buttress for the roof. The ceiling was

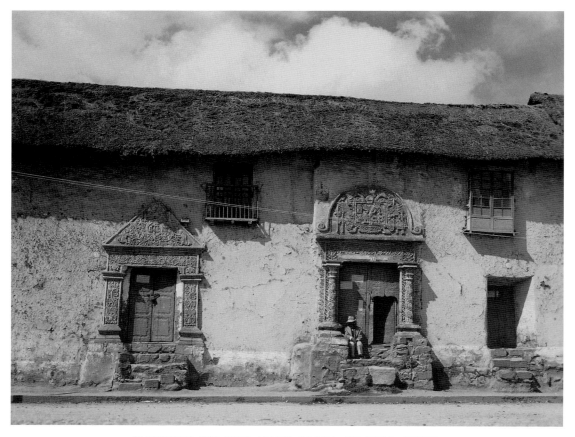

MANSION ON THE MAIN PLAZA IN JULI, PERU.

Gilded wood carving and fine statuary decorated a side altar. The wall space between the altarpiece and the carved sheathing of the arch above was covered by mural painting. The lovely, unspoiled example of the eighteenth-century regional style of carving and painted decoration combined angels, fruits, flowers, and vines into a tapestry-like design. The forms had sharply drawn outlines, emphasizing their contours and giving the effect of appliqué needlework that was popular in the period. Painted designs of architectural elements and angels also framed the baptistery door. Before the main altar was a large rug, needed for early morning and late evening services, since standing there was like immersing one's feet in ice water. The rug was undoubtedly native weaving. Much of its area was occupied by floral arrangements and figures of mermaids playing the

of wood, and the nave lined with a series of paintings on canvas. Their elaborate frames had a luxurious, gilded, filigree pattern, and the paintings showed a strong influence of imported prints. The deep-set windows were also lined with lace-like, gilded carving. Within the composition were creatures resembling peacocks and monkeys amid bananas, pineapples, and papayas. The windowpanes were of paper-thin slabs of alabaster, which let in a pale, even light. The soft illumination of the rich display of carved wood gave the interior extraordinary warmth.

Not only the ecclesiastic buildings had this characteristic intricate carving of the High Andes, but also a few of the mansions of bygone centuries on the opposite side of the plaza. The Zavala mansion, although weathered, gave us a good idea of a colonial manor house of

the region. Its two portals had exquisite carving with motifs including grapes, open flowers, and hanging melon shapes. The larger door bore a heraldic transcription, and the smaller one had religious symbols, flanked by a local artisan's version of lions. The thatched roof, warmer than wood, was typical of the region, since large timber was scarce, while reeds grew in abundance in Lake Titicaca.

On the way out of town we stopped at the Church of La Asunción, where the stone tower with its columns and finials was so well built that it still stood as an outstanding example of the regional style. Its polygonal-shaped apse was unusual. The transept arch was painted with colored murals framed in gilded plasterwork, and painted scrolls explained the subjects. A large carving in wood, once part of the main altar, represented the ascension of the Virgin Mary to Heaven. The color was still visible, but some vandal had cut an opening in the lower part. One side altarpiece was still in good condition, unusually built of masonry instead of wood, and its statues were also of stone. The fourth church left in Juli, Santa Cruz, was a ruin, with only its belfry still intact.

Our picnic lunch was along the road, on a promontory, from where we had an unbroken view of the vast range of Peruvian and Bolivian Nevadas; snow peaks in fantastic shapes rising to 20,000 feet along the entire horizon on the other side of the lake. The great lake covers 3,200 square miles and is the highest navigable body of water in the Western Hemisphere. Its wind-swept waters were the foreground for the endless snowfields in the distance of the dazzling Cordillera Real of Bolivia. The blend of the snow from the mountain ranges, the sparse colorless vegetation, the reflection of the immense body of water, and the glassy stare of the light at such an altitude gave the scene a strange magic.

Another drive took us to Pomata, its name derived from the Aymara "House of the Puma." The town was reported to have been a relay station on the Inca road into Bolivia. Pomata's great rose-colored stone church was situated on a promontory with a broad view of the lake. It was all that remained of the monastery complex dedicated to Santiago (Saint James the Great) and the Virgin of the Rosary. It was fantastically carved, inside and out, with sirens and grotesque figures in a jungle of leaves and flowers. The high relief "embroidery in stone," although toned down a bit by the tropical sun

INTERIOR VAULTING OF CHURCH AT POMATA, PERU.

and the dust that drifted across it, was a fine example of the impressive regional style that displayed a virtuoso handling of various materials, whether wood, stone, or stucco. Although the church had been much photographed, we once more found details that still needed recording. These included an exquisitely carved wooden bas-relief on the pulpit, details of the magnificently carved portals, and the great arched main entrance, missing its statues, but including a projection of the roof above the doorway. The most elaborate portal was on the side, a common occurrence in the region. The tower was somberly plain, with small windows at the top. Surprisingly clean-cut design characterized the interior, and the supporting arches made us wonder how the magnificent barrel vault was constructed and still stood. Among the motifs used as decoration in the stone tracery along the nave were plants, vines, leaves, a particular flat-faced, large-petaled flower, and animals interspersed among the vegetation. The sacristy doorway was similarly decorated with a torch-like flower; alternately heavy and light carving created variety. The main altar was framed using the motif of a strange, fish-like monster. An old wooden gate remained with forty carved panels, confirming that the Pomata artisans were masters of both stone cutting and woodcarving.

Somewhat off the main road, the church of San Pedro at Zepita stood against a great outcropping of rock, in a town remote enough

to have been little visited. This was another great, red building, rising magnificently over the thatched roofs of the village. The brilliant sun illuminated the roof of the tower and cupola, but it could not warm up the sober, though majestic, ensemble. The building seemed larger than all the other churches around the lake, and its interior was more impressive, stark and half-empty, but still preserving its best features. The barrel vault and the arch of the choir loft were both structurally sound. The corbels of carved stone at the base of the vaulting, were little masterpieces of sculpture. Even the flight of steps at the entrance was in good shape! The side entrance was unique, with a great deal of original decoration. It was recessed under a huge arch, and even the saints in the niches on the first story were still in place. St. Peter, the patron saint, stood at the left of the entrance and St. Paul on the other side, intact after hundreds of years. The main altar glistened with deep, gilded carving, probably from the eighteenth century. Beside it, the whole vast hall was empty except for a few paintings of Biblical figures and a warrior archangel hanging haphazardly on a wall. It was a melancholy sight, but not without magic. We looked far down the slope before being able to make out the village, baked by the sun and dusty in the haze, wondering if the townsfolk knew they possessed an architectural jewel of a church.

After Elisabeth looked at her watch, we quickly gathered up our belongings for a dash to the Bolivian border before it closed for the night. More quarrels over the car's papers, which had taken a whole morning to get in order in Puno, held us up for some time, along with the matter of the border between Peru and Bolivia being in dispute. We charged over the dusty road, halted every ten minutes at yet more check points. Finally, we rounded a misty, opalescent bay and rode onto the peninsula of Copacabana, which was a series of pointed peaks sticking out of the water. The sun was setting as we arrived at a lovely crescent of beach and the picturesque town of Copacabana. In a recent boom period, a large, modern, pink stucco hotel (rapidly deteriorating) had gone up in that inaccessible spot. We settled in, and a little bellboy came and nailed blankets over a drafty window, but it turned out to be the first night that we could actually undress for bed, as Copacabana was much warmer than Puno. Well rested the next morning, we watched the much-lauded sunrise over Lake Titicaca.

PICNIC ON DRIVE FROM SAN CARLOS DE PUNO TO LA PAZ.

After the relatively small towns and village churches we had just seen, the spacious main plaza of Copacabana was very impressive. This was probably the most venerated pilgrimage spot in Latin America, comparable to the shrine of Guadalupe in Mexico. The ancient native legend sanctifying the site told that the Father-Sun created the first man and his sister-wife, who gave birth to the Inca people at that place. In Quechua, Copacabana meant "the place of the blue stone," and an idol was fashioned from this stone. When the Spanish missionaries arrived, they found a number of inhabitants quite willing to adopt the new god, which they worshipped along with the old ones. A native Indian sculptor named Francisco Tito Yupanqui created an image of the Virgin Mary, which was gilded and painted by a Spanish friar. After overcoming the objections of Spanish ecclesiastics, the statue was carried in a great procession to the church at Copacabana on February 2, 1583, the feast day of the Presentation of the Child Jesus in the Temple. In Spanish, it is called the festival of the "Virgin of La Candelaria," in reference to the Madonna with the Child in her arms, surrounded by candles.

We landed in Copacabana during the last part of the festival of Corpus Christi. The holy images that had been visiting from many villages were going back home, and there was an undertone of

ancient rites. The plaza swarmed with Aymara Indians, the women in little derby hats, flounced skirts, and a heavy woolen blanket as a cape held on the right shoulder by a big safety pin. Their colors were striking: bright green, dark blue, fuchsia, golden yellow, and brick red; the finishing touch was a striped carrying cloth. The men wore store-bought clothes but often had on the typical, colorful, knitted caps with earflaps under their black felt hats. Wooden constructions at the corners of the square, watched over by village elders, had gaudy displays of silver cups and plates; crossed spoons made into pins, brooches, and platters, stretched on pieces of brightly colored cloth. It seemed that the Indians wore or carried their property with them; a young Aymara bride customarily would appear on her wedding day decked out in her fortune. Later, in La Paz, we were lucky to obtain a lovely, late-nineteenth-century color lithograph of the whole Copacabana marketplace, the basilica, and its large open chapel with water flowing in the old fountain. Villagers were shown carrying their *santos* in processions among lamps and flags.

The most imposing structure was the basilica. Besides the spacious central building, there was a large columned pavilion full of pilgrims. The interior of the basilica indicated the high standards of eighteenth-century building, when it was expanded into its present form. The influence of Quito on the construction was noticeable. Many changes had taken place inside the church as a result of donations over the centuries from devoted believers. The most sensational aspect was the vast altar, which spread around the walls of the entire sanctuary and onto elaborate pillars, with altars all the way into the transept. A continuous Mass was being celebrated before the miraculous Madonna. Elisabeth photographed all through the morning, while Pál and our driver kept the faithful from walking into the lens!

Early the next day we drove farther south. The lake was at its most sensational, a blinding blue that looked as if lighted from underneath. It was replanting time, and the Indians communities were out harvesting their staple food, potatoes. The potato originated here in the *altiplano*, but what we saw were little balls, nearly black, no bigger than tennis balls, and very unappetizing! The Indians were Aymaras of Tiahuanaco stock, round-faced with wide-set eyes, heavier featured and more stolid than the Quechuas. Their bronze faces glowed in the

STREET SCENE IN LA PAZ, BOLIVIA.

light at this high altitude. After Guachi, a boat station, we stopped only for a brief look around at Tiahuanaco. The famous ruin consisted of lumpy, uneven fields with a few haphazard stones standing about; the sun gate, smaller than it seemed in a photograph, perched a bit haphazardly in the middle. We drove across miles of astounding *altiplano* that were practically desert, on the worst road we had ever seen, without a soul or even a llama in sight. Apparently it had not been used in years, as the only markings were human and animal footprints, and vicious drainage ditches cut through the road that

couldn't be seen 10 feet ahead. Then the car went over a ridge and into a mountain range almost close enough to touch. The sunset over the snow was indescribably magnificent. In the far distance across the plain, we saw a little light that seemed on the very edge of the mountain range and had to be La Paz. As we approached, there were more lights, but they did not seem to be extensive enough for a big city. The light turned out to be only a high-powered searchlight at the airport. We passed an iron gate, turned sharply left, and suddenly stood on the brink of a deep canyon with the city at its heart. It took nearly half an hour to reach the center, as the drop must have been at least 800 feet, and we got thoroughly lost before finding our hotel and getting settled for the night.

La Paz had been prosperous in colonial days because of the rich silver and gold mines of Potosí. It had since become a jumble of dust and dirt; piled-up building materials; cheap, squarish, modern buildings and steep streets; picturesque, tumble-down shacks; vast Arabian so-called "villas," with multi-colored windows; neat, modern bungalows; palm trees and pine trees, but no leafy trees! At the far end of the fierce canyon was the snowy mountain range, topped by Illimani Volcano, over 20,000 feet high. In the following days, as we made our way around the city, articles in all of the eight daily newspapers told about our activities, and we found copies of our *Medieval American Art* in private libraries. That kind of publicity, due to the work of the coordinator of our project in Washington, was a great help, as always. From hotel personnel to drivers and shopkeepers, people recognized us and cheerfully offered their assistance.

The city was not very rich in colonial architecture, since it was even more modernized in the nineteenth century than most of the other places we had visited in South America. The churches were nearly bare of any colonial works, as they had been replaced with neo-Gothic style altars and images. A great discovery for us was the painting of what was called the "Potosí Circle." It showed a remarkable individuality when compared with the paintings in Quito and Cuzco, as well as a more pronounced three-dimensionality. Its gilding was more economic, the color range richer, and the themes more ambitious, than the totemistic tendency that we had observed in the other cities. Our first visit was to the Director of the School of Fine Arts, Cecílio Guzmán de Rojas, who was also a leading painter. His subject matter was the landscapes and Indians of the altiplano. His landscapes expressed the deep shadows and brilliant surfaces of the country with an amazing story-telling quality, but nothing was romanticized. He had just spent several months in Machu Picchu, painting a series of its changing moods, occasioned by changes in the light.

Thanks to Rojas, we were able to photograph a number of private collections. One belonged to Señor Cuenca, a bank director who had many excellent photographs of colonial art, as well as beautiful paintings; some of them we published in *Baroque and Rococo*. Again, the difference from colonial paintings in the Cuzco circle was noticeable. Two styles or tastes existed in colonial painting in Bolivia, both with brighter colors and more animated subject matter than we had seen previously. One was a good, solid realism, developed by a friar from Italy by the name of Bitti, who was brought to light by the art historian, Martín Soria, whom we met in Colombia. The other style was more in the line of folk art, with elaborate gold tooling and a rather static design, which was loosely attributed to the native painter Holguin.

Later on, we photographed another collection, belonging to Colonel Diez de Medina, a retired military attaché who had been stationed in various Latin American countries. Using his diplomatic privileges, he had amassed a varied archaeological collection, with better examples, from a number of cultures, than there were in the archaeological museums. The museum in La Paz was housed in a building styled after Tiahuanaco: light and dark, colorful and drab—like the rest of life in that remote place. Its collection needed care, especially the pathetically deteriorating piles of colonial documents. Unfortunately, twenty years later we heard that everything was still in the same state.

Another afternoon we went hunting textiles in the old part of the city above the ancient church of San Francisco, where the Aymara Indians lived. Wedged between the buttresses outside the church were little shops, and Pál remarked that it reminded him of El Greco's painting of the moneychangers in the temple. In a tiny shop, whose owner was the typical Bolivian *mestiza*, wearing a little felt derby, dangling, antique, silver earrings, and a matching shoulder

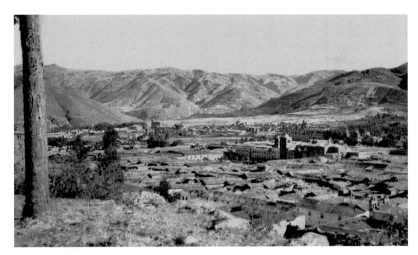

CITY VIEW, SAN FRANCISCO AND BELEN
(FROM CRISTOBAL), CUZCO, PERU.

RETURN TO LIMA

AND HOME TO THE STATES

brooch, we found two old pieces of fabric. They were spotty and dirty and had holes in them, but they were old and rare. We took them back to the hotel and soaked them in hot water in our bathtub, to kill anything that might be crawling around in the wool. We noticed considerable differences in the weaving and color schemes between Bolivia and Peru.

Our stay lasted two weeks, at the end of which Rojas and his wife gave us a fine party at their small villa up on a hillside looking out on the panorama of the Andes. We were beginning to feel the wear and tear of six months of travel, but nevertheless had a very good time. Just as we were saying good-bye, Rojas surprised us with a remarkably astute comment. He said, "When you came to my office at *Bellas Artes* the first time, I saw that the Señora is aural, because she turned her ear toward me to hear better. But Señor Kelemen is purely visual. His two eyes were fixed on my face, and he 'listened' with his eyes. Having the aural and the visual both, makes you an extraordinary couple." As we parted, he presented us with a small, icon-like painting in oil on wood of St. Anne and the Virgin Mary, portrayed as Aymara Indians with wide-apart eyes, round faces, and pouting red lips. We all stood in the doorway as the moon shone on the Illimani Volcano, reflecting its eternal snows. It was a moving farewell to Bolivia and our congenial friends.

OUR FLIGHT FROM LA PAZ was preceded by a three-quarter of an hour drive up to the edge of the canyon that harbors the city. The planes land high above and away on the high plateau to avoid the draughts and winds of the canyon. One can just imagine how high we were, realizing that La Paz lies higher than Lhasa in Tibet! The pilots of our plane, which came from Argentina, were certainly in a hurry. It is always amazing how quickly after the bell rings for "passengers aboard," the doors slam shut, the engines start, and the machines are off. We retraced, in a few minutes in the air, our entire trip across the Bolivian high plateau and along the shores of Lake Titicaca. It was fascinating to see the villages and their colonial churches from above. The snow mountains of the Cordillera Real and, later, the Peruvian Andes were the most majestic sight we had seen in our lives! We had to rise over 20,000 feet to make the highest pass, and the deliciously browned pork chops set before us, just before that last rise, were left half-eaten because of dizziness and being a little gaspy due to the altitude, since we didn't think to use the oxygen. We landed and stayed overnight in Arequipa, and the next morning headed for Lima. Halfway through the trip, the pilot announced that he might have to go back to Arequipa, meaning we would have to take a train or fly north to Trujillo, if he couldn't find an opening in the clouds to descend, but luckily, he did. At that time, planes flew mainly by "contact," without any refined technical instruments. The layer of clouds was so close to the surrounding mountains that the plane had to be maneuvered into the valley like a canoe into its dock. There was a small opening in the clouds just behind the mountain ridge, and suddenly we ducked through in a sharp dive, just as though between a ceiling and the floor. Land appeared, and we came in smoothly at Lima Tambo, marveling at the sight of tangible winter. It was damp and gloomy all along the coast, while only a few hundred feet above and clear to the farthest mountains, there was gorgeous cloudless sunshine.

It was wonderful to be back in Lima again. The climate was beginning to show its most contrasty side. During the day, the skies

were still cloudless and the sun burning, as in the tropics; but after an accelerated sunset, it became so cool that wraps were needed. The Big Dipper was briefly visible at that season, but otherwise all the stars were different, the sky seemed fuller, and there was no Milky Way, while the moon stood at a different angle. At the Hotel Bolívar we had the same rooms as before and soon found our balance at sea level. The following day, we went over to the American Embassy to discuss our trip with Howard Nostrand, with whom we had spent such an interesting time in Cuzco. He said that our publicity, the interviews, etc. that arrived from Cuzco had aroused great interest in Lima. He had received five invitations for Pál to lecture, from the Men's Union Club, the Ladies Club, the University of San Marcos, and an artists' group. Mr. Harper, the Head of the United States Information Service, also wanted a lecture for people on the mailing list of the embassy.

We both had laryngitis from more than a month in the high altitudes and abrupt temperature changes, and Pál said that that he could not deliver more than one lecture. Howard and the Press Attaché set up the lecture at the country club and made it also our farewell party. Pál suggested presenting the audience with a question and answer sheet in Spanish. We thought up everything possible to include, from the banal and technical to the slyly political. Nostrand said that we could expect at least thirty people, since on the corner of the invitations was the magic word, "cocktails." The event was two days later, from 7:00 to 9:00, and 250 people showed up, from all our friends to the Minister of Education. Quite a number of people came with specific questions. Pál had anticipated an inquiry concerning the importance of Peru's place in Latin American tourism and culture. He replied, "After Mexico, Peru is, without a doubt, the most important country." The next morning the leading newspaper gave his statement a big headline, and then we really started getting attention!

Sometimes strange things happened regarding the local specialists. We received a number of commissions for photographs, among them one from Dr. Bennett of the Andean Institute, who asked us to record a detail on a map that Dr. Julio Tello, the leading archaeologist of Peru, was preparing for him. After telephoning, we arrived at Tello's museum only to be told that he was not in. The second time we made an appointment, he was ready and pulled out the map. But while we were still looking at it, he rolled it up and put it away! We had no choice except to tell Dr. Bennett that we couldn't complete his request. One afternoon, an old friend on his way back to the United States, a well-known Americanist, came by to chat and complained that some of his requests for information had not yet been forthcoming. He warned Pál not to count on the National Library and to be circumspect in asking for some titles, because there had been a great fire among the rare books. The old librarian, a political appointee but much revered, had for years been secretly providing library books to a New York book dealer to sell. When a young scholar, apparently one of the feisty "Young Turks," repeatedly asked for a volume and was also told that it was being used by a local academician and could not be recalled, he became suspicious. Through another government official, the matter was brought to the attention of the president. An investigation was made, there was a mysterious fire in the wing of rare books, and the old librarian suddenly became ill and disappeared!

A few days later, a stranger was announced by a call from the Swiss concierge: "There is a rather queer Englishman down here who says he is a photographer and has important matters to discuss with you." The gentleman was William Harold Eagle, and he looked like an overgrown Boy Scout, very well kept but with short pants, bare legs, and no hat. He told us that he was a graduate of Cambridge University and had been coming to South America since 1939, studying important archaeological sites and the native people. Otherwise, he was quite reticent about his past and why he was in Peru; we got the impression that he might be one of those Englishmen who did not agree with the war, perhaps an agent or just an *aficionado*. He named an English bank in Lima where he had an account, so we surmised that he had some income to keep afloat. He also took photographs for factories and other businesses. He had worked in Ecuador, Peru, and parts of Bolivia, even Chile, and accumulated a great many photographs of archaeological material, landscapes, folklore, and colonial architecture. As he spoke, he unpacked his rucksack and showed us some excellent 4 x 5 enlargements printed from 35mm film. We said that we had all the archaeological material we needed but would be interested in photographs of colonial art, landscapes, people, and folklore.

Eagle came again the next day, and what a fabulous package he brought! On the back of every print he had noted the number of the negative, the subject matter, and its location. In four pocket notebooks he had recorded the subject, where it was, how to get there, what the temperatures were in the region, and if it was possible to stay overnight. It was a wonderful little guidebook, meticulously documented. There were even measured plans of ruined buildings, churches inside and out, photographs of motels and institutions where he had obliged the owners for publicity and money to continue his research, and remarks about special points of interest and people. His photographic archive consisted of strips of thousands of black and white negatives, numbered and coordinated with his notebook, and all sharp enough to be clearly enlarged. He said that his work was scientific in nature and hoped that it would someday provide study materials for students, perhaps at the British Museum. When we told him that we were on our way home, he agreed to keep in touch and gather more colonial material on his travels. Thus began our agreeable and very stimulating communications with William Eagle over the ensuing years.

Eagle continued working in South America until 1954. That year he wrote to us that he would like to go to Asia, especially to India. Eventually he wanted to return to Europe, provided there was peace, as his health was being affected due to many years of roughing it, and he wanted to attend to it at a mineral bath. Furthermore, he said that he would be willing to sell us his Latin American photographs for an amount that would allow him to carry out his plans. We decided to purchase his fourteen notebooks and more than 19,000 black and white negatives and place them in a distinguished American institution if the British Museum did not want them. Only later, when we could study his archive in detail, did we realize how unique and sensational it was. We published his wonderful photograph of the north end of Lake Titicaca taken from Juli, showing the church and village, in *Baroque and Rococo*. In 1981 we gave Eagle's archive to the Arizona State Museum in Tucson, along with some 300 other photographs.

Eagle's years of dedicated work placed him in the long line of distinguished explorers who documented Latin American sites. Grand in design and scope, both in text and in pictures, his material included many monuments and ruins no longer in existence. For example, he had photographed square burial towers of the Incas from Northern Peru, monuments which were usually only in the round in the Cuzco region, and a pre-Hispanic aqueduct chiseled in a rock ledge with the water still flowing. Eagle had followed the course of the spring to the source and photographed all of it! Although there was no particular focus in the photography, such as a naturalist, architect, or art historian would have created, Eagle's personal involvement with his material was so pronounced that the notebooks and photographs became more than single purpose, one-discipline documents. He shared, in common with the institutional research teams, such as the Carnegie group, an overriding desire to reveal and preserve our cultural and artistic heritage.

Due to our press conference, another surprise was an invitation to one of the big sugar plantations to view a private collection of colonial paintings. We went off early in the morning, and although it was only a few miles east of foggy Lima, we suddenly emerged into brilliant sunshine, as if a curtain had lifted. The paintings were not only religious subjects, but also landscapes, still lifes with native fruits and flowers, and genre pieces of festive gaiety. It was quite late when we returned, and the concierge met us with a broad smile, to report that the Presidential Palace had called. We telephoned back and reached the president's personal secretary, whom we had met socially. He extended an invitation to meet the president, adding that Dr. Nostrand would accompany us. So on Thursday, all dressed up, we drove to the Palace. As we entered the gardens, a platoon of eight elegant horsemen stood on parade, and the officer gave us a salute. The Presidential Palace was no longer the beautiful colonial building it had once been but still had touches of the earlier style, and the interior was done in respectable modern taste. The Secretary received us and introduced us to some other people standing around.

Soon President Prado arrived and greeted us cordially, relieved to learn that we spoke Spanish. After a few more guests arrived, we were led into a dining room overlooking a sunny, well-kept garden. The table was laid with gleaming damask and a heavy silver service. At each end of the long table, where two empty places had been laid, two infantry captains slipped into the chairs wearing large revolvers. The courses were expertly served from side tables. Pál sat opposite the president, between the Ambassador of Argentina and the archaeologist we had already met, Julio Tello. Behind the president,

in the exquisitely paneled wall, was an outline marking what must have been a concealed exit. Dr. Tello asked Pál which was his favorite ruin, and he answered, "Sachsahuamán is the *bon vivant*, Machu Picchu is the *prima donna*, and Ollantaytambo is the character actor," at which Tello laughed heartily. In the meantime, President Prado's conversation revealed his intellectual curiosity, and he invited us to come and see his collection of archaeological and colonial treasures. He asked us what we could suggest to further tourism in the country. Pál replied, "Machu Picchu is the most important place and needs a good road, to make it easy for people to get there."

The hotel concierge had been telling our callers to come during the siesta, to be sure we were there. Among the various dealers who showed up was a Polish refugee with an antique shop in the Calle Union. He came several times to show us objects that he was not sure about. One day he brought a red shell, a rather large, flat, spiny shell, muddy on the outside, but inside a delicate cream color splashed with brilliant red on the flared edges. In the center was carved a human body with crossed arms, holding two four-footed animals with large snouts, perhaps alligators. The figure was clad in a thin scalloped loin-cloth but didn't have any feet. It was balanced on the head of a tiny squatting figure with upheld arms. The face was striking, with the nose, a straight mouth, and long neck forming a sort of T-shape. The eye slits protruded a bit and pointed upwards, with blackened eyeballs. It was an expertly realized piece, using black to bring out the features and other details. The dealer had a big bag of similar shells, with different figures in the same style, and asked if Pál thought they were original. He said that Sam Lothrop had been in his shop, seen the whole pile, and declared they were fakes. The dealer had been assured that they were dug up somewhere on the Nasca coast, and would he have been able to buy them all for fifteen dollars otherwise?

Another caller was a Limeño who showed us a huge jaguar fang about 5 inches long, fashioned into a gold-covered figure of a jaguar devouring something at its feet. Every detail emphasized the animal's ferocity, from the sharply defined, vertical, stiff tail, to the straight legs and open mouth. Judging from a hole in the bottom of the piece, it must have been an amulet and may have played a role in ceremonial rites, or worn to indicate extraordinary feats of valor by the wearer. Seeing that we were quite struck by the object, the man offered to

sell it. We hesitated, since being in Peru in an official capacity, we did not want to be caught and accused at the border when we left. To that the man replied, "Oh, don't worry about that! My brother-in-law is the Head of Customs."

One day, as we were walking toward the embassy, a well-dressed citizen hastily crossed the street and asked if we were Americans. With an earnest face and solemn tones, he expressed his condolences at the death of President Roosevelt, just broadcast on the radio. It was no surprise. Only a few days before, we had been invited to a showing of a movie of the Three Greats, Stalin, Churchill, and President Roosevelt, together on the deck of a battleship. The broader scene panned to a close-up of the president lying in a steamer chair, with a plaid rug over his knees. The familiar cape was flung jauntily over one shoulder, and he wore his well-known smile, but it might have been on the face of a wooden doll. At the sight, a murmur of shock went through the film audience. The embassy arranged a memorial service and sent a special invitation to the Papal Nuncio. Many Limeños came and signed the guest book with praise and condolences. As it was vacation time, the Ambassador and a number of other officials were in the United States. It was disappointing that no American Protestant minister could be found for the service, so the chaplain was borrowed from a British ship that happened to be offshore. The flower tributes were very showy, and the arrangement sent by the Chinese was praised the most. It was very sad to mourn our president in a foreign setting, and we were suddenly homesick.

The time had come to tie up loose ends and prepare for our trip home. We had taken nearly 400 photographs ourselves in just the last six weeks, all of which had to be developed in Lima, and they turned out grand! When we went to the airline office, we were told that the best flight would be via Panama, but we would have to obtain a visa from the Panamanian Consul. The next morning we drove down to the consulate office in an old building, which was also the consul's apartment. We had to wait four days before the visas were ready, and left on a flight originating in Buenos Aires. There was a bit of a skirmish about taking all our luggage with us on the same plane, until Elisabeth presented two bouquets of flowers from a friend at the embassy to an airport official "for your wife." Some other freight was

taken off to accommodate our big suitcases, but fortunately we had already shipped most of the books, photographs, and textiles. We happily snacked on the chocolate cake which Mrs. Nostrand had provided. The passengers were all exhausted from the long stretch they had been in the air. When Elisabeth turned around to speak to Pál, sitting some distance away, all the men had taken children on their knees so their wives could have a nap, and even Pál was dangling a sleeping baby!

We stayed overnight in Guayaquil at the same comfortable hotel, remembered well from the visit to Ecuador. The next morning in Calí, Columbia, also familiar from our previous visit, the plane took on gasoline again. We would be crossing the Panama Canal, with views of American and British navy battleships passing through from the Atlantic to the Pacific. That was also our first sight of jet planes that seemed to whiz by our heads almost before we saw them. We landed at Balboa, in Panama. That night we had no rest, due to enormous bats making a racket, as they swarmed around the street lights chasing insects.

Balboa, which is at the Pacific side of the Panama Canal, was overcrowded with planes destined for the Pacific theater. Aboard once more the next day, the pilot informed us that we would have to stop in Jamaica for some repairs, which took more time than expected. Then it was on to Miami, where we arrived late at night. The hotel room that was reserved for us had been given away, and instead the honeymoon suite was offered to us at an outrageous price. Apparently this was the only hotel open to transients, as the rest of the city was a big hospital for convalescent servicemen.

Realizing that our young pilot, accompanied by his wife and two children, had been on the plane since Buenos Aires, we let them have the rooms and went out to find a place to lie down. It was well after midnight. We wandered around the sleeping city and decided that with only a few hours until dawn, we might as well stay up. Passing an all-night cafe, we spotted our young pilot sitting in the window with a cup of coffee. We joined him, and learned that he had been able to find another hotel place for his wife and children, as again the hotel had asked an outrageous price, and they walked out. The three of us had a snack and then went to the park and sat on a bench, trading stories of our adventures in South America.

The sun came up early, and a few hours later, we joined the long queue before the railroad ticket office. Our young pilot went to fetch his family; he was bound for California and eventually service in the Pacific. Our reservations were intact at the railroad station, and there were the long, shining Pullman cars like those we took to Santa Fe in 1936. The porter apologized that he couldn't give us any fresh bed linen until we got to Jacksonville, to which Elisabeth replied, "Just lay out the mattresses and let us lie down and sleep!" Our secretary, Helen Hartman, had reserved a hotel for us in New York and came to meet the train. We reached our home in Connecticut early in July, just as the laurel was beginning to bloom. All our packages with books, maps, photographs, and plans had arrived safely from Lima and had been placed in our library. No one could have told us what an amazing adventure we would have in South America, and, back in such a different world, we could hardly believe it ourselves!

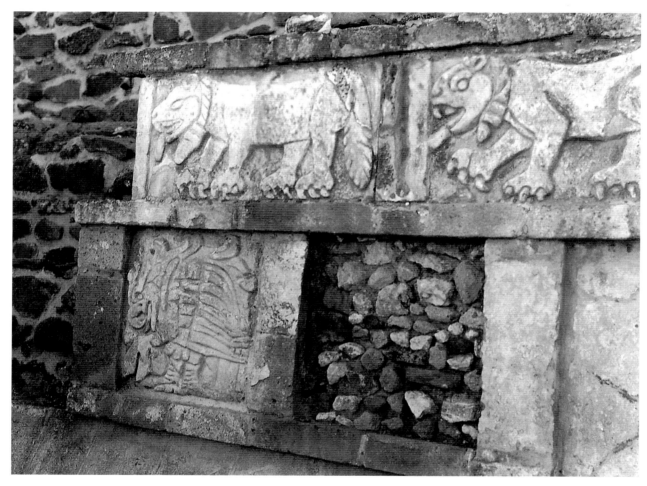

JAGUARS AND EAGLE, TOLTEC RUINS AT TULA, MEXICO.

RETURN TO MEXICO, 1946–1947: MEXICO CITY, TULA, TAXCO, CUERNAVACA, AND TEPOTZLAN

IT WAS NOT UNTIL 1946 that we again visited Mexico and Central America. We planned to see old friends, visit more pre-Columbian and colonial sites, and continue researching. We left in November, by train in the evening from Norfolk, and all too soon were overtaken by a terrific rainstorm, just as the train entered the pass in the Berkshires into the Hudson Valley. Due to a strike, there was a half-hour delay in Albany putting two sections of the train together. By the time we reached San Antonio, Texas, we were already three hours late! The crossing of the border was therefore unpleasant, because, although only a matter of going through formalities, it had to be done at 2:30 A.M. Luckily, we were able to sleep late to make it up, as the train picked up another three hours delay during the trip to Mexico City. At first, we traveled through desert dotted only with small plants; later the big cactus of various types appeared, some blooming in a lovely red. Then came irrigated sections, really quite rich, and as a background the distinct, irregular volcanic forms of the skyline. The bigger cities such as Monterrey, San Luís Potosí, and Querétaro remained prosperous, because they were logically placed not only for colonial times, but also for modern-day activities.

In Mexico City we were met at the station by Dr. José Lengyel and his wife, who were old acquaintances of Pál from Budapest. They accompanied us to the Hotel Majestic, where instead of the quiet apartment promised by Thomas Cook and Sons, we were given a small double room overlooking the main plaza. As it was the night before the presidential inauguration, the whole town was upside down, and they simply gave us what they had. Seldom had we heard such a hysterical combination of noises, from auto toots and streetcar whistles, to loudspeakers on the plaza, all playing different programs. Elisabeth heard the inaugural speech over a loudspeaker and took movies of the parade. With the vast cathedral as background, there were some very effective scenes.

The next morning, Pál rushed over to the old Hotel Geneve, where we stayed in 1933 and 1940, and had the good luck to encounter the owner, who let us have a sunny, two-room apartment in the same wing as before. He assured Pál that despite their fourteen-day limit, they would give us quarters for the entire time we spent in the capital. That would allow us to return there after our trip to Nicaragua and Honduras and leave our heavy luggage there in the meantime. We moved that afternoon, and got established with two extra tables, many good, newly acquired books, and a shelf of grapefruit, twisted breads, and tiny yellow limes for occasional snacks. The town was completely out of the normal for a few days, a good opportunity for us to get used to the altitude.

Our work began under very pleasant auspices. We had a discussion with Manuel Toussaint, Director of the Institute for Colonial Art, the Dirección de Monumentos Coloniales. We spent two mornings looking through their albums, and quickly found nearly thirty photos of real interest, although we had not seen even a tenth of what there was to go through. The backbone of our daily routine became the morning's work in the archive. Located in a large, villa-like house, divided into two departments, the upper floor housed the archaeological section under Alfonso Caso, and the lower

half the colonial, managed by Manuel Toussaint. Albums of photographs, sometimes with descriptive text, were stored on four long shelves. After a few weeks we had gone through about thirty albums. When we entered the archive, the little secretary, María Luisa Mendez, would turn the electric heater in our direction. We put on our topcoats, and settled down with our feet on the bar under the big table to keep them off the stone floor. That was okay for at least two hours of concentrated work, with a short pause for a cracker and a stroll outside in the sun.

Toward noon, various personalities began to drop in. Besides Manuel Toussaint, with whom every exchange was stimulating and rewarding, our greatest help came from Lauro E. Rosell, with the title of "investigator," who had traveled around for many years with a fine, ancient "slow" camera, taking pictures and gathering information for little more than love of the subject. It was our good fortune to find his recently published book on colonial architecture while browsing around in the bookstores. We took it to him for an autograph, and he became a devoted friend. Through talking with him and others, we got information about a few absolutely unknown places not far away, with very interesting indigenous creations. The collection of photographs in the archive indicated that our suspicion was right that the high plateau of Mexico had more variations in its architecture, than any other part of the New World. The area was the foothold from where further conquests were made, and therefore, it had more early fortress-like church-and-convent structures than appeared elsewhere. Later, the political power and riches from the mines made possible a lavish life that was expressed in all the arts. We took notes on various sites, illustrated in the photo archive, which seemed promising and fairly easy to reach.

We spent an evening with Elsie Brown, editor of the *Pan American Bulletin*, who had just come from Nicaragua and Honduras, and gave us some valuable information. Another evening was spent with Elizabeth Wilder, formerly with the Hispanic Archive at the Library of Congress and working on Mexican sculpture on a Guggenheim. She had just come back from Hidalgo state and knew the country as well as its personalities very well. Yesterday we went to the Teatro Lírico to hear the Mexican Gershwin, Agustín Lara, with his own revue, rather a fantastic mixture, but he and his orchestra were worth

the money. The "picture of the week" was the Mexican showgirls, nude and rather embarrassed, dancing a Viennese waltz!

Mexico had grown enormously in the past six years, and traffic at rush hours was a real jam. What had been open fields around the city had been turned into colonies of small apartment houses. Most of them were rather impractical European cement blocks, and there was a horror of a modern hotel going up in the heart of the city. Mexican architects still needed to grow adult enough to recognize the specific and absorbing problems that faced them: the altitude with its hot, glaring sun and deadly, cold shadows, and the wet and dry seasons. We were having a cold wave, and had to wear all the heavy clothing we brought from the U.S., especially indoors. In the morning, there was fog, which partly lifted by noon; or at least it did the day of our visit to Chapultepec Castle, which had been converted into the new historical museum. We could see the snowy outlines of Popocatepetl and Ixtacihuatl from its terrace, seeming to float in the sky. The museum was very nicely and interestingly arranged, with colonial, Independence (nineteenth century), and modern exhibits. We saw some fine eighteenth-century portraits, almost Goyaesque in their unaffectedness, that we would later photograph. Our borrowed typewriter was a great asset. There was not a single one to be rented in the town, but when Pál went to Underwood and told them about his work, they said that they would be delighted to lend us one during our stay.

Elisabeth was busy with the typewriter every day. Along with descriptions of our trip, she sent our secretary, Helen, instructions about business and personal matters, including a request for her special stockings, a fairly serious matter. Namely, Helen was to inquire at Altman's and Lord and Taylor for service-weight rayon stockings, size 10 ½, which had to be 33 inches or more, if "extra length" was not to be had. Altman's "Nomend" extra lengths would be perfect, but were hard to find. "Send four to six pairs by ordinary, registered mail, one pair at a time; I am going through them much faster than I expected; rayons are not to be seen here, and nylons cost 3 dollars and 50 cents to 5 dollars per pair."

Prices in Mexico were very high, and the situation was really very serious for the poor people. But the Mexicans remained the friendly, peppy individuals that gave this country its peculiar charm. U.S. imports and luxury goods reached ridiculous heights. It cost

Elisabeth 4 dollars to have a felt hat pressed and bound with a ribbon edging. Butter was 1 dollar and 50 cents per pound, and meat higher than at home, around 80 cents to 1 dollar per pound for the simplest cuts; a chicken, usually the standby of the Mexican simple folk, was running to about 2 dollars for a frying size. The ordinary people were reduced to beans and tortillas, and hence malnutrition. The new regime was doing a great deal of discussing and promising, but how were they going to stop the runaway inflation that was undermining the working and the bureaucratic classes?

Last Sunday, we made our first field trip with our Hungarian friends, Dr. José Lengyel and his wife. It was the festival of the Virgin of Guadalupe, so everything was closed up. Thousands of pilgrims from miles around converged on the famous shrine on the hill of Tepeyac at the edge of the city, but we went in the opposite direction. On good main roads, we soon reached Indian villages where the colonial style of the churches was still preserved. Just 10 miles from the city, we turned off the highway onto a dusty road, and after bumping along for fifteen minutes, passing pigs and cattle, we reached a small grove of trees hiding the village of Santiago Acahualtepec. It had a small church the size of a chapel, with a carved and painted facade rich in ornamentation with many human figures. Inside the church, the arch before the altar was ornamented with similar carvings, and the keystone was transformed into an angel's body facing downward, as if supporting the structure.

About 10 miles farther along at another village named Huexotla, we looked for a stone cross with the face of "Christ at the Crossing," a typical Mexican "transition" piece carved by the Indians, but it had disappeared. The convent was half in ruins, but it had a beautiful patio with enormous columns and beams of primeval wood, some of them 3 feet in diameter. Mass was just over in the town of Chalco where we turned south, and men were shooting off dozens of rockets, creating a fearful racket. A fine relief of Santiago on horseback was the most noteworthy of the sculptured figures we recorded. The Lengyels had brought along a delicious picnic lunch, which we devoured under enormous, gnarled trees along an irrigation ditch at an old hacienda. We went to take a look at its little chapel, with a rococo window supported by flying angels, and a tower full of Puebla pottery bowls, all shined up like a birthday cake.

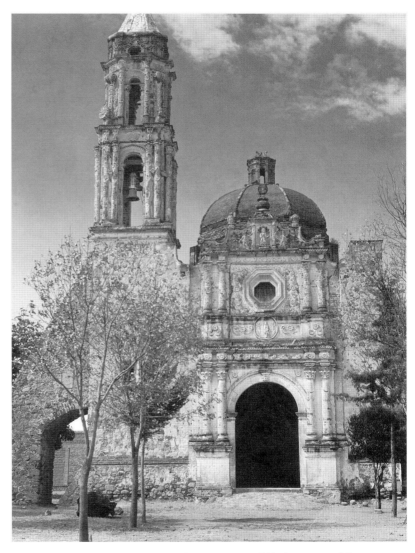

CHAPEL SAN MATEO AT HUEXOTLA, MEXICO.

Afterward we drove across one end of the vast Valley of Mexico, ringed around by its dormant volcanoes. The two beautiful snow-capped volcanoes were always within sight, Ixtacihuatl (the "Sleeping Woman") and Popocatepetl (the "Smoking Mountain," actually smoking!). The weather was rather chilly and misty, the colors autumnal. The corn had been harvested, leaving the fields full of brown stubble, bordered by the usual rows of bluish maguey

THE VOLCANOES OF IXTACHIGUATL AND POPOCATEPETL
IN THE VALLEY OF MEXICO.

cactus. The effect was of a gentle Corot landscape, magically turned into an enormous mural! We passed the shallow lakes with their "floating gardens" that furnished vegetables for Mexico City, and climbed one of the steep shoulders of the valley wall. On top were a little hermitage and the remnants of an impressive, early church and monastery. The view by early evening was staggering, yet we didn't find anyone else who had ever been there! It was hard to come down, and we did not reach home until nearly dark.

Last night we were invited to the home of Jean Charlot, the successful fresco painter, who helped preserve the murals at Chichén Itzá. He was a man of great charm, with a fairy-tale imagination, an American wife, and four children under six, who all spoke Nahuatl with their Indian nurse. One sang and played Spanish songs on his guitar. It turned out to be a birthday party for Mrs. Charlot. The other guests were a linguist named Mr. Barlow, Elizabeth Wilder, the Guggenheim fellow who was winding up her study of Mexican sculpture; and John MacAndrews, an architect who taught in Boston and was finishing a mammoth study of sixteenth-century Mexican architecture. The dinner was all Indian, with beef in hot *mole* sauce, beans, tortillas (one had to eat the beans with the tortillas as a spoon), and a wonderful salad of baby squash and avocados, for us

the only part not really too spicy. The handsome and statuesque Nahua cook, every bit as drunk as the guests, went around pouring *pulque* (a horrible concoction of fresh and fermenting maguey juice), and urging us in Nahuatl to enjoy ourselves. We drank only enough for the toasts, but even so, it was quite overwhelming!

The next Sunday, which was December 15th, we started out early with the Lengyels and drove north through the sprawling outskirts of Mexico City. Many places had been settlements since pre-Columbian times and still bore their Nahua names. Our first stop was Cuauhtitlán, where the parochial church contained two valuable paintings by Martín de Vos, dated 1581. One represented an Immaculate Conception of more or less the conventional type; the other was called a Saint Michael, but had a completely unfamiliar iconography for the saint.

Continuing on our trip, the road was still good for a stretch. But by 11:00, we were in the state of Hidalgo on a road that was "passable in all weathers" only on the map! Deep ruts alternated with sandy sections and invisible trenches. The altitude was considerably lower than at the capital, and the vegetation much richer than on the high plateau. Some of the trees and great pear cactus were blooming, while other vegetation was turning the gold and russet of autumn. We went astray twice, and became impressed with how intelligent the native people were in giving directions, even though they never thought in terms of a car but only in terms of footpaths and mule trails! Thanks to the wonderful, huge basket lunch brought by the Lengyels, there was no reason for despair, since we would eventually reach our destination. Thus we bumped along over the washouts, and through subtropical vegetation with banana trees and other lush foliage, well provided with all manner of snacks. We passed the remnants of a colonial aqueduct and sometime after 2:00 reached the ancient ruins of Tula, about 120 kilometers from Mexico City.

The site was believed to have been the capital of the Toltec people, and the home of the king named Quetzalcoatl, the great civilizer, who later became a god. The excavated section of the city revealed stone reliefs of mythological subjects, on the bases of various temples. In the main plaza stood some colossal stone figures, 20 feet or even taller. Considerable similarity existed between Tula and some of the monuments at Chichén Itzá in Yucatán, an interesting

manifestation considering the great distance between the sites. The strategic location of Tula indicated that it was a bulwark against attacks by savage tribes from the northern desert regions. Traditional lore was that some of the group migrated to the south, where they supposedly conquered the Maya city of Chichén Itzá.

After the Conquest, Tula became an outpost of the Spanish crown. A small Franciscan mission was soon established in a fortified compound with crenellated walls. At the time of our visit, it stood in the center of a thriving city, surrounded by autos, buses, trucks, and the tents of vendors selling manufactured goods. The anachronism was heightened by a radio loudspeaker in the plaza blaring out the action at the bullfights in Mexico City! The most beautiful evening hour, between 5:00 and 6:00, when all the colors were the deepest shades, found us enjoying a civilized supper (even with plates and forks), at the side of a quiet road under tropical trees. Indians on burros went by unhurriedly, driving their herds of cattle, sheep, and goats home for the night. By dusk we were on Highway No. 1, the best that Mexico possessed, as it was the Pan American Highway from the United States. By 8:00 we were home, hopefully with many good photographs.

Two days later, we went by a luxury bus called the "Estrella de Oro" (the "Golden Star") to Taxco. The ride took about four hours, passing through Cuernavaca. The first hour of the trip was up one side of the mountain range that divides Mexico from the western plateau. Along the curving road, wonderful views appeared of the flat Valley of Mexico, which in the misty light still seemed to contain the long dried-up lakes. As the bus reached the saddle of the pass, human settlements and vegetation grew scarce. As soon as the downward slope began, there were deep forests of pine trees, and lots of wild flowers. The plateau was in the state of Morelos about 700 meters below the Valley of Mexico, with tropical heat and vast fields of sugar-cane irrigated from distant streams. The first plantation in the valley was started by Hernan Cortés, the *Conquistador*, who had farmed in Cuba as a young man, and later was an excellent manager of his estates in Mexico. Our bus climbed for about an hour through an almost uninhabited mountain desert. A few small villages had churches with noble lines, although very dilapidated. Entire fields were covered with "heavenly blue" morning glories, as big as one's palm, and dark as forget-me-nots, which grew wild and were called the "Virgin's Mantle," as they

SMALL VILLAGE ON THE BUS RIDE TO TAXCO, MEXICO.

bloomed in December. The bus was still grinding upward, when the first glimpse of Taxco appeared on a distant shoulder.

In the midday sun, the tile-covered cupola of its famous church, Santa Prisca, glittered like fire, and its tall, rose-colored, rococo towers stood out sharply against a blue sky and white clouds. The bus left the tarred road and climbed up an old cobblestone street. After a few swinging turns we stopped in the plaza before a fountain. We were very glad to get off and stretch our cramped muscles. With a boy carrying our luggage, we walked up to the hotel that perched on a promontory overlooking the town. In the eighteenth century, Taxco was one of the richest silver mining towns in Mexico. The main church of Santa Prisca and some noblemen's palaces still stood from that

period. The hillsides were covered with humbler houses where the townsfolk and the miners lived. Taxco had been declared a national monument, and no changes could be made to its architecture. All this could be observed from our hotel window.

Our main interest was Santa Prisca, facing the plaza, which was begun in the mid-eighteenth century and completed in a unified style, inside and out. The organ turned out to be older than was generally believed (originally dating from 1759; it was enlarged in 1806). The data was furnished by a charming local historian, *Licenciado* Flores, who was also the apothecary of the town. We made another interesting acquaintance in Fidel Figueroa, a local painter, married to a woman from Indiana. His house was a modernized colonial mansion, profuse with tiles, flowers, and antiques. Flores owned a colonial painting that made our visit more than worthwhile. But for all that grandeur and picturesque charm we paid with somewhat disturbed sleep, for the formation of the mountains augmented all the noises from the valley. While it was counter-balanced during the day by the wonderful vistas, at night the frantic barking of dogs, braying of burros, and lastly the hysterical crowing of cocks reached amazing proportions!

We finished our work in two days and returned by car to Cuernavaca. The sprawling city was a favorite resort of Mexicans and Americans, on account of its pleasant climate and proximity to Mexico City. Through the recommendation of the Lengyels, we went to the Hotel Savoy, run by Germans from Westphalia, who installed us in a bungalow room in a long garden. Our chief interest in Cuernavaca was the Franciscan church of the Third Order, another fortified compound with the cathedral in one corner of the churchyard, and small chapels in the other three. Alas, very few colonial objects remained.

The next afternoon we drove to the village of Tepoztlán in a valley surrounded by fantastic cones eroded from the cliffs. Turning a corner, as we rapidly descended the road into town, a relic from another world appeared: a small pre-Columbian temple base nestled against the mountain wall. Down below jutted up the towers and massive walls of a sixteenth-century Dominican monastery. Tepoztlán was a national monument, and among the few best-preserved sixteenth-century foundations, with traces of line-drawn frescoes and late Romanesque

capitals. Alas, the ravages of time and multiple revolutions had destroyed all the interior furnishings in the massive church and convent.

Back in Cuernavaca, we visited the Borda Gardens, built on various levels with waterworks, artificial lakes, and century-old trees, that some travel writers have exaggerated into a "tropical Versailles." That beautiful place, once frequented by Emperor Maximilian and the ladies of his court in the 1860s, was all forsaken, and the handsome villa at the entrance was in very bad repair. An American concern had recently bought it, probably to convert it into a Mexican Villa D'Este, with foreign women lounging about three-quarters naked! Among the people we met in Cuernavaca, a Franciscan priest and editor of a local publication, named López Beltran, was one of the most interesting. After fifteen minutes of discussion, he presented us with his only copy of a long-sold-out volume on the history of the cathedral and convent. Another helpful friend was *Licenciado* Elias, a local historian, who was preparing a two-volume work on the pre-Columbian and colonial past of the state of Morelos. He had a beautiful collection of photographs that he showed us with considerable pride. We wondered when those books would be published, and how much of the fine, illustrative material would be discernible on the usual cheap cheese-paper, greatly reduced in size. Elias was the typical Mexican provincial scholar: alive, intelligent, and resourceful, but at the same time limited, and slightly suspicious. We promised each other everything under the stars and wondered if he would even answer our letters!

At Christmas, a very unusual cold wave arrived, seemingly to give the illusion of the season to the many foreigners who were in Cuernavaca. It was colder in the house than out-of-doors, since the sunshine never failed. It was quite strange to see the Christmas trees set out for sale in this tropical landscape. The Mexican custom was to set up an elaborate Nativity scene, and to swing out overhead a piñata, a big clay jar covered with colored paper and filled with gifts and goodies, which the children broke by swatting at it with sticks, and then shrieked and scrambled for their rewards. But the Mexicans were adopting American customs more and more, with holly, Santa, and other imported ideas. Their most unpleasant form of celebration remained the shooting off of rockets and giant fire-crackers. We had both caught colds by the time we arrived home in

Mexico City, and didn't go to the institute. There would be no getting rid of the colds sitting for hours in our overcoats in a cellar, even if we could take a walk in the sun afterwards! Nevertheless, we had a pleasant Christmas with Hungarian friends, later moving along to trim the Christmas tree with a group from the American Embassy. We were home by midnight, but the fireworks kept us awake, with the radios out on the street adding to the noise. We wondered what it would be like at New Year's!

Our latest letters went off to be forwarded by Helen, including one to Peter Penzoldt in Geneva (the son of Elisabeth's teacher, Sigrid Onegin), and two and a half pages of travel stories to Pál's family in Budapest, the latter by regular mail, as they were probably still reading what we sent previously. Keeping track of our correspondence and the affairs of house and family was fortunately working out quite well, since the mail arrived fairly quickly, and Helen efficiently carried out our instructions.

HOTEL GENEVE, MEXICO CITY
JANUARY 13, 1947

Three days after Christmas, our friends the Lengyels went to San Antonio for a week's visit. We settled down to finish our work at the institute, and finally wound up placing an order last week for 105 photographs from all over Mexico in their archive. We hoped to get much better shots ourselves of some of those places, but meanwhile we took what was available. The Sunday before New Year's we took a leisurely drive in the outskirts of Mexico City, which had been the Indian suburbs and still kept their Indian names and character. The small local churches were almost all constructed by Indians, who hesitantly at first, and later intentionally, adopted forms and motifs from Europe. In the process, they created an original art style called *tequitqui*, which flourished during the early years of the colony. Being near the capital, these small churches all suffered a great deal from successive revolutions.

Perhaps the most impressive of these churches was Santiago Tlatelolco, once Bishop Zumárraga's Franciscan church, where Juan Diego took his mantle with the miraculous image of the Virgin of Guadalupe, after his vision at the Hill of Tepeyac. The

COMMENTS BY THE CONSUL GENERAL OF HONDURAS WRITTEN DIRECTLY ONTO PÁL'S PASSPORT (BOTTOM RIGHT), ASSURING CERTAIN COURTESIES AT CUSTOMS.

church had four amazing pendentives under the dome depicting the four Evangelists in high relief, mounted on their winged symbols (the Lion, Eagle, Angel, and Bull), as if on Pegasus. There was also an eighteenth-century fresco of Saint Christopher, about three times life-size. Another was at Ixtacalco, a junction of the many canals that brought fruit, flowers, and vegetables into the city in prehistoric and colonial times. This was an outing spot for aristocrats; one could imagine them floating down the Indian canals, playing at Versailles, with every bit as much pomp as the Roi Soleil could hope to muster!

New Year's was much quieter than Christmas in regard to revelry and the shooting-off of firecrackers. The next day, we renewed our passports and obtained visas for Nicaragua and Honduras. The Ambassador of Nicaragua was most courteous, and full of promises, but we never imagined that he would write such a beautiful letter to the Secretary of Education on our behalf! The Consul General of Honduras wrote some

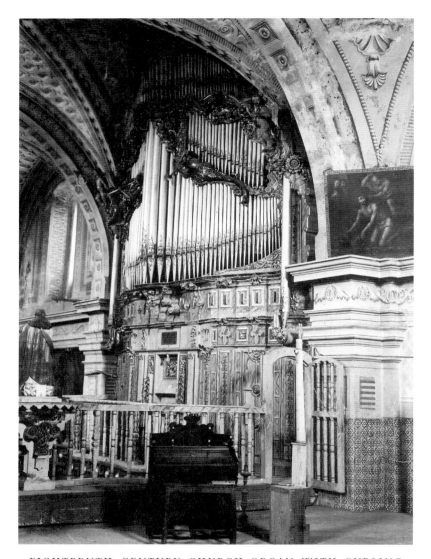

EIGHTEENTH-CENTURY CHURCH ORGAN WITH CURLING
MERMAIDS AT SAN MARTÍN TEXMELUCAN, MEXICO.

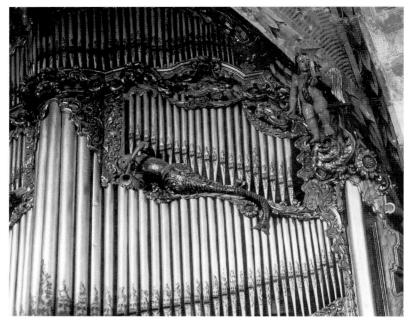

DETAIL OF ORGAN WITH CURLING MERMAIDS.

and he not only telegraphed for us to be met, but also telephoned the airport in Mexico City for assistance at our departure! Since the closer one got to the Equator, the more important personal contacts became, we did everything we could to assure getting along.

On January 5th and 6th in the company of the Smilovitses (he was the violist of the Roth Quartet and a passionate collector of pre-Columbian pottery), we drove out of the Valley of Mexico over the beautiful eastern pass (at 10,000 feet, on the watershed) toward Puebla, the "City of the Angels." It was one of those days of fierce north wind, and the famous view of the volcanoes was obscured by fog. We stopped at the little town of San Martín Texmelucan on the other side of the slopes to photograph the eighteenth-century organ in the parochial church, with its two lovely golden mermaids curling around the pipes and blowing trumpets. From there we drove to Tlaxcala, which was enthusiastically described in Pál's book *Battlefield of the Gods*. The rich, quiet valley had the same charm as back in 1933. Indeed, only a few miles outside the metropolis in any direction, the eternal, tranquil beauty of the Mexican countryside swept over the traveler. We visited the Sanctuary of Ocotlán, a lovely,

lines right on the visas about the importance of our mission, to make certain of courtesies at Customs, and gave us his calling card for the aide-de-camp of the president. Along with the recommendations from the Pan American Union and the United Fruit Company, one would think we had enough to get along on. But knowing Latin America, we also called on the special representative of the Pan American Airways,

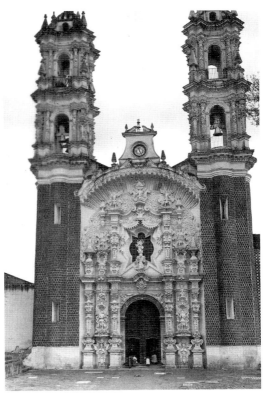

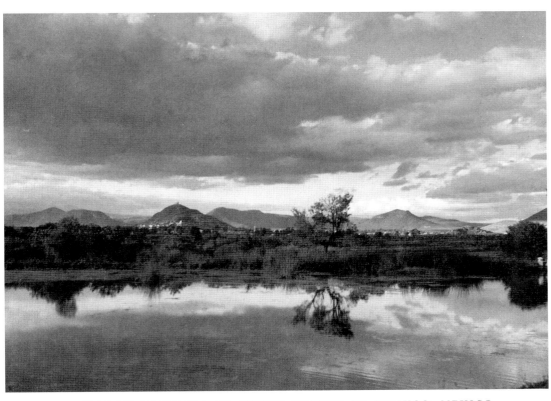

PILGRIM CHURCH, CHAPEL OF
OCOTLÁN AT TLAXCALA, MEXICO.

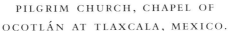

VIEW FROM HACIENDA DE CRISTO GRANDE AT ATLIXCO, MEXICO.

ornate, pink and white pilgrim church on the hill, overlooking the town. The seven Archangels adorned the facade, with an interesting portrayal of Saint Francis and the Virgin, seemingly a scheme born in the Western Hemisphere. Inside was more abstruse and complicated symbolism than usually was seen elsewhere in Mexico, and so perhaps we spent more time there than we should, but did not regret it. Lunch was a picnic in the yard of the old Franciscan monastery that we could not resist visiting again. We made a swift run through the familiar Valley of Puebla, bejeweled with its many domes of colored tiles, and onto the new road to Oaxaca.

Our destination was Atlixco, an hour south of Puebla. It was a tiny, walled town climbing up a steep volcanic hill, and fifteen years ago it must have been enchanting. But it had become a major bus stop for Oaxaca; the sale of food and soft drinks (other kinds also!) brought prosperity, and with it, the usual ambition to refurbish and "modernize." There were some lovely facades, faced with tile and trimmed with the region's frothy white stucco, but more that were already ruined. The setting sun found us a few miles outside the town, on the Hacienda de Cristo Grande, named after a big crucifix in the chapel from colonial times. Through the sculptured, three-arched churchyard gate, the cattle were coming home. The tremendous carved doorway of the great main house, by then in ruins, looked over a little artificial lake, rimmed with willows, and framed by a stucco wall, decorated with carved fruit baskets. The tiny town beyond and the two tremendous volcanoes jostled each other, as if to look in the lake-mirror. We would have stayed overnight there at the drop of a hat, but there were only farmers in the place, so we returned to Puebla and civilization, driving in the light of the full moon.

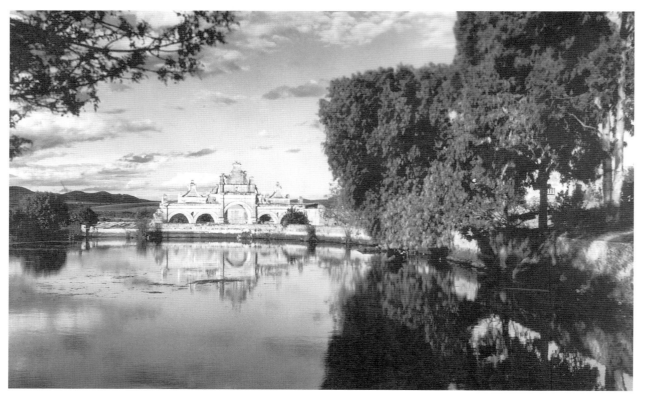

VIEW OF SANTO DOMINGO CHURCH FROM
HACIENDA DE CRISTO GRANDE AT ATLIXCO, MEXICO.

weather. We tried to go over the Pass of Cortés between Popo and Ixta but found it was only possible in a Model-T Ford or a jeep. Still, no one could have asked for a more glorious weekend!

We also made two other short trips. The first was with the Smilovitses to a brickyard in Tlatilco, where workers had come upon a whole area full of those small "archaic" pottery figurines, known as "Pretty Ladies." We wandered around on the edge of the pits, where the workers were digging out clay and asked for *muñecas* (dolls). The call went out: "*Monos, muñe-quitas!*" (monkeys, dolls), and women and children came running with small objects in their hands and aprons. The finest pieces had already risen to ridiculous prices, but we bought enough little figures and heads to be delighted with the adventure.

Another trip took us to the region of Texcoco in the Valley of Mexico. Though the town still had a charming atmosphere, it was spoiled for our purposes. But the tiny villages, just a mile or two off the main road, which at first appeared to be a wash-out, still harbored many treasures, as well as wise old men to show us around. We visited a church built on a pagan temple-base and ornamented with extravagant stucco carving, with a sweet, quiet, little cloister of ancient wood and stone that we should have liked to move into at once. Our pet village was Chiconcuac, where Chinese stucco lions that looked like sugar candy adorned the graceful *atrio* wall beside the churchyard gate.

Puebla was known as the "Angelopolis," and it had an angelic serenity about it. The city was modern enough, but still homogeneous and traditional, not restless, ragged, and rootless like the capital. We visited the famous Rosario Chapel in Santo Domingo church, which was either the mother or the climax of a certain style of rich and fantastic sculpture that was apparent everywhere in the Valley. Pál performed a tour de force in diplomatic wrangling and got the lazy lawyer-director of a private collection to grudgingly open it to the public on the morning of the holiday of Epiphany, so we could photograph the organ. After a hail to the golden cathedral, which must have been cleaned, as it was a little brighter than six years before, we retraced our road for one of the most wonderful days we had in Mexico. Our picnic was within sight of the three volcanoes, for as well as Popocatepetl and Ixtacihuatl, Orizaba Peak appeared in good

CHINESE STUCCO LIONS AT SAN MIGUEL CHURCH
IN CHICONCUAC, MEXICO.

Another day back in Mexico City, Pál had lunch with the famous Hungarian writer Lajos Zilahy, in town to lecture and see his publishers. He asked Pál's advice about publicity, but unfortunately we left before his public appearances. In the long-gone days, living in Florence, we saw a great deal of him and his wife, when he lectured at the Maggio Musicale. A few days later, the Assistant Cultural Attaché of the U.S. Embassy, a charming woman whom we

knew in Lima, gave a cocktail party for us to meet the writer Anita Brenner, and her husband, who was a doctor at the American Hospital. The evening was certainly worthwhile, and very pleasant. At a wonderful dinner at the Smilovitses, we were brought together with Salvador Toscano and Canessi, the Director of *Bellas Artes*. The former was a rather fishy and unimpressive young man; the latter one had considerably more character and contour. The trouble with people in the younger generation in Mexico, as in all Latin America, was that they seldom left the country. A new and fierce nationalism was on the rise, based primarily on ignorance of the rest of the world! We began packing madly and only interrupted it for a farewell dinner at the Lengyels.

Our last week in Mexico was a quiet one, rounding up photographs from the Colonial Museum at Chapultepec to retake over again with our Panchromatic film, if time allowed on our next visit. Searching for a clipping for Harold Wethey from an old newspaper, we paid a visit to the Hemeroteca, an extremely well-organized institution, with all the old papers and periodicals on file. We located the article in ten minutes, and found, much to our amusement, that it was a violent repudiation of a book review by George Kubler including some stupid assertions of his own, concerning Toussaint's book on Patzcuaro. Toussaint was the real colonial expert, making all his studies in the field!

Sunday we spent with the Lengyels, visiting their pretty suburban house, which was being fixed up before they rented it. Saturday evening, we dined with the former Hungarian Consul in his charming villa in the suburbs. There was wonderful food and conversation in three languages—no, four! We photographed some of the Lengyels' collection of colonial paintings, statues, and pre-Columbian pottery, and were delighted to find a distinct genuine signature against the dark background, when we put one of the big pictures into the bright sunshine. The last batch of films came in from our trip, all excellent, and highly exciting in retrospect. We also ordered some pictures from the archive of the National Railroads of Mexico. Our last visit was to the collection of Mr. Behrens, said to be the best collection of colonial art in Mexico. In late January and February we made a trip back to Central America, which is related later in our memoirs, and then returned to Mexico.

HOTEL GENEVE, MEXICO D.F.
FEBRUARY 28, 1947

Back in Mexico City in our old rooms at the Geneve, we were again very pleased with their tranquillity. We visited the Lengyels, unpacked our books, sent our clothes to the cleaners, and spent several days resting up and writing letters. The Central American films were developed and surpassed all our expectations. We also had a report on the movies, and they apparently were coming out just fine. Saturday evening we went to the Summer University building, the famous "Casa Mascarones" (House of the Masks), once a Viceregal summer palace far out of town, to hear Salvador Madariaga speak on "Democracy." He was a brilliant, if nervous speaker, all brain, with more logic than poetry and beauty, and more analysis than drama in his talk. The subject always bears repeating, especially in a country like Mexico.

Our more than 100 photographs from the archive in Mexico (that we selected in December) were taken to our old friend Limón. He did wonders with some of the weak films, so a very fine selection was put together. Among our new acquaintances were Dr. and Mrs. Neumeyer. He was a Professor of Art History and director of the art gallery at Mills College in Oakland and an enthusiast of Pál's book, which he used in his classes. They had called us for advice on a Sabbatical trip to view colonial art monuments from Mexico to Peru. It was Neumeyer's introduction to the subject, but he brought along a refreshingly open mind and good eyes, and we were delighted to help him formulate his plans.

One day we had lunch in one of the courtyards of the old Franciscan convent of San Angel, the property of a German Baron, Dr. Alexander von Wuthenau. He was a former diplomat, a sort of architect and enthusiast of colonial art, who was then in the process of restoring the seventeenth-century building into a most charming and restful home. His three small beautiful children played about, as rosy and blond as though fresh from Germany, although all were born in Mexico. Wuthenau's frustrating experiences with governmental and ecclesiastical authorities paralleled ours in Central and South America, but he said that slowly he was beginning to get across some of his ideas, and it was good to hear some of our observations corroborated. Our dessert was the fruit of the *zapote* tree, mashed and blended with orange juice into a sort of thick marmalade, which looked like prune pulp but tasted much better.

Elisabeth was extremely pleased to receive a letter from Helen mailed February 20th, our Christmas mail, and a pair of nylons! She replied, "May the Lord keep the lucky stars above us all! All four letters in large brown envelopes arrived here in good order with all enclosures. And this morning your personal letter of Feb. 16th arrived with the Peruvian clipping from Winternitz and Hungarian letter from Ervin Balazs. Please write a few lines to Mr. Balazs letting him know that his letters were received. But say that we will not be able to do anything about them until our return to Norfolk, which is not expected before the middle of May. The survey trip has taken us to various countries, where all our plans are indefinite because of varying living conditions and the vagaries of the postal system. Tell him that the survey up to now has been very successful, but we still have five strenuous weeks ahead in the silver-mining towns of the Northwest of Mexico."

We planned our trip to the eighteenth-century "silver cities," intending to start out by train to Querétaro on March 2nd; to spend two full days there and arrive March 5th in San Miguel de Allende; ditto, to Guanajuato on March 7th or 8th. Then we would headquarter at Guanajuato (the birthplace of Diego Rivera!) and make two very important field trips to Salamanca and Yuririapúndaro. We decided to cut out Zacatecas and on March 11th or 12th arrive in Guadalajara. The beginning of the following week, about March 17th, we would go to Pátzcuaro for about three days and on March 21st to Morelia, like Guadalajara reputed to be very beautiful and charming. We sent Helen our address in Guadalajara, c/o Mr. José Pintado, Gerente, Banco Nacional de Mexico, Sucursal Guadalajara, Guadalajara, Jalisco. After about three more weeks to finish up our work, we intended to leave for Washington, to stay the week of April 21st at the Carroll Arms near the Library of Congress and Union Station.

Helen remained our essential link to home and business affairs with the rest of the world. When we arrived back in Mexico City in March, after visiting the "silver cities," she had sent more of Elisabeth's nylons, unfortunately along with news of the death of our warm and understanding friend, Julian Street. A letter from the Encyclopedia Britannica also came about Pál writing an article, and one from Dr. Erwin Walter Palm, who had written about colonial architecture in the Caribbean.

SAN MIGUEL DE ALLENDE, GUANAJUATO

MARCH 7, 1947

LAST SUNDAY, WE LEFT MEXICO on the train that ended up in El Paso, Texas. On board was a typical Sunday crowd of families with many children buying food from the platform, piles of parcels, and jumbles of baggage in the aisles, including the ubiquitous bright baskets to hold the tourists' overflow. We reached Querétaro after a seven-hour trip. What a beautiful, *señorial* place without any skyscrapers and

VIEW OF SAN MIGUEL DE ALLENDE.

mostly colonial houses, some of them bearing extraordinary sculptural decoration. The use of *mudéjar* lines in the rococo was very marked and blended beautifully with the tropical plants and flowers filling the patios. Our hotel occupied a whole city block, and was on land once part of the Franciscan monastery, which housed more than 400 monks! It was pleasant, clean, and spacious; beyond it was the public market area, with small bright booths where the laboring population and visiting Indians ate. These booths were very picturesque, with their bright cloths and their pottery vessels on charcoal stoves. The only innovations were radios and jukeboxes, called *sinfonolas* here, all of which were running at once and as loudly as possible. We got more than an earful of "Cuando," "Maria Bonita," and other sentimental ditties. There was a new noise rule silencing the radios from 10:00 at night to 10:00 in the morning, but it was already being ignored.

On our first evening's walk we met a young student who showed us around the town by the light of the full moon. He mentioned the Herrera Tejeda collection as the most important one in the city and its owner as the best local historian. The next day we started photographing the interiors of Santa Rosa de Viterbo and Santa Clara, both former nunneries for women of noble birth. They both dated from the late Baroque, were almost over-rich in total effect, and could be truly enjoyed only by studying the details. Possibly by that time the artists were so accustomed to the lavishness of line, shape, and gold that the decoration was acceptable to them, but it appeared overloaded to us. The real discovery of the place was the Palace of the Ecala family, on the Plaza de Independencia, the main plaza in colonial days. It was built on a great arcade but had only four upper windows on the facade. The rich, flowing, stone decoration around the

windows imitated curtains and ornate cornices. Iron balconies bore the double-headed Habsburg eagle, and the date 1784.

In each of these cities we had the names of the local Inspectors of Colonial Monuments, branches of the main office in Mexico City. Making a call on Mr. Patiño, we found him in the impressive main patio of the former Franciscan monastery, since converted into the Colonial Museum. The statues showing a typical Querétaro provenance were the most interesting finds, beside a large "Flight into Egypt," by an eighteenth-century painter named Juarez, one of the best Mexican paintings we had seen thus far. Through Mr. Patiño we followed up the lead to the collector Herrera Tejeda, a former governor, diplomat, and bibliophile. His house was an old colonial mansion, with one wing full of books and colonial art pieces. We photographed one of his finest Mary and Joseph sculptures from an old crèche in absolutely untouched perfection, about 2 1/2 feet high. The technique and coloring of decoration in the garments was quite different from what we had seen in Central and South America. The explanation for their neither retouched nor damaged perfection was that they had belonged to the Prioress of Santa Clara and were presented sixty-four years before to the Herrera Family doctor's father, in gratitude for his devoted treatment of the nuns.

The next morning, our car started out across the hot and dusty valley for San Miguel. The populated sections were soon left behind, and we crossed a barren, rocky, dry mountain plateau, descending into a rich and well-watered valley. The road was under construction and someday may be very good, but we spent most of the time on detours between giant cactus. Before 6:00 we passed a mountain saddle opening into the wide valley of Guanajuato state before us, and immediately on surmounting the hill came upon the city, most picturesquely situated.

San Miguel was blessed with the valley's water, and it ran in open channels from one house block to the next, to be used for irrigating the delightful gardens. Some years ago, a Society of the Friends of San Miguel was founded, and took over responsibility for the old street lamps being repaired and kept in electric bulbs; it prevented the great stone doorways from being broken down to make shop windows, and the use of posters, neon advertisements, and jukeboxes! The city deserved all this devotion, because it had a

great many beautiful colonial buildings, and also some very worthwhile churches. San Miguel had been a rich mining center and thus had plenty of money for elegance. In contrast to Querétaro, it lay on a hillside, which offered vistas of great charm and variety. It had a mountain dignity when compared to the urban stamp of the city on the plain.

Thursday morning we visited the mayor, who was also the Inspector of Monuments. He was grateful to have our praise and support, and sent one of his young officers along to show us the interesting buildings. As the streets were narrow and all up and down, very little was visible from a car, and so we walked. The Church of La Salud was very unusual with a shell-shaped facade. The Oratorio of San Felipe Neri with chinoiserie altars had a fine, late eighteenth century organ, decorated with a pile of orchestral instruments on top: cellos, horns, flutes, and drums, all life-size. The Monsignor was unfriendly in the beginning, probably from bitter experiences with tourists, but later he warmed up and gave us the freedom of the place to photograph anything of interest. Our guide was a novice, unusually intelligent, levelheaded, and interested in photography and music. He showed us a cello with a stamp of Stradivarius inside that he had bought in a nearby village. We took a tracing of the F-holes and decided to try to identify it. It was quite possibly a Stradivarius, for there was a great deal of luxury and culture in the region, due to the rich mines.

The young man gave us the address of Don Miguel Vidargas, a somewhat strange but friendly old gentleman living in one of the old houses, who had a fantastic collection of antiquities. Upon entering his parlor, we thought we had made a mistake, because there were terrible Victorian pictures on the wall. But then he brought out small statuary of local make, which we photographed. He had a remarkable collection of china, colonial pottery, iron keys, locks from the early seventeenth century and later, and large silver coins, minted locally. That afternoon we went out to take some panoramic shots, and by chance asked for entry into the house of the famous former bullfighter Pepe Ortiz, high up on the hill. The somewhat unprepossessing facade led into a magnificent house with terraces and wonderful vistas. Ortiz was a graceful, graying, handsome man in his early forties. He graciously showed us all over his home.

Our hotel was an imitation colonial mansion, with many fine details copied from the owner's family house. It was a very clever combination of atmosphere and comfort, with many flowers, a garden fountain, and a wonderful bougainvillea three stories high. The hosts were proud of their good water and sophisticated cuisine with Mexican touches. The hotel would be an ideal spot for a longer stay, especially when the annex, then in construction, would be finished. The family dated from colonial times, and the former home was at that time occupied by the two elderly sisters of Don Ramón Xavala. In order to help some of their friends and indigent women, they had established a weaving and embroidery enterprise, producing native costumes adapted to American use, woven materials from the region, blouses, and table linens all using traditional designs. We had finished our plan of work and left San Miguel to drive to the City of Guanajuato, via Atotonilco and Dolores Hidalgo.

POSADA DE DON VASCO, PÁTZCUARO, MICHOACÁN
MARCH 17, 1947

We left San Miguel de Allende by car on March 8th, stopping about 10 kilometers out at the pilgrimage church of Atotonilco. This was the place where, in 1810, Father Dolores Hidalgo took up the banner with a picture of the Virgin of Guadalupe, to lead the revolution for Independence from Spain. Our interest, however, was the sanctuary, dating from early colonial times. It had been enlarged several times, and painted from ceiling to floor with mottoes and scenes in a variety of styles, ranging from late Renaissance to Rococo. In one chapel there were three "stages," with life-sized figures arranged in scenes from the Passion. Unfortunately, it was much too dark and crowded to photograph them.

On the road again, we made endless detours across the desert plateau; it was very hot among the cactus. Then it was up into the *sierra* and suddenly, after we crossed the pass, we came on a deep valley, where the city of Guanajuato sprawled with its mining communities all around. The city was once one of the richest silver mining regions in Viceregal Mexico, and both silver and gold were still being mined there. As we descended into the gorge, where the town was located, we passed whole sections of abandoned houses,

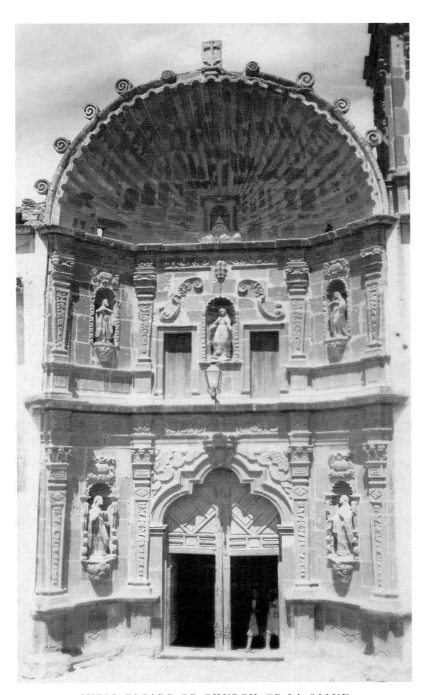

SHELL FACADE OF CHURCH OF LA SALUD
AT SAN MIGUEL DE ALLENDE.

former processing plants and even churches, where the mines had been exhausted. All this change of scene came about in an hour and a half. As deep as the city was tucked between the hills, it was cheerful and sunny, prosperous-looking, and its parks were full of beautiful tropical trees. There was an unusually fine water supply from dams built in the mountains, but when there was an abundance of water, it used to drain down the gorge and sweep some of the town with it. So a great tunnel was built to take away the surplus water. Little summer villas lined the roads that led to the *presas*, the dams.

Our hotel, originally a colonial house and partly modernized, looked over the main plaza jammed full of trees. Two or three times a week there was a band concert, when the young people promenaded, according to tradition, in three columns. The single girls and aspiring young men circled in opposite directions, with much chattering and flirtatious glances, and the more staid couples walked around quietly on the outside. There was also a Sunday morning dance at the hotel, lasting until about three, probably, because in the old days many people came in from outlying regions for the fiestas and had to get home before nightfall. Our room was in the back of the hotel. The space above the doors and the windows were worked out into large shells in the extra-thick walls, dating the building from the second half of the eighteenth century. It was so charmingly typical that Elisabeth photographed it.

The owner of the hotel, a Mr. Orozco, lived in a rented neo-Classic palace, a former governor's mansion, built by the famous local architect Tresguerras. We were invited there one evening. The place was not only cold in its neo-Classic style, but could have been an exhibit of the complete lack of taste in the modern generation, with its overstuffed satin furniture and Napoleonic bathrooms. It was as if a totally different race of people had moved in, where their own grandfathers had produced real and original art! Señora Orozco, homely but intelligent, took us very much to heart. When we left, she embraced Elisabeth in the charming Latin American farewell hug, with a light kiss barely brushing the cheek, assuring us that the palace was *su casa*, our home, whenever we wished to return. Since all of this was connected with a 20 percent reduction of the room price, we especially could enjoy all the courtesies.

During the revolutions and the Empire of Maximilian, there was tremendous fighting in this region. The churches had practically all been renovated inside, but the exteriors remained, with few exceptions, as they were in colonial times. Since the town lay in the deepest part of the gorge, every street had to go uphill. This was highly romantic, with sudden turns, steps, overhanging gardens, and flowery balconies. Considerable local pride in the appearance of the city existed, and hopefully it will not be ruined by new cement and Duco paint!

We met the Inspector of Colonial Monuments, originally a painter and teacher of design and art history at the University of Guanajuato. We went with him to visit the university in the old Jesuit monastery, then being rebuilt and enlarged, but in excellent form. The main portal was the transplanted facade of a church that was about to collapse in one of the nearby "ghost" towns. The rector took us around, and the charming old librarian showed us his various ancient documents with pride, and presented us with his history of the state, unfortunately three-fourths of it dealing with the Republican era. The courtyard was piled high with boxes and chests, containing a very fine collection of pre-Columbian Tarascan pottery, which they were not going to unpack until they could put it under lock and proper guardianship. With the Inspector of Colonial Monuments we had a most interesting day, visiting first La Cata church in a mining suburb, with so little space before the buildings that we could not back up far enough to photograph the whole facade. The sacristan tied two ladders together, and we mounted the roof of the priest's house to view the entire story of the Passion carved on the portal, in medallions placed in rococo shells!

From there we went on to the more famous church of Valenciana, where there was a splendid view of the city. It was built by the Conde Rul y Valenciana, upon the discovery of the richest silver vein in the region, and supposed to have stood right over the mine. The miners of the community helped to build and embellish the church, evidenced in the indigenous character of the elaborate ornamentation. The church dominated its surroundings, a community that once had thousands of people, but in 1947 only a handful. We took eighteen pictures of the place, a record up to that time. The church was built of a beautiful pale red, native sandstone, and had a Churrigueresque facade with strong rococo influence. The interior was intact and in perfect style, even the

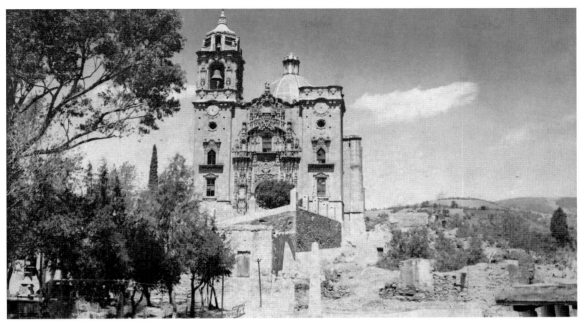

CHURCH OF VALENCIANA IN GUANAJUATO, MEXICO.

its certainly Bohemian disorder. He had a jumbled but interesting collection, especially of old books and of fine nineteenth-century portraits (of which little notice had ever been taken, and they were much better than our beloved "primitives"). The house was built in several tiers on a hillside, and had a most romantic view over the town, looking out past a great eighteenth-century dome.

On March 11th we left by car in the early morning, stopping in less than half an hour at another "ghost" town named Marfil. The first thing we noticed was a great dam, with a row of eight pillars set on the top of the curtain, bearing statues of saints still more or less intact, in spite of having been used for target practice. Then came a church on the hill, with a statue-embellished gate. We drove into the valley below the main road, to the lower end of town where there was another church, this one with lovely, shell-shaped windows. The last place was so isolated that trucks had drawn up in broad daylight and taken away the bells and the great ancient beams of the choir loft. Such pillaging was one of the reasons the other facades had been transferred to safer locations in the city.

furniture and silverwork, just as when it was originally finished. The main and two side altars were fashioned of heavily gilded wood from top to bottom, with projecting consoles, niches, and draperies, with polychrome statues catching the light from the windows above. Every stone in the pilasters was carved with a different design.

The most original character we had met for some time was "Mustafa," a photographer whose real name was Cevallos. He was the son of an ironsmith in Valenciana and could not read or write until he was 30, when he became a porter at the university, so as to be able to study there. He lived in a small tower-like building called the "minaret," on the hilly side of the town, with a wonderful view from every window. He was very poor, but the "minaret" was scrupulously clean and ingeniously arranged. He did very fine and artistic work and wore quite original costumes that became him very well. His best outfit was a black felt *gaucho* hat with a broad straight brim, and a white bolero jacket with Mexico's eagle and rattlesnake embroidered on the back.

Guanajuato was particularly charming for its lack of pretension and genuine friendliness, provincialism at its best. On our last afternoon, Inspector Leal invited us to his house, full of apologies for

We were soon out of the hills and crossed an abundant verdant valley. An hour and a half beyond, on the plains, we reached Salamanca. It was a fair-sized town on the main road from Mexico to the mining towns, with an agricultural heritage. We had seen some poor photographs of the church and convent of San Agustín at the Archive of Colonial Monuments in Mexico. Manuel Toussaint had categorized it as "very provincial." The facade was nothing special, and the main altar had been renovated in the mid-nineteenth century, but the superb side altars began at the cupola and extended down both sides of the nave to the very entrance. Almost untouched by later centuries, they represented the clearest, richest, most

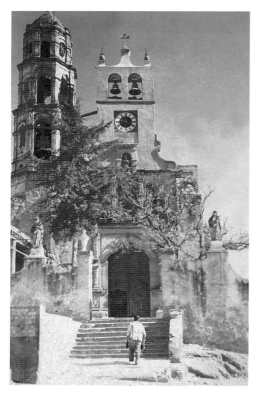

PAROCHIAL CHURCH AT
MARFÍL, MEXICO.

dignified expression of the late seventeenth century. They were equal in size but different in every other element, such as columns, background, ornamentation, and statuary. The two most striking features on either side of the main altar illustrated the lives of Mary and of Joseph. They were tableaus in half life-size and polychromed, arranged on platforms on different levels, like the scenes of a *tableaux vivant*. Especially touching were the "Marriage," like a scene in a doll house, and the "Flight into Egypt," where Mary sat on a white mule, and a tall, American, tropical tree shaded Joseph. Giant gold crowns about 4 feet in diameter crowned each individual scene like domes. There we surpassed our record at Valenciana, taking two dozen photographs of the interior.

After eating a hurried picnic lunch in the car, we visited Salamanca's old parochial church, especially interesting for its use of early Plateresque motifs and its shell-like semi-circular pediment. Then we drove part of the way back to Irapuato, a large rail center, and boarded the train coming from Mexico for Guadalajara. There was a *coche observatorio*, half lounge and half dining car, which to our good luck had only one other passenger. We were able to sit in comfortable armchairs, had quite a delicious light dinner, and tried to relax after the strenuous but very worthwhile day, going over our impressions. Our companion turned out to be an eighty-two year old Mormon, a Mr. Beasley from Salt Lake City. He entertained us with many stories always ending with Mormon lore, and asking intelligent questions about our subject.

It was midnight when our crawling *rapido* train reached Guadalajara, capital of the state of Jalisco and the second largest city in the country, and we learned that although our telegram for reservations had arrived, the hotel had not held our room so late. The night clerk called up a number of other hotels, all of which had nothing but double beds; but we were finally accepted at the Parque, somewhat out of town. It looked like a modern penal institution, with glass doors to the rooms opening onto a covered central courtyard. There was only one room with a very short, narrow, "double" bed, but the porter fetched linen for a couch in the anteroom. The next morning we left as fast as possible and settled at the Hotel Roma, run by an Italian. It was extremely clean, but so noisy that we tried out several rooms before taking an inner one, where the buses and trucks did not seem to be driving straight through the place.

Guadalajara must once have been a most charming southern city, with a very good climate, rich agricultural surroundings, and a distinguished citizenry. Architecturally, there was still much left from colonial times, and colonnaded buildings framed the two main squares. But in the side streets and farther out modern buildings abounded, and there were plans to replace the colonnades with bad imitations of skyscrapers in a mongrel style! Our best impression was of the Government Palace, finished in 1774, a curious mixture of baroque and rococo, especially the main entrance with curtains and cornices carved around the doors. The gargoyles, or waterspouts, a favorite feature in the city, were little cannons at the cathedral, complete with carriages. The best church was Santa Mónica, with richly carved twin portals that looked somewhat Peruvian in photographs, but turned out to be a Puebla design in stone, evidently characteristic of the region. The only church left with an interior from colonial days was Aranzazú, with two gilded altars. The museum, in a former Augustinian monastery, was well arranged but had no special interest for us.

From Guadalajara we sent eight filmpacks by air to Mexico, hoping they would be developed by the time we got there. One afternoon, we drove out to Tlaquepaque, famous for its pottery, and

SANTA MÓNICA CHURCH AT GUADALAJARA, MEXICO.

kept one eye out for the typical *serape*, or blanket-cloak, of the region, white with a garland of roses in the middle, and blue hummingbirds flying about. In a pottery factory, after we had been through all the rooms and seen the men making and drying plates, painting and dipping them by hand, and getting ready to fire them in a large wood-burning furnace in the yard, we discovered a really good serape, and walked out with a textile instead of a piece of pottery! Sunday, we drove to the pilgrim shrine of Zapopan, constructed in honor of an indigenous figure of the Virgin about 2 feet high. It was a tremendous basilica church with a great *atrio* (walled churchyard), but it had practically nothing left from colonial times. The greatest thrills were the charming spring landscape and an avenue of blooming jacaranda trees without a sign of green, but covered with lilac blossoms. When we returned, there was a band concert in the plaza, in an iron pavilion imported from Paris, with half-nude caryatids and griffin lamps. It was as tasteless as the age of Eiffel from which it came, poor Empress Carlota's contribution to the culture of Mexico! There was a bit of a promenade, and it was noticeable how handsome the entire population was. This was the Mexico of the romantic pictures, with wide-brimmed hats, *serapes* over the shoulder, sandals, and many guitars.

The next morning, somewhat delayed by the fact that nothing opened before 9:30, we collected money from the bank and a picnic lunch from a delicatessen run by Chinese (often the case there), and finally got away in a large new car with a most intelligent driver. The road was fine, and for once we could go 50 miles an hour for long stretches. We skirted the great Lake Chapala for a whole hour, very Switzerland-like, dotted with native villages and a few simple summerhouses, as it was only an hour from the city. The hot season was in April and May, and after the rains began, the climate was not so agreeable. The region was enormously rich; we saw great prehistoric lake beds with the best humus. Large haciendas dominated the economy, inherited from early colonial days and dedicated in great part to animal husbandry.

The villages on the map were actually quite large and prosperous towns. We had made notes to look at several churches along the way. At the first stop, we found the lovely old church undergoing complete restoration. No protest was appropriate, because they

showed us the terrible cracks in the walls and vaults, caused by earthquakes from the volcano Paricutín about 50 miles away. And sure enough, when we crossed the next pass, on the horizon the mushroom-shaped cumulus formation of its eruption appeared. We could not see flames or an explosion, but there was a high wind, and all the valleys ahead were fogged with smoke with an unpleasant sulfurous smell. Then came another pass with pine forests. The air cleared, and we suddenly came upon beautiful, serene Lake Pátzcuaro, with its seven-plus little islands in a frame of conic volcanic peaks. Turning off the main highway, we stopped at the Tarascan village of Tzintzuntzán, "Place of the Hummingbirds," where there was a romantic ruin of a monastery complex founded by the Franciscans in the early sixteenth century. The most interesting facade was on an early chapel, where the main double window was placed into a large overhanging shell, all in carved stone.

The hotel on a hill above the village of Pátzcuaro was only a few years old, built on the lines of a large hacienda house, with furniture more or less in style and the beds, linen, bath, etc., up to the best modern standards. The waitresses were dressed as hacienda servants in their holiday best, in embroidered white blouses, wide, flounced, colored skirts, and long braids. There was a little shop with arts and crafts and a large garden where roses were blooming in spite of a very cold wind and an altitude of 6,000 feet.

The next day we took a taxi into the village and studied the light on the various buildings that we wanted to photograph. Surprisingly, the town was 3 kilometers from the lake, where founder Bishop Quirogua, still the hero of the region, had located the best water. It was enchantingly romantic and unspoiled, and except for the two-story arcaded houses on the two plazas, all the others were one story. There were some very fine carved stone windows and portals on the private houses. All the roofs were of tile and overhanging the streets on carved wooden beams. Here and there were small plazas, with fountains in stone basins from the time of the town's founding. Enormous trees dwarfed the buildings.

The townsfolk were handsome and animated, mostly Tarascans with their peculiar conic heads, still speaking their ancient language. They wore different types of *serapes* from the various regions, and although the styles were beginning to degenerate, Pál bought two

EL HUMILLADERO CHAPEL AT PÁTZCUARO, MEXICO.

excellent pieces off the backs of a man and a boy along the way. The sale was carried on with remarkable dignity and logic, nonetheless. The patios were all full of flowers: giant geraniums, both single and double, in the most unusual colors, and we saw lemons, oranges, and bananas all in one garden. For the most part, the churches had been much changed, both inside and out. Details of

CHRISTO DE TERCER, SAN FRANCISCO CHURCH
AT PÁTZCUARO, MEXICO.

three-dimensional engraving. On an opposite hill outside the town, in the Chapel of El Calvario, we found a life-sized group of the *Pieta*, with Mary holding the dead body of Christ, surrounded by the mourning St. John, and Mary Magdalene; at the sides were Joseph of Arimathea and Nicodemus, carrying linen and myrrh. The figures were dressed in real cloth, and only the faces and hands were carved, with an excellent high-glaze *encarnación* finish.

The best single piece we found was a crucifix in San Francisco. It stood in the center of the main altar, encased in glass in such a way that Elisabeth could photograph it only from inside. She accomplished this by kneeling, and was in constant danger of falling through the glass, or getting burnt by the electric light bulb that had to be turned on because it was so dark! The body of this Christ was made of a curious plastic material that dated back to pre-Columbian times. It was produced by mixing the juice and stems of a certain type of orchid with other ingredients to make a very pliable kind of stucco. This was put on over a carefully constructed armature of corn stalks. Where an especially fine curve was needed, quills were added to avoid breakage. A layer of fine canvas covered this construction, then the gesso was molded, and *encarnación* applied. The result was an amazingly soft and ivory-like effect. The anatomy was very subtly modeled. The head of the figure hung far forward, and he was bleeding from his many wounds, which was traditional in most Indian Christs. The face was also absolutely Indian.

At 8:00 the next morning, we took a launch to the nearby island of Janítzio, the largest and most attractive island in the lake, and famous for the fishermen's butterfly nets. But this was not fishing season, and the whole town was dead asleep from having celebrated a fiesta the day before! However, we took some characteristic shots of the dugout canoes in action, nets drying on their poles, typical streets, and dirty children. Since the Tarascans have always been very good at their folk art (weaving, pottery, woodcarving, and brasswork), and the arts were beginning to deteriorate in modern times, a museum of popular arts was established in an old convent in the town of Pátzcuaro some years ago. They had several rooms displaying the changing styles of their famous lacquer work on gourds, and we took a colored movie of one big piece, with the really enchanting garden of the patio as a background. The exhibits were enlivened by

certain facades were interesting enough, but the finest of all was the stone portal of a tiny chapel outside the town called "El Humilladero," or the "Humble Place." It had a wide frieze around the whole doorframe, an enlargement of a silversmith's pattern influenced by illuminated codices, which produced the effect of a

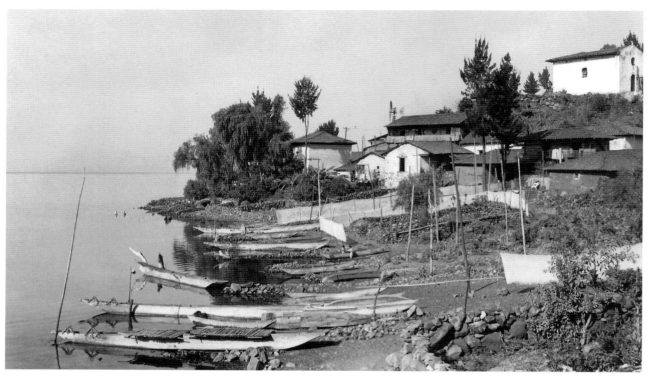

VILLAGE ON THE ISLAND OF JANÍTZIO, ONE OF THE SEVEN ISLANDS OF LAKE PÁTZCUARO.

men's faces, wide hats with bright ribbons, and performed an intricate tap-dance leaning on the crooked canes of the old folks. As was usual in all Indian dances, two little boys performed at the end of the row, learning the steps, and later gave a short solo. The program may sound very rich, and so it was, but not too strenuous, since the hotel was spacious, beautifully outfitted in furniture, flowered patios and gardens, and very quiet. The absence of city noise, after our various city quarters, was a real recreation. All the hotels and restaurants in the region served enormous mid-day meals between 1:30 and 4:00. Each dish arrived separately: soup, rice, enchiladas, meat, salad, beans, the sweet for dessert, and coffee. The suppers ended the day pleasantly with Mexican spiced chocolate and sweet rolls.

being placed in typical peasant rooms with furniture and even stoves, beds, and bathtubs!

The Inspector of Colonial Monuments in Pátzcuaro was a painter named Salvador Solchaga, a descendent of one of the thirty Spanish families that Bishop Quirogua invited to help him settle the district (together with 30,000 Tarascans!). Solchaga was a mild, soft-spoken artist, from whose mainly inherited collection we photographed an exquisite, small, polychrome group, a Crucifixion head, and a canvas of the "Mater Dolorosa." He made some interesting and helpful observations about his own region, but once again, it amazed us that none of these men ever seemed to show an interest beyond their own borders.

Later that day, the hotel filled up with a party from Cook's, and we were all entertained by singers and guitar players in typical costumes. Later, another group of natives performed the famous Pátzcuaro dance of the *viejos* (old men). Their heads were bound with white cloths to indicate gray hair. They wore masks with old

Before leaving Pátzcuaro, Elisabeth wrote to Helen, sending her the latest pages of our travel adventures and acknowledging her letter of March 8th that awaited us in Guadalajara. There was more to do about stockings: "You were quite right not to buy any more stockings; if they all wear as well as these are doing, the four new pairs should carry me through the summer!" and, "We gave more or less definite dates to Catherine and Bedore" (our faithful help at the house in Norfolk) "in our last letter, and trust they realize by now that we shall not return before the first week of May at the earliest." And lastly, "We are looking forward to the letter from Dorfmüller, in Munich; he was Sigrid's best and most faithful accompanist. His address was lost to us since the war."

MORELIA, MICHOACÁN, AND THE RETURN TO MEXICO CITY

MARCH 28, 1947

THE FOLLOWING MORNING, we left Pátzcuaro and drove a little more than an hour to reach Morelia, a very pretty and pleasant city. The Virrey de Mendoza Hotel in Morelia was a transformed colonial palace, where we had practically the only quiet room, as there was no getting away from the auto traffic, bells, and juke-boxes. As everywhere else in Latin America, the taxis relied equally on their personal prowess and their horns. That meant that every driver blew as loudly as possible at every crossing, and then forged ahead, daring anyone to get in his way! We headed immediately to Las Monjas, which had a life-sized, beautifully expressive "Christ in the Casket" made of a paste like papier-mâché from the pitch of corn stalks. We were deeply saddened to find the figure resting on a very high catafalque covered with purple veils, and absolutely impossible to photograph, especially since the sisters of a lay *cofradía* were gathering like a bunch of solemn crows for a special service! That was the last interior photograph we wanted to take, and indeed as though on a train schedule, the next morning all the churches had their main altars and principal statues covered. That was the reason for our rush, as no more interior work would be possible until after Easter.

In our desperation, we went hunting for photographers who might have taken the miraculous figure; we found a Mr. Chavez who had one picture, which was not the one that we had seen in the *Annual* of the Michoacán Museum. Thereafter, we went to the museum, where the efficient young secretary started to make connections for us, telephoning the director and also the organist-composer of the cathedral, Miguel Bernal Jiménez. The director arrived in good time and turned out to be an ultra-nervous but cooperative person, as was proved the next morning. He gave us the address of the photographer, who had taken the photograph that we wanted. So we went to see Mr. Dominguez at Foto Hollywood, who was a fashionable photographer of society girls. After the necessary

UNUSUAL TWIN PORTALS OF LAS ROSAS, A DOMINICAN NUNNERY IN MORELIA, MEXICO.

preliminaries about our survey trip and to what purpose the picture would be used, he told us to return about 7:00 that evening. When we did, Dominguez presented us with a beautiful 5 x 7 inch print and refused to accept any payment for it!

In the museum, we photographed two indigenous Christs and some very interesting new Tarascan discoveries, a big pottery jar and two pieces of jade. The building was a colonial house and would someday be very effective, but they seemed to be reconstructing every room at once. Saturday afternoon, we made our usual tour of

the churches with a car, finding practically all the facades reconstructed, but with some fine details remaining. The most unusual was the nunnery church of Las Rosas, with its stunning twin portal, and a very fine Santo Domingo polychrome statue inside, which, by some miracle, had not yet been covered up.

For the evening we had an invitation to visit the organist Jiménez, who lived in the same building that housed the Conservatory of Music. In fact, he seemed to be the Conservatory himself. He had studied for two years in Rome, was married to a charming woman, and they had three children. When we started to introduce our survey, and ourselves mentioning Pál's article in the *Pan American Bulletin* on "Colonial Organs in Mexico" (also in a Spanish edition), he assured us that no further explanations were necessary. The evening was very valuable. We had always felt that there could not have been this love of music, manufacture of organs, string, and other instruments in the colonies, if there had not been original work done there. Jiménez corroborated this, and showed us examples of eighteenth-century compositions that he had found in the archives of Las Rosas, which was a musical conservatory. He had a chorus which performed those works in church and concerts. After much urging, he played some of his own compositions for us. They showed a good deal of originality, vitality, and good workmanship, untouched by any imitation of European music.

Our last field trip was to the Augustinian convents of Cuitzeo and Yuririapúndaro. We started off around 10:00, crossing at once the inevitable pass and coming upon an immense lake bed that stretched clear across the horizon. In the brilliant morning light it was impossible to tell whether it had no water, some water, or a lot of water! As we descended to the long colonial causeway (probably based on a pre-Columbian structure), we could see that the lake was practically dry. The water had been drawn off by the construction of a dam to supply some of Mexico's large cities. Shortly after 11:00, we came to Cuitzeo, one of the earliest outposts of Christianity in the region. It was a fortress-like church with a convent. The cloister was especially fine, with double round arches between the buttresses, quite Romanesque. There was also a beautifully preserved example of the "open chapel," the function of which made possible the attendance at Mass of great crowds of Indians congregated in the atrio or churchyard. For the first

CLOISTER WITH DOUBLE-ROUNDED ARCHES
AT AUGUSTINIAN CONVENT IN CUITZEO, MEXICO.

PLATERESQUE MAIN FACADE OF CHURCH IN
YURIRIAPÚNDARO (NOW YURIRIA)
IN GUANAJUATO, MEXICO.

SIDE FACADE OF CHURCH IN YURIRIAPÚNDARO.

time, we encountered the figure of the Siren as a bird or harpy, as in old Catalan symbolism, and apparently also Augustinian.

Driving on, we came to another lake bed, out of which Cuitzeo rose like an island. That time, instead of taking the bumpy elevated road of the causeway, the driver turned onto the lake bed itself, smooth as a landing field, and dotted with green tufts and cattle, with a few boats stranded in the middle. Another hour brought us to Yuriapúndaro, where the border that separated the Tarascan and the Chichimeca peoples was located, before the Spaniards came. In our time, it was a thriving provincial town with another beautiful fortress-like church, the main attraction of our trip. It had Plateresque main and side facades, as if a Florentine reliquary casket from the time of Benvenuto Cellini had served as inspiration to the designers of the decoration! What once was an ornamental composition, intended for a small object not longer than a foot and a half, was here enlarged to cover the whole facade. In the process the European character was lost, and a strong indigenous spirit replaced it. Although a dilution of the composition had to take place, nevertheless, not one section appeared weak or not fully decorative, producing a striking effect absolutely unique, both in the New World and in Europe. We said we had never seen anything so Florentine that nevertheless spoke a forceful American language! In the last century (as happened nearly everywhere), a large wrought iron fence had been erected around the building, reducing the size of the *atrio* considerably. Then we understood why we had never seen better photos. Really good long shots were to be had only after Pál had talked his way into the storage room above the local barbershop, the only building nearby that had a second story. After negotiating a ladder, we found a balcony with an excellent view to take the picture. Returning to Morelia, we were able to enjoy the Sunday evening band concert in an outrageous iron bandstand next to the beautiful austere cathedral. The entire city was promenading under the Victorian clusters of round lamps around the park. We left Morelia by car early the next day, headed for Mexico City via Toluca. The drive was very pretty, and proceeded rapidly on one of Mexico's best roads. Our driver was heavily bearded from his role as a Spanish *Conquistador* in the movie *Captain of Castille*, with Tyrone Power! The road led across the golden plains into Toluca, which we knew from our jaunts with the

great linguist Roberto Weitlaner, in previous years, when we went to visit the ruins of Calixtlahuaca and Malinalco. Toluca had become very commercialized. The most beautiful church, the Franciscan Third Order, was completely built into the large, bazaar-like market building and had lost its facade, except for an interesting carved door, which we photographed. The pass from Toluca into the Valley of Mexico was spectacular and green with pine forests. We had no view because the distance was submerged in mist and dust, due to the impending rainy season. We had scarcely reached the hotel when a dust storm started up, forcing us to close the windows in haste.

We were glad to reach Mexico City three days early, to get as much as possible accomplished before the holiday weekend. Everything was already beginning to shut down, as practically the whole town departed on Easter vacation. One of the oldest and largest bookstores simply closed for the week, as did our photographer, since none of his helpers would come in, even if he did! Officially, the holidays were supposed to last from Maundy (Green) Thursday evening until the following Tuesday morning. However, by that time our sixteen film packs would have been developed and shown how our work turned out. During the following week, we caught up on some correspondence and did some photographing in a very good private collection. We had a few invitations for the evening, so the time passed pleasantly enough. The trip to the "Silver Cities" revealed not only powerful and original colonial art, and even a school of woodcarving quite different from those we had seen, but also the atmosphere of "Old Mexico" with its charm, courtesy, and friendly, cooperative spirit, all devastatingly obsolete in the capital.

HOTEL GENEVE, MEXICO D.F.
APRIL 13, 1947

The weather in Mexico was beguilingly spring-like, sometimes very muggy during the day, and then a thunderstorm or a dust storm would arrive. It was early for all those manifestations, but people accounted for the unusual weather by saying that the rains the year before were meager, and short of duration. We wrote to Ecuador and Argentina for the photos that were promised to us nearly a year ago.

Goodness knows what happened with our friend in Brazil, whom we already acknowledged for sending pictures! In Latin America, as we learned more and more, there could be a great distance between the intention and the execution.

We received a welcome letter with enclosures from Helen on April 5th. Two related to pending subscriptions to the *Catalogue on American Indian Archaeology* and the *Gazette des Beaux Arts*, which we turned down. But a clipping about the ex-Archduchess of Habsburg had special interest for us in that her sixth child, Monica Pia, became the wife of Joseph Franz, one of the Hungarian Habsburgs, with whom Pál had plenty of contact. Elisabeth was introduced to her in Budapest in the neighboring box in a movie theater, and said that her hands were as chapped and dry as those of a washerwoman! Elisabeth's favorite dinner-dress, with the pleated skirt and big, red, embroidered sleeves was a copy of one designed for the Duchess.

Our last three weeks were spent finishing up our research and tying up loose ends. We expected to have a pleasant round of company, which had constantly been postponed because of our many side-trips. But we both had bouts with a mild dysentery, which the doctor said was not so much a germ, as the effect of the altitude on our general weariness. So we cut our program to the bone, living quietly, eating safely, and seeing only our Hungarian friends, whose kitchens we could trust, and who understood the situation! We had a sure cure for most intestinal upsets, frequently used here, consisting of three or four raw apples a day, shaved or grated into pulp. It was wonderfully healing, and not at all as primitive as one might think. Nevertheless, we managed to get everything done and see all the important people we intended to. Elisabeth opened the next-to-last film pack to take her last pictures in the Colonial Museum, and then we began to pack in earnest.

Before we left, Elisabeth sent a last letter to Helen saying that we were packing to start for home the following Tuesday, April 22nd, and that we had a marvelous amount of material: over 600 new photographs of her own making and at least as many from others, and it had given us quite a different perspective on all colonial Latin American art. The various localities, even in Mexico, were far more original and varied than we dared to expect. This bore out Pál's theory that the indigenous population (the Indians, to be specific) colored and tempered both the art and religion imported by the Spaniards, until it became their own, and it varied in different localities as much as the Indian tribes themselves.

Her letter continued that we planned to arrive by train, changing to the C&O in St. Louis and reaching Washington Saturday noon, April 26th. We expected the four days on the railroad to be fine; we would have a drawing room, and Pál intended to do some writing as well as much putting up of the feet. We were delighted that she (Helen) would meet us in Washington, and help us with our final research at the Library of Congress. We planned to stay at least a week or ten days, for Pál was to have some discussions with the State Department and the Pan American Union, as well as work at the library. He also needed to do the final research for four articles on Latin American colonial art for the Jubilee Edition of the *Encyclopedia Britannica*, since it had a deadline already once postponed out of regard for our trip. Our Washington hotel would be the Carroll Arms Hotel, First and "C" Streets NE, Washington, D.C. Then we planned to take the morning train to New York, where the cook was to meet us as usual with our car, and drive us straight home. We did not intend to stop in the city at all or go back unless very pressing business arose, until Pál was ready for consultations with his publisher on the new book, sometime in mid-summer.

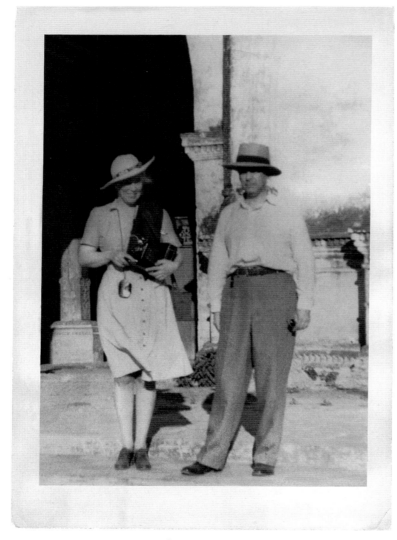

ELISABETH AND PÁL IN SUBTIAVA, NICARAGUA.

CENTRAL AMERICA, 1947:
MEXICO TO NICARAGUA

WE ARRIVED SAFELY IN MANAGUA and checked into the Gran Hotel, after a rough but beautiful flight from Mexico. The pilot gave us a scenic ride, flying out between the two volcanoes of Popocatepetl and Ixtacihuatl, as the sun rose over them. Pál complimented the captain for a fine take-off, and when we mentioned that we were interested in ruins, Elisabeth was invited to sit in the cockpit to film Monte Albán, the great ceremonial center near the City of Oaxaca. The window was opened for a clear view, but it created a terrific suction. There was just time for her to check lighting and focus. Then we saw the great bluff, on which the ruins stand, and came in quite low to view the many mounds outlined against the sky. The co-pilot pulled a few stops, like an organist getting ready for the big finale, and the plane swooped over at such an angle that Elisabeth thought her head was coming off! She hung on to the camera for all she was worth, and later remembered no impressions of anything, except the magnificent, familiar Zapotec buildings, scooting by the sighter-lens.

After that, we ran into so much wind that she did not get up front again. We flew over a smoking volcano in Guatemala, and over Lake Atitlán, blue as a sapphire. It was amazing how each of these countries had its own individuality of landscape, as well as of people. Guatemala had a special dark, intensive color; Salvador was more arid, with choppy contours. We saw Honduras from over the ocean as a long green slope disappearing into clouds. Over the border of Nicaragua, one volcano followed another all the way to Managua. Nicaragua had the volcanic temperament of Guatemala, but was less

violent, more capricious, and had considerable open land between its cone-shaped peaks. If we wrote an article about it, we would call it "Few Attractions, Many Delights." It was hot, the few roads were terribly dusty, and all the usual precautions were necessary regarding food, water, and mud. On the other, more favorable side, that month a wind was blowing that cooled things a bit, and it was dry with only a few insects.

The hotel in Managua was comfortably built and very clean, as it was run by a Swiss. Our room had a small, semi-enclosed balcony, which was the "living-room," where Elisabeth wrote our letters; it overlooked the patio and swimming pool. Inside was a very large dark bedroom with great transoms in the walls for ventilation. Big double doors could be opened onto the balcony or closed tight against the heat; our entrance door had a screen lattice so that it could be opened and no one could see in. No glass anywhere; the lobby and dining room were pavilions, just roofs supported on posts. The town was shabby and unpretentious, but the people were gay, friendly, and remarkably energetic considering the climate. It was customary to open everything up to the evening cool. After dinner, we took walks past rows of brightly lighted houses, with hospitably open doors. Inside, neatly arranged parlors appeared as on a stage set, sometimes in wicker, sometimes in Victorian plush. The families were inside reading, sewing, or receiving guests. If space allowed, there was a view of the patio or second parlor; otherwise the vista was discreetly closed with a screen.

Upon finishing our walks, we stopped at the "Bonboniere" around the corner from the hotel for ices and lemonade, where a white turkey perched under exotic, flowering trees. Two sisters once Hungarian, later Romanian, ran the place. All the recipes were

boiled, the cakes homemade, and the place had become a rendezvous for all Managua. The limes and fresh pineapple were delicious, and the native honey as heavy and exotic as the perfume of the flowers it came from.

When we arrived, we were met by an American of long residence here, the president of the Tropical Radio Company, and a representative of the United Fruit Company. He drove us the 12 miles from the airport (a U.S. bomber base during the war), and had engaged the nicest rooms in town for us. The next morning we visited our embassy and met Ambassador Warren. The cultural relations officer was an engaging young man named Canter, a former teacher in Boston, who cut red tape with serenity. Within an hour (while we visited the famous American Library and acquired some books on Nicaraguan history), he got together reporters for a press conference, which appeared in print that afternoon. He also called for Dr. Cuadra Cea, the director of the Instituto Indigenista (Indigenous Institute), who would accompany us on our trips to León and Granada.

Mr. Canter also made efforts to reach an engineer, who could advise us about living conditions in these towns. It turned out that this man was away, but his brother invited us to dinner that evening. About 8:00, two young men in white linen appeared, with their very pretty wives, and a little later a serious, slightly older man, with our friend from the institute. We drove to the country club, a handsome mahogany pavilion, and after drinks on the terrace we dined sumptuously on the open verandah. Dinner started about 10:00 and broke up about 11:30. We had *tournedos* in a delicious, thick tomato sauce with peas, and finally canned peaches with a lump of ice in the center, apparently the height of elegance, as we ran into it on several special occasions.

It was not until the next day, when we had the chance to talk to Dr. Cuadra Cea alone, that it became clear just who was who in that eager and intelligent party! The silent young man was actually our host, Roberto Lacayo; the gayest was his partner Julio Cardenál; and the round-faced, most brilliant one, his brother. The next day, Julio came about 8:30 in the morning (everything started early here, with a rush to get finished by 11:00 and achieve complete stagnation until 3:00, if must be, but preferably until 5:00 or 6:00!). We drove around with Julio to admire his well-adapted, modern, tropical style of house design. We stopped at the lovely little crater lake that was the city's water supply, right on the shore of great Lake Managua, but separated by a natural volcanic ridge. Then, within 15 kilometers (9 miles) out of the city, we rose nearly 2,800 feet up from the tropical lowlands, past heavily forested shoulders, into the coffee country, with its calmer outlines and exotic evergreens. Julio was building a house there for the president of a large gold mine. It stood on a huge bluff, with marvelous views of Lake Managua and the Pacific. The day was stormy, and enormous clouds were racing; some scattered our hilltop with rain. Below we could see Managua and the distant volcanoes in bright sunshine. The house was pretty but quite impersonal, although beautifully planned for the changing weather and taking advantage of the prevailing winds.

We visited a couple of private collections the next day, but so far had seen nothing pre-Columbian that was better than what was on display in the Managua Art Museum, except for two fine burial jars to be photographed later. The rest of the weekend was spent preparing for the trip to León, resting and swimming with a nice new friend from the American Library. Monday we started off to León on the 10:00 o'clock train in our lightest clothes, Elisabeth's hair tied up in a bandanna against the dust. We were accompanied by Dr. Cuadra Cea, who was a pleasant companion, but so shy that Pál still had to do all the bargaining; however, the man knew all the history dates! The ride was not too bad. It was the windy season, and for half the way we skirted the lake and came close to the foot of smoking Momotombo Volcano. We saw the sardine fishers' shacks, their primitive traps, and the fish drying on the shore. Egrets and blue herons were fishing. The water was shallow and muddy brown, always restless; it was populated with alligators and fresh water sharks, apparently stranded ages ago, when the rising line of volcanoes cut the region off from the sea. At noon Indian women boarded the train with wooden trays of tortillas, cheese, and meat thick with red pepper; also the native drink of chocolate and cornmeal gruel, served in delicately carved, hollowed-out gourds. We resisted the temptation to eat anything other than our own sandwiches, but we were so crazy about the cups called *jicaros* that we subsequently made quite a collection of them.

In León, we were met by a Mr. McGuire, an agent for U.S. farm machinery, to whom we had introductory letters, and had telephoned ahead. In the midst of the dizzying bustle and noise of a tropical station, it was certainly good to hear an American voice, and to be carried away in a comfortable Dodge. Taxis were terribly expensive, and it was preferable to ride in a horse-cab, usually lined with red leather and with two tiny, bony animals up front. We parked our things at the Hotel Metropolitano in a vast 14-foot-high room, with furnishings of about fifty years old, including the metal washstand. Cuadra Cea went to lodge with his sister. We lunched and dined in the unpretentious but well-kept three-patio house of Mr. McGuire, whose wife was Nicaraguan. There were also three children, bilingual and blessed with musical and poetic talents. The sensible parents indulged them with books and records to keep them off the streets, where the native adolescents drifted too aimlessly to suit them.

León was the old university town, politically always on the liberal side. Most of the churches were heavily reconstructed, but there was enough left to observe that this part of Central America got little inspiration from Mexico. Even the few towns were built with a different layout. Structure and decoration also were different, proving again that no matter what plans may have been sent from Spain or made in the large centers of the New World, in execution the buildings took on the expression of the Indian or *mestizo* who created them, and thus had a strong local flavor. Especially striking was the church at Subtiava (an Indian suburb), with twelve columns in the nave, each a single 40-foot cedar shaft. The Calvario was also interesting, finished in 1810, with polychrome stucco panels of Passion scenes, like large medallions on the facade. The overall aspect of the town was charmingly colonial, and the market showed the richness of the country and its primitive ways. The sounds of the solid-wheeled oxcarts going down the old cobblestone streets and the shrill whistles of the brilliant tropical birds were another new experience.

Thursday we postponed our flight and took the train at 8:45 A.M., getting off an hour later in Masaya, the Indian center. We found it rather disappointing. The old churches had been remodeled, and the interiors were gone. The market was uninterest-

ing (guidebook to the contrary!). We took a two-horse coach and jogged 5 kilometers out of town to the village of Nindirí, to see one of the country's best archaeological collections. Some twenty-five years ago, the Rockefeller Foundation gave money for a sanitation campaign in Nindirí. The digging of wells and outhouses unearthed countless burials, for this elevated area between the two great lakes was once a vast pre-Columbian settlement. The owner of the collection, who was also the postal and telegraph chief, gathered what he could from the diggings, ahead of an American rival in Managua. The collection revealed at least three types of cultures, and some of the pottery showed strong Maya influence, indicating a connection much farther south than had been recognized previously. We got back on the hot dusty road to make the afternoon train to Granada and passed an old colonial church, far gone, but with two wonderful wooden lamp holders in the form of lions. Granada had fewer colonial buildings than León, but was picturesquely situated on an elevation overlooking Lake Nicaragua with its islands, live volcanoes, and tropical flora and fauna. The hotel, appropriately called the Alhambra, was the ideal tropical hostelry of the last century, complete with hammocks, and the walls open along the roof, to leave space for air circulation.

On our last morning in Managua, there was an earthquake about 4:00 A.M., for what seemed much longer than its one-minute duration. We heard a strange roar, and the mirrors and pitchers all rattled, but no other excitement or damage occurred. A few hours later, we visited the Jesuit Seminary, constructed on a promontory into the lake. The superior, a well-versed, shrewd, and gracious individual, showed us stone idols in the courtyard from Zapatera Island and some unusual pottery. Afterwards, Elisabeth photographed in the Managua Art Museum, and Pál bought a basket, 2 feet in diameter, for our growing collection.

At 1:00 we drove with Ambassador Warren, the Cultural Attaché, and a visiting pedagogue to the Ambassador's house, a twelve-minute ride south that took us 500 feet above the city. What a wonderful view and breeze off the lake! He and his wife were very cordial, cultured people with a good understanding and appreciation of our interests. The view was wonderful, with rainstorms crossing the lake. In the afternoon, the Ambassador had to return to the office, because

of pre-election tensions in Managua. Pál went for an interview at the home of Colonel Mendieta, a leading writer specializing on the economy of Nicaragua, who wanted to write about our visit. He was a self-made man of mixed European background, and he was considered a possible future president of Nicaragua because of his popularity and perspicacity.

Then we had a last coffee-ice, and were off to Honduras. The airports in Central America were as busy as La Guardia, with a huge amount of freight being shipped, since it paid better than the passengers did. Just before our flight was to leave, a loudspeaker announced that the plane was too heavy, and the passengers were all invited to stay over a day or so. A furious, somewhat violent protest broke out, but to no avail. Pál got hold of the head man of the port, pulled out the newspaper with his picture on the front page, and our immediate departure was arranged!

TEGUCIGALPA, HONDURAS

THE FLIGHT FROM MANAGUA TO HONDURAS was extraordinary! It took us once more over the lakes and volcanoes, through a curtain of clouds and out over an entirely different landscape of rough, green grazing land. Tegucigalpa lay in a sort of crater formation at about 2,000 feet. The climate was enchantingly spring-like and bracing, with clear mountain mornings, but quite warm during the day. The city spread up a mountain slope, with a reservoir on top and a vast artificial terrace, built out as a palm garden. The effect was every bit as charming as Taxco, and much less spoiled.

We had to get used to rising early in Central America, the same as back in Yucatán in 1933. The entire world, both in Nicaragua and Honduras, seemed to rise with shouting and bells between 5:00 and 6:00. To add to this, the Virgin of Suyapa, a tiny colonial statue and Patroness of Honduras, was visiting the city on her 200th birthday, so before the pre-dawn bells and trumpets, rockets were shot off to greet her. Their timing was such that if we happened to sleep through numbers one, two, and three, numbers four or five were bound to wake us up. The Virgin went home on Monday, accompanied by the entire town, with even serious persons breaking important appointments to accompany her. We were only hoping that the great red draperies would be taken down from the cathedral altar, so that we could study and photograph it.

Tegucigalpa was probably the only world capital without a railroad, and as there were almost no roads, "civilization" was still on the way. Elderly folk still talked about their delightful fifteen-day trips by horseback to the coast, when they spent each night with friends at a different hacienda. The people were quite distinct from the gregarious chummy Nicaraguans, friendly but rather reserved and featuring fierce eyes and wide, generous mouths. We did not see the extravagant wealth that contrasted so glaringly with the general poverty in Mexico and Nicaragua. Honduras had no industry at all; people lived on bananas and beans or had to pay U.S. prices plus import costs for American goods, even for such simple things as cotton and soap. There were good taxis for fifty U.S. cents per ride with walking as an alternative, but no cute little horse carriages as in Nicaragua. The town was on a slope—it was once a mining town— and sooner or later, every street turned abruptly uphill. The gardens had banana and orange trees, grapefruit and limes, with bougainvillea in full bloom. Our hotel on the top floor of the new Pan American Airways building was a salvation. It was the final link of an attractive international chain, and we stayed there all during our trip.

The U.S. Cultural Attaché, James Webb, was our first contact and a fine man with a welcome understanding of our requirements and the country. He arranged (and often accompanied us) for meetings with the Minister of Education, who was assisted by the Chief of Protocol, and the Director of the School of Fine Arts, a painter with a good feeling for the native arts and crafts the school was developing. We also met the Director of the National Library, a pathetic, depressing place with a political appointee at the head; and the officials of the Instituto Interamericano (U.S.-Honduras Center), a lively group.

Above all we enjoyed meeting Monsignor Lunardi, the Papal Nuncio. A few days after our arrival, a servant girl came to our hotel room bringing a bouquet of flowers and his calling card. The next day we went to visit at his mansion in a beautiful garden full of tropical trees. The maid guided us into a large room, where he

sat on a throne-like construction with a canopy over him. After a formal greeting, he waved us to sit down beside him on the ordinary chairs in his reception room. The Nuncio was a roly-poly, balding, typical Italian, very cordial and pleasant, who spoke in a mixture of Spanish and Italian. He didn't say "plaza" but "piazza," and very often used Italian words after he realized that we would understand him. He also seemed happy to indulge our Italian learned in Florence and provided us with valuable information. He wove all his experiences into such fantastic theories that it was difficult to finish our meetings on time.

Lunardi was an archaeologist, historian, and more than well informed about the country. He owned our *Medieval American Art* book and said that he was a Maya collector, then told us how he went about it. The priests in the small villages in Honduras, especially in the northern half where the Maya influence spread out from Copán, had good communications with each other and Tegucigalpa. Thus the Nuncio was always able to telephone or send a message to any particular village that he wanted to visit and have facilities waiting for him. Whether he went by coach or by mule, he managed to visit many areas that archeologists had not yet investigated.

The Carnegie Institution of Washington had started working in the Yucatán and soon at Copán. The Carnegie people asked us, when we went to Honduras and also other places, when we found any trace of anything of archeological significance to report it to them. The Papal Nuncio also wanted to know what we had seen. We told him that during the war we had been as far as Bolivia and found the Andean area perhaps the most interesting. The Peruvian excavations on the Pacific Coast were so delayed that the so-called grave robbers had dug into many valuable cemeteries and village sites to get the mummies, their gold, and other valuable objects, which meant obtaining reliable data was difficult.

Monsignor Lunardi showed us some pottery pieces that were beautiful examples of the southern Maya civilization and some outstanding bone and metal objects. Later when we showed the photographs of these to Maya scholars, the writing on the vases usually would be Maya, but sometimes the southern Maya pieces had so-called "pseudo" glyphs, merely decorative letters without any meaning. We returned to take photographs in his courtyard, where the sun was excellent and thus assembled a fine photographic collection of southern Maya pieces. Later we had several more meetings with Monsignor Lunardi and formed a fast friendship. He was so pleased by our attentiveness to his torrent of archaeological theory that he put his most valuable negatives at our disposal, which we had printed. Pál wrote an article on the Nuncio's Honduran Maya collection published in Spanish, and about the importance of the archeological and colonial treasures of Honduras. We had by that time gotten our photographs and documentation together and confirmed that Comayagua and Honduras, although not well known, contained valuable additions to the body of Spanish colonial art.

Some years later we met Ambassador Webb and his wife again in Washington. He had by that time retired from the diplomatic service and moved into a renovated, former slum section of Washington. Webb told us that the Papal Nuncio had left Tegucigalpa about two years after our 1947 visit. Twenty-four large boxes were shipped out as diplomatic luggage. They ended up in the Papal Nuncio's birthplace of Livorno, destined for the Lateran Museum, where a collection was being formed. One day in Italy during the 1960s, we drove out to the Lateran Museum and were shown around by a young Franciscan. When we asked where the Lunardi ethnographic collection was on display, he replied that it was still in the boxes in which it had arrived twenty years earlier! We then looked in the *Baedecker Guidebook*, which stated in the 1922 German edition that an ethnographic collection was in preparation and would soon be open to the public. We knew what fine material Lunardi had collected and that there would be no chance to see any of it because, as the young Franciscan stated, preparations for the Marian Years were underway, and everything else was on a list of things to be done in the future. Nor was the Vatican very generous to the Lateran when it came to money.

Several articles appeared about our visit to Honduras, and as a result we received an invitation to visit the president. James Webb drove us to the palace. The president lived as many did other Latin American presidents, at a site protected on one side by the river and on the other side by a fortress-like structure on a hillside. Two broad masonry towers framed the entrance to his villa. Between them was a metal chain curtain, as large as in a theater, that was raised to give access as at some European prisons. When our car arrived at the

COLONIAL CATHEDRAL AT TEGUCIGALPA, HONDURAS.

gate, a guard looked over our car, saw the U.S. flag, and signaled for the curtain to be lifted. After we entered, it clanked down behind us. Inside there were at least a company of infantry with their guns ready and a machine gun directed toward the entrance. The Chief of Protocol appeared to escort us up a zigzag stairway with a gun port at every turn, constructed in such a way as to prevent storming the building.

The building itself was like something from the Victorian era. The furniture and whatever decorations there were of pictures and mirrors dated from the era of 1910 to 1915. We weren't there more

than a minute when the president appeared, a stocky, graying man who said his name as we were introduced and stood to attention in military fashion. Once he realized that we could speak Spanish, he became very friendly. Pál spoke to him about the purpose of our visit and the importance of Honduras in archaeology and colonial art. He listened with interest because he was passionately patriotic, and with the meager means of Honduras had done more to further humanistic interests than had many larger Central American republics.

He asked what we needed, and Pál said that we would like to go to Comayagua, because we were interested in Spanish colonial

architecture. He said, "Why don't I loan you my own airplane, so that you can go and return in one day?" Pál assured him that we very much appreciated his offer, but that we had heard so much about the beautiful Honduran forests that the drive, which would take about half a day by road, would be a very interesting experience. He asked "Can I do something else for you?" Pál said, "Sir, I have nothing to ask for myself but I have a very important request to make." He explained to the president that the Cathedral of San Miguel, which had only been so designated a cathedral when the colonial capital was changed from Comayagua to Tegucigalpa, was seemingly the beneficiary of the last great wave of silver production in Honduras. Pál said that he had never found a church in the New World that equaled San Miguel, with seven archangels on the facade, three-quarters life size and in good condition, and that the interior of the church was an example of the finest colonial architecture. The president agreed to declare the cathedral a national monument, and this was subsequently announced over the radio with a statement about its potential as an important tourist attraction.

That evening, the Webbs gave a cocktail party in our honor with about fifty guests. Mrs. Webb had an original way of serving, which might be worth adopting. The maids went round with large slabs of mahogany trays on which were neatly laid out buttered bread and rows of cheese, meat, and sausage so we could make our own sandwiches. We were invited to have an informal supper afterwards with a chance to talk, but everyone stayed so late that we were practically the first to leave. This was "cocktails" in Latin America. Dinner was missed!

TEGUCIGALPA AND COMAYAGUA, HONDURAS

ON WEDNESDAY, THE 5TH OF FEBRUARY, the First Attaché gave a luncheon for us in place of the Ambassador, who was ill. Present were the Webbs, the Director of *Bellas Artes*, and a newspaperman turned dentist, who was a press photographer and flashed around taking candid shots, making everyone self-conscious. It was amusing to see the concern of the hostess about what was going on in the kitchen, and her occasional dismay at what came out. The culinary high point was a wonderful upside-down cake made with fresh pineapple: delicious!

The following day, we started off for Comayagua by car with some trepidation, because the chauffeur was half an hour late and brought along a very small, big-eyed child, his six-year-old son. When Robertito was settled in the back with Elisabeth, he turned out to be terribly cute and perfectly well behaved. We crossed the first mountain range in the early hours, and came to a plateau that was lower than Tegucigalpa, a beautiful alpine valley surrounded by pine forest. We passed a few villages with uninteresting churches, crossed plank bridges and forded shallow streams, with the road growing rougher by the yard.

This was followed by another valley slightly lower down, and then we reached a big "jump-off" into the valley of Comayagua, with a wonderful panorama. At the foot of the hill was a peculiar formation called Tenampoa, a sort of mesa or separate bank of foothills that formed a natural fortress. This was the site of the last stand by the Indians, and reported to have extremely interesting tombs and architectural remains. No real excavation had ever been undertaken; the interested parties were apparently content to quarrel endlessly as to whether the inhabitants were Mayans or not!

The old colonial capital of Comayagua lay in the valley below, at about 1,200 feet, baking in the sun. The small church on the knoll, San Sebastian, had once been within the town itself. Its primitive statues were set out on a floor strewn with pine needles. It was Saint Sebastian's Day, and a procession was in preparation. The governor and the local historian had already been notified about our visit through the Secretary of Education, and been asked to reserve a room in the best hostelry, the Hotel Comayagua. It was a one-story building with a patio, where the dining room, a separate little box, was enclosed in screens. Everything was clean and pleasant, and we were overwhelmed with much more food than we could eat, including the always-reliable chicken with rice and beans. Comayagua was very neglected, and the governor explained the city's very difficult situation to us. Most of the population suffered from malaria, which was very prevalent in the region.

While we were resting after lunch, we had a visit from two slightly drunk, masked figures called *diabolitos*, or "little devils," representing the Romans who killed Saint Sebastian, actually dressed as Turks or Saracens. Both in Honduras and Nicaragua, we were always surprised at the casualness with which strangers would walk in and out of our room without knocking or announcing themselves. Pál got rid of them fast with some money, and we headed to the cathedral, where the governor joined us.

The main church (of which we already had published data and pictures) was a colonial building of a much earlier style than the Cathedral of St. Michael on the main plaza of Tegucigalpa. Some claimed it was the mother church of Central America. Although it was a large and imposing building, it differed considerably from the Mexican type. It also contained some very fine and well-preserved altars and a confessional, which recalled Manon Lescaut! In the Sagrario were the characteristic four archangels on the pendentives, as in Guatemala, and some colonial paintings that we photographed. The main altar of the church was somewhat modernized, but the right side altar, the Rosario, was most unusual. It had a whole series of small, colored bas-reliefs depicting the life of Christ in tones from milk to rose and antique gold that produced an appealing color effect, complementing the storytelling content.

The famous church treasures were on display in glass cases across the street and did not compare favorably to those at Popayán, Colombia, although there were some fine emeralds in the *custodia*. Proceeding with the enthusiastic guidance of the governor, and our car as transport, we comfortably visited and photographed the four other local churches. As the sun was setting we returned to the hotel to rest, and after dinner walked out to see the full moon rise over the old city. There was practically no one on the streets, and the scene was quite magical, even in its deterioration. We wanted to see the cathedral by candlelight, but a mass was going on for women only.

The evening was growing cool. When we went back to hotel to get jackets, we found two gentlemen patiently waiting for us, both of them pale green from chronic malaria. *Licenciado* Ceballos was the Dean of the Law School and the local historian, and Mr. Lagos was the archivist at the local library. They politely excused their tardy arrival and said that they had already come to the hotel twice. The

Law School gentleman proved to be terribly conservative, repeating dates and the names of Spanish local colonial history without much connection to what we were interested in, which were the still-standing remains! Mr. Lagos, on the other hand, soon picked up Pál on several points and led him on to give a lengthy discourse. The next day we found out that he had written it all up as an interview for the largest paper in Honduras, the *Diario Commercial* of San Pedro Sula. The men stayed until the hotelier shut the doors, and we went to bed in our "gringo room," with two double iron beds in a room with only one opening that was closed by double doors, like a garage.

In the morning, the governor took us to his archaeological museum, which only contained objects excavated by him on his free Sundays, as he could not take a subsidy from the state. He had some very beautiful examples of pottery with fine and unusual Maya designs, but nearly all were in fragments. The graves must have been violated during colonial times in a search for gold, and the pottery smashed and left there, as not considered of value. Later, we attempted to catch the city on movie film. The architecture and atmosphere were almost entirely colonial, unpretentious but with a certain elegance. And then, after lunch, the "gringo photographers" performed a tour-de-force by fetching a ladder and climbing to a roof-edge on a corner of the plaza to shoot a better view of the cathedral than had ever been taken before!

A little after 2:00 we drove off in the terrible heat, again with little Robertito (who had been at his auntie's) at Elisabeth's side. We made a detour of about an hour and a half to visit the villages of Ajuterique and Lejamani, with their *alcaldes* (mayors) expecting our visit, due to notification by the governor. The towns were definitely an anticlimax, two dilapidated, depressing, tropical holes with their once-fine churches irreparably deteriorated, although the influence of such a powerful artistic center as Comayagua could be still noted on the facades. On the return to Tegucigalpa we had an hour's hard drive through dry country, fording two sizable, if shallow rivers, with the car pitching about like a ship. Until we reached the highway after that, we bounced along paths dug up by oxen and cattle. As we mounted the hills, we recalled that this was the route of the Spaniards, who came up from the sea. To them, Tegucigalpa was long just a remote mining town. About then our modern equipment

broke down, first with engine trouble; and after being repaired, with a blowout scarcely around the next bend. Few passenger cars were on the road, but there were scattered buses and trucks and one that was helpful, so we did not lose much time and arrived back just after dark. Little Roberto, who had been terribly excited and helpful running about fetching stones to chock the wheels, was sound asleep on Elisabeth's shoulder.

Tegucigalpa meant the "mountain of silver," and some of the buildings in the late Baroque, colonial style were an indication of how silver production in Honduras enriched the architecture, after the last quarter of the eighteenth century. The city had an agreeable climate, because of its altitude, and the roads within the city were quite good. We began our major photography at the Church of La Merced, where Pál got very excited about an old painting, unfortunately too far gone to do anything about. The ignorance of all the local Franciscans was sad, not only about their own art, but even about the iconography of the church. Pál dictated the short lecture he was giving that Wednesday before the Society of Anthropology and History at the National Library. Sunday was a day of rest that we spent with the Webbs in their house on the hillside. The culinary features were a wonderful filet, a deliciously cooked slaw, and strawberry meringue pie.

The next day we started assembling our many bundles, some meant to go home by ship. At 1:00 P.M., when the light was best, we went to photograph the cathedral, which until then had its altars draped in honor of the ancient image of the Patroness of Honduras. The main altar covered the entire end of the apse, as one vast wall. It was covered with gilded woodcarvings broken by eight niches in polychromed wood, with graceful statues of the Virgin, the Trinity, and the seven archangels. It was late rococo in style, with lacy ornamentation around the edges to blend it into the wall, and the sacristan told us that it had never even been cleaned. Thus, while some dust was visible on the statues, we were spared the frequent, tasteless repainting of later epochs so often encountered. The

altarpiece was an amazingly harmonious expression of a single period without any alien objects thrust in, and a flawless, overall unity. All seven archangels were intact on the altar, as well as on the facade, because Honduras never had such violent earthquakes as the rest of Central America. Another perfect masterpiece was the exquisite, gilded rococo pulpit in the shape of a goblet, dating from the last quarter of the eighteenth century. It was complete with stairs, balustrades, consoles, and even a canopy overhead, with a triumphal car on top! We had never seen anything better anywhere. The carving had a fluency, clarity, and originality of design that the best European rococo could not surpass.

We continued to rise early. The rockets and church bells kept going off about 5:00 and woke us, so we ate breakfast not later than 7:00. Appointments were made starting at 8:00; we frequently lunched at 12:00 to get in a long afternoon of work with good light. By 9:00 in the evening, everything was dead quiet, and at 10:00, even the water was turned off. Tuesday morning we photographed in the Museo Nacionál, a former church building that was very narrow and awkwardly arranged, but had some good Maya sculpture. There was a zoo in the patio; the parrot cage had to be moved to give us a range of focus, and the peacocks fed constantly to keep them from pecking Elisabeth and the camera!

We sent off a package with books and handicrafts to New York by boat via the United Fruit Company, and wrote to Helen to fetch it at Pier No. 3, North River, c/o United Fruit, and send it to Norfolk by "Express-Fragile," which assured the least damage. Only our last day remained after that, with Pál's lecture. The evening before, we visited Dr. Jost, a banker and amateur archaeologist, with a Latin American wife and daughter. He was highly intelligent, and practiced many good works, including helping a school for the deaf that was founded by a daughter in the family who suffered from that condition. Their house was full of *fin-de-siecle* furniture, and we heard the tales of a radiant ninety-year old Guatemalan Indian, who had been the nana to four generations!

VISITING OLD MINING TOWNS AND THE POPENOES IN HONDURAS

THE PEOPLE WE WISHED MOST TO SEE in Honduras were the Popenoes. Dr. Wilson Popenoe was a specialist in tropical agriculture. As the Director of the Pan American Agricultural School that had been functioning for many years outside of Tegucigalpa, he was a very influential person. We left a message at the United Fruit Company's office requesting a meeting, and one day, as we were in a church examining a rococo altar, a secretary came to fetch us with their car. We had a delightful half hour with the Popenoes, who were about to leave town for the school, and were invited out for the next weekend. Saturday after lunch, we took the *lechero* or milk truck, half station wagon, and half truck. About ten other people from all walks of life were already boarded. Thank heavens they gave us the front seat, in polite deference to the obvious strangers!

The road led straight over the mountain behind the city on a hard roadbed, washed out and full of ridges. We had heard a lot about the pine forests of Honduras; the landscape was primarily green due to their cover. At the crest, we gazed down into the beautiful valley of Zamorano, not extraordinarily rich but chosen because it was typical of most Latin American agricultural situations. Half-way down the winding road was a big sign, announcing the boundaries of the school, and then an eloquent appeal: "Hondurans, save your forests from their worst enemy: FIRE!" The school owned about 3,500 acres, a third of it forested, that was generously sponsored by the United Fruit Company. First, we saw the great tower of the main building, which housed the auditorium, classrooms, and offices, with separate dormitories, mess hall, and faculty homes. Everything was built of volcanic tuff from a quarry in a hill nearby, which was cut in blocks and brought to the school by oxcart at no cost, except for the labor. The stone was soft to quarry and hardened upon contact with the air. Being volcanic, it was faintly streaked pink and green on a white base, and gave a lovely, soft tone to the buildings based on Dr. Popenoe's designs. The idea was to accommodate the structures to the local scene, and this was accomplished very cleverly and successfully by Harlow Von Wald, an architect.

The school's purpose was training young men from the Latin American Republics (chiefly Central America, Colombia and Ecuador, where there was a similar climate) in advanced practical farming, including raising vegetables, sugarcane, and fruit, in addition to animal husbandry and dairy production. Only a primary education was required to enroll. The course lasted three years, and everything was furnished free, including clothes and materials. Every Latin American country could send at least two students. Our host told us that in the beginning, it was mainly elegant boys who came, because they thought that they would have a good time with the Americans paying the expenses. But that did not turn out to be the case. They had to go through all the steps that an agricultural school in the United States would teach, from digging ditches and taking care of the stables, to learning all about plant and animal life. They all became very healthy and robust on the American food, a pleasant surprise to their families when they returned home.

We were met by Dr. and Mrs. Popenoe, who took us to their house at the edge of the community, in a beautiful grove of natural palms. It was a charming adaptation of Honduran colonial style, one-storied, of stone, and roofed with tiles made on the place, and doors and shutters of fine cedar or mahogany, carved in colonial designs. The house was furnished with a remarkable collection of Honduran colonial furniture, not well known at the time, which Helen Popenoe acquired during her travels to the villages. Most of the pieces were from the eighteenth century, with a few well-done replicas. Their idea was to create the nucleus of a small museum for the inspiration of visitors, and eventually donate it to Honduras.

There were a number of excellent quality tables, benches, chairs, and highboys, some of which we photographed. A number of pieces were solid mahogany, which does not warp in humid climates, but much of it must have been pine, or perhaps even oak, from the gorgeous forests around the school. The effect of the interior was heightened by abundant flowers displayed in the enclosed patio, with palms, a fountain, and a lawn framed with ferns, orchids, and other blooming plants. Add to this a well-equipped and supplied kitchen, large bathrooms with lots of hot water, big towels, and comfortable beds, and imagine the inspiring atmosphere of this luxurious home in the tropics! And it was all put together during the difficult years of the war.

Helen Popenoe realized that sooner or later they would return to the United States, and took an opportunity at a party to speak with the Secretary of Education (who was the second or third person of importance after the president) about her collection. She told him of her intention to present it to the state museum. The Secretary of Education replied, "Madam, don't you know that what you put in a museum here will sooner or later disappear? Take it with you and give it to an

THE LITTLE MINING VILLAGE OF SAN ANTONIO DE ORIENTE, HONDURAS.

American museum!" This tale gave us a glimpse into the state of museology in Honduras at the time. (Not that a case should be made of it, because stealing also took place in American museums!) But the Popenoes decided to have their furniture stay in Honduras anyway, except for some given to a museum in Guatemala.

It was a great luxury to be able to eat everything that Helen Popenoe served to us: fresh fruit, ice cream; and especially the fruit salads, which always stood heaped high on the table. We had to eat to the very end of it to realize that it was all stacked on a single, large slice of avocado about eight inches in diameter! Dr. Popenoe was especially proud of the fact that he had brought the avocado from California and planted it there. The best part of our visit was the company of these two remarkable personalities. Popenoe knew all of Latin America and its special psychology, as he had traveled and lived there for thirty years. Helen Popenoe was interested in Spanish art,

had lived in Spain, and traveled in Latin America since 1933. She was his second wife, and had been connected to the Chicago Art Institute before they married. Her artistic interests and his comprehension of our needs were responsible for an extraordinary program. The day of our arrival was spent enjoying their company, the fine points of the house, and its collection. Darkness fell like a curtain at 6:00, and we all retired at 9:30.

We spent several days at the Popenoes' house, and made two trips from there. One was to a sort of hideaway that Dr. Popenoe recommended, a little mining village called San Antonio de Oriente. There was no telephone or other connection with the outside world, and on occasion our host camped out there in a peasant's house to get away from the pressures of the school. By 8:00 A.M. we were already in the saddle at the foot of a mountain path. Elisabeth, who was not a rider, was mounted on a stolid plug that did her the least harm

possible under the circumstances. Pál had a very good horse and was enjoying the ride. We were amazed when the groom, patting the horse on the flank, said "Ungaro," for Hungarian, and it took a minute to realize that he meant the horse and not Pál, for he couldn't have known that he was from Hungary, or even where Hungary was!

After about twenty minutes of climbing through wooded slopes, we were at the top of a pass, with wonderful views of the forest on either side and two valleys below. We made a loop along the side of a deep ravine, and passed between two large rocks. The little colonial mining town of San Antonio de Oriente was nestled in the ravine. It could have been a second Taxco, had its mines been as rich and easier to access! Approachable only by horseback or on foot, San Antonio retained its colonial charm almost undiluted. Its very small, unspoiled church preserved most of its original interior of a fascinating, rustic style, proof that art objects were not always imported into such towns, but fashioned by local workmen.

The next morning we spent an hour looking around the school, and went off by car about 9:00 for another excursion. Dr. Popenoe could not go with us, because the teachers worked with the boys in the fields and gardens to break down the traditional feudal aversion against manual labor and the idea that educated men did not work. He also had an article to finish, but did not get it done, because seven Coffee Commission members arrived unexpectedly and stayed to lunch. We went off over a different mountain pass and saw some tropical lowlands, some desert, and some arable land; all of it empty, since Honduras had only about a million inhabitants. The country was not very rich, but could support many more people if agriculture were more intensive and the horrible infant mortality rate was reduced.

After a while, we reached another mining town, Yuscarán, standing on a great bluff. The mine was still being worked, and it was also a thriving agricultural community. Tile roofs, palms, and banana trees were silhouetted against the sky. One rolling range of hills loomed beyond the next, as far as the Nicaraguan border. The church had been more modified than the one at San Antonio de Oriente, but the village was charming, with wooden balconies on the second floor of the houses, and wide galleries across the facades, supported by tall wooden columns and carved beams. Oranges were ripening in the gardens, and flowers of all colors climbed everywhere. The people in all these places were extremely friendly and quite casual, completely unspoiled by tourists. It was in such villages that, while her husband was plant hunting, Mrs. Popenoe made friends and got many of the unusual antiques in her home.

We picnicked on the way home on a bluff in the woods, with a wide view over the wild valley. The big rock at the edge was unfortunately swarming with ants in such numbers as only the tropics can produce. In a moment, it was evident that an army of them was headed for our food! There was a scramble to gather everything into the basket, and we ate standing up, out near the road. A few minutes later, there was a swoop of dark wings, and a black vulture the size of an eagle arrived, having smelled the food. He was too shy to come near while we were there, but gave us a fine exhibition of gliding and swooping to the ground as the car pulled away.

The Popenoes were preparing for the visit of twenty ladies from El Salvador the next morning, and expected sixty Argentines the following day. No wonder they were building a weekend house in San Antonio, reachable only by horse! They sent us back to Tegucigalpa in a station wagon, along with an elderly photographer and his wife, who had been living at the guest house and made documentaries for schools in the States. Helen Popenoe, alas, died not long after our visit, and he retired to their house in Antigua, Guatemala. Later on, he paid us a visit in Winter Park, Florida, and gave a lecture at the Casa Iberica of Rollins College about his beloved school in Honduras.

In Tegucigalpa we took it easy for a day, and made a few photographs of colonial altars. Everyone recognized us, since the local newspapers wrote about us six times, which was a great help for opening doors and obtaining special favors. We were presented with a large selection of books by the Historical Archive, so heavy that we sent it straight home to Norfolk via a United Fruit ship. We very much enjoyed Tegucigalpa's rather cool climate and tremendous charm as a mountain resort. The Honduran cloud effects were marvelous and most sunsets sensational, the sky a more brilliant and translucent blue than we had ever seen.

LAST DAYS IN HONDURAS
AND TRIP TO MEXICO

OUR LAST MORNING IN TEGUCIGALPA, we drove with our faithful Roberto to Monte Picacho, a great bluff standing above the city. It had been made into a national park, as it was the source of water supply, and no pressure pumps were needed at 1,400 feet above the town. We went one way, came back another, and had the opportunity to see again the roads we had taken to Zamorano and Comayagua, thus bidding a pleasant farewell to all of Honduras that we knew. They were creating a botanical garden on top of the mountain that was amazingly tasteful, and, as in Managua, the wealthier class was building new villas in the hills. With the same car, we carried back to the American Embassy the army blankets that the Chancellor had lent us for our field trip, and a surplus of books presented to Pál by the National Library (on such specialized subjects that there was no use sending them home). Meanwhile, Elisabeth made the last photographs in the cathedral, which turned out as good as etchings!

At 7:00 we were at the National Library for Pál's lecture, where half the room was already full, and the rest soon filled to capacity. The occasion was the monthly meeting, called the "Popular University," and young seminary students and cadets filled the last rows. As the room was on the street level, all the windows were full of attentive listeners. The first speaker was Señor Navarro, who was quite up-to-date in his paper on prehistoric migrations to America. Pál came next with "Observations on the pre-Columbian and Colonial Art of Honduras," presented in Spanish, and lasting about twenty-five minutes. Although some of the accents may have been on the wrong syllables, everyone said that it was all very clear. Then, a young newspaper editor who had attended Pál's press conference, spoke on "Errors in Philosophy." The closing attraction was a paper by Monsignor Frederico Lunardi, the Papal Nuncio, on the "Maya Ceremonial Staff," which still had considerable significance in the purely Indian parts of Honduras. It was very amusing to us, who had seen him in his house running about, fetching dusty books and objects, to catch him got up in his purple beret, silk stockings, and

silver buckled shoes with an impressive cross on his chest! He spoke of his experiences among the Indians, linking pagan rites and Catholic ceremonies, smiling at the irony. We escaped further talk and went to an American-run grille with the Cultural Attaché and the Chancellor's wife.

The next morning we were fetched at 11:15 for the airfield. Through the courtesy of the Secretary of Pan-American Airways, we had nothing to do; our luggage was passed without going through customs, our passports handled without delay, and even our Honduran money changed into dollars. It was a rough, windy day, and the flight did not look too promising, but it turned out better than the trip down. We stopped for fifteen minutes in San Salvador, where the coffee at the port was delicious. Later we stopped over for about half an hour in Guatemala, where one of the airport officials recognized Pál from six years ago from reading his name on the passenger list, because he had interviewed him for a newspaper.

Heading for Mexico, we did not fly over the countryside full of lowering clouds but out to the Pacific, where the next stop was Tapachula in southern Mexico. The same tropical broiling heat of the afternoon sun reminded us of our walk in 1940 across the Guatemala-Mexican border. When the plane took off from Tapachula and sailed over the beautiful sweltering landscape, there were only seven passengers. The stewardess served cake and lemonade, and the captain came out of the cockpit, whenever things were going smoothly. Pál engaged him in conversation, and he displayed his maps to show us that since night flights to Mexico were involved, they did not fly over the mountains or by sight after 5:00, but "on the radio beam." He pointed out the angles and numbers that signified our route, first straight across the Isthmus of Tehuantepec, then leaving the Pacific to sight the Atlantic within an hour, after that on to Veracruz and beyond. We turned sharply from north to southwest, at an altitude of 12,000 feet, to climb over the surrounding mountains and descend into the Valley of Mexico. Soon the plane took another sharp turn to make the landing field. All this time we were in dense fog and clouds. As the captain was talking, the sun set into a sea of clouds with strange colors glowing all around us. Just as the stars came out, we

apparently got our signal and made a great swoop downward, and when we reached the valley, the sky was completely cloudless. The vast stretch of Mexico City astonished our Salvadoran comrades, whose entire country did not have the population of that single city. We whisked through the airport, again due to the courtesy of Pan Am officials.

THE MURALS OF BONAMPAK, 1949

EARLY IN JULY OF 1949, we had a telephone call in Norfolk from Sir Eric S. Thompson at the Carnegie Institution, regarding a gentleman-explorer by the name of Giles G. Healy. He had previously brought the Carnegie photographs of unknown ruins in Yucatán, and had recently photographed a ruined building in the western lowlands of Chiapas, on the Mexican side of the Usumacinta River. The building, later designated Temple I, had three rooms decorated with mural paintings, and Sir Eric had been to see them. Thompson and A.V. Kidder thought that we should see Giles' photographs. We replied to Eric that Healy was welcome to visit us, and asked him to arrange it.

On August 11th we got a telephone call from Healy. He was in Canaan, about 10 miles from Norfolk, in a desperate state because his Peugeot had four flat tires, so we drove down after him. As all the local inns were full, we put him up at the Coon Club, a private lodge for Hartford businessmen who hunted deer, raccoons, porcupines, skunks, and grouse in the forested foothills of the Berkshires. Fortunately, the hunting lodge was only half an hour from our house. Healy was a wiry man of medium height, with brownish hair and rather sharp features. He arrived with only one small, heavy bag to hold his photographs. After some lunch he began to feel more relaxed, and told us his story of visit to Bonampak.

It was a *chiclero*, a hunter of chicle for chewing gum, who guided him to the ruins. They found the building overgrown by trees and bushes and practically invisible. First they entered a doorless building that evidenced a lot of damage from exposure to the elements and had three rooms with murals covered over by stalactites. Healy

showed us his black-and-white photographs (it was too hot and dark for any other type of photography). The outlines of the figures in the murals were more or less visible, but the paint within the outlines was faded and gone in places. Nevertheless, the murals were extremely important because it was the first time that such a quantity of classical Maya painting, dating between the sixth and ninth centuries AD, had been found. The name of Bonampak, meaning "painted wall," was bestowed by Sylvanus G. Morley, the great Maya archaeologist we met in the Yucatán in 1933, who had died in 1948. He was one of the few who had visited the site, actually not far from other, better-known Maya ruins such as Yaxchilán and Piedras Negras. The Lacandon Indians inhabited the region, and Lacandon braziers had been found at the Bonampak ruin.

We had a very exciting afternoon, as between the photographs, slides, and a movie, the great beauty and sad state of the murals were revealed. Healy told us that an expedition to Bonampak had been arranged with financial backing from the United Fruit Company, and the head of the firm's daughter, Doris Zemurray Stone, had taken a lively interest. Dr. Stone, whom we knew from our work in Central America in the 1940s, had done a great deal for Maya archaeology. The scenes in the murals were difficult to decipher, because the glyphs were not clear. However, it could be seen that a festive occasion was depicted. The participants were in elaborate dress, both chiefs and attendants. Among the prisoners, one was shown leaning back on an upper terrace in a pose that suggested three-dimensionality. Weapons in the pictures were arrows and lances, and there was also a group of musicians playing clay tubas, drums, and rattles. There were many puzzles that we could not solve, especially the presence of musicians burying rattles and other

unidentifiable instruments, something not represented elsewhere by the Maya that had thus far come to light.

Not only was Healy getting tired; for us it was also an exhausting experience trying to comprehend the amount of riches at the site. We were happy to hear that a Guatemalan painter, Antonio Tejeda from Guatemala City, had taken accurate measurements and color notes during the expedition when he was there in 1947 and 1948 as a guest of the Carnegie Institution of Washington. He made watercolor copies under artificial light, and the colors of the murals, obscured by the heavy deposits of the calciferous material, were brought out by the application of kerosene that rendered the deposits temporarily transparent. The final paintings were in the possession of the Carnegie Institution and intended for the Peabody Museum at Harvard.

By repeated projection of the slides, we became more familiar with the murals, which were completely different from anything known in Europe or Asia. In Room 2, toward the upper part of the wall, the scene took place on a series of straight horizontal levels, like platforms. The scene had no perspective, and projected an atmosphere as alien as strange music from a distant hemisphere. The chief, evidently the main figure in the ceremony, stood against a blue background. His headdress was held together with a Jaguar skin, and he wore a vest and footwear of the same material. He appeared very dignified, as he looked over the chiefs who had come to pay him honor. Six figures stood before him, not one dressed like the others, garbed in Jaguar skins and other animal pelts, and textiles with elaborate patterns. A number of women standing behind the chiefs also wore elaborate costumes. The jaguar skins over their shoulders indicated their importance. Some of the figures seemed to be standing to attention, and others saluted the chief with gestures. On the lowest levels, prisoners were bound and crouched in submission. In one remarkably realistic scene, an elaborately dressed warrior was pushing the head of a prisoner, in a highly realistic gesture. A similar warrior was prodding another prisoner with his lance. One movement was forceful, the other a mere gesture. The figures were outlined without hesitation and the question arose, How did the Maya artists coordinate the details of the same ceremony in three different murals in three rooms?

We knew that the Maya artist, when Maya art was at its highest point, produced cylindrical vases which were perfect in their physical shape, and the surfaces were decorated with painted, incised, and high relief scenes. Those works evoked our admiration for the masterful hand whose feeling for proportion and spacing recorded the stories with sure sweeping strokes. Such strokes were evident in the almost life-size figures of the Bonampak murals, where the flowing movement and extended form was not limited by the surface of a pottery vessel. Despite the absence of three-dimensional space, the murals were not crowded. There were seven horizontal lines on which the various groups were placed. As Healy's slides appeared one after the other, with sometimes fifty figures on one wall, we had the feeling that it was not just a visual performance, but also aural. The noise of tubas, rattles, drums, and other instruments played by so many participants seemed to sound in the room around us. The August sun outside augmented the atmosphere, as with the blinds drawn for better viewing and the intensity of our contemplation, we were stuck to our seats. Healy did not speak much, and at the end, we were left with a feeling of oppression. By then our woods were full of shadows, and the peacefulness of the mid-summer night brought us out of the macabre experience. We thought that having dinner at a nearby restaurant might break the spell, but unfortunately, neither the service nor the food were of a quality that could snap us out of the eerie mood that the visit to Bonampak had instilled. We drove Healy back to the lodge, which with its rustic simplicity seemed to have revived him, and the next morning around 10:00 he was told that his car would be ready at noon. We tried to keep him for lunch, but he replied that he had plans for the weekend and drove off.

Reflecting on the murals, we could not free ourselves from their spell. Despite the fact the some of the wall surfaces showed considerable sloughing of the plaster, their total impact almost overwhelmed our aesthetic capacity. During the Classic period, Maya artists did not have the implements and materials used to decorate the monuments in Europe. They utilized colors, tools, and methods that originated in the region, all beyond the limits of our experience. Such a monument, for the time being, could only raise questions, a puzzle to be unraveled by future generations.

Since our first look at Healy's photographs, numerous other visitors, including tourists, have visited Bonampak. Its murals have been studied and compared with other Maya works of art at sites such as nearby Yaxchilán on the Usumacinto River. The Bonampak glyphs and dates have been deciphered, the identity of the personages revealed, and the subjects interpreted as events surrounding the formal presentation of the king's young son as heir and the endowment of the temple with a soul. The murals include the celebration of a successful battle and tortured captives, some dying in a sacrificial dance that was part of a house-dedication ritual; also the presentation of the young heir to high-ranking lords, three lords being dressed and performing a feather dance, thirteen vassal lords in procession toward the dance, and musicians and dancers costumed as gods. The masked dancers are of special importance, for they appear in similar rituals at a number of other sites and on pottery vessels. Scholars are peeling away the many layers of meaning in Maya art and ritual, and relating them to ancient practices still enacted by the modern Maya.

In late 1951 we embarked on a lecture tour up the Pacific Coast of the United States and into British Columbia and Toronto. One lecture was scheduled at the University of California in Los Angeles. By that time, Pál's standard lecture included both pre-Columbian and Spanish colonial art. Pál was well received, and we were delighted to see Giles Healy in the audience. He became enthused by our work on Spanish colonial art, and later furnished us with data on a number of unknown colonial sites in Yucatán. He introduced us to a small, delicate, gray-haired lady who spoke to us in French, exuding pride in her explorer son. They invited us to lunch, but we could not accept due to Pál's lecture at Berkeley, which was soon to begin. In all the ensuing decades, we have still not forgotten the first impact of Healy's photographs of the murals at Bonampak. And the mystery of how Maya art evolved into the magnificent performance at Bonampak has still not been fully explained.

PHOTOGRAPHING A VILLALPANDO PAINTING, "SAN LORENZO EL MARTIRO,"
OUTSIDE EL CARMEN CHURCH IN TLAPUJAHUA, MEXICO.

TEXAS TO MEXICO CITY, 1953

IN THE SPRING OF 1953 an invitation came from a very old friend, Lewis Hanke, one of the most prominent Latin American historians, who was then Chairman of the Latin American Department at the University of Texas in Austin. Hanke's invitation was for Pál to give thirty lectures to a seminar class at the university, from February to early May. We decided to accept, and left from Norfolk by train for Philadelphia. There, we went to see two colleagues at the university museum to discuss additions and alterations for the forthcoming paperback editions of the books, and to collect photographs of objects in the collection we had on order. We attended a number of parties, and at one met a famous writer, known for biographies. Her works were examples of how well personal histories could be written, with thorough research, and employing the author's imagination to fill out the known facts, rather than relying on footnotes. It was an illuminating concept, which we applauded, because books heavy with footnotes burden the reader. The university museum was a wonderfully quiet place to work in those years, not at all crowded. We could go around with the curator and an excellent photographer, and leaned on the museum staff, particularly for our pre-Columbian research. It was no wonder that the director was later brought to the Metropolitan Museum in New York by Director Henry Francis Taylor, who was a very educated and civilized gentleman, and one of the finest museum directors Pál said he had ever met.

During our stay in Philadelphia, Pál was invited to appear on a weekly television program called, "What in the World?" which showed various art objects, located in the area, and quizzed experts about their origins. That day the first object presented was an archaeological piece, and the first expert to give his opinion was Alfred Kidder, a curator at the Philadelphia Museum of Art. His comment was "It looks to me as if it is Peruvian." Then he changed his mind and said, "Perhaps it is Mexican." When the object came to Pál he said, "I don't believe that it is from Mexico," turned it over and continued with, "This side is not Mexican," then turned it over again and said, "This side is not Peruvian." The show's host interrupted and said, "You are right, it is a fake!" Pál had the first go at the next object, a reliquary of French or Spanish origin, perhaps North German or Gothic. It was a reliquary of the twelfth or thirteenth century, strongly Byzantine, and in a style that, at that time, was not very recognizable as to geographical origin. Pál said it might have been Spanish or French, and it turned out to be a French piece, loaned by the Philadelphia Museum. That was an easy answer, because every reliquary was standard, and Pál was accustomed to seeing them in Hungary, even as a child. The program had a wide audience, and it was surprising how many people wrote, and even telephoned to congratulate him, so for half an hour Pál was a television personality!

With those pleasant memories, we took the train to Austin, Texas, where through the kind attention of the Hankes, we were able to rent a house from the widow of a professor. It was quite a comfortable place, and as we had our housekeeper, Catherine, with us, we were able to get established in a few days. Pál had ten days to prepare for the beginning of classes. One thing that impressed us in Texas was that when we went out for breakfast, the servers would ask, "How do you want the meat?" Now, of course, in other parts of the United States, the breakfast didn't include a steak, a filet, or a roundsteak, but that was Texas!

Austin's climate in January and early February was quite capricious, and it was a little difficult for us to get accustomed to it after the climate of Northwest Connecticut, but we enjoyed being among colleagues, who treated us with sympathy. There was, however, one disappointing encounter at a cocktail party at the Hankes. Lewis told Pál that he could expect contention from only one teacher, Mr. M., a somewhat closed individual who was teaching the same subject, colonial art. The man was a specialist mainly on Mexico, Texas, and Southwestern missions. When Hanke introduced him, he looked sourly at Pál, who, nevertheless, took the first opportunity to sit down and talk to him, to which he listened morosely. Pál told him that it was his first experience teaching on an American campus, that in Europe he was a gentleman scholar, and had never taken away anyone's job, and besides, in early May we would leave Austin for Mexico. Pal's action was not very pleasant but necessary, with no unfavorable residue, at least as far as he was concerned. But it was an example of the destructive professional competition present at many universities, which could be difficult to counter or diffuse.

Fortunately, Austin was an excellent place to do research. The University of Texas had a library with a distinguished Latin American collection, directed by the very competent Nettie Lee Benson. Not long before, two teachers from the University were in Mexico City when a famous archeologist died, and his library, which included valuable manuscripts and archival material, came on the market. His widow was willing to sell it to the University of Texas, but since it was America, she was holding out on the price. It was our good fortune that they came to an agreement, and the collection was made available in time to consult it before we left for Mexico.

At Pal's university seminar, which was only for graduate students, there were sixteen or seventeen participants at first, who were all fairly well versed in art history, although almost none of them had ever left Texas! One of the students was very skillful using a projector and preparing the slides, maps, and book pages, so Pál was able to present a wonderful show twice a week. We also had all kinds of movies to add to the atmosphere, including pictures of coffee production, shipping, and tourism-related subjects. When teaching, one cannot show enough of a variety of good materials to make an impression on young people who have lived only in one place. Soon more students were sitting in from other departments, and even people from outside the university, a number of whom became good friends of ours.

Pál was asked to give a public lecture, and afterwards, a member of the audience introduced himself. He had a Ph.D. in anthropology and was teaching at the university. Although the lecture took place halfway through Pál's seminar series, the professor said that he wished he had known about the lectures before! That was one example of a not-uncommon situation at American universities that could be blamed on over-departmentalization. When the course finished at the end of April, Pál was invited to give a lecture in Dallas, an interesting city with an excellent museum. The Dallas audience was also very receptive. There Pál received an invitation to lecture in Corpus Christi, which we did not have enough time to accept, although the sponsors offered to send a plane to pick us up. Regretfully, we have never gotten to see that intriguing, historic city.

From Dallas we went to San Antonio to investigate the missions, not very well known at the time, but blessed with a local ladies' group looking after them. Some of the missions were interesting in terms of plan and decoration, and others for their colorful history. Texas had a wild population in the old days, and some of the mission churches were utterly destroyed, except for a couple of windows or doors. The ladies' group gave us a very sweet party by candlelight at one of the missions, just as the sun was setting. We were glad to give our opinions about the value of the buildings, and the importance of preserving them. A gentleman was there from the newspaper, equally as full of local patriotism as the ladies. Later, we located documentation about the original stucco material and decorations from the reports of visiting churchmen and others, and furnished it to the ladies. In various other ways we also contributed to preservation efforts for the missions.

From San Antonio we headed for the border at Laredo, spending a day and a night at the famous King Ranch. Allegedly of over a million acres, at that time it was still managed by the direct descendants of the King family. We were driven around to see the oil wells, the irrigation, and other systems. A guest wing of impressive proportions and décor was put at our disposal. In the evening all the members of the Clayberg family gathered together, and we felt as though we were

seeing the real Texas! The majordomo was a Swede who handled the evening meal like an excellent headwaiter at a four-star hotel. The meal featured the wonderful filets produced on the ranch. The next morning, when we lazily got up, all the Claybergs were already up and out. As we drove away, we saw the majordomo, who told us goodbye in shirtsleeves, and looked just like any other cowboy.

In Laredo, we were confronted by the North American border patrol. The officer observed that Elisabeth was wearing a man's shirt and a Borsalino hat, and asked her about her citizenship; at the same time he accepted Pál's declaration of being an American citizen without question! After Elisabeth emphatically declared that she was born in Indiana, he passed us on to the Mexican border police. They checked our visas, and put a little sticker on our windshield that said "Mexico" and "Turista," and we rolled into Mexico. A few hours later, we approached a gloomy mixture of dust and gasoline that marked the site of Monterrey, the first really industrial city in Mexico. In one way, it was very Americanized, being near the border, but in another, it still had vestiges of the old colonial life. Regarding historical buildings, it was not very inspiring. The side portal of the cathedral bore a few remnants of the colonial tradition, and we took a picture of the heavily decorated upper part.

The next place we visited was Saltillo in the state of Coahuila, which still had a feeling of the time just after the Revolution, when things began to change radically. Saltillo turned out to be quite a pleasant place, and on the facade of the decidedly Mexican Baroque cathedral we encountered skillfully applied *argamassa* decoration, an original, Latin American kind of stucco work that we had seen in Tlaxcala and Puebla. *Argamassa* was an excellent material, a cement-like clay mixture, blending lime, fine sand, and water that could be formed when it was wet, and then dried hard. The Italians called it stucco, and the mixture varied from the European version only as to its basic ingredients. The Maya had already developed the technique, as we had seen at Chichén Itzá in Yucatán. It permitted creating a decorative element, whether a bas-relief, a whole statue, or an entire facade, by molding, rather than chiseling.

At Saltillo's cathedral, a series of eight panels decorated the bases of the dome with figures kneeling as if at a communion rail. It had been painted over, but was nevertheless worth photographing. It represented a choir of the Patriarchs, angels, and the confessors of the virgins and the martyrs, and was a visual representation of the phrases of the Glory of the Mass. This was a popular theme that was sung about in choirs at Holy Week and on other occasions. A second building, a large chapel, was connected to the cathedral, and was also handsomely decorated with *argamassa*. By the mid-eighteenth century, there must have been many skilled workmen and raw materials in a place like Saltillo, which was prosperous and fairly secure, although Comanches and Apaches from across the border would raid the houses during market and harvest times. As in a number of places, the Mexican viceregal government brought in Indians from Tlaxcala (who were the first allies of the Spaniards and very loyal subjects of the Crown) to settle frontier regions that were difficult to subdue. They were a good example for the local Indians, and helpful in policing the area.

In Saltillo, excellent *serapes* were produced, some of which we had purchased many years before in Mexico City. By the 1950s, Saltillo textiles were worth thousands of dollars, and they were eagerly sought by collectors. Now, the product is no longer of the same quality, and textile museums are proud if they have a fine Saltillo piece from the last century. After the Mexican Revolution, from the 1920s into the 1930s, buffalo robes and copper vessels came down from New Mexico to the annual September fair in Saltillo, and could be exchanged for luxury goods of Mexican manufacture. Even very good quality wines, oil, and other foodstuffs from Europe were brought in, as well as mining tools and other equipment. The ranchers trading for grain, livestock, and hides valued the famous *serapes* highly, for they were long-wearing and good protection against harsh weather, as well as handsome garments.

Durango was a little over 5,000 feet above sea level with a more temperate climate than some of the other cities in the interior. It was originally an outpost against the Chichimecas, an extremely wild regional tribe of Indians, which quickly adopted the horse and became impossible to catch. The horse had come to the New World with the *Conquistadors*, and was a creature of wonder to the Indians, since it had been extinct in the Western Hemisphere for a millennium. The Indians of New Mexico at first thought horses were large dogs, and captured and ate them. But soon they learned

to ride expertly even without saddles and became very difficult to track down and conquer. The Indians adopted Spanish cavalry elements into their own culture, and became some of the finest horsemen in the world. When the U.S. Army engaged in the Indian Wars in the last part of the nineteenth century, killing all the Indian horses was part of the campaign.

The cathedral of Durango was part of the body of mining architecture, which appeared around the very end of the 1600s, but mainly developed from the 1720s to the 1760s. It had two exceptional features: one was the lovely fresco painting of heavenly figures on the dome over the sacristy, with the Lamb of God at the top, and figures from the Old Testament, such as the prophets, saints, and Dominican monks, surprisingly well preserved, with its colors still bright. The other interesting feature was the carved wood choir stall at the far end of the nave, its polychrome finish somewhat deteriorated, but the figures in bas-relief on the back of the chairs almost completely intact. The cathedral was begun in 1695 and completed in 1765, while the mines were producing great quantities of metals, and enormous wealth flooded into the city. When a man could establish himself as a *minero*, he was able to get a noble title from the king, and become a *Conde* or a *Marqués*. He would then try to live in luxuriant elegance, imitating the style of life he had seen in pictures at the courts in Madrid and Aranjuéz. The imitation was sometimes grotesque, but often impressive, and it was reflected in dress, manners, art, and architecture.

A number of secular buildings and private palaces in Durango were as splendidly showy as in the other silver cities. One wealthy miner was Zambrano, originally a landowner. He became a multi-millionaire during the second half of the eighteenth century, as well as the regional governor. His fine house, which could have stood with pride in Madrid or Valladolid, even had its own theater and ballrooms, where a variety of important guests and townsfolk would gather. Zambrano appointed his theater with velvet hangings, and such expensive upholstery that it was written up in a Mexico City newspaper, the *Gazette*. Over the stage was painted the family coat of arms, obtained in the usual manner from the Crown. Various political and military events brought about the deterioration of Zambrano's great house, but later it was restored to become the Government Palace of the state of Durango.

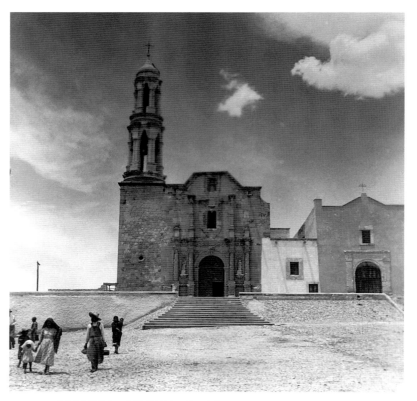

SOLEDAD CHURCH IN SOMBRERETE, MEXICO.

Sombrerete, located south of Durango, on the main road to Zacatecas, was another city that owed the creation of its elaborate churches to silver. In the second half of the sixteenth century, the Veta Grande mine, located in Zacatecas but close to Sombrerete, was the richest vein of silver in all Mexico; in one year alone it produced four million pesos worth. Although in a ruinous state due to natural decay and vandalism, the remains of the churches in Sombrerete still stood with a kind of solidity, and were proof of the region's tremendous wealth. The Franciscans and the even more powerful Dominicans established important complexes there. One of the richest miners and owner of a hundred haciendas, the Conde de San Mateo de Valparaiso, built a chapel at the rear of the Dominican church for his tomb. Despite the fact that Sombrerete became a ghost town after the demise of the mines, as long as there was sufficient income, a bishop or a lesser priest continued to live there.

It was still populated when we visited. Santo Domingo church had a very fine window over the entrance, with statues and beautifully varied designs on the facade and side portal. The church had lost its roof and become a monument to the destruction of time and the passing of centuries, as had the old cloister. The pity was that there were too many wonderful buildings to preserve, as was also true at our next destination.

Zacatecas was south of Durango on the Camino de la Plata (silver road). It was among Mexico's most important colonial cities, but the Battle of Zacatecas, during the 1910 Revolution, devastated its economy and left much of it in ruins. A few years later, many buildings were restored under the leadership of José Rodriguez Elias, a progressive governor, and his Director of Public Works, the talented young architect Roberto Felix. The once-prestigious city chronicled by Baron Alexander von Humboldt in the early years of the nineteenth century miraculously regained its beauty (and eventually won the first prize for restoration of a city in Mexico). Humboldt stated that the mines of Zacatecas were of primary importance, which was the reason why the Dominicans, Augustinians, Franciscans, and Jesuits maintained monumental establishments there, to implement their missionary efforts to the North. In spite of the deplorable state of many of the buildings, the view of the city from the hill of La Bufa confirmed to us that Zacatecas was probably the most impressive of all the mining towns of Mexico. The region has produced more silver than any other. Before the end of the colonial period, it was one-fifth of the world's entire output! As we drove down from Durango, we could see enormous slag deposits, built up over the years along the highway. This enormous wealth was directly responsible for the magnificent colonial churches and residences constructed by miners, merchants, and owners of the huge haciendas who were dedicated to the processing of metals, agriculture, and raising cattle, mules, and horses for use in the mines and ranches, and for sale to other regions.

We had a special interest in Zacatecas, because of its outstanding cathedral. Luckily, it was still standing, and certainly could stand comparison with any church in Spain. Ruskin said that stones can talk, and if the Zacatecas cathedral was an example, Ruskin was right. Stones can talk, but each talks in a different dialect; no one could confuse the lovely elaborate facade of the Zacatecas cathedral with one in a Spanish town. It was created when the city was at the height of its wealth and glory. We marveled at the eighteenth-century facade in relatively good condition, and the elaborately framed niches, with the twelve apostles and Christ at the top. The four church fathers were carved in relief next to the window, encircled by a heavy garland. At the top, God the Father was enthroned and surrounded by eight angels playing musical instruments. It was an exercise in virtuosity and technical skill, unfortunately impossible to photograph in its entirety, because in the nineteenth century, houses had been built too close for us to take an overall shot. We obtained an old photograph from the Mexican Railways, and ended up using it in our book.

Zacatecas had row after row of brownish-rose stone houses and civic buildings, mainly from the eighteenth and nineteenth centuries, and magnificent churches. They were all constructed of the local stone, which was soft when quarried, but hardened after being cut, permitting delicate detail work by its sculptors. The municipal market was located in a handsome building in the center of town. The most magnificent residence, on a plaza next to the cathedral, had become the government palace. Its magnificent courtyard boasted a large staircase, and double story colonnade all around. San Francisco and its convent were in ruins, but we were able to study the church of Santo Domingo and others.

One church we visited again and again to study the relief depicting the vision of Saint Augustine, over a side portal, which had been covered over for decades and only recently had been revealed. In Baroque art, portraits of saints were carved in conformance with the biblical idea of that particular saint. But in Zacatecas, instead of the robed father of the church, a young man lay on the ground, dressed in sixteenth-century clothes, and resembling a figure out of Shakespeare. He was reading a book, surrounded by vegetation more European and Latin American than African, although Saint Augustine was an African! Above him a huge friendly sun was shining, and hovering angels playing musical instruments completed the heavenly panorama. The overall flat, decorative style was delightfully New World colonial. Four elaborate niches, two with headless statues apparently vandalized, flanked

CARVED RELIEF ON STONE PORTAL, DEPICTING ST. LUKE PAINTING THE VIRGIN, ON A CHURCH NEAR ZACATECAS, MEXICO.

the carved relief. The church of San Agustín had been gutted of all its original furnishings during the many years it was used as a movie theater and for the storage of lumber. At the edge of the colonial city (above a later bullring), was another impressive structure, a long aqueduct to carry scarce water into the city from a higher altitude, for mining processes required a great deal of water. The aqueduct was a living memorial to the tremendous power and discipline of the viceregal authorities, essential in the building of such a monumental structure.

In a suburb of Zacatecas known as Guadalupe, the Franciscans maintained a powerful college, once part of a great chain of missions stretching north into what is now the United States. The northern frontier was a dangerous territory, where monks had been murdered more than once by savage Indians. The Spaniards maintained garrisons of soldiers along the Silver Road to protect the wagons, laden with precious metals, from Indian raids. At Guadalupe, wood was so scarce, and demanded in such quantity by the mines, that the construction of the monastery complex and its furnishings had been interrupted

many times. The building complex was still standing, more or less, and was dedicated to the Virgin of Guadalupe. The Guadalupe Virgin, carved on the stone relief on the facade, stood alone in glory, surrounded by a local sculptor's rather original version of clouds. A charming portal on the left side of the church showed St. Luke painting the Virgin on the stone portal. The saint held a palette in his hand, and colored stones glistening in the light, indicated the pigments. She was a slender young woman, with her two hands together before her chest, the version of the Virgin as depicted in Mexico. (In the Spanish version, her left arm held her infant son.) The Virgin of Guadalupe was possibly a forerunner of many other mother and child versions of the Blessed Virgin Mary that were extremely popular all over Spanish-speaking Latin America.

Not far from Zacatecas, and also in the North, was the once very wealthy, pompous, and elegant city of San Luís Potosí. Our good friend and one of the best Mexican colonial art historians, Francisco de la Maza, was born there. He wrote an excellent book about its colonial monuments. The churches in the city had been extremely well documented, and every *retablo* displayed an abundance of gold leaf and fine carving. We were especially taken with the robust relief decoration on the vaults of the Chapel of Aranzazú in San Francisco, and on the facade of the small Loreto Chapel, with birds and lovely twisted columns wrapped in grapevines, as decoration. San Luís was an extremely comfortable town in regard to climate. About its name: Why was the name of a saint, not connected in any way with Latin American history, coupled with the word Potosí? Potosí was also the name of a legendary silver and gold mining town in Bolivia. The enormous silver production of Potosí became proverbial; probably, when the city in Mexico was developed into a mining region, the South American city's name was adopted.

On our way to Mexico City, we stopped in Toluca, the capital of the state of Mexico, where we had wandered around during several previous visits. We vainly searched for a memory that had disappeared. In 1933 we had found a lovely type of *serape* in the market, of natural white wool, and shot through with a coral design. The local colors and weaving were so fine that the Toluca textiles could compete with the finest *serapes* from Saltillo and Oaxaca. Those were the three outstanding cities in Mexico where we collected textiles, eventually donating ninety-three pieces to the Textile Museum in Washington, D.C. In the many decades of our travels we had become enthusiastic connoisseurs, because weaving was one of the folk arts that was terribly neglected. More than a few times we encountered wonderful colonial textiles being badly mistreated. Once in South America we observed a piece terribly raveled and folded flat for the priest to kneel on during Mass! We even saw valuable old textiles being used as rugs and seat covers in trucks. The famous anthropologist Ralph Linton, who had a better eye than many art historians, bought up and preserved many colonial textiles, but few others did.

In Toluca we went into the local museum that was founded by the Carmelites. This order played a big role in the Mexican colonial world, and the former convent, once connected to the church next door, was serving the public in a new way. In back of the museum, illuminated by a single light bulb, we found a catafalque, a type of burial ceremony artifact that had become very rare. The idea dated from classical times and expressed a touching devotion to the dead, and the friars' continuous meditation on death. The catafalque in Toluca was a four-sided, four-tiered structure. On one side of the lower part was a recumbent figure in sixteenth-century garb. On the second panel was a pope, on the next a cardinal, and on the top a bishop. It was perhaps not such an extraordinary piece in terms of aesthetics, but the catafalque was valuable as a document, and we later published an article about it and also included it in one of our books.

The museum's curator told us that he had discovered the cotton pieces of the catafalque among pieces of decorative canvas and religious paraphernalia in the old convent that were brought out for holidays. With the help of the governor, he was able to get it away from the priest and assemble the pieces for the museum. It became very well known, probably due in part to our publications, and eventually was taken to Mexico City, where it was placed in the Fine Arts museum. Later, a fight ensued with the authorities in Toluca, and the catafalque had to go back to the museum in Toluca, by then the prosperous capital of a very large state. It was a battle over possession of a work of art, or religious relic, repeated many times since early colonial days, when favorite *santos* and shrines vied for popularity, and pitted civil authorities, the church, and worshippers against each other over their possession.

To the west of Toluca, at a still higher elevation in the state of Michoacán, was a famous mining community, named Tlapujahua. It came to our attention in Manuel Toussaint's book *Paseos Coloniales* and was one of the forgotten colonial sites he rediscovered, and took his students to visit. Tlapajahua had been taken over by the British after the Mexican Revolution, who built a three-story residence for the European engineers and administrators that was still there. The town was completely abandoned by 1953, when we reached it from Toluca via a poor serpentine road. As we stood on the platform before Tlapajuhua's main church of El Carmen, admiring its impressive three-story, stone, altarpiece-style facade, we contemplated the many facets of Mexican civilization, including the tremendously important role of mining, from early times into the present. We recalled something we had seen in Yucatán in 1933, when we were the guests of Raphael Regil, a former *henequen* hacienda owner, who lived in a lovely villa on the outskirts of Mérida. Regil had a collection of archaeological and colonial art, and in between trips to the Maya ruins, we examined his treasures, among them a silver cup or beaker of Indian workmanship, obtained by Hernán Cortés in 1522. It was about 1 1/2 feet tall, with a scene depicting a throne, and a figure surrounded by people prostrated on the ground, perhaps a royal personage and Indians giving homage. Cortés wrote in one of his letters to King Charles V that he ordered the silver mined in Mexico to be converted into plate and cups, vessels, spoons, and other objects. What was even more interesting was that the handle on Regil's vessel depicted a medieval knight with a helmet and complete military equipment, as if he had just returned from battle! It was a remarkable piece for anyone to have in his private collection.

After the colonial system broke down, there was much speculation on various stock exchanges in many European capitals, and mines in Mexico and California had a fascination for investors. European companies, using modern equipment, were able to pump out the water that had inundated the mines, and work them again. At the time of the Mexican Revolution, the great mine at Valencia, Guanajuato, was being worked by an American mining company that Pancho Villa requisitioned for gold bars for his army. The headquarters of the Fresnillo and Plateros mining companies in Zacatecas were eventually relocated to Park Avenue in New York City.

A truck, arriving from INAH (the Institute of Anthropology and History, in Mexico City), suddenly interrupted our mental wanderings in front of Tlapajahua's El Carmen. Out jumped our friend Francisco de la Maza, the art historian of San Luis Potosí, and his photographer and driver. We enjoyed a *fuerte abrazo* as we had not seen him for a very long time, and he told us a wonderful story. In prosperous colonial days in Tlapajahua, a chapel was erected and the famous painter Villalpando commissioned to portray San Lorenzo el Martiro (the Martyr), who died by fire. De la Maza was preparing a volume on Villalpando, and wanted to include a photograph of the painting.

We all went into the chapel and found the Villalpando in a very bad state. We tried to photograph it inside both with and without light, but finally had to take it outside. As we washed off the dirt of centuries, the painting turned out to be much better than even de la Maza had imagined. Some of the photographs that Elisabeth shot that day appeared in his book. Afterwards, we had a picnic lunch accompanied by much animated conversation. Elegant in his velvet coat and necktie, with his artistically cut hair, Paco was a wonderful person to exchange ideas with in that wild, romantic, abandoned place. We had no idea that, when he told us goodbye, and we waved to each other, it was the last time we would ever see him, because he died just a few years later. De la Maza was a great and generous scholar, who along with Justino Fernández, both disciples of Manuel Toussaint, trained the next generation of Mexican colonial art historians, who in turn have enlarged our knowledge greatly and trained an even larger group of young scholars. It was Paco de la Maza who located the bones of Hernán Cortés that had been hidden away for many years, inside a wall of the Hospital de Jesús (of the Immaculate Conception) in Mexico City, where funeral rites were held for many of his old companions in the Conquest.

Driving down to Mexico City from Toluca, we could not forget the time we first made the dramatic descent twenty years before. In former days, the horizon was clear, and one could marvel at the two great, dormant, but still smoking, famous, snow-capped volcanoes, Popocatepetl and Ixtacihuatl. We had observed pine forests, dwellings, cultivated land, and the abundant raw nature of that beautiful valley.

It was a breathtaking variety, which very few other panoramas could match. At that time, there existed a school of painting in Mexico City that was appreciated only by a handful of Mexican connoisseurs. The style pictured lovely moments of rural life, with small figures placed against the vast landscape of the Valley of Mexico. One of the painters was a Catalan who made his career in Mexico City: Clavé, who lived from 1811 to 1880, and was born and died in Barcelona. Clavé was a real charmer because he had a very light touch and, being European, used many themes that were just beginning to be socially acceptable. He sketched a theme of a picnic in 1849, for instance, which the French painter Manet made famous twenty years later as "Luncheon on the Grass." The other painter was better known, the Mexican José María Velasco, who was born in 1840 and died in 1912. Velasco was able to portray what was most characteristic in the Mexican land-scape. He sensitively captured the subtlety of the many colors of the earth and vegetation, and the white of the two snow-topped volcanoes he painted repeatedly looked whiter than any tube could press out, a brilliant vision against the clear sky.

In 1953, as we started the drive down into the Valley of Mexico, we looked forward to seeing the magnificent panorama that Velasco so skillfully eternalized. Unfortunately, nothing was visible because of the great layer of smog that completely covered the city, and even the great snow mountains! One of the things that made Mexico so inexhaustibly rewarding for the eye was gone forever; it was as though a theatrical scene painter had put a thick layer of fog, rain, and clouds over the entire landscape. It was so thick that we couldn't see anything, until a few buildings appeared out of the haze at the edge of the city, where by then the road was full of trucks, and smoke from gasoline and factories. Our trip to Mexico ended with a visit to Franz Meyer, a wealthy businessman who owned the most important private collection of religious sculpture and paintings, furniture, ceramic ware, and decorative accessories in the country. He had a very good eye, and an excellent Chinese cook. His large house was stuffed full of outstanding works of art, which were well arranged, but unfortunately there was not enough light to take photographs in those dark interiors.

On a subsequent trip we were invited by Director Ignacio Bernal to visit the new Museum of Anthropology in Mexico City, at that time the greatest museum in existence featuring archaeology, ethnology, and folklore. From a distinguished, aristocratic, old Mexican family, Dr. Bernal was an archaeologist who spent many years excavating archaeological sites in Oaxaca. Since by that time we were well acquainted in Mexico, we had met him socially. The new museum was very interesting, due to its innovative, completely open design. In Bernal's office, at the edge of the dramatic center room, with its roof supported by a single, massive column, we reacted enthusiastically to a lively, small landscape painting that turned out to be by Velasco. Bernal enjoyed our reaction to the picture very much, and the more we talked, the more we had to talk about. He related that, when they packed up his office in the old museum building that had been the Casa de Moneda, he went to take a last look and saw a tall cabinet, which he had moved out from the wall. Hanging there, forgotten for who knows how many years, was the Velasco. Bernal had it cleaned and hung in his new office. Thus we had not only a charming new friend, but also another Velasco added to our experience!

VISTA FROM GUAYMAS, MEXICO.

MEXICO, 1963:

NORTHERN MEXICO BY TAXI

FOR A NUMBER OF YEARS, we were in contact with colleagues at the University of Arizona, Tucson, where the Southwestern Mission Research Center published an excellent newsletter to which Pál contributed articles. Bernard Fontana, a specialist on the history and the missions of the Southwest, was one of the editors. He was always encouraging us to visit the old missions in Sonora in northern Mexico, and in 1963, we decided to go and also to investigate other places on the West Coast.

We drove down from Tucson, entering Mexico in Nogales, and found lodging at the Marcos de Niza Hotel for the night. A taxi driver by the name of Chávez agreed to drive us to various villages and towns that were on our program for five days. Since we told him about the kind of work that we were doing to promote Mexican art, he gave us a good price. It helped that we spoke Spanish, and he could see from our equipment that we were not tourists. The next morning, we loaded our things into his taxi and headed south into the state of Sonora where the fabled mines were active until the 1860s, when Napoleon III sent Maximilian von Habsburg to rule Mexico as Emperor. The French ruler was planning to reap the riches from the mines, and establish a dukedom in Sonora to administer the region.

There was a lot of variety in the scenery and plenty to look at as we approached the little town of Caborca. The place was a demonstration of what can happen to the good intentions of missionaries who arrived to convert such uncultivated lands. The territory was

first given to the Jesuits, who brought their pupils and priests from Europe to augment a shortage of missionaries and teachers. They had difficulties covering the extensive territory of Mexico and South America, which put a strain on the Jesuit establishments. In 1767 the Jesuit Order was expelled from New Spain.

Lesley Byrd-Simpson was an outstanding classical scholar who translated Spanish and colonial documents. In his famous book *Many Mexicos*, he wrote that the Jesuits were expelled because they grew too powerful for their own good. From their humble beginnings as the spiritual militia of the church, they had become a de facto guard of the Throne of Saint Peter (the Papal power). The institutions of the Spanish Empire were jealously guarded autonomies, and in the totalitarian state of Charles III (1759 to 1788), the Society of Jesús was an anomaly. The order was expelled in Spain in March of 1767, and even the pope had to admit that there was a reason for it.

The writings of Central and East European Jesuits, who went back to their homelands after they were expelled from the New World, eloquently documented Jesuit efforts to educate and bring the Faith to the natives. One of these was a Hungarian Jesuit who became a village priest in the northern part of Hungary, and described his life in America in his memoirs. It was a harsh life for those Jesuits and later missionaries, fraught with danger. The establishments in the west and north of Mexico depended on the ones farther south for replenishment of their supplies and equipment. A mule train was supposed to be sent to them every two years with the necessities of life that were not locally produced. The local populations were very skillful producing clothing material, but better utensils, and certain household articles, such as chinaware and silver, had to be purchased elsewhere. Historical archaeologists who

SAN IGNACIO DE CABORCA IN CABORCA, MEXICO.

the Caborca temple was built entirely by Franciscans between 1803 and 1809. It was all built of brick and clay, adhering to the laws promulgated by Charles III, the Spanish Bourbon King, to save the native timber for use in mining. In the west coast sector of the rich state of Sonora, we found numerous partly maintained mission churches with remnants of *argamassa* (stucco) work, indicating the existence of once-elaborate buildings. Clay that hardened when dry was a good solution instead of using carved wood from the diminishing supply needed in the mines. Indian and *mestizo* artisans, well versed in the technique of the eighteenth century did the work. After leaving Caborca, we went by the village of Tubutama, which also had a church with amazing *argamassa* work.

Twin towers flanked Caborca's *retablo* facade, and one of the big doors was missing. Inside, instead of the usual decorations and niches with statues, there was almost nothing, because the Río Concepción behind the church had washed away the bottom of the rear wall when summer monsoons converted it into a raging river. It was a great pity, as originally the church must have been quite a distinguished edifice, in keeping with the successful mining ventures in the area. As happened also at other missions, there were not enough Franciscan personnel to take over all the positions that the Jesuits had begun, and a number of settlements remained without a priest. Later, the *visita* system was developed, where the priest came only on special occasions, whether it was a Sunday, a Holy Day, or for a baptism, wedding, or funeral.

In the colonial period, even if the landscape was barren and there were no settlements, when a mine started working it drew missionaries and a labor force. Originally, the mission headquarters were in Mexico City, later in Querétaro, and even later still in Zacatecas. While the Jesuits were established in the northern territories, running their well-organized operations, there was a certain stability. But the Indians were not entirely converted, and after the Jesuits were expelled in 1767, the whole organizational landscape deteriorated. Political upheavals shook the system and showed up in the lack of upkeep of church buildings, as well as services.

Caborca was situated relatively near the Gulf of Mexico. A branch of the Ferrocarril del Pacífico (built in the 1880s) headed west to Baja California from Benjamin Hill through Caborca, but paving

have excavated northern mission churches, even found Chinese cups that came via the Manila galleons.

Caborca was a rather neglected place, with very little human activity visible. We could not determine if the church was still Jesuit or Franciscan, as had happened in San Francisco Xavier del Bac in Arizona, where a Jesuit establishment was abandoned and the Franciscans built a new church, still standing. Later we learned that

AN EXAMPLE OF ALL *ARGAMASSA* (STUCCO WORK)
CHURCH IN NOGALES, MEXICO.

Highway 2 was what really opened it up for tourists. They came in increasing numbers, particularly from California and the Southwest, attracted by the varied landscape, water sports, and excellent fishing. More motels were built, increasing entertainment facilities and greatly adding to the traffic in the area. Government officials apparently realized what a gem they had in the church at Caborca. Subsequent to our 1963 visit, the apse section and the back wall of the church were restored, and a new door given to the facade.

We had a special reason to visit the village of Batuc, lying in the bottom of a bowl 200–300 feet deep. It was a convoluted, hilly area with highly developed mining. The population was to be moved, as a badly needed hydroelectric plant would flood the entire basin. Even the buildings on the rim were condemned. The dam was already under construction and would be called "El Novillo," meaning a bull calf. The water source was the Río Moctezuma, and in about two years it would inundate the whole basin. As we approached the bowl, we looked down and saw that much of the low-lying land had already been abandoned. Even on the highway down from Nogales we had seen trucks loaded with construction materials headed for the hydroelectric dam site, passing trucks going north, piled high with Mexican vegetables for the U.S. market. Maneuvering on those narrow roads took a lot of skill on the part of our driver!

As we arrived at the bottom of the bowl, we saw two churches. The larger one had a tower entirely of stone and still relatively undamaged. We went inside and found that the entire building was done either in stone or in *argamassa*. Even the confessional and the baptistery were entirely constructed of masonry. Beneath the *argamassa* work falling off the pulpit, we could see the well-cut stone base. The holy water container had a fluted bowl and probably also served as a baptismal font, as necessity arose. The Batuc church was an example of how a building and its interior could be entirely constructed without using wood. The other church, standing beside the first one, was only a relic, roofless and full of dirt and garbage, with only some classical columns and a pediment to show its former nobility. One especially well-carved element should be mentioned, the keystone of the main entrance. It had not only one but three pieces, so well integrated that only the professional eye would perceive they were individual. It was a masterpiece of stone masonry

RUINS OF LONG BARREL-VAULTED CHURCH
ON TOP OF HILL IN TEPUPA, MEXICO.

VIEW OF TEPUPA PLAZA FROM CHURCH RUINS.

with an unusual subject, the dove of the Holy Spirit hovering over Saint Joseph, who held the child Jesus, and grasped a flowering stalk in his left hand.

The town was so dirty that when we wanted to take a little rest and eat our lunch, we could not find a green or decent place to sit down. Many of the people had already left this bowl of land, and it was becoming desolate and neglected. We were happy to get in the taxi again and head for the village of Tepupa, just a few miles south

of Batuc but situated a little higher. It had a very long church, which was again a virtuoso solution on the part of its builders. What was most worthwhile to see was the long, barrel-vaulted roof. It was constructed of a single row of cut stones, standing intact without the support of buttresses, or of extra-heavy walls. The apse at the east end had been carried away in a landslide, but a finely carved lintel remained over the side entrance and bore the carving "JHS," the insignia of the Jesuit Order, an indication that they had built the church. We drove up to the rim of the bowl, and Elisabeth took one more photograph. We recalled the twelfth-century Normandy folk tale about a village near a river that was very anti-religious, causing its church to sink under water by divine intervention. But during the evening meal, the church bell could be heard all over the village ringing and ringing, sending fear into the townsfolk. No such dread seemed to have affected the remaining inhabitants of Batuc, apparently waiting to see the water rise around their homes.

Our headquarters for those journeys to mission churches was Hermosillo, the capital of Sonora. It was a university town, and the hotel was quite convenient for our comings and goings, but

MASONRY AT TEPUPA.

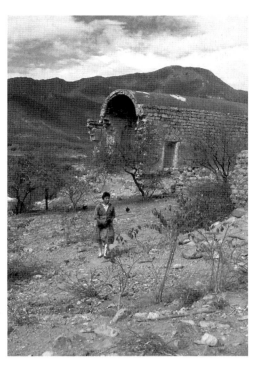

RUINS OF CHURCH AT TEPUPA.

become intensive around Alamos. When we were there, the church was being refurbished, but twentieth-century religious paraphernalia were not very attractive. Some of the houses, on the other hand, had excellent colonial paintings and statuary. One charming resident, who had a lovely colonial home restored and modernized, told us how she had to have a person as pro-forma owner of her house, because it was less than 100 kilometers from the California border, and therefore she was always in a twit about the gentleman, who had to be a born Mexican, possibly playing an unpleasant trick on her. With the various political upheavals and changes of personnel in government offices, American citizens who obtained property in that fashion never felt completely safe. The main plaza of Alamos had an opera-like appearance. Some of the older houses and shops spoke of a bygone era. One of Mexico's most prominent colonial scholars

unfortunately, it was next to a radio station. The station opened its windows by 6:00 in the morning, and everyone in the hotel and neighboring houses went outside to hear the blaring music! The Southern Railway, which connected California and Arizona with the west coast of Mexico, brought prosperity. The large town of Guaymas had easy access to the Gulf of Mexico, its water sports and other entertainment. The stay in the hotel was very pleasant due to the temperate climate. To the east, the mountains had many colored streaks and stripping, signs of mineral deposits. The region was very much visited, even in the time of Cortés, and had a fascinating history. Somewhat more inland was another mining town, called Alamos, that in its heyday was probably a great place for entertainment. The church once was quite elegantly furnished, but as the area was a highway for the Revolutionaries, there were very few colonial relics left. There was a law in Mexico that didn't permit foreigners to own land within 50 kilometers of the seacoast. That made a lot of difference in foreign ownership of property, which had

and restoration architects, a former student of Justino Fernández and Francisco de la Maza named Manuel Gonzalez Galván, played an important role in the later restoration of Alamos. Born in Morelia, Michoacán, González Galván was in charge of the restoration of that city as well.

Five miles from Alamos was a settlement called Aduana, where the ruined and abandoned structures spoke eloquently of bygone wealth and grandeur. There were still a few homes where people lived, who probably were truckers or worked in Alamos, but previously Aduana was a great mining settlement. Perhaps its citizens contributed to the embellishment of Alamos with their work in the mines or perhaps as artisans. Aduana was interesting for us because the patron saint was the Lady or Virgin of Valvanera, represented in her historical appearance, and reputedly connected to a miracle. There was also a photograph in the church that showed her with the Christ child sitting in the open trunk of a tree, enabling the iconographical identification. The Valvanera statue in Santa Fe,

New Mexico was made of stone, along with the rest of the altar-piece. It was carved around the second half of the eighteenth century, when it was prohibited to use wood to decorate churches in the region as it was in California and the Southwest.

We visited another old town on the Gulf of California, with a wide sandy harbor, named Mazatlán. It was famous since colonial days, although the Crown directed most ships from Asia to land at Acapulco, farther south. Mazatlán served the North and the area inland around Guadalajara, the most important city in the western region of New Spain. The northern coast was hard to defend from the land, because of the many mountain passes closing it off, and the port of Mazatlán was important militarily. A historian in Mazatlán gave us a booklet in which he told the story of shipping in the colonial period, and the diseases that ravaged the population. He argued that the illnesses could be explained only by contact with germs brought from Asia by the crew and passengers, along with the tea, ceramic wares, and other goods. The wealthier citizens frequently moved up into the mountains to get away from the unhealthy conditions on the coast.

In 1585, five Japanese noblemen who had learned to speak Latin and Portuguese, were encouraged by Jesuit missionaries to go to Spain and meet King Philip II. After leaving Japan and crossing the Pacific, they first landed in Acapulco and then went to Spain, after which they went to Italy and met the pope. Detailed accounts of their dress, knowledge of religion, eating habits, calligraphy, and Japan's military organization were published in Spain, Germany, the Netherlands, and also in French, Portuguese, and Latin editions. Foreigners were not welcomed by the Crown in its colonies because of protectionist trade policies, and English, Dutch, and French pirates repeatedly attacked Spanish ports from Mexico to Panama. But in the first decade of the seventeenth century, a former governor of the Philippines named Rodrigo de Vivero was shipwrecked off the Japanese coast en route to Mexico from Manila. He was cordially received by the Shogun, and furnished with a ship to carry him to New Spain. A number of Japanese merchants sailed with him to investigate the prospects for trade. They landed at Acapulco, were presented to the viceroy in Mexico City, and after five months returned home, evidently unsuccessful.

In 1614, another delegation from Japan, of distinguished diplomats and merchants, attempted to establish relations. They journeyed to Mexico City and, diplomatically, had themselves baptized. Part of the delegation returned to Japan via Acapulco, and six of the leading Japanese aristocrats journeyed to Spain, via Veracruz. They made ceremonial visits in various parts of Europe, and were granted audiences by the king of Spain and the pope. Before returning to Japan, they spent three years in Mexico, but apparently without much success, due to the Crown's relentless monopoly of trade and commerce that also adversely affected the merchants who lived in the colonies.

Some very interesting woodcuts of American and European life have surfaced depicting European ships, dress, and even table linen, and a museum in Lisbon has a wonderful collection of magnificent "Nambam" screens (as the style was called) portraying Portuguese merchants in China. In Mexico, ivory from Asia was imported in the form of religious statuary and other paraphernalia, as well as great quantities of ceramic ware. We saw some of those pieces in museums, private collections, and in a few churches. In general, outside influence was no more welcomed in Japan than it was in the Spanish colonies, and a Japanese who spent any length of time living abroad risked being beheaded! But no laws could prevent vessels from being blown off course by storms, and nineteenth-century literature gave numerous accounts of shipwrecked seamen and travelers. One such published tale told of Japanese who went as far as Baja California, and then made their way back to Japan. Finally, in 1853, when the Perry expedition broke down the barriers, Japan was opened for trade with the West.

The Spanish Crown began an elaborate defense of its ports in the New World in the sixteenth century. Impressive forts endure in Yucatán, Campeche, Veracrúz, Acapulco, Havana, and Puerto Rico. By the end of the seventeenth century, a harbor was needed between Acapulco and Mazatlán, where ships could be fitted out and replenished. San Blas was chosen, in the state of Nayarit. The inlet where San Blas is located was surrounded by insect-infested marshes, but there were advantages facilitating the construction of a naval base and shipyard. The site was guarded by a bluff 150 feet high, and was ideal for a fortress. However, in the rainy season, it was surrounded

by water, and the ground became very marshy. But fresh drinking water was abundant, and the port became important in lucrative trade and the production of salt. San Blas, although in ruins and much diminished in importance at the time of our 1963 visit, still had an impressive fortress of solid stonework, with a cannon or two. A finely designed church had been preserved, with notable lines and decorative elements on its facade. Otherwise, San Blas was not much more than a good fishing place. All those settlements along the Pacific coast, and a few miles inland, suffered from a lack of good water. Perhaps nature blessed them with gold, silver, and other mineral wealth, but the water shortage and unhealthy climate greatly hindered development.

Before settling down again for a few days in Mazatlán, we spent a night in Topolobampo, where a restaurant on a little propeller boat served the best shrimp on the coast. It was a starlit night. The stars glittered from locations much different in the heavens than from our Northwest Connecticut home, and the whole experience was very memorable and romantic. Another important stop was Tepic, which dated from the time of Cortés, where foreign mining interests had invested heavily in the nineteenth century. Even in 1963, it had a number of handsome, centuries-old buildings. Our guide was an excellent young man with an English surname, who could not speak a word of English, his father having been an American mining engineer who established himself there and married a local girl. At the local museum, we encountered very interesting pre-Columbian pottery known as Nayarit. A painted figure was most unusual, because half of the face was covered so that the face was shown only from the nose upward. Was that ceremonial garb, or due to another reason? In any case we published it, realizing that the West Coast had very interesting local cultures that were not much studied, although the prehistoric peoples of Nayarit were powerful and influential. In the 1960s, both Mexican and North American archaeologists had their hands full with the plethora of sites in other regions. The collection of the museum also included a wonderful miniature funeral procession, with a number of small figures, the whole piece only a few inches in diameter!

We found a very good photographer in Tepic who did some work for us, and furnished the address of his brother in Mexico City, who dubbed American films in Spanish. Later, we sought him out and were invited to the studios where he worked. We were really amazed to see the process by which the American films in English were turned into Mexican films to be shown there and marketed throughout Latin America. Tepic's population reacted the same way as that of Mazatlán to the climate, and moved to higher ground whenever possible. Thus the city gradually moved inland, closer to the mountains and forests to the east.

Not far from Tepic, toward San Blas, was another town named Santiago de Compostela, after the great pilgrim site of Santiago de Compostela in Spain, where lies the body of Saint James the Great, the Apostle. He appeared as a mounted warrior at the Battle of Clavijo in 939 AD against the Moors. He became the Patron Saint of Spain and the Knights of Santiago, a military order that included the *Conquistadores* Cortés and Pizarro. Saint James was said to have appeared fourteen times in the New World. The special chain of Santiago that the knights wore around their necks was even used as decoration on early facades, as on the Franciscan church in Texcoco in the state of Mexico. The colonial church at the modern Compostela in Nayarit that we visited had an interesting equestrian figure inside, representing the saint, and another in relief on the facade.

The presence of many mines around Tepic, Santiago de Compostela, and San Blas rapidly brought prosperity. In 1536, a group of wandering Spaniards and soldiers reached Compostela. They included the leader, Cabeza de Vaca, and four other survivors of an expedition from Cuba, shipwrecked off the coast of Florida. They trekked for twelve years west across the North American continent, more than 3,000 miles! Sometimes they traveled by canoe, but mostly on foot, and were both helped and harassed by the Indians. Within 100 miles of the Pacific, they turned southward, on hearing from the natives that other Spaniards were there. The Spanish soldiers, who were exploring Sonora and Sinaloa on the West Coast, took them to Compostela. The provincial governor was dumbfounded by the story, and those barefoot men who spoke hesitant Spanish and preferred to sleep on the floor!

Tepic and the Pacific Coast lost importance, and Guadalajara in the state of Jalisco was made the administrative capital of the

region, and became the second largest city in Mexico. Its conquerors included the First Lieutenant of Cortés, Pedro de Alvarado, who was killed in battle during the conquest of Jalisco. The city figured importantly in the exploration and development of the mines in Zacatecas, Durango, the other northern regions, and the southwest of the United States. Guadalajara was a very pleasant and civilized city, with monumental colonial buildings that owed much of their magnificence to the riches of the northern mines. The Government Palace, built in 1743, with a handsome, two-story, inner courtyard, displayed a fine example of how curtains could be imitated in stone above a window on its facade. The cathedral, dedicated in 1618, had surprising Gothic vaults and an austere stone facade, in stark contrast to the heavily decorated ones in Zacatecas and elsewhere.

In the mining towns, churches were often constructed near the mouth of the mine to bring good fortune. As the mines fell into disuse and their churches into ruin, the statues of the saints would be transferred to another church. Some of these were being restored and regilded when we were in Guadalajara, and Elisabeth photographed the process. The restorer would clean the statue and apply a special heated glue. The glue created a good adhesion for a piece of extremely thin gold leaf, not larger than a cigarette paper, which was then laid on and brushed down, to be subsequently burnished with a bone tool. Within ten years, after being exposed to light and human handling, the newly gilded surface would achieve a patina and look old.

Outside of Guadalajara was the prosperous village of Tlaquepaque, long famous for its textiles, pottery, glass, furniture, woodcarving, and gold- and silverwork. As we walked through one of the pottery factories, we noticed a folded piece of textile on a little chair, with a dusty sack on top. Pál lifted the sack and unfolded the cloth, upon which the shopowner came out and said, "That is nothing important." But we recognized it as an early piece of Guadalajara weaving and bought it. It is now one of the fine pieces in the collection of the Smithsonian's Textile Museum in Washington, D.C., where we placed our oldest textiles. It was woven from the typical white wool employed in the locale, and its bright colors reflected the cheerful nature of the local weavers, in spite of both the cold or very warm climate. The ends were always bordered with roses in bright tones, and red between serrated bands. Blue birds framed the sides, and in the center, where all the motifs came together, they circled in a wreath of roses as though part of a musical game. Unfortunately, after World War II, a wave of commercial production hit the Latin American countries, as foreign merchants and tourists discovered them. Whether it is a violin virtuoso who is discovered or a nameless native artisan in a poor country, he is very often spoiled by success, and sooner or later the quality of his work deteriorates. Very often we encountered unlikely, even vulgar figures woven into a textile, for instance, and received an explanation from the weaver that it was "for the tourist." If it was not enlivened with something vulgar, they thought, it wouldn't sell, just as music can't be sold to a certain audience if it lacks vulgarity.

GEORGE ECKHART AND PÁL, FIRST LUNCHEON ON THE ROAD IN SONORA, MEXICO.

MEXICO, 1964:

SONORA WITH GEORGE ECKHART

DURING OUR VISITS TO TUCSON over the years, we had met George Eckhart, an expert on the missions of Southern Arizona and Sonora. Our friendship started when he corresponded with us in Norfolk about an acquaintance who wrote about the *milagros*, the popular little painted stories frequently seen in Mexico, which told of a miraculous healing or other escape from catastrophe. Professional educators might have considered George unqualified because he lacked formal education and degrees to give him status in the academic community, but he had developed a respectable historical approach, and firsthand knowledge of the missions. George was a very modest and courteous fellow. His house was a comfortable, well-lighted place in the middle of a small garden, with a library containing a considerable number of books, photographs, and other information about Sonora. Although George was employed by the railroad, he had enough time to travel. Finally, in 1964, the opportunity came to make a trip to Sonora together, to see those neglected sites. We had already acquired firsthand knowledge, archives, and photographs of Mexico, Central, and South America that were used in the publication of *Baroque and Rococo in Latin America*, and the Sonora material would add another facet to our study of Spanish colonial architecture.

We laid out a route with George. There was no regular highway to those seldom-frequented, impoverished towns, but he knew his way around. We rented a Wagoneer Jeep station wagon with a four-wheel drive and a low clutch. The shock absorbers weren't very good, and the jack fairly useless, but nevertheless, the car gave pretty good service. We filled it with bathing and sleeping equipment, boxes of canned goods, and bedrolls. By January 29th, we were rolling along under a clear, light blue sky to the Mexican border at Douglas/Agua Prieta. The name on the Mexican side means "blackish water," after the blackish river water, due to intensive mining, for Sonora was one of Mexico's richest mining regions in colonial times. The color of the hillsides changed from dark brownish red into dark yellow, indicating a high mineral content close to the surface. Underground water washed through veins, and then leached into the river, darkening it.

After fording the Río Fronteras, we sat down for a tasty lunch of sandwiches, tea, and coffee, warmed on a little gasoline stove. A small Indian boy with a large stiff cowhide on his back waited nearby for a lift, and soon got one from a truck. About 3:00 in the afternoon, we had driven as far as Nacozari, a town with a very bizarre appearance. Once headquarters for mining operations of Phelps Dodge, it had a two-story hotel with a long gallery on the plaza, rather like a New England railroad station and not bad for a mining headquarters. As it was too early to stop for the night, we went on to the town of Cumpas. The place didn't have a colonial church, only a new one, being built as they pulled down the old. Our so-called hotel was a kind of lean-to with broken windows and rooms opening out on the streets. But supper was a delicious stew with *frijoles*, accompanied by cold tortillas and fried potatoes. After supper we talked by lamplight with the *patrona,* Señorita Ollas, as she sat with her feet in an upturned carton to keep warm. We laid out our bedrolls on camp cots, and kept on our clothes to keep warm. The next morning, the drinking water was frozen, and it was certainly good to have some warm breakfast and get off again.

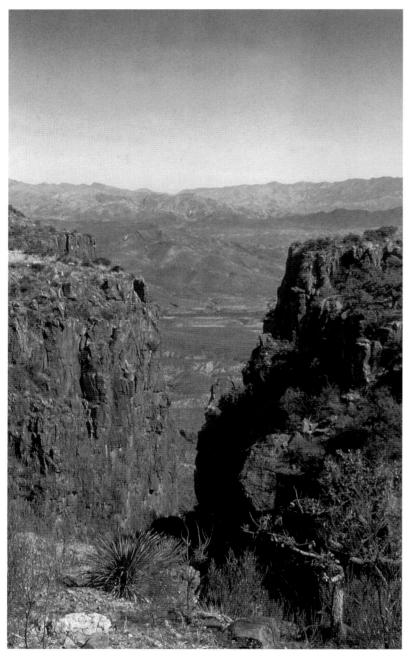

GORGE WITH VIEW OF BEVISPE VALLEY
ON THE WAY TO HUÁSABAS, MEXICO.

REPAIRS AT
MOCTEZUMA, MEXICO.

We drove to Moctezuma through a greening landscape, finding a lively town with a ruined church, only a remnant of its original form. The outline of a large apse stood on barren ground, and the empty facade indicated it had once been ornamented with stucco. Elisabeth also photographed what was left of a weather-beaten pediment over a side entrance. Modern statues of the Virgin and Joseph stood on a small, early altar. Benches filled the nave, the only seating. The road out of town continually worsened, as we entered a varied landscape of peaks, valleys, and highlands. We came to the village of Huásabas, where George took us to the home of the Fimbres family, the parents of an English teacher in Tucson. It was an old tradition there to take in strangers with recommendations. Our hosts were very gracious and had a good supper for us, as they bought fresh food from the market every day, due to a lack of refrigeration. We had only lamplight and one wash basin, but a good night's sleep in spite of the cold. We ate a hearty breakfast of red-yolked eggs, leaving them a bag of canned goods with some pesos slipped in since the Fimbres were too modest to ask for money.

After taking some photographs, we drove to San Luís Gonzaga de Bacadéhuachi. The road went on and on, with many serpentine curves so steep that we couldn't see around the elevated hood of the car! At last we were headed downhill, surrounded by a formation of rocks with magnificent colorations. It was the Sierra Madre range, a jumble of fantastic peaks so high that they blocked the view to the east. We went higher and higher, and came to a flat section with a church tower in the distance, where there once was a mining town,

VIEW OF THE SIDE ALTAR OF THEO EL AMBULATORIO
AT SAN LUÍS GONZAGA DE BACADÉHUACHI
IN BACADÉHUACHI, MEXICO.

DRAWING A CROWD WHILE MAKING INQUIRIES
IN BACADÉHUACHI.

Bacadéhuachi once had a considerable income from mining, but in our time had turned into a dusty, shabby little town of non-descript adobe buildings. Cowboys rode about in heavy cowhide chaps, with lassos on their leather pommels. We inquired for Señor Valéncia, a correspondent of George, and one of his boys told us that his father was away, and recommended a place where we could stay, the Villa Real. We had lunch there, nothing special, except for tasty sweet biscuits, which we took along to nibble on the road. The church was our reason for coming so far, a massive building that illustrated just how far-reaching was the early missionaries' dream. Until their expulsion in 1767, the Jesuits thought their establishment would develop into a very important enterprise. In most cases, where the Jesuits had started a church, the Franciscans took over. But a few decades after the Franciscans arrived, the Mexican Independence movement of 1810–1820 halted many religious activities, particularly church building. In some places, it seemed as though the ghosts of both the Jesuits and the Franciscans were haunting the ruins. There were many legends about buried treasure inside church buildings, and treasure seekers made holes in the walls that the elements enlarged, which eventually collapsed whole structures.

in the neighboring state of Chihuahua. That was the marker indicating the farthest point of our journey. Then came a flat field, where some boys were playing soccer; it was also used for a landing strip by local ranchers.

GEORGE ECKHART AND PÁL AT
SAN LUIS GONZAGA DE BACADÉHUACHI CHURCH
AT BACADÉHUACHI, MEXICO.

ELISABETH (ON LADDER) TAKING PHOTOS
IN BACADÉHUACHI.

The Bacadéhuachi church was built during the tenure of the Jesuit Father Nicolás de Oro, from 1709 to about 1740. The towers on either side of the facade hinged forward, like the wings of a triptych, but were toppled to a third of their original height by an earthquake in 1887, and shortened when repaired. The long, very narrow nave roof supported a bold, strong dome and lantern with three openings into the building. It was the largest church we had seen so far, and dazzlingly whitewashed. The interior was equally impressive, the high nave white and empty. Tall slim pilasters supported the central dome and the vast barrel vault. The capitals, cornices, bases, and brackets for statuary were of whitewashed bricks. An intact, vaulted ambulatory of connecting chapels ran around the thick inside walls, even behind the main altar and the sacristy, a feature of Spanish churches unusual in the New World. A statue of the Virgin and Child was perched in an open arch on the main altar, glowing in the light from the dome, even after the afternoon shadows darkened the nave. The sacristan showed us a processional cross embossed with silver, and also a reliquary in good condition dating from the early days. Its iconography included an intriguing frog, which indicated water in pre-Columbian times, but meant

nothing to the Christians. The main body of the church was still functioning, although without a priest, so the missionaries had achieved at least part of their dream.

An old woman who had come over to watch us, pointed out a house opposite the church on a corner of the plaza, larger and better built than the others nearby. She said it was once the Casa Real, the official guesthouse. The town had two famous springs that had dried up, one cold, and the other flowing with hot water. The missionaries in colonial times made much use of them, and people came to bathe, even from across the mountain pass and the neighboring state. When night came, it was colder than ever, and we had to sleep under heavy rugs. The next morning Elisabeth took some photographs, and George bought a pack of cigars. We decided to drive back to Cumpas, with George shifting into low on each slope, as smoothly and carefully as possible. We were able to appreciate more than ever the strange force of the erosions and splits in the canyons, sometimes 100 feet deep. Beyond the town, shadowed by the tall mountain range called the Sierra Madre Occidental, was the Río Bevispe. A number of working ranches were visible in the distance. Between the desolation, poverty, and

CHURCH FACADE OF FIRED BRICK IN ARIZPE, MEXICO.

the rugged mountain terrain, we had a graphic display of the difficulties of travel a century or more ago. Again, we did not pass a single passenger car, only trucks.

We were headed toward Arizpe, the capital of Sonora in the colonial period. We drove through a valley with unimportant former missions, only one of which had any historic remains, but had been completely rebuilt. It was pretty dark when we went through the last village of Banamichi, consisting of a row of adobe huts. It kept getting darker and darker. We plodded along dusty roads and riverbeds, and once got lost, the road getting narrower and leading into a pasture. We kept seeing truck tires, but nothing else except fields. George could not see beyond the hood, and Pál had to peer out into the dark and direct him. We passed a group of completely dark houses and arrived at another river valley. We turned off and followed the tracks of another car, but otherwise it was just fields, and border land, and stones. We crossed another river, or was it the same river? The dark canyon walls were close around us, and stars by the millions shone brightly overhead. We tried another road, but it didn't lead out of the canyon, and we had to admit that we were really lost. The next day, we found out that a village nearby was called Tetuachi, but who knows where it was! It was then about 10:30, and we stopped and got out our sleeping bags. George was really pooped, so he got the front seat to stretch out on. We snuggled under the comforter and a big down-filled bag. George fell asleep immediately, and to our amazement, so did we. The moon kept us company as the cold, clear, dark night enveloped us.

The whole night, it was as quiet as if in a magic land, where there were no pumps, electricity, auto horns, no coyote howls, or stomping of *burros* and cattle, which in Mexico, at least, gives the feeling that some life is out there. It might have been a little before 6:00 the next morning that we were ready to drive on. Half a dozen jackrabbits danced in the light of dawn, with long teeth in grinning mouths and big ears flapping. Luckily, we had a reserve of 2 1/2 gallons of gas. Again, we drove over the rough, boulder-packed rise we had traversed the night before, and on top of a bare spot, we had a blow out. George lay down on the sleeping bag, and tried to get the spare out from under the truck, while Elisabeth started the gasoline burner, and tried to heat water for some coffee. There was no possibility to get much heat. Pál walked down the hill to a small, isolated house we had passed by in the night. It was completely dark, but had a trickle of smoke coming out of the chimney. Two men let him in and gave him some coffee, and he told them our story. A young man entered from a back room, combing his hair with brilliantine.

FIRST OF FIFTEEN FORDINGS OF RIO SALIORA, NEAR TETUACHI, MEXICO.

lunch, was not as promising, so we decided to use our provisions for that evening. Nobody was staying at the guesthouse besides us, as the priest was in Agua Prieta. The caretaker was a very shy *jovencita*, who was happy that we took the rooms and quickly disappeared.

Since the guesthouse was opposite the church, we went there first, and were disappointed to see that the main altar had been re-erected in a modern interior decorator's style, with so-called drapes in a kind of mid-Victorian, Italian, or French manner, in taste no better than might appear in any area of provincial Europe. Arizpe had gained special fame, when the bones presumed to be those of Anza were found there. He was the local celebrity because, as an official of the Spanish government, he was the founder of San Francisco, California. Born in Mexico, in 1735, Anza was the governor of New Mexico between 1777 and 1788 (the date of his death); and out of gratitude San Franciscans paid for a new floor in the Arizpe church. In the upper part of the church, in the center just before the main altar, was an exhibition case covered with glass, and placed deep down, as if in a tomb. There lay the slender remains of a man in uniform with his weapons by his side, supposedly the figure of Anza. A balustrade and neon lights rimmed the tomb, presenting visitors with a very somber spectacle.

He turned out to be a teacher named Castro, doing a required assignment at the local school. He went up to help George and Elisabeth, and they all came down together. We had a wonderful talk, and they said that if we had taken the other road at a fork, where we made the wrong choice, we could have made it to Arizpe.

George persuaded Castro to act as our guide, and we started off again, fording one river after another and finally, after about two hours, saw the church tower of Arizpe, by which time the road had considerably improved. In Arizpe, everything was much more friendly, especially since it had become a tourist destination for people from Arizona. We filled up at the one open gas station and bought a new tire two blocks away. The local priest had a motel-like operation, promising a night that would be a lot better than the one we spent in the canyon! The restaurant, where we looked forward to

The interior of the church had some old gilded *retablos*, various paintings, and statuary, faded and not well cared for. Although the

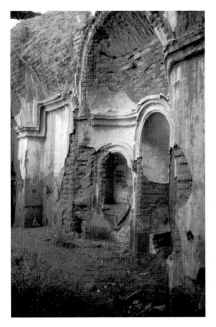

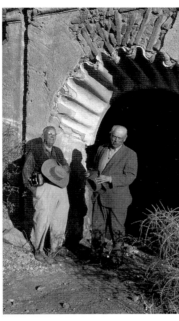

LEFT NAVE WITH SIDE
CHAPELS AT THE MISSION
RUINS AT COCÓSPERA.

PÁL AND GEORGE ECKHART,
AT THE MISSION RUINS
AT COCÓSPERA.

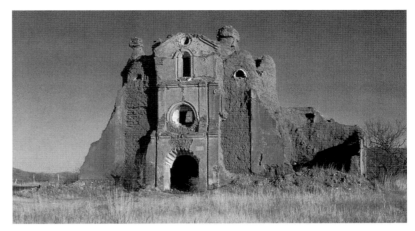

MISSION RUINS AT COCÓSPERA, NEAR NOGALES.

workmanship was quite good, and we could visualize the church when it was a cathedral, the interior did have some colonial remnants, or at least an echo of a style. While interiors of churches can be ruined (as in an orchestra, where the strings are playing all right, but the wind instruments are off key, or too fast), a similar cacophony can occur in art. In Arizpe, the screamingly new main altar jarred horribly with the colonial, *churriguersque*-style side altars. The main facade of the church was something else. Although the stucco decoration was completely gone, the construction of the building revealed fascinating details for anyone interested in colonial construction methods.

The tower on the left side had been somewhat reconstructed and had a new helmet, although the opening for the bells was original. Old, garland-like decoration was still intact there as well. Although many of the churches and other buildings of colonial-period Sonora were fashioned out of sun-dried adobes, the entire construction at Arizpe was of fired brick set in lime mortar, which was very apparent, because the walls were completely exposed. To create a frame for the traditional, round rose window on the facade, lighter bricks were laid down very thinly, with such skill that every brick was visible as it turned around the half circle, so the structure was not in danger of collapse. As elsewhere in Mexico and in Central and South America, when such a portal or similar elements of buildings were constructed, a wooden support was placed underneath that would be left in place for half a year to a year, until the arch was completely solid. Then the wooden sub-structure would be taken down. The round windows and arches stood firm for centuries, if not destroyed by earthquakes or human intervention. The brickwork was a decorative element in itself. The garland, circular wreath, and other patterns created in stucco or *argamassa* all over Spanish America were also present at Arizpe. Hopefully, the money collected for visits to the tomb would be tastefully applied to restoration of those valuable, older features, and not squandered on any more modern substitutions.

After a restful night and two satisfactory meals from our provisions, we were in a good mood when George came up with a new idea the next morning. He proposed that, instead of going back over a well-known road, we should see one more place, which, although in ruins, was extraordinary, and from there go back to Nogales on the U.S. border. We heartily agreed with the plan and headed for the former mission church at Cocóspera, stopping in the rich mining town of Cananea to telephone Tucson for hotel reservations. By 3:00, we entered a rich valley surrounded by mountains.

On a promontory stood the ruin of a building, which gave us many valuable insights. The afternoon sun was shining warmly over fields waving with grain and studded with trees, a very different setting from the previous mission sites. Wherever we looked were rivulets, greenery, and blooming trees.

Unfortunately, the church was in a very bad state. During its construction, the Apaches were constantly raiding the region, which continued after the mission was abandoned. Originally a Jesuit construction, it was said to have been the favorite place to visit of Father Kino, the early priest. Later the Franciscans took it over, and used the outer adobe walls, building a smaller church inside them. The roof had fallen in, and most of the large shell that had framed the main altar was on the ground. The masonry altar was decorated with two big vases in relief, filled with pomegranates and painted flowers. Painted fruits and flowers of the region were faintly visible over the sanctuary, where the shell had been. We were only able to photograph a few of the remaining delicate features. The pathetic ruin was in its last stages of life, the work of treasure hunters all too evident in the destruction of its walls. Beside that sad church was a cemetery, where tombs with brief, chiseled words eternalized their owners. It was eerily quiet except for the trickle of a rivulet running through the rocky ground.

We said goodbye to the landscape and all its ruined treasures, and drove over a pretty good road to Nogales, where we had a very good meal, in spite of the fact that the head waiter put us in a separate room from the other American tourists, because we showed the signs of eight days in the field! Across the border there was a very well-known ice cream parlor, where we had the courage to eat our first ice cream in eight days, a real delicacy! George covered the last 60 miles to Tucson, flying along the unfrequented road, and we arrived at the Arizona Inn with all our limbs in good shape. What a unique and rewarding experience! The lovely fruits and flowers in tragic decline at Cocóspera reminded us once again what a treasure house of magnificent and beautiful art Mexico was, when its treasures were preserved and cared for. What a loss to all of us that enough funds to save such wonderful buildings and works of art probably will never be available!

Since then we have made other trips to Mexico, but none as enchanting, and with such thrilling revelations, as on those first, early journeys. As so many visitors have discovered, Mexico is inexhaustible.

ABOUT THE TYPE

THIS BOOK WAS SET IN BEMBO, a typeface that originated in Venice, Italy, an important typographic center in fifteenth- and sixteenth-century Europe. It was first used for Cardinal Bembo's tract *De Aetna*, published in 1495 by Aldus Manutius. Next to Gutenberg, Aldus was perhaps the most influential printer of the Renaissance and the first of many great scholar-printers. The original type was cut by Francesco Griffo, a goldsmith turned punch-cutter.

The typeface became eminently popular in Italy, and soon found its way into France. The design came to the attention of Claude Garamond, the famous French type founder, and through his efforts to duplicate the design, eventually spread its influence to Germany, Holland, and the rest of Europe. The Aldine roman, as it came to be known, became the foundation of new typeface designs for hundreds of years.

In 1929, The Lanston Monotype Company of Philadelphia used antique books and specimen material set with Aldus' original fonts as the foundation for their revival of the Bembo type. In the 1980s, Monotype produced a digital rendition of their original metal revival.

INDEX

PÁL KELEMEN served in the Hungarian cavalry during World War I (which inspired his *Hussar's Picture Book: From the Diary of a Hungarian Cavalry Officer in World War I*). In 1931, the young officer-turned-art historian was traveling in Europe, studying art and architecture, when he met his future wife, Elisabeth Zulauf. Elisabeth, born to privilege in the United States, was a protégé of the famous opera star Sigrid Onegin and was touring with Onegin when she met Pál. The two married and soon were on their way to New York, where Pál became interested in pre-Columbian art, and then on to Mexico.

The next thirty years would see them travel all over the Americas, documenting Maya, pre-Hispanic, and colonial art. Their journeys spawned dozens of articles, papers, and eventually books on art, architecture, and the culture of the Americas, including the classic art history text, *Medieval American Art*. Elisabeth was not only Pál's chief photographer and collaborator, but wrote a book based on her father's life, entitled *A Horse-and-Buggy Doctor In Southern Indiana: 1825–1903*.

Other books by Pál Kelemen include *Battlefield of the Gods, Baroque and Rococo in Latin America, Folk Baroque in Mexico, Art of the Americas: Ancient and Hispanic, El Greco Revisited,* and *Vanishing Art of the Americas.*

JUDITH HANCOCK SANDOVAL studied art and anthropology at Ohio Wesleyan University, the University of Arizona, the University of New Mexico, and the Instituto de Bellas Artes in Mexico, D.F. She has been writing about and photographing Latin American art since 1967. The National Gallery of Art, the Fogg Art Museum at Harvard, the Western Americana Collection at Yale University, the National Bank of Nicaragua, and Tulane University's Latin American Library own more than 150,000 of her photographs. Her archive of 30,000 photographs of historical Mexican buildings is part of the collection of the Centro De Estudios de Historia de Mexico Condumex. Her exhibition, "Folk Baroque in Mexico" sponsored by the Smithsonian Institution Traveling Exhibition Service, visited thirty U.S., Canadian, Mexican, and Spanish institutions. Pál Kelemen wrote the text for the exhibition catalog. In 1985 she collaborated with Elizabeth Weismann on the book, *Art and Time in Mexico/Art and Sculpture in Colonial Mexico*. Her photographs and articles have appeared in six books and many magazines and journals. For six years, her exhibition "Historic Ranches of Wyoming" toured the Rocky Mountain region and Europe, where she lectured. Currently, Sandoval is photographing historic cities in North America, Scandinavia, and Spain. She was a friend and colleague of the Kelemens for thirty years; they convinced her to make her career in Latin American art.

MARY E. MILLER is the Vincent J. Scully Professor of the History of Art and the Master of Saybrook College at Yale University. She has served as chair of both the History of Art Department and the Latin American Studies Program at Yale and is a leading expert on Maya art and architecture. She earned her Ph.D. from Yale in 1981 and joined its faculty in the same year. The author of many books on Maya and Mesoamerican art, she was the guest curator of the National Gallery's 2004 exhibition, "Courtly Art of the Ancient Maya," and co-author of its catalog. Professor Miller now directs the Bonampak Documentation Project, whose work has been supported by the National Geographic Society and the Getty Grant. Professor Miller came to know the Kelemens in the 1980s.

DIANE HALASZ met Pál and Elisabeth Kelemen as the bride of their great-nephew, Nicholas, to whom she was married to for 35 years. When the Kelemens moved to California, she became closer to them and spent a great deal of time with them in their later years. She has traveled to and photographed many of the sites in this book, and her photograph of Calakmul graces the cover. In the years since their passing, she has spent hundreds of hours at both Tulane University and the University of Arizona, and with other relatives and friends of the Kelemens, helping to compile their extensive letters, journal entries, and photographs for this book.

Abracadabra: Mexican Toys
(Amaroma)
ALDRETE/MORENO

A vibrant, colorful pictorial of handmade folk art toys, including dolls, puppets, and tops, accompanied by poetic, insightful text. Available in English and Spanish editions.

Antigua California
(University of New Mexico Press)
HARRY W. CROSBY

The definitive history of Baja California during the peninsula's mission and colonial frontier period. Includes maps and illustrations.

Baja Legends:
Historic Characters, Events, Locations
GREG NIEMANN

The popular journalist and author of *Baja Fever* shares his knowledge of the peninsula—its colorful past, unique populace, and amazing lore. Photographs and maps.

California's El Camino Real
KURILLO/TUTTLE

The story of the important roadway, from its beginnings in Baja California to the present day, focusing on the groups that helped save the road and its bells.

Caminos de Baja California/
Roadside Geology of Baja California
(Minch)
MINCH/LEDESMA VÁSQUEZ

The fascinating geology to be found along the highways of Baja California, with road logs for self-guided trips. Available in English and Spanish editions.

Casas del Mar/Houses by the Sea
(Amaroma)
ALDRETE/MORENO

Stunning full-color photographs of the architectural delights to be found on the Pacific Coast of Mexico, with text by architects and owners. Available in English and Spanish.

Cave Paintings of Baja California, Revised Edition
HARRY W. CROSBY

This full-color account depicts the author's journeys to, and documentation of, hundreds of world-class rock art sites in remote central Baja. Maps and illustrations.

Gateway to Alta California
HARRY W. CROSBY

The Portolá expedition to San Diego in 1769, through the then-unexplored wilderness of northern Baja California. Includes photographs and full-color route maps.

Casas de Cabos/Houses of Los Cabos
(Amaroma)
ALDRETE/MORENO

Gorgeous full-color photographs of the Cape's modern architecture, cleverly integrated into the starkly beautiful landscapes of Los Cabos. Available in English and Spanish.

Journey with a Baja Burro
GRAHAM MACKINTOSH

Travel with the author and his trusty companion, Misión, 1,000 miles along the old mission trail from Tecate to Loreto for the tricentennial of the former capital.

Lands of Promise and Despair
(Heyday Books)
BEEBE/SENKOWICZ

Early California history, as told through first-person writings of many Hispanic and Mexican-American pioneers of California. Illustrations.

Loreto, Baja California: First Mission and Capital of Spanish California
(Tio Press)
ANN O'NEIL

A comprehensive illustrated history of the small, quiet seaside town that was the first capital of Spanish California, from the indigenous peoples to the modern inhabitants.

Mission Memoirs
TERRY RUSCIN

This award-winning full-color book is a collection of historic vignettes, modern photographs, and poetic reflections on the missions of Alta California.

The Baja California Travel Series
(Dawson)
VARIOUS AUTHORS

More than a dozen titles in this hard-to-find series of Baja California histories, including *The Natural History of Baja California* by Miguel del Barco.

www.sunbeltbooks.com

La fonda
The Inn at the End of the Trail
Santa Fe, New

October 9, 1936.

Dearest Daddy !

 There was not enough time before de
scribe the Jung lecture, so I shall begin wit
had interesting sidelights to offer on folk-
logy - in which of course we are deep here.
on collective ideas (Begriffe), bringing out
that certain general and accepted symbols, suc
ose and the circle for unity, the idea of dual
cal and spiritual - etc. present in pre
present in the individual wh
contact with these
they neverthe
this by showi
ncient pictu
from dream
of his and
marked, a
ccepted s
ving solutions
s that there is
which manifests
taught, but rea
interesting c
to our heart

go was an ul
taining do
observation
very pret
n, as th
and leg-ro
light for spe
vertheless we ar
eered up conside
l her father smili
ation. Mr. E. too
ds - he had alread
our next train's
the compartment

RELIABLE
ONE BLOCK P

450 ROOMS AND BATHS
STEAM HEATED

HOTEL GENEVE

7ª DE LONDRES 130
MEXICO CITY
MEXICO

December 25, 1946.

Dear Helen :

 Merry Christmas!
 Please send the l
family (the diary of 2 1/2 pa
as they are doubtless st
they received before.
oes to Peter, please send
ress is:

 Mr. Peter Penzo-
 10 Boulevard de
 Geneva, Swit

are moving along for us;
co City in a real cold
Institute this week, be
s no getting rid of a ca
for hours in overcoats i
in the sun will do wonde

a pleasant Christmas wit
along later to "trim the
rom the American Embassy
t - but certainly not as
ge-podge of customs, Mex
cial one of shooting off
s all night and putting
to add to the noise. Is
r New Year, I wonder??

n affectionate greetings to y

No 169.

PASSPORT

United States of America